Reconfiguring
Modernism

Also by Daniel R. Schwarz

AUTHOR

Narrative and Representation in the Poetry of Wallace Stevens (1993)
The Case for a Humanistic Poetics (1991)
The Transformation of the English Novel, 1890-1930 (1989; revised ed. 1995)
Reading Joyce's Ulysses (1987)
The Humanistic Heritage: Critical Theories of the English Novel from James to Hillis Miller (1986)
Conrad: The Later Fiction (1982)
Conrad: Almayer's Folly *through* Under Western Eyes (1980)
Disraeli's Fiction (1979)

EDITOR

The Secret Sharer (Bedford Case Studies in Contemporary Literature) (1997)
The Dead (Bedford Case Studies in Contemporary Literature) (1994)
Narrative and Culture (coeditor) (1994)

Reconfiguring Modernism

Explorations in the Relationship between Modern Art and Modern Literature

Daniel R. Schwarz

St. Martin's Press
New York

ISBN 0-312-12655-7 cloth
ISBN 0-312-12660-3 paperback

Library of Congress Cataloging-in-Publication Data

Schwarz, Daniel R.
 Reconfiguring modernism : explorations in the relationships
between modern art and modern literature / Daniel R. Schwarz.
 p. cm.
 Includes bibliographic references and index.
 ISBN 0-312-12655-7 (alk. paper)
 ISBN 0-312-12660-3 (paperback)
 1. Art and literature. 2. Modernism (Literature) 3. Modernism
(Art) I. Title.
PN53.S38 1997
809'.93357—dc21 97-3588
 CIP

First edition: September, 1997
10 9 8 7 6 5 4 3 2 1

For Marcia Jacobson and my sons, David and Jeffrey

Contents

Acknowledgments

I am indebted, as always, to my Cornell students over the past three decades and the participants in my NEH seminars for College and School Teachers. I wish to thank Anne Marie Ellis for her editorial and research assistance, and Irene Perciali for her research assistance. Lisa Melton provided invaluable secretarial support. I would also like to thank Lee Konstantinou, Stephanie Mullette, and Teresa Young Reeves. It has been a pleasure to work with my St. Martin's editors, Maura Burnett, Alan Bradshaw, Ruth Mannes, and Garrett Kiely. My greatest debt is to Marcia Jacobson, whom I acknowledge in my dedication.

Preface

In this work what I want to do is suggest diverse directions for studying the relationship between modern literature and modern art. I am interested in the high modernist period from 1890 to 1940, and how we understand the cultural interrelationships of that period. My method is to work from the inside out, drawing on specific texts and paintings to suggest sources, parallels, correspondences, continuities, and affinities. My emphasis is both on strategies of seeing relationships and on locating some cultural patterns. By juxtaposing works of art and literature, we shall consider texts—visual and written—of the modern period as a contoured textual field without absolute borders. My principle focus is works in English, but I refer often to works in other literary traditions.

I think of myself as a curator of a museum, selecting for my reader from among diverse possibilities the examples I would like to share. Some of the chapters focus on sources and influence; other chapters—for example, chapter 6, "Searching for Modernism's Genetic Code: Picasso, Joyce, and Stevens as a Cultural Configuration"—ask what happens if we think about these works and writers together. That chapter not only argues for specific relations among those writers, but suggests how a humanistic version of cultural studies might work. I imagine my book to be a contribution to the debate about how we define cultural studies and, specifically, whether Marxist explanations need to be given preference over all others or, alternatively, whether socio-economic explanations for artistic creation are no more valuable than other ones. The chapters follow a rough historical movement from the late nineteenth century to World War II. We shall also explore how European Modernism was influenced by African, Asian, and Pacific island cultures.

The first chapter, "'I Was the World in Which I Walked': The Transformation of the English Novel," discusses how modern literature and art differ from their nineteenth-century predecessors. In this chapter I show how modern authors use innovations in form to dramatize their own psyches and values and how form begins to become as important, if not more so, than content. I also examine how the reader and perceiver is asked

to play a more active role in recomposing discrete formal units. The following chapter on Manet and James, "Manet, James's *The Turn of the Screw*, and the Voyeuristic Imagination," focuses on changes in the way humans perceive one another and are perceived and relates these changes to a variety of cultural forces, including the invention of photography. The chapter also examines how these changes in looking at and being looked at play out in such diverse texts as Mann's *Death in Venice* and Conrad's *The Secret Sharer*. In the third chapter, I argue that in all likelihood, Conrad knew Gauguin's text *Noa Noa*, his journal of his visit to Tahiti, when he wrote *Heart of Darkness* and that his characterization of Kurtz's reversion to savagery and Marlow's temptation to abandon Eurocentric values is in part as a response to Gauguin. Chapter 4, comparing T.S. Eliot and Cézanne, discusses the formalist and classicist strands of Modernism; while considering the possibility that Eliot was influenced directly by Cézanne, I differentiate between Cézanne's secular formalism and Eliot's Christian formalism.

The fifth chapter, "Painting Texts, Authoring Paintings: The Dance of Modernism," examines diverse ways that we might "read" paintings and explores various issues in cultural studies, including the place of the aesthetic. Clearly, Picasso and Matisse were influenced by each other's work, but my focus is on how we read paintings as narrative and how we read the intertextual relationship between painters. Finally, the seventh chapter, "'Spiritually Inquisitive Images': Stevens's Reading of Modern Painting"— which follows "Searching for Modernism's Genetic Code: Picasso, Joyce, and Stevens as a Cultural Configuration"—explores how Stevens uses twentieth-century painting in his work. Stevens was fascinated by Picasso and was profoundly influenced by modern art.

In her fine study, *The Eye in the Text*, Mary Ann Caws has written of her own efforts to juxtapose painting and literature: "It is certainly not a question here of influence of one art on another, but of their meeting in the place of the mind's own reflection in its working" (5). My goal is to try to convince my reader that what follows is not merely "the mind's own reflection" but cultural agons that are crucial to our understanding both of Modernism— what we call the modernist imagination—and of ourselves in the last years of the twentieth century.

<div align="right">

Daniel R. Schwarz
Ithaca, New York

</div>

Introduction

I. Toward a Definition of Modernism

For the past 30 years I have been studying literary Modernism. In this book I shall be speaking about some of the sources of the modern imagination. I have been struck about how little the relationship between modern art—painting and sculpture—and modern literature have been studied. What I am offering is a synthesis of and reflections on conjunctions of authors and artists. Often my argument proceeds by inference, nuance, and suggestion. Sometimes art and literature cross-fertilize one another; at other times they use the same source material for the creative act. I am looking for affinities; I am not suggesting that these writers always knew the work of artists, but at times I suggest that in all probability they did. We shall use art to read literature and literature to read art. We shall see that the use of disparate elements in juxtaposition is central both to Cubist collage and to modern narrative. The experiments in technique and theme of Joseph Conrad, James Joyce, Virginia Woolf, T. S. Eliot, and Wallace Stevens parallel the challenges to mimesis in Henri Matisse, Pablo Picasso, and Paul Klee. Their experiments in color, line, space, and abandonment of representation provided a model for writers, who challenged traditional narrative linearity and concepts of lyric. My own story of Modernism is a quarry of memories, recollections, images, metaphors. This seems appropriate for a tradition that is part elegy, part nostalgia for a time before the fault line between present and past, and part a self-conscious enactment, like Picasso's collages, of fragmentation.

Modernism in painting took diverse paths. Cubism fractured objects into component planes and dramatized diverse perspectives, which the perceiver would presumably reconstruct into the object in space as the painter had imagined it. Surrealists, such as Max Ernst and Georgio de Chirico, sought to tap the emotional world of dreams and unconscious. Ernst was interested in presenting chance meetings and remote realities in a plane that was, according to traditional expectations, unsuitable to those objects. Theo Van Doesburg in *Art Concrete* called for art that was impersonal in execution and based on scientific or mathematical data. Indeed, Jean Metzinger and Albert Gleizes—notably in his book *Du Cubisme*—related

Cubism to Einstein's idea of relativity, a fourth dimension, and Modernist notions of simultaneity of perception. While nineteenth-century realists and naturalists held nature to be the center of the universe, various symbolists—antimaterialistic, antipositivistic—rejected rules of reason while exalting feeling, dreams, and mystery. Symbolists followed Schopenhauer, who believed that everything is an infinite succession of transitory phenomena and that everything is infinite.

Modernism sought new ways of doing what art always does: sharing the immediacy of artistic experience in an effort to connect oneself to the rest of the world. Picasso and Matisse never abandoned figure representation. Both depended on the fiction that art has access to the world; yet their art calls attention to an awareness of the fictionality of art. Art represents—signifies an a priori signified, perhaps a vision of the self or of others and/or of an anterior place and time—but does not copy the subject. Modern art depends on two forms of essentialism. First, it self-consciously and knowingly uses a web of signs, a condensation that renders what the artist sees as the essential nature of things; that condensation is mediated by conventions and, often, by a sense of audience expectations. When art critic John Elderfield discusses Matisse's technique, do we not think of Eliot's objective correlative? "The mental image he is painting condenses not the appearance of the subject but the feeling it evokes in him. The painted image that results will therefore correspond to that mental image—will become a transposed, realized form of that mental image—only when it evokes the same emotions that the subject itself did originally" (26). Second, following romantic antecedents, Modernism often embraced the view that the response to the nature of things needs to be *personal* and *engaged*—a mixture of what the mind perceives and what it creates.

We must not look for reductive consistency in our narrative of Modernism. Modernism depends on the interpretive intelligence of a reader's perspective. We need to look at assumptions from a postmodern point of view that is open to destabilizing shibboleths, but we also need to try to understand the world of modern authors and painters from a perspective that understands how they intervene, intersect, transform, and qualify the culture in which they are part.

As Charles Altieri notes, "Although the Modernist poets and painters worried a good deal about history as a general phenomenon, for the most part they had little interest in the specific texture of their own historical moment. Theirs was a lonely and, ultimately, self-regarding art, more concerned for the intensity and clarity of its constructed sites than for the social world out of which the sites were made, and to which they had to

return for their validation" (378). Lacking preconceived metaphysics, Modernism understands artistic creation as self-discovery. Playwright David Mamet once remarked, "What you say influences the way you think, the way you act, not the other way around" (quoted in Richards, 5). The very act of writing the word, painting the canvas, carving the stone—these shape the way the artists think and act.

Modernism is a response to cultural crisis. By the 1880s we have Nietzsche's *Gay Science* (1882-87) with his contention that God is Dead as well as Krafft-Ebing's revolutionary texts on sexuality; we also have the beginnings of modern physics in the work of J. J. Thomson. All challenged monistic theories of truth: Let us recall that *Origin of Species* appeared in 1859 and *Essays and Reviews*, which questioned the Bible as revealed history, in 1860; in the period from 1865 to 1870, Karl Marx began to publish *Das Kapital*, Alfred Nobel invented dynamite, Otto Von Bismarck and Benjamin Disraeli dominated Europe, and colonialism expanded its reach.

Modernism is paradoxically both an ideology of *possibility* and *hope*—a positive response to difficult circumstances—and an ideology of *despair*—a response to excessive faith in industrialism, urbanization, so-called technological progress, and the Great War of 1914 to 1918 as the War to End All Wars. Notwithstanding some notable exceptions, such as Woolf's *To the Lighthouse* and *Between the Acts*, the Great War is the absent signifier in much of the literature and art from 1914 to well into the 1920s. What does Claude Monet's obsession with water lilies in 1917-18 tell us about his historical sense and the position of the artist? Is the site of the classical in Eliot and Joyce a response to the disorder and chaos of the war? In 1922, the year of *The Waste Land* and *Ulysses*, Jean Cocteau's version of Sophocles's *Antigone* was staged in Paris with sets by Picasso. Yet *where* is the Great War in either Eliot or Joyce? And what do Stevens, Matisse, and Picasso have to say about the Holocaust? As Paul Fussell writes in *The Great War and Modern Memory*, "[The Great War] was a hideous embarrassment to the prevailing Meliorist myth which had dominated the public consciousness for a century. It reversed the idea of Progress" (8). Yet it is well to remember that Arnold's "Dover Beach" (1859, 1867) speaks of a world without "certitude, nor peace, nor love, nor light" where "ignorant armies clash by night." In "The Darkling Thrush" (1900), Hardy uses ironically the traditional romantic image of the bird's association with poetry, song, and joy (Keats's "Ode to a Nightingale," Shelley's "To a Sky-Lark," Hopkins's "The Windhover"); he grimly sees the departing century as a skeleton, and imagines the thrush throwing itself upon the gloom. Both Hardy and Arnold anticipate the angst and dubiety of Eliot.

In response to the Great War, Matisse's paintings became more disciplined and less decorative; compare the sensuality of *The Red Studio* (1911) with *The Piano Lesson* (1916), with, as Kenneth Silver writes, "[its] narrow horizontal band of arabesques formed by the continuous frieze of the music stand and the balustrade and, at his right, . . . a tiny Matisse bronze of a lounging nude, who tauntingly suggests the sensual fulfillment and [aesthetic flights]" of the past (35). Yet *The Piano Lesson* owes much to the formal rigor of Cubism; Matisse redid it as the less abstract *The Music Lesson* (1917). Picasso reverted to pre-Cubist themes and representation. Note that Matisse and Picasso exhibited jointly at Galerie Paul Guillaume in 1918, as if, in celebration of the war's end, they would, at least temporarily, suspend their lifelong rivalry.

Modernism, as James Clifford notes, takes "as its problem—and opportunity—the fragmentation and juxtaposition of cultural values" (117). Isn't Modernism a search for informing principles that transcend cultures *as well as* a recognition of both the diversity and continuity of culture? Modernism sought to find an aesthetic order or historic pattern to substitute for the crumbling certainties of the past. Yet at the same time Modernists were aware that the order was elusive—as Eliot put it, fragments, to shore against the ruins of their present lives. Certainly *Ulysses*, where Joyce defines a pacifistic, humanistic, urban, family-oriented Jew whose adventures take place within the space of his mind, does both, and Picasso's *Les Demoiselles d'Avignon* (1907)— with its ethnographic masques in a European brothel fronted by a still life— affirms a delicate balance between tradition and innovation, between the quest for order and inchoate forces of anarchy and misrule within the work. Yet within each of these seminal texts are strands of irony and disunity, for the fragmentation—the 18 techniques in *Ulysses*, the breakdown of representation and perspective in *Les Demoiselles*—undermines the possibility of a unilateral perspective giving shape and coherence to a single vision.

As we shall see, Modernism goes beyond previous cultures in engaging otherness and questioning Western values. As Clifford notes, in 1900 "'Culture' referred to a single evolutionary process." He articulates an important aspect of Modernism:

> The European bourgeois ideal of autonomous individuality was widely believed to be the natural outcome of a long development, a process that, although threatened by various disruptions, was assumed to be the basic, progressive movement of humanity. By the turn of the century, however, evolutionist confidence began to falter, and a new ethnographic conception of culture became possible. The word began to be

used in the plural, suggesting a world of separate, distinctive, and equally meaningful ways of life. The ideal of an autonomous, cultivated subject could appear as a local project, not a *telos* for all humankind. (92-93)

Modernism contains the aspirations and idealism of nineteenth-century high culture and the prosaic world of nineteenth-century city life; both are colored by an ironic and self-conscious awareness of limitation. Often convictions are framed by or within an ironic stance, an awareness of the difficulty of fulfilling possibility. Prior to Modernist questioning, the possibility of a homogeneous European culture existed. As Elderfield puts it, "history was not always thought to be quite possibly a species of fiction but once comprised a form of order, and might still" (*Matisse in Morocco*, 203). In "Tradition and the Individual Talent," Eliot wrote that tradition meant writing with a historical sense that

> compels a man to write not merely with his own generation in his bones, but with a feeling that the whole of the literature of Europe from Homer and within it the literature of his own country has a simultaneous existence and composes a simultaneous order. . . . No poet, no artist of any art, has his complete meaning alone. His significance, his appreciation is the appreciation of his relation to the dead poets and artists. You cannot value him alone; you must set him, for contrast and comparison, among the dead. I mean this as a principle of aesthetic, not merely historical, criticism. (4)

Modernism contains the prosaic, thick textures of high and low culture, and ironic awareness of its own self-consciousness. Modernism focuses on the vernacular in painting—Cézanne's card players, Degas's laundresses, Picasso's whores, café life, and circus performers—just as writers like Thomas Hardy and D. H. Lawrence not only include the working class, agrarian workers and miners but focus on their lives and aspirations. Yet writers such as William Butler Yeats, Joyce, and Lawrence also believed in the power of art and in the artist as visionary prophet. Joyce believed that he—the artist hero—along with his humanistic, pacifistic, family-oriented, secular Jew Bloom, could be the heir to Charles Parnell as the hero that Ireland required. Justifying the Dadaists and his own retreat to Zurich during World War I, Hans Arp wrote, "We were seeking an art based on fundamentals, to cure the madness of the age, and a new order of things that would restore the balance between heaven and hell" (quoted in Marcus, 1). Yeats and Joyce belonged to the Irish tradition, which believed in the power of art; it believed

that artists could become possessed by inspirational forces and reveal hidden truths. Phillip Marcus argues, "As seers, the bards had direct access to ideal images. Viewed historically, those images were to be found in the past, closer in time to the Edenic or pre-lapsarian state, and in sacred texts where they had been embodied by bardic predecessors and preserved through a tenaciously conservative tradition" (8).

Modernism is often a dialogue between Platonism and empiricism. In contrast to Eliot's empiricism, one strand of Modernism—what we might call the Platonic strain—believes in the power of art to reveal higher truths, invisible reality. Yeats, a Neoplatonist, felt that Joyce and Pound were seduced and enslaved by whatever happened to enter their minds. For Yeats, whom we now categorize as a Modernist, Modernism often meant values he ostentatiously rejected: positivistic science, Newtonian physics, pragmatism, democracy, and a kind of naturalism he abhorred. Rather naively, Yeats articulated a credo of purity of mind and ascetic contemplation; he mourned the gradual loss since the eighteenth century of an organic community and a systematic world view. He would have agreed with Klee: "Today the reality of visible objects has been revealed and the belief has been expressed that, in relation to the universe, the visible is only an isolated case and that other truths latently exist and are in the majority" (quoted in Di San Lazzaro, 112).

Modern painting is a journey toward abstraction; yet abstraction expresses meaning, often—as Wassily Kandinsky argued in *Concerning the Spiritual in Art*—transcendental ideas. He believed that contemporary humans had lost their ability to see the spiritual and that *his art* could awaken dormant imaginative, intuitive, and inspirational powers. Abstraction was often part of the Symbolist movement, which sought to go beyond traditional representation to create higher realities and discover cosmic order. As Pepe Karmel writes, "The Symbolists rejected the scientific rationalism of late 19th-century society. Instead they sought new sources of faith, turning to pagan myth, Oriental religion and the childlike, uncritical Christianity of peasants. Or they decided that the real truth of human nature lay in the instinctual drives toward death and reproduction" (31). Kandinsky was influenced by Paul Gauguin's primitivism and mystical imagery and by Matisse's freeing color from naturalism and his outlined forms. Kandinsky was interested in synesthesia, the interrelationship between senses, and wanted to create a total art work, *Gesamtkunstwerk*, integrating painting, theater, music, and poetry. Influenced by Aleksandr Scriabin, he wrote *The Yellow Sound (Der Gelbe Klang)*. He also used colored lights symbolically: yellow is a "worldly color," while blue signifies spirituality. Like Diaghilev's Russian ballets, Matisse's *Dance I* and *II* and *Music* are efforts to integrate painting, dance, and music.

Picasso never abandons the human subject, and in fact except for the brief analytic Cubist period and concomitant enchantment and dialogue with Georges Braque, he retains a strong interest in the human subject, as do the literary Modernists that we will discuss. While Picasso anticipates abstract art, in his early work he begins with academic art before moving to a Corot phase and later to a Manet phase; and in his later years he is fixated by such traditional works as Velasquez's *Las Meninas* and Manet's *Déjeuner sur l'herbe.*

One cannot cite the exact moment when color and form begin to share with subject the focus of painting. When we see Vincent Van Gogh's *La Salle de danse à Arus* (1887), we know something has happened and that explosive blocks of color, seething dynamic lines, the materiality and *energy* of paint have changed the very nature of painting. Painting expands infinitely until one subject is paint, whether it is Camille Pissarro's layering or Claude Monet's experiments with light. When reading literature we always recuperate the word into subject. Yet, in modern painting, too, the stress on formal experimentation and stylistic innovation does not overwhelm the centrality of the subject. Even such an abstract figure as Klee believed in the centrality of the human subject. For Klee, it was nonoptical conceptions that paradoxically led to the humanization of the subject: "First of all there is the nonoptical conceptions of our common roots in the earth, which reaches the eye from below, and secondly, the non-optical approach of the cosmic community, which reaches from above." Finally, for Klee, "Art does not reproduce the invisible; it renders the visible" (quoted in Karmel, 120-1; 105).

Imagism in its effort to catch the response to experience at an intense moment parallels Impressionism—recall that Monet was painting his water lilies from 1912 to 1914—and in its formal rigor, precision, and effort to achieve objectivity parallels Post-Impressionism. In his 1913 manifesto, Ezra Pound called for hardness ("Direct treatment of the 'thing,' whether subjective or objective"), exactness ("To use absolutely no word that does not contribute to the presentation"), and cadence ("As regarding rhythm: to compose in sequence of the musical phrase, not in sequence of the metronome") (quoted in Ellmann and Fiedelson, 145). In Pound's two-line poem "In a Station of the Metro," he juxtaposes his response to an experience with an image that renders it: "The apparition of these faces in the crowd / Petals, on a wet, black bough." The poem evaluates and structures the experience as an epiphanic moment of revelation for the speaker. In the characteristic Modernist way, it is a poem about looking. Even if the first time we read from left to right and down the page, we can choose in these short poems— as a kind of exercise in seeing—to let our eyes rove on the page to discover

other patterns. Our memories of texts, particularly short texts, are rarely in narrative order but usually are partly visual, even if the visual may have the distortions of dreamscapes.

Modernist texts such as *Ulysses, The Secret Agent, Mrs. Dalloway, The Waste Land* and *The Love Song of J. Alfred Prufrock* show the intricate network that holds together the modern city. The city—and the texts about the city—rescues space from neutrality, laying invisible tracks of human connection, even while highlighting terrible moments of marginalization, isolation, and loneliness. The self is cut loose from its spiritual attachments, often from family, and from a common place, such as a village or a piece of land. The Jews— embraced by Joyce, rejected by Eliot and Pound—become an image of the deracinated rootless self. Eliot's pejorative image of the Jew in *Gerontion* is the obverse of Bloom:

> And the jew squats on the window sill, the owner,
> Spawned in some estaminet of Antwerp,
> Blistered in Brussels, patched and peeled in London.

Modernism responded to modern urban culture. As Conrad and Eliot—and Charles Dickens before them—saw, the city can be huge, drab, dirty. When Eliot writes in "The Love Song of J. Alfred Prufrock" of

> certain half-deserted streets,
> The muttering retreats
> Of restless nights in one-night cheap hotels
> And sawdust restaurants with oyster shells,

he asks us to recompose the city's fragments into our mental neighborhood. The vast interconnections of elaborate canvases with their separate neighborhoods such as Matisse's *Moroccans* and Picasso's *Guernica*—or Eliot's "Prufrock" and *The Waste Land*—as well as novels with one-word titles that imply pulling together vast networks of relationships such as *Ulysses* and *Nostromo* may be the result of living in cities or imagining the city as a labyrinth. Such large canvases and texts are pulled together by a willful and often visionary overview. While leaving the city to experience cultural otherness and difference, Matisse, and Gauguin before him, never left its imaginative environs. Underneath Gauguin's Tahitian paintings and Matisse's Moroccan paintings is the wish to resolve the difference, diversity, busyness, and commotion of urban life into a unified and even reductive picture.

Modernism stressed that we lack a coherent identity and sought techniques to express this idea. Stressing how each of us is changing every moment, Henri Bergson wrote in *Creative Evolution*, "Duration is the continuous progress of the past which gnaws into the future and which swells as it advances. . . . the piling up of the past upon the past goes on without relaxation. In reality, the past is preserved by itself, automatically. In its entirety, probably, it follows us at every instant; all that we have felt, thought, and willed from our earliest infancy is there, leaning over the present which is about to join it, pressing against the portals of consciousness that would fain leave it outside" (Ellmann and Fiedelson, 725). Bergson continues: "What are we in fact, what is our *character*, if not the condensation of the history we have lived from our birth . . . ?" (ibid, 725). Note the parallel to Bakhtin's concept that when each of us speaks or writes, our prior systems of language voluntarily and involuntarily manifest themselves in a heteroglossic voice. Given the multiplicity and ever-changing nature of self, each of us has multiple selves and points of view; that shared perception of Modernism is a cause of the dramatized consciousness of James and Conrad, Joyce's diverse techniques in *Ulysses*, and the development of Cubism. Is there not a continuity between Oscar Wilde's concept of lying and Henri Bergson's of duration in their effect to transform the tick tock of passing time—what the Greeks called *chronos*—into significant time, or *kairos*? Wilde, hounded for his homosexuality, created a masque of the aesthete and decadent who flouts conventions of society.

Bergson's example of consciousness in terms of color might have both reflected and informed Fauvist experiments with color:

> But just as consciousness based on color, which sympathized internally with orange instead of perceiving it externally, would feel itself held between red and yellow, would even perhaps suspect beyond this last color a complete spectrum into which the continuity from red to yellow might expand naturally, so the intuition of our duration, far from leaving us suspended in the void as pure analysis would do, brings us into contact with a whole continuity of durations which we must try to follow, whether downwards or upwards. . . ." (quoted in Ellmann and Fiedelson, 729)

In *Notes of a Painter*—a text begun in November 1908, Matisse wrote, "Underlying this succession of moments which constitutes their superficial existence of being and things, and which is continually modifying and transforming them, one can search for a truer, more essential character,

which the artist will seize so that he may give reality a more lasting impression" (quoted in Flam, 37). We see the obsessive presence of the past in Matisse's paintings, but in *The Red Studio* (1911; Museum of Modern Art)— full of references to his prior work—we also see the promise of the future in the plant as well as in the crayons and pencils that will be used to create a work of art. The clock without hands both suspends time, while paradoxically calling attention to its perpetual presence of time, and expresses an awareness that clock time is an arbitrary measurement imposed by humans. Such self-consciousness about the self as an artist revealed as self-referentiality is characteristic of Modernism. It is a feature of Eliot's and Stevens's poetry and is exemplified by the continuity of Marlow and Stephen Dedalus in the works of Conrad and Joyce. Thus in the "Scylla and Charybdis" chapter of *Ulysses*, Joyce calls attention to the presence of Shakespeare the artist in his artistic creations as a way of teaching us how to read Stephen as a surrogate for Joyce in his epic novel.

Matisse and Picasso represent diverse streams of Modernism. Never far from the here and now or from bourgeois desires, Matisse wanted always to maintain a dialogue with, and response to nature, while Picasso sought to show that the imagination could do what it wished when it wished. Such a debate is mirrored by the artistic differences between the following pairs: Joyce and Lawrence, Eliot and Stevens, E. M. Forster and Woolf—with the second member of each pair emphasizing the independence of art from representation.

The Modernists thought of themselves as essentialists and often tried to insulate art from history and even to apotheosize the aesthetic. While aestheticism is an ironic comment on materialism, it is also another form of essentialism. Why did so many Modernists excuse themselves from the Great War and from history itself, while finding refuge in inner systems, "play" politics, or art as fetish? Modernism's focus on the past can be a way of eschewing present-day politics and history. At times the retreat to art is an escape from history and leads to a kind of historical myopia. In *Death in Venice* Mann analyzes the necessary relationship between the two. Among other things, *Death in Venice*, Kafka's *Metamorphosis*, and Tolstoy's *The Death of Ivan Ilych* are about the impossibility of escaping history. The effort to eschew history by Matisse, Picasso, Stevens, and Eliot has been ironized by history. That the past is a relentless fury is an important Modernist theme; yet, paradoxically, at times Modernists have a myopic view of the past. Mann dramatizes how Aschenbach idiosyncratically turns myth and history into versions of his own life; Mann weaves a perspective in which Aschenbach, imagining himself to be Socrates, inevitably is caught in the web of his own

making. In his understanding of how we myopically turn the subjective into seemingly objective reality, Mann provides a postmodern critique on Modernism. Yet paradoxically—and inevitably—he does the very thing he critiques in Aschenbach; he creates a myth out of his own experience. Indeed, he is an ironic Dedalus, a maker of his own labyrinth.

For the great Modernists, art was a quest; as Jack Flam writes of Matisse and Cézanne, "great painting was not merely a matter of stylization and technique but the result of deeply held convictions about vision in relation to life" (17). While the impulse to make oneself the subject of one's own art includes Rembrandt's self-portraits, the impulse crystallized in the nineteenth century with Gustave Courbet's *L'Atelier* (1854-55), known as the "Real Allegory Determining a Phase of Seven Years of My Artistic Life," with its intense focus on Courbet at work. In the middle of that painting is a godlike Courbet with a model—if I may quote Julian Barnes, "reinventing the world . . . and perhaps this helps answer the question of why Courbet is painting a landscape in his studio rather than *en plein air*: because he is doing more than reproducing the known, established world, he is creating it himself. From now on, the painting says, it is the artist who creates the world rather than God" (3). Does not this description recall Stephen's argument about what the artist does in the "Scylla and Charybdis" section of *Ulysses?*

To suggest his own biographical relationship to *Ulysses*, Joyce has Stephen propose his expressive theory of the relationship between Shakespeare's art and life. What makes Shakespeare a man of genius is that he encompassed in his vision "all in all in all of us" (Gabler, Steppe, Melchoir, IX. 1049-50).* Joyce re-creates Shakespeare according to his own experience of him and thus becomes the father of his own artistic father and the artist whose imagination is so inclusive and vast that it contains the "all in all" of Shakespeare plus the very substantial addition—or, in current terminology, the supplement—of his own imagination. Like Joyce, Shakespeare used the details of everyday life for his subject: "All events brought grist to his mill" (IX. 748). The major creative artist discovers in his actual experience the potential within his imagination: "He found in the world without

* Quotations refer to *Ulysses: A Critical and Synoptic Edition*, edited by Hans Walter Gabler with Wolfhard Steppe and Claus Melchior (London and New York: Garland, 1984), hereafter abbreviated as *U*. Episode and line number refer to the Gabler edition. Where there is a change in the Gabler edition from the 1961 Random House edition, I have underlined the episode and line number.

as actual what was in his world within as possible" (IX. 1041-42). To activate that potential, the artist must have as wide a range of experience as possible; to get beyond the limitations of his own ego in order to achieve the impersonality and objectivity that is necessary for dramatic art, his imagination must have intercourse—and the sexual metaphor is, I think, essential to understanding Joyce's aesthetic—with the world: "His own image to a man with that queer thing genius is the standard of all experience, material and moral" (IX. 432-33).

Joyce, like Mann, is aware of the irony of his youthful artist comparing himself to the master artist or thinker. Joyce's relationship to Stephen in "Scylla and Charybdis" reaches a turning point when he twice penetrates Stephen's mind to show Stephen briefly imposing dramatic form on his experience by using the traditional typography of plays to organize his monologue (*Ulysses*, IX. 684ff, 893ff). In the second and longer instance, a play that lasts little more than a page, Stephen is the major character speaking to his friends about the same issues that he has been discussing throughout the chapter. And the entire chapter puts the argument about the relationship between the author's life and his work in the form of a virtual monodrama. If, according to Stephen's theory, Shakespeare's transparently disguising his identity in his early work foreshadows *A Portrait of the Artist as a Young Man*, the more subtle disguises of biography in *Hamlet* anticipate the technique of *Ulysses*.

II. Metaphoricity

I understand metaphor as the use of words or images to suggest a resemblance between something that is part of the teller's or painter's focus of attention—part of his or her real or imagined world—with something that is not literally or actually a part of the phenomenon that is engaging his or her mind. Joyce's concept of metaphor not only defines the fundamental relationship between words and reality in *Ulysses*, but enables us to behold a paradigm of how metaphor works in modern literature and art. Since the unique aesthetic form of each major literary work creates its critical inquiry, *Ulysses*, with its emphasis upon linguistic patterns and its de-emphasis of traditional plot, requires serious discussion in terms of its language and internal verbal relationships. From our vantage point we can see that *Ulysses* is Joyce's inquiry into how language signifies; it is about the creation of metaphors and their importance as a means of understanding ourselves and the world we live in.

Joyce would have been skeptical about much of Deconstruction—particularly its skepticism about the signification of words—but he would have understood why Jacques Derrida quotes Nietzsche on metaphor: "Logic is only slavery within the bounds of language. Language has within it, however, an illogical element, the metaphor. Its principle force brings about an identification of the nonidentical; it is thus an operation of the imagination. It is on this that the existence of concepts, forms, etc. rests" (83). Joyce is interested in the process or "operation" of the imagination where something absent and nonidentical is summoned into the present to both enrich and be enriched by that present.

We might think of metaphor as a radical version of the copula "to be," for metaphor brings into existence something that is absent simply by declaring its presence. Both seek to transform, in Derrida's words, "a 'subjective excitation' into an objective judgment, into a pretension of truth" (84). Certainly metaphor depends on the ability of the verb "to be" to declare the presence of something absent from the immediate field of vision that the author is presenting to the reader. Metaphor is by definition synchronic and knows no temporal boundaries. Joyce's title *Ulysses* announces the metaphoricity of the novel; it announces "This man is Ulysses" in a novel in which Bloom, not Odysseus, is the major figure. By its implied use of the present tense of the verb "to be," metaphor summons what is absent from the literal world and by so doing implies what the world lacks. In the case of *Ulysses*, what is summoned are the historical figures and literary characters of the past; they in turn summon the cultural milieu and values of the historical era to which they properly belong. For the reader, the relationship between past and present is a continuing variable in the adventure of reading; as Wayne Booth notes, "What any metaphor *says* or *means* or *does* will always be to some degree alterable by altering its context" (*On Metaphor*, 173). And of course every chapter—indeed, every passage—provides different mixtures of historical and literary allusions and places its stress on different resemblances between contemporary and prior areas.

As we shall see, metaphoricity enables painters and artists to suggest relationships beyond the thematized subject and the formal arrangement on the canvas. Paintings, too, depend on patterns of allusion—patterns that are a kind of metaphoricity which we understand by means of contrast and comparison. That is another way of saying we perceive paintings intertextually; they are enriched by their antecedents and often their successors. We look at Velasquez's *Las Meninas* with new eyes in light of Picasso's fascinating series of late paintings based on Velasquez's works. Picasso's *Les Demoiselles d'Avignon* (1907) is enriched if we see it as a comment on Manet's *Déjeuner sur*

l'herbe or Cézanne's *Great Bathers*, just as we shall see his *Three Musicians* (1920) and *The Dance* (1925) take some of their meaning from their response to Matisse's *Dance I* and *II*, and *Music*.

The significant form of *Ulysses* depends on the kinds of metaphorical substitutions Joyce makes when he lets Bloom and Stephen be signified by literary and historical figures as well as by real and imagined cosmological events. Reading the novel establishes how Stephen and Bloom become metaphors or signifiers for one another as well as, in their potential fusion, a metaphor for the creative presence who narrates the novel. But Joyce's concept of metaphor includes both historical allusions that evoke the values and personalities of past eras and the styles he parodies to evoke a variety of perspectives, past and present. By showing his power to make whatever metaphoric and metonymic substitutions he wishes, Joyce shows that he is, as Stephen puts it in "Oxen of the Sun," the "lord and giver" of language, the God in his imagined world (U. 415; XIV. 1116). By creating an original world within his imagination, Joyce shows that the aspiring artist need not replicate the art of his artistic fathers, including Shakespeare, and can thus himself be the "father of all his race" and the "father of his own grandfather" (U. 208; IX. 868-69). *Ulysses* depends upon a continuing dynamic relationship between two members of a comparison. The comparison may be drawn between someone within the imagined world (Bloom) and someone whose identity derives from literary or historical sources (Odysseus); it may be drawn between two characters (Stephen and Bloom) who are part of the present imagined world of the novel's action; it may be drawn between, on the one hand, the characters (Stephen and Bloom) and, on the other, the fictionalized author (the narrative presence for whom the characters are dramatized metaphors); or it may be drawn between the fictionalized presence and the biographical author (Joyce). Metaphor in *Ulysses* depends, to adopt a distinction of Duerot and Todorov's, not merely on "words substituting for each other," but on the "syntagmatic relationship" or "the contiguity of words to each another" (quoted in de Man, 125). For modern paintings, we can replace "words" in the previous quote with "visual images." Thus Joyce is erasing the traditional distinction between metaphor and metonymy, a distinction that differentiates between metaphor, which depends on the necessary substitution of the figurative for the literal, and metonymy, which depends on the contiguity of two elements in a represented sequence.

Metaphoricity—the making of comparisons—is a way of bringing together apparently dissimilar entities for the purpose of revealing resemblances and differences. It is a resource of the individual imagination—developed more intensely and subtly in the artist—by which we extend our

experience. It can be a means by which we draw upon the experiences of others to supplement our own and to show the convergence between our experiences and those of prior eras. Joyce's search for recurring cultural experiences and for the language to describe those experiences is characteristic of the search in the later nineteenth and twentieth centuries for a common reservoir of cultural and human experience. We think of the work of James George Fraser (*The Golden Bough*), the Cambridge ethnologists, Nietzsche, Sigmund Freud, and, later, Carl Jung as they seek to locate a shared pattern of mythic and personal experience and to define a collective unconscious. As shared orthodox beliefs lost their hold after Darwin, the search for a common thread of universal experience was a central theme in the work of British moderns from Yeats and Eliot to Lawrence and Forster.

In the concepts of metempsychosis and parallax, Joyce believed he had discovered, respectively, mythical and scientific precedents for the kind of metaphoricity that depends not on substitution of one thing for another but upon simultaneous presence. Even if Joyce did not literally believe in the reincarnation of souls, the concept of metempsychosis provided him with a paradigm for his idea that people do not change. In *Ulysses*, where the principal metaphors are the representation of one person by prior ones, metaphoricity is a linguistic version of metempsychosis because it keeps alive someone who is absent by comparing him to someone who is present. Thus metempsychosis gave Joyce conceptual grounding for the metaphorical systems of *Ulysses*—most notably, the pattern of Homeric allusions— that derive from extended literary and historical correspondence. As we shall see, modern painting uses prior paintings in the same way.

One might argue that when one character stands for another in a contiguous relationship, we have metonymy rather than metaphor. But, I would argue, metonymy is simply a kind of metaphor where the signified is explicit or implicit in the world represented. One could say that metonymy, the substitution of a part for the whole or the whole for a part, is a metaphor depending on contiguity, that is, a metaphor that depends upon the reader's perception of the substitutions among elements *within the imagined world*. This horizontal concept of metaphor, depending upon combinations of words and concepts within a text, enables Stephen and Bloom to represent one another. The concept of parallax—the phenomenon that the same object appears different from different points of observation or from different perspectives—appeals to Joyce precisely because, like metonymical correspondences, it depends on the perceiver's resolving apparent differences within the same temporal plane. Just as parallax depends on the apparent difference of an object when viewed from different perspectives,

so historical, literary, or personal figures look different even while they actually are, in crucial ways, counterparts.

In *Ulysses*, the figure of Leopold Bloom substitutes for the absent Odysseus or Elijah or Shakespeare, the way in the line "my love is a red red rose," "red red rose" substitutes for "my love." But, in Joyce's mythic method, the pervasive metaphorical systems—*The Odyssey*, the life and works of Shakespeare, the Passover story and its rituals, the Christ story—become a supplement to what is already complete within itself, namely the story of Stephen and Bloom. Rhetorically, these metaphorical systems urge readers to understand that not only must they read literary texts, but, like the modern artist, they must "read" day-to-day life in the contemporary world within the context of an interpretive framework. In other words, the metaphoricity of the novel reveals not only that what is present requires something more but that whatever might be present in the contemporary world—a world that seems to lack purpose and meaning—would necessarily require the something more of metaphors.

Joyce's metaphoricity or, to use a pun Joyce might have approved of, *metaferocity*, illustrates his belief that examining the events of 16 June 1904 enables him to define what has been significant in human history and what can be significant in the future. Allusions for Joyce are kinds of metaphors that depend on the process of bringing the past into proximity with the present, as a way of giving synchronicity to the temporal or historical dimension. Because Joyce was skeptical about the supremacy of past eras or prior authors, his historical and literary allusions are not in the nostalgic mode of T. S. Eliot. For Joyce, Bloom's dignity, quiet courage, sense of self, humanity, and integrity are equivalent, if not superior, to the values glorified by Homer or even the Bible; for Joyce, the Bible is not a source of God's revelation but a humanistic narrative—and thus a model for *Ulysses*—that reveals humankind's hopes and aspirations.

When Eliot wrote of "the immense panorama of futility and anarchy which is contemporary history," in his famous *Dial* review of *Ulysses*, he is more accurately describing his own work than Joyce's (quoted in Ellmann and Feidelson, 681). Joyce writes less in the nostalgic mode than Eliot and perhaps even than his major contemporaries, Hardy, Conrad, Yeats, Lawrence, Forster, and Woolf. Manet, Cézanne, Picasso, and Matisse often use prior references less nostalgically and elegiacally and more as reference points for their own formal experimentation. What is unique about *Ulysses* is that prior literary and historical figures are not merely extrinsic to the text but are summoned into the world of the text. Let me overstate a distinction: In *The Rainbow* and even for the most part in *The Waste Land*, the author no

sooner brings together two distinct worlds than he satirically compares the modern world disfavorably to a previous one; by doing so, Lawrence and Eliot imply devolution from past to present and thus implicitly re-establish a diachronic perspective as an argument for the superiority of the past to the present. By contrast, *Ulysses* examines the modern world and prior ones by the same synchronic standards.

III. Cultural Criticism

As an interdisciplinary field that does not want to divide foreground and background reductively, cultural studies offers promising alternatives to formalism, particularly the parochialism of de Manian deconstruction, which would exclude author, history, themes, and subjects. Social and political contexts shape works of literature and are in turn shaped by them. Literature is, of course, a form of cultural production, but it is also many other things. Like other aspects of culture, what literature represents and signifies changes in response to changing historical conditions, and a text, like any social practice, means different things to different people and different eras. New historicism and cultural studies by the left have been useful in reminding us that texts, as Gerald Graff has put it, "are not, after all, autonomous and self-contained, that the meaning of any text in itself depends for its comprehension on other texts and textualized frames of reference" (256).

Cultural studies wishes to probe anthropologically into the practices that underlie a culture, but at times in its emphasis on symbolic constructions, it is in danger of missing the role of individual genius in the process of transforming the object of mimesis into the aesthetic object. Need we, it might be asked, totally abandon the category of the aesthetic? Do we want to focus only on the systematic social relations around social production, or do we not need to highlight what is produced? After we focus on the artistic creation as a function of forces, an object that needs to be contextualized and framed, should we not see how that object transforms the cultural and historical forces into something that is very much the artist's own?

We need to expand the frontiers of critical inquiry—or reclaim cultural and historical perspectives—without abandoning the aesthetic and the formal. Can we think of texts both as imagined ontologies and as reflections of an anterior reality? Does not the arrangement of words on a page, like the elements within a painting, by definition imply a spatial and temporal formal arrangement; do we not need arguments about genre,

structure, narrative codes, and conventions to describe such arrangements? Need we choose between aesthetic and hermeneutical approaches? For whatever our immersion in the aesthetic, we respond to words differently than we do to musical notes or colors. We understand them at once in terms of immediate experience. Our responses to "cancer" and "heart attack" and "brutality" and "Holocaust" within a novel or poem are conditioned by our experience of those words outside it.

Let us think whether we make distinctions between kinds of aesthetic experience. Do we differentiate between the quality of soap operas, on the one hand, and Picasso's, Joyce's, and Stevens's masterpieces, on the other? When we respond to art we distinguish between the quality of mimesis, its intensity, unity, integrity, and ability to create a structure of effects. Certainly we need to be aware of the world in which art is perceived and we need to study social practices, but is the study of literature to become a branch of sociology? Isn't it time to reclaim the aesthetic, not as the transcendent category but as one of several categories? What is the place of the aesthetic in cultural criticism? Indeed, what *is* the aesthetic? It is the category of the beautiful as opposed to the moral, the useful, and the utilitarian. It involves our emotional response as opposed to our rational response; it validates the sensuous response to art, and it acknowledges that there is something inherent in our reading that goes beyond the political and the ideological. Yet our aesthetic pleasure depends on how the form discovers the moral and political, and how the parts relate to the whole; it depends on the pleasures of seeing and reading and even thinking retrospectively about why a work or text or film pleases us. It may be a community experience when it includes our pleasure in sharing artistic experiences with our friends, students, teachers, and colleagues.

The category of the aesthetic acknowledges that we value beauty, wit, complexity, and subtlety; that we care about how the parts relate to the whole; that the quality of mimesis as well as its "truth claims" matter; that the way a work fulfills, modifies, and departs from generic expectations can be a part of our pleasure; that there is a difference between soap operas and *King Lear*. The aesthetic assumes that the category of art is different in some ways from other categories of life experience and that it matters. As M. H. Abrams has shown brilliantly in his study of romanticism in *The Mirror and the Lamp*, aesthetics should not be restricted to objective theories of art, but needs to include the relation of the artist to his art. It also needs to include, as Booth has shown in *The Rhetoric of Fiction* and elsewhere, how art shapes its audience. As in Aristotle's focus on tragedy

as an imitation not of persons but of action and life, it should also include how action imitates reality.

Objectivism still has, I believe, a place in aesthetic theory; as Abrams puts it, objective theories regard "the work of art in isolation from all the external points of reference analyzes it as a self-sufficient entity constituted by its parts in their internal relations, and sets out to judge it solely by criteria intrinsic to its own mode of being" (26). But the aesthetic goes beyond objective and ontological theories of art. Should we separate the aesthetic from the political and ethical? As Aristotle understands, aesthetic form—plot—enacts values, and we learn from the texts we read.

Do we not need to stress that literary works teach us and give pleasure? Painting and sculpture as well as literary works have a structure of effects created by their authors for the specific purpose of shaping our responses. The aesthetic can be expanded to include aspects of how poets achieve their telos by selection and arrangement of a structure of effects; in fact, objectivism can include the *doesness* of the text, its effects on the readers. The aesthetic also can include the kinds of imitations artists create, that is, the genres of art and the pleasures of responding to how the genres fulfill and depart from expectations. The aesthetic includes the wonderful human quality of curiosity, the zeal to know for its own sake about the authors and painters and the period in which they wrote. For each author or artist has a characteristic personality, a compendium of gestures, attitudes, values, and emotions, and we as human readers want to get to know that figure within—not behind or beyond—the text and to hear her *voice*. Our studying paintings, like our reading, contributes to greater self-understanding. Reading complements our experience by enabling us to live lives beyond those we live and to experience emotions that are not ours; it heightens our perspicacity by enabling us to watch figures not ourselves but, as fellow humans, like ourselves. For me, books are written about humans by humans for humans; for this reason, elaborate "theories" that ignore narrative and representational aspects of literature—or of painting and sculpture—in favor of rhetorical, deconstructive, or politically correct readings are unsatisfactory.

What is culture? The term derives from *cultus*, the past participle of *colere*, the Latin word for "to till" or "to cultivate." It means the state of being cultivated, especially the enlightenment and excellence of taste acquired by intellectual and aesthetic training; it also means the intellectual and aesthetic content of civilization and refinement in manners, taste, and thought. Canonicity is an aspect of this concept of culture. The concept of canonicity is not simply the imposition of a set of texts upon a culture; it is the very act

of cultural memory. Take classical music, which depends on creative interpretation of a received text. As Martin Mueller has pointed out in *Profession* 89 (23-31), when a musician plays Bach, she has an allegiance to the notes on the page. While the musician may be honored for an illuminating and insightful interpretation, she needs to respect the notes Bach or Mozart wrote on the page. So with our interpretations of Shakespeare, and our reading and perceiving the canon of literature and painting.

Culture also means the total pattern of human behavior and its products embodied in thought, speech, and artifacts; it is dependent upon the capacity of humans for learning and transmitting knowledge to succeeding generations through the use of tools, language, and systems of abstract thought. And it means the body of customary beliefs, social forms, and material traits that constitute the distinct, complex tradition of a racial, religious, or social group—such as Jewish-American culture or Mexican-American culture; it means also the complex of typical behavior or standardized social characteristics peculiar to a specific group, occupation, or profession, sex, age, grade, or social class. The cultural practices of various enclaves—black, Chicano, Asian-American (and its subdivisions, Japanese-American, Chinese-American, Vietnamese-American)—deserve a prominent place; the cultural practices of homosexuals and bisexuals deserve a place. But so do the practices and values of other hyphenated Americans: Jewish-Americans, Italian-Americans, Irish-Americans, and the way these practices have evolved from generation to generation and how their practices are in a continually evolving dialogue with the dominant culture's hegemonic values and with the other subcultures.

The concept of culture as high culture—the concept Arnold used in *Culture and Anarchy* (1869), culture as "a study of perfection"—still has a place among the diverse definitions of culture. It is such a concept of culture that Arnold had in mind in "The Function of Criticism." He wrote that criticism seeks "to know the best that is known and thought in the world, and in its turn making this known, to create a current of true and fresh ideas." For Matthew Arnold, criticism was a metonymy for culture, and culture meant the best that was thought and expressed. As Donald Kagan has remarked of the Western heritage, "More than any other, it has asserted the claims of the individual against those of the state, limiting its power and creating a realm of privacy into which it cannot penetrate" (23). What Western civilization has valued if not always practiced is democracy, tolerance, belief in the individual, respect for diverse views vigorously propounded. Our American version of the Western culture is a pluralistic and hyphenated one. We might read the Bill of Rights as an eloquent testimony of individual liberty—

notwithstanding the historical injustices committed in the name of the U.S. Constitution. What is happening in the former Soviet Union is that the individual is—not without resistance—being reclaimed from the collective, and the human and idiosyncratic personality is discovering a validation separate and distinct from cultural production. We need to recognize the place of humanistic perspectives in a multicultural environment and to include in our concept of cultural studies diverse forms of historical and social contextualism. We also need to include approaches that represent the humanistic and democratic traditions, traditions that have enabled the opening of the doors and windows of literature departments to more diverse, multicultural perspectives.

Multiculturalism is embedded in the Bill of Rights and our Jeffersonian democratic heritage, and we have belatedly, since the Civil War and Reconstruction, been trying—not without significant turmoil and setbacks—to reclaim that heritage. Our American traditions are different from the elitist European cultures where aristocracies and kings are part of the cultural heritage. The words of the Declaration of Independence are our ideals: "We hold these truths to be self-evident that all men are created equal." Do we not still subscribe to the ideals of Abraham Lincoln's words in the Gettysburg Address that ours is a "government of the people, by the people, and for the people"?

What form does a humanistic cultural criticism take? Lionel Trilling defines humanism as:

> the attitude of those men who think it an advantage to live in society, and, at that, in a complex and highly developed society, and who believe that man fulfills his nature and reaches his proper stature in this circumstance. The personal virtues which humanism cherishes are intelligence, amenity, and tolerance; the particular courage it asks for is that which is exercised in the support of these virtues. . . . The aspects of society that humanism most exalts are justice and continuity. (3-4)

We need to recognize the place of humanistic perspectives in a multicultural environment and to include in our concept of cultural studies diverse forms of historical and social contextualism. A humanistic cultural criticism is interested in cultural configurations of major figures and does not apologize for studying the canon in ways that include and supplement stories of influence. It considers the problem of studying living authors in contemporary culture; it is aware, too, of the world the readers inhabit in terms of similarities and differences from the author or artist being studied,

whether that artist is a living one—which creates different problems—or one from a prior period. It is alert to how interpretive history reveals the history of a culture's values and awareness, but it also knows that all critics are idiosyncratic just as authors are, and it would avoid reducing all cultural effects—either in the form of the created act or the reader's response—to socioeconomic explanations or micropolitical phenomena or polemics about the base and superstructure. It is dialogic in response to other cultures and other forms of cultural criticism. It also proposes a dialogue among the various cultural, social, and historical factors that are part of the warp and woof of culture as well as between history and literature and between literature and the other arts. While there is obviously a prominent place for popular culture in cultural studies, we also need to include discussions of value and how we determine value. If one criteria of value is what a work reveals about a culture, or how and whether it acutely represents political intricacies and power relationships, other criteria are surely whether a work is aesthetically pleasing, coherent, complexly unified, and attentive to diverse points of view, that is, dialogic.

One

"I Was the World in Which I Walked": The Transformation of the British Novel, 1890–1930

I.

In the Sculpture Garden of the Museum of Modern Art stands Rodin's large 1897 statue, *Monument to Balzac*. The imposing figure of Balzac is ten feet tall, and it rests on a five-foot-high slab. At first, the observer may wonder what this seemingly realistic piece is doing in the citadel of Modernism. But gradually he realizes that the work is a crystallizing image of Modernism, for it depicts the artist as outcast and hero. Towering above onlookers, Balzac is wearing an expression of scornful magisterial dignity. With back stiffly yet regally arched past a 90-degree angle, Balzac looks into the distance and the future as if oblivious and indifferent to the opinions of the Lilliputians observing him from below. The large mustache, massive brows, flowing hair, and enormous ears and nose all emphasize the figure's immense physical stature. As observers we crane our necks to see the features of this commanding figure whose gigantic head is disproportionate to his body. His features are boldly outlined but not precisely modeled. His huge head dominates the massive form; the body enwrapped in a cloak is a taut cylinder; the only visible feature is the feet, which are in motion as if they were going to walk off the slab. Indeed, one foot actually overhangs the slab as if it were about to depart. In the geometric shape of an isosceles triangle, the intimidating figure asserts the dependence of content upon form.

In a number of ways this sculpture, I think, helps us to understand literary Modernism. Rodin has presented the artist as an *Ubermensch*, as a physical and moral giant who is indifferent to the opinions of his audience. He depicts Balzac the way Rodin would have liked to see himself. "I think of [Balzac's] intense labor," he wrote, "of the difficulty of his life, of his incessant battles and of his great courage. I would express all that" (quoted in Elsen, 93). As Albert E. Elsen remarks, "Rodin has transformed the embattled writer into a godlike visionary who belongs on a pedestal aloof from the crowd" (101). Rodin's presence in the sculpture of Balzac speaks for art as self-expression and thus declares a new aesthetic that questions the impersonality and objectivity that Balzac sought in his role of moral and social historian of the human comedy. Rodin's Balzac is not someone who serves the community but someone who answers to the demands of his own imagination and psyche; he does not imitate reality but transforms what he sees into something original. He is more a visionary than a realist. His integrity derives from his genius and his independence. The sculpture shows, too, the inseparable relationship between subject and object—the poised tension between content (Balzac) and form (the original stone)—that is central to Modernism. Finally, Rodin understands that art requires an audience to complete the hermeneutical circle, for he declared that the suggestiveness of his Balzac required the viewer to use "the imagination to recompose the work when it is seen from close up" (quoted in Elsen, 102).

I would like to take the Rodin statue as a point of departure for speaking of the great change in major British fiction from the realistic to the expressionist novel, a change that begins roughly in 1895, the year of Thomas Hardy's last novel, *Jude the Obscure*, and reaches a climax with Virginia Woolf's major novels, *Mrs. Dalloway* (1925) and *To the Lighthouse* (1927). That some or all of the great British Modernists—Joseph Conrad, James Joyce, D. H. Lawrence, E. M. Forster, and Woolf—withdraw from their work, eliminate the intrusive author, and move to objectivity and impersonality is still one of the shibboleths of literary history. In this chapter I shall argue that by making themselves their subject they have, in fact, created a more subjective, self-expressive novel than their predecessors, and that they *are* present in their works.

Influenced by English romanticism, developments in modern art, and a changing intellectual milieu that questioned the possibilities of universal values or objective truth, these novelists erased the boundaries between art and life. They no longer believed that they could or should re-create the real world in their art, and they questioned the assumption that verisimilitude was the most important aesthetic value. They realized that each person

perceives a different reality and lives in what F. H. Bradley called a "closed circle" (346). Thus, while mid-Victorian novelists believed in the efficacy of their art, twentieth-century writers have often despaired at the possibility of communication. They wrote not only to urge their perspectives upon their audience but to create their own identities and values. On the one hand, the artist doubts that he can change the world but, on the other, he tries to convince himself and his audience that he can.

Twentieth-century British writers invent ways of seeing the human psyche in a more subtle and complex manner. While the Victorian novel focused upon man in his social aspect, Conrad, Lawrence, Joyce, and Woolf isolate their characters from the social community by focusing on the perceiving psyche. As J. Hillis Miller has noted, there is little self-consciousness in most Victorian novels: "the protagonist comes to know himself and to fulfill himself by way of other people" (5). But the English novel from 1890 to 1930 made self-consciousness and self-awareness its subject, and the streams of consciousness within the soliloquy and interior monologue—both direct and indirect—became more prominent. Since characters are often versions of the author who either does not or cannot achieve the traditional distance between author and characters, the experience and self-consciousness of the characters reflect those of the authors.

In traditional novels we are more conscious of the characters, actions, themes, and rhetoric and less conscious of what I shall call the author's presence. Patricia Meyer Spacks notes: "Writers before the nineteenth century . . . often insisted by implication on their *lack* of psychology, defining themselves in relation to their audiences or in terms of a historical tradition rather than by personal reactions or feelings" (xv). The conventions of editor or omniscient narrator deserve such a description. In *Moll Flanders* and *Clarissa*, the presence of the author is often felt as an editor; in *Tom Jones* the author depicts himself as the reader's host. In Victorian fiction the author becomes an omniscient voice. Yet because modern writers write first for themselves, they are more insistent on affirming their living presence in their works than on using rhetorical tools to shape their readers.

II.

Twentieth-century novels are often songs of myself, and anxious self-doubting ones at that. In varying degrees the later Thomas Hardy in *Jude*, Conrad, Forster, Woolf, and Joyce take their own imaginations as a major subject. In a sense their novels are about the process of transforming life into

art. While reading *Emma* is the discovery of a finished three-dimensional imagined world, reading the major British novelists in the period from 1890 to 1930 involves participating in their process of struggling to define their values and their concepts of the novel. It is the difference between a Constable or a Gainsborough and a Matisse or a Picasso. The novel depends on a continuing dialogue between the author's avowed subject and his efforts to discover the appropriate form and values for that subject. Writing of how the artist finally must discover the world in himself, Stevens defines in "Tea at the Palaz of Hoon" (1921) the relationship between text and author that informs the writers under discussion:

> I was the world in which I walked, and what I saw
> Or heard or felt came not but from myself;
> And there I found myself more truly and more strange.

The author's struggle with his subject becomes a major determinant of novel form. In the 1898-1900 Marlow tales, *The Rainbow* (1915), *Ulysses* (1922), and *Mrs. Dalloway* (1925), each author writes to define himself or herself. The writer does not strive for the rhetorical finish of prior novels but, rather like Rodin in his sculpture, instead invites the reader to perceive a relationship between the creator and the artistic work, and to experience the dialogue between the creative process and the raw material. While the Victorian novelist believed that he had a coherent self and that his characters could achieve coherence, the Modernist is conscious of disunity in his own life and the world in which he lives. The novelist becomes a divided self. He is both the creator and seeker, the prophet who would convert others and the agonizing doubter who would convince himself while engaging in introspective self-examination. Even while the writer stands detached, creating characters, we experience his or her urgent effort to create a self. Thus the reader must maintain a double vision. He must apprehend the narrative and the process of creating that narrative. In such diverse works as the Marlow tales, *The Rainbow*, and *To The Lighthouse* (1927), the process of writing, of defining the subject, of evaluating character, of searching for truth, becomes part of the novel.

Telling becomes a central action in these novels. The reader experiences the author's engagement in defining his values as he writes. As the search for values often takes precedence over story and as the form of these novels enacts the author's quest, traditional chronology, linear narrative, and ordinary syntax are discarded. Sometimes, as in the Marlow tales, the

author's quest for values is transferred to another character whose central activity becomes the search for meaning and for the appropriate language with which to tell the tale. Sometimes a character will become the spokesman for values that the omniscient voice articulates; this is the case in *Jude the Obscure, Sons and Lovers* (1913), and *Women in Love* (1920). But this kind of doubling—the protagonist (Jude, Paul, Birkin) and narrative voice saying much the same thing—is a function of the author's need to convince himself of the accuracy of his perceptions as well as of the difficulty of his achieving irony toward a version of himself. The structure of a novel is no longer a preconceived pattern in which characters move toward discovering values held by an omniscient voice who is a surrogate for the author. To read the novel is to participate in a process by which, through his characters, the novelist proposes, tests, examines, and discards moral and aesthetic values.

Thus it becomes increasingly difficult for writers to remove themselves from the text. In fact, the major modern British authors remain in their work in much the same way as those Renaissance painters who placed an image of themselves in a corner of their canvas watching the main spectacle. The stream of consciousness, which has been thought of as a movement toward objectivity, is actually often a disguise for authorial presence rather than a means for the author to absent himself. For example, do we not feel that Joyce is selecting and arranging the stream of consciousness, including mythic parallels and image patterns that help give the stream its meaning and significance? We know a great deal more about Joyce from *A Portrait* (1916) and *Ulysses* than we know about Jane Austen from *Emma* and *Pride and Prejudice*, or about Fielding from *Tom Jones*, notwithstanding his host narrator. Austen or even Fielding would hardly have asserted, as Conrad did in 1912: "A novelist lives in his work. He stands there, the only reality in an invented world, among imaginary things, happenings, and people. Writing about them, he is only writing about himself. But the disclosure is not complete. He remains, to a certain extent, a figure behind the veil; a suspected rather than a seen presence—a movement and a voice behind the draperies of fiction" (*A Personal Record*, xv).

While there was always an autobiographical strain in the English novel (*Tristram Shandy, The Mill on the Floss, David Copperfield*), this was surely a minor motif in the history of the genre. In *Jude the Obscure, Sons and Lovers,* and *A Portrait of the Artist* the presence of the author is thinly disguised. The quest of Stephen for artistic values, for self-recognition, and for the approval of others is Joyce's quest. The *agon* is the author's quest to

understand himself. Hardy becomes a spokesman for *Jude* because he sees Jude as a version of himself—the outsider aspiring to be recognized by a more educated elite society. In *Sons and Lovers* the omniscient narrator of Part I gives way in Part II to a spokesman for Paul's perspective. He strains to justify Paul's (Lawrence's surrogate) role in his relationship with Miriam (Jessie Chambers). Our reading of Lawrence's dramatic scenes often belies the interpretation imposed by his narrative voice. For example, the voice does not recognize that Paul suffers from the very problems of frigidity and repression of which he accuses Miriam. Nor does he understand that he turns away from Miriam at the very time that she begins to respond sexually to Paul or that Paul discards Clara because his relationship with her threatens to succeed. Paul's oedipal relationship with his mother requires that he find fault with Clara as soon as he consummates that relationship.

Once there is no longer agreement about values, an author cannot depend upon the reader to recognize the ironic disjunction between what a character thinks and what the author wants the reader to think. The omniscient narrator may be thorough and careful in establishing his point of view, but he has no special status. The novelist does not believe that any single perspective holds the entire truth. As we read modern novels told by an omniscient speaker, we realize that the novelist's commentary has imposed a perspective upon events, even while implying, through the dramatic actions, and sometimes his pluralistic values, the possibility of another perspective. This is true not only for *Jude the Obscure* and *Sons and Lovers*, in each of which the omniscient narrator becomes more and more an empathetic spokesman and apologist for the major character, but even for *The Rainbow* and *Ulysses*. Thus the technical convention of omniscience survives, but not the concept of a shared value system that originally gave rise to the convention.

The recognition that self-expression and subjectivity are at the heart of the transformation of the English novel was long inhibited by the acceptance in fiction criticism of the New Critical credo that the best literature depends on the author's separating his personal life from the imagined world of his novels or, at the very least, on his repressing those aspects of his experience that do not have "universal" interest. If we are to come to terms with the expressive aspect of fiction, we must develop an appropriate aesthetic. For example, can we separate the prophetic voice of *The Rainbow* from Lawrence's personal quest for self-realization or his quest for the appropriate grammar of passion with which to render sexual relationships, if we recall his writing, "Now you will find [Frieda] and me in the

novel, I think, and the work is of both of us" (quoted in Huxley, 19)? Nor can we ignore the parallels between Marlow's search for values and Conrad's. Wayne Booth's *The Rhetoric of Fiction* (1961) still stands as the indispensable study of rhetoric and voice in fiction. Booth's reluctance to appreciate the ambiguous rhetoric of modern literature has often been criticized. But has anyone gone beyond his work and developed a rhetoric to describe the authorial presence within a novel that may be either narrator or character or both? Nevertheless, Booth's concept of implied author, while valuable, does not seem quite satisfactory to define the mask that the author wears within his works. This presence is somewhat different in each of an author's novels because its personality and character are functions of the words chosen and the events and characters described. Booth's implied author may be somewhat workable for a Fielding or Austen novel, where the narrative voice is an artifice controlled and manipulated by an objective author in full command of his or her rhetorical devices. But it does not do justice to the strong subjective authorial presence within much modern fiction. To approach the modern writers under discussion, we must reconcile fiction as rhetoric and as self-contained ontology with fiction as self-expression. For there are frequent moments in twentieth-century fiction when the subject is the author's quest to define himself or herself. In much of the work of Conrad, Joyce, Woolf, Forster, and Lawrence, the speaker is a thinly disguised version of the writer's actual self who is actively seeking moral and aesthetic values; this authorial self, or presence, of the author is a dynamic evolving identity that is an intrinsic—not an implied—part of the novel's form. The presence that the novelist projects reflects the particular circumstances of the novelist's life when he wrote the novel and the *Zeitgeist* in which the novel was written. While we should begin with what a book is and what a book does, we should not ignore what the author does, particularly in novels where the subject is the author's self. The best way to locate the presence within the text is to know beforehand something about the historical figure. In other words, the text more readily yields its presence to those who know about an author's other works, life, and historical context.

As readers we respond to an imitation of the real creator of the text. The actual author is in the imagined world as a distortion—at times a simplification, an obfuscation, an idealization, a clarification—of the creating psyche. In earlier periods the words of a novel signify a human presence within the text; that presence may be urging the reader to a particular attitude. But in modern fiction the presence also is usually involved in affirming his or her identity and values. The reader, knowing that the presence mimes a historical figure who wrote the book, imagines that figure

as a reality. As Spacks notes, "if poets create themselves as figures in their poems, readers choose, consciously or unconsciously, to accept such figures as more or less appropriate to reality" (xii).

Since novels are written by people, it seems the antithesis of a humanistic approach to settle for a formalism—whether it be New Criticism or more recent varieties—that excludes authors from the text. The process of locating a human being within the text recognizes that reading is not merely a verbal game but a shared experience between writer and reader. It is another way of saying that we wish words to signify something beyond themselves. Because we desire coherence and meaning, we seek a tangible identity within the imagined world and respond to the energy of the author's creative imagination. We demand of words that they form connections to human experience, even though we make fewer demands of lines and shapes or musical notes. (Painting and sculpture, of course, have had a tradition of mimesis while music has not.)

The author's presence in the text usually serves the rhetorical purpose of reinforcing the meaning conveyed by other elements: structure, narrator, language, characterization, and setting. But at times the presence is subversive in that it undermines the meaning that the author intended. In many modern novels that voice is divided into two or more aspects, each of which projects a different identity. Sometimes we can speak of a dominant and a secondary voice or, as in *The Nigger of the "Narcissus"* (1897), of a tension between competing voices. Conrad's effort to overcome writer's block by means of mastering the raw material of his narrative—the sea experience of his earlier life—is as much the subject of the novel as the journey of the *Narcissus*. For Conrad the sea voyage—with its clearly defined beginning and ending, its movement through time toward a destination, its separation from other experience, and the explicit requirements that must be fulfilled by the crewmen and officers—provided the necessary model for completing a work. Since he had actually sailed on a ship named the *Narcissus* in 1884, he could draw upon romantic memories of an ordered and accomplished voyage at a time when his creative impulses were stifled by doubts. Thus the voyage of the *Narcissus* provided Conrad with an imaginative escape from his writing frustrations. *The Nigger of the "Narcissus"* also reflects a reductive dichotomy within Conrad's psyche between the evil land, where he was terribly frustrated as he launched his new career, and the sea, where, as he remembered it, he had been fairly tested and had ultimately succeeded. This dichotomy explains the schism between the first-person speaker who is a part of the crew and the third-person speaker who strives to play the role of the traditional omniscient narrator.

Ulysses is Joyce's attempt to resolve the Stephen and Bloom within his psyche and that effort is writ large on every page. Among other things, *Ulysses* is a search for values, a dialogue within Joyce's psyche among the intellectualism and abstraction of Stephen, the humanity and empiricism of Bloom, and the sensuality and spontaneity of Molly. The novel works its way through a panorama of values in modern life. It tests and discards patriotism, nationalism, piety, Platonism, and aestheticism and affirms the family paradigm, affection, consideration, tolerance, and love. Beginning with "Wandering Rocks," *Ulysses* examines not only ways of living but ways of telling. Joyce parodies romantic fiction in "Nausicaa," examines whether fiction can be patterned on musical composition in "The Sirens," explores the possibilities of the scientific temperament in "Ithaca," and tests the mock epic in "Cyclops." "Eumaeus," narrated by Joyce's omniscient narrator in the style in which Bloom would have told it, is Joyce's love song for Bloom in the form of an affectionate parody and the author's sequel to the end of "Hades," where Bloom has affirmed the value of life. In "Ithaca" not only Bloom's humanity but the possibility of significant action in the form of personal relationships emerges despite the mechanical nature of the scientific catechism, a style that represents the indifference and coldness of the community to individuals. Thus *Ulysses* is Joyce's odyssey for moral values and aesthetic form. It is not only Bloom but Joyce who survives and triumphs over what he calls in "Aeolus" the "grossbooted draymen" of the modern city. This kind of pastiche of former styles in the service of a quest for personal values is also very much a part of modern painting and sculpture. It is in this sense, in this profoundly humanistic sense, that modern painting is about painting and modern literature is about writing.

III.

In "Mr. Bennett and Mrs. Brown," Virginia Woolf wrote that "on or about December 10, 1910 human character changed," because the first Post-Impressionist exhibition organized by Roger Fry and called "Manet and the Post-Impressionists" ran in London from 8 November 1910 to 15 January 1911 (96-97). According to Samuel Hynes, she "chose that occasion as an appropriate symbol of the way European ideas forced themselves upon the insular English consciousness during the Edwardian years and so joined England to the Continent" (326). The Post-Impressionists provide an example for the abandonment of realism and the movement of the artist to center stage. They had discarded representation for form. For example, in his

famous *The Card Players*, Paul Cézanne is less an observer of peasant life than a composer of formal harmony and disparate pictorial planes, while in his works Paul Signac is concerned with the possibilities of objectively capturing light. These painters demonstrated that artists could create their own order in a chaotic world. Thus they intentionally neglect some details, while they simplify, distort, exaggerate, and stress others to express their emotions, solve problems of pictorial space, and create effects. In a sense, the artist's temperament and perspective become the subject in the work of Van Gogh, André Derain, Matisse, and Picasso. We recall Van Gogh's insistence that "what is eternally alive is in the first place the painter and in the second place the picture" (the Metropolitan Museum of Art). It is quite possible that the abrupt cutting of figures, the elimination of traditional perspective, the foreshortening of images influenced the tendency of Woolf, Lawrence, Forster, and Joyce (who, of course, saw similar paintings in Paris) to move beyond realism to more expressive forms of art. Can we read *Ulysses* or *The Secret Agent* without realizing that something has happened to the visual imagination of nineteenth-century novels and that even Dickens did not continually create the kinds of illuminating distortions, cartoons, and grotesques that populate these modern urban novels? Novelists no longer wrote what they saw, but what they knew.

The 1978 London exhibition entitled *Great Victorian Pictures* made clear the revolutionary character of Fry's exhibition. Victorian painting often told a story, either of history or of contemporary life. As Rosemary Treble wrote in the introduction to the catalog for that exhibit: "The constant refrain in all the writing of the period and the touchstone of every judgment was whether the work attained 'truth' generally to nature and therefore, by implication, to God's creation, whether its sentiment was appropriate and whether it was morally healthy and therefore fit for consumption" (*Great Victorian Paintings*, 7). And the values by which Victorian fiction writers were evaluated were not too different. A painting like William Powell Frith's *The Railroad Station* (1862) was considered a national epic because it included every class. William Edward Frost's allegorical women were thought to be uplifting, although to us they seem self-absorbed and repressed. The avant-garde in England, beginning with the Pre-Raphaelite brotherhood and including Burne-Jones's precious symbolism, hardly affected the supremacy of conventional painting. To be sure, the works of James Whistler and Walter Sickert were exceptions. But the fact remains that until Fry's exhibit fiction usually conformed to the existing theories of art, and those theories (most notably orthodox realism, often in the service of Victorian pieties) with few exceptions tended to serve conventional morality.

The English novel after Hardy was deeply affected by Russian art in a number of ways. In the Edwardian years the Russian influence challenged British insularity. Fyoder Dostoyevsky, although patronized by Conrad, now became popular, and the exuberant and flamboyant Russian Ballet appeared in 1911. In the pre-War years Russian music and painting made their mark on London. (Russians were included in the second show of Post-Impressionism.) In general, Russian art, more than British art, depended more upon energy than craft, more upon fantasy than realism, more upon the artist's vision than subjectivity, more upon flux than stasis, more upon experimentation than tradition, more upon mysticism than reason, and more upon the spiritual and psychological than the moral. As Woolf understood, these qualities inevitably questioned the conventions of the British novel: "The novels of Dostoevsky (sic) are seething whirlpools, gyrating sand-storms, waterspouts which hiss and boil and suck us in. They are composed purely and wholly of the stuff of the soul" (*The Common Reader*, 182). In the essay "Modern Fiction" in the same volume Woolf wrote: "If we want understanding of the soul and heart where else [but in Russian fiction] shall we find it of comparable profundity?" (157). The violence of Dostoyevsky's emotions influenced not only Conrad in *Under Western Eyes* (1911) but, in more subtle ways, Woolf, Lawrence, and Forster (Woolf, *The Common Reader*, 157). Indeed, Lawrence consciously imports this element into his imagined world in the person of the Slavic Lydia Lensky, who is the mysterious, libidinous, passionate soulmate for Tom Brangwen, Lawrence's *Übermensch* of the passions, and the grandmother of Ursula, the novel's heroine, who, like Lawrence, must come to terms with twentieth-century life. Indeed, Lawrence used the Dostoyevskian strain—the inchoate, urgent, uncon-trolled "stuff of the soul"—to fertilize the English novel of manners.

The novel also changed because artists increasingly felt that the modern world required different kinds of art. The search for innovation in form and technique is inseparable from the search for values in a world where the British empire had lost its sense of invulnerability, the political leadership had suffered a crisis of confidence, and industrialization had created worker unrest. We see the effects of the first two in *A Passage to India* (1924) and *Mrs. Dalloway*, and of the third in the character of Verloc in *The Secret Agent*. The urbanization of England undermined the sense of continuity that had prevailed in the country since Elizabethan times, a continuity that even the Revolution of 1640 did not entirely disrupt. This continuity derived from land passed down from generation to generation, from the rhythms of rural culture, from monarchical succession, from the strong sense of English family, and from the relatively stable role played by the clergy, the

aristocracy, and Parliament. George Dangerfield has described how England had become by 1914 "a liberal democracy whose parliament had practically ceased to function, whose Government was futile, and whose Opposition had said enough to put lesser men in the dock for treason" (366). Modern writers are conscious of writing in a period of crisis and transition; certainly this sense of crisis gives *Nostromo, The Rainbow,* and *Ulysses* much of their intensity. It may be that the boldness and scope of these novels are a response to the ennui, cynicism, and solipsism of the *fin de siecle,* a response all the more violent because their writers felt threatened by these negative attitudes. The great Modernists—Joyce, Lawrence, Conrad, Forster, Hardy, Woolf—have a clear and ordered sense of a past from which they feel permanently separated. Conrad realizes that traditional personal values are threatened by compulsive materialism, often in the guise of politics. For Hardy and Lawrence, a pastoral vision of agrarian England is an alternative to present mechanism and utilitarianism. *Jude the Obscure* and *Howards End* (1910) are elegies for this rural civilization. For Joyce, like T. S. Eliot, it is European cultural tradition that has been debased by the meanness of the present. Joyce, Conrad, Woolf, and Forster long for a tradition of social customs and personal relationships that has become obsolete under the pressure of urbanization and materialism.

Noel Annan has written of the change in England between 1880 and 1910, a change that affected the subject matter of the novel:

> The restraints of religion and thrift and accepted class distinctions started to crumble and English society to rock under the flood of money. The class war, not merely between labour and owners, but between all social strata of the middle and upper classes began in earnest. . . . A new bitterness entered politics, a new rancour in foreign relations and a materialism of wealthy snobbery and aggressive philistinism arose far exceeding anything hitherto seen in England. (252-53)

Although often bourgeois in their impulses and unscathed by these factors, novelists began to write more frequently about class struggle (*Jude the Obscure*), the ethics and effects of imperialism (*A Passage to India*), the implications of politics on private lives (*The Secret Agent*), and the corrupting influence of industry and commerce (*Nostromo*).

If we compare *Mrs. Dalloway* with the novels of Austen, we see how the sensibilities of Woolf's major characters have been deeply influenced by war, empire, and commerce (although these play less of a role in the rather anachronistic life of Mrs. Dalloway than in the lives of Peter Walsh

and Septimus Smith). The lack of community values is enacted in the fragmented form, in the lack of meaningful purpose in politically influential figures (Richard Dalloway, Lady Bruton), and finally in the crystallizing image of Septimus Smith, who, as he walks the streets of London, seems to epitomize the failure of Londoners to discover purpose or coherence in their city. The confrontation of traditional English values with those of other cultures is central to *A Passage to India, Heart of Darkness* (1898), and *Women in Love* (especially in the Bohemian and European sections). Yet even as these modern novelists write about different value systems, they explore the importance of those systems for their own lives. They do not, like eighteenth-century novelists, simply measure the strange cultures against established values. The structure becomes a process, a process that mimes the author's quest for values. Thus even in *A Passage to India*—which we think of as an heir to the Victorian novel—the oscillation among Moslem, Hindu, and English and the shifts in narrative distance between the limited perspective and the geographic perspective reflect Forster's search. As Wilfred Stone has written, Forster's novels are "dramatic installments in the story of his struggle for selfhood. . . . They tell of a man coming out in the world, painfully emerging from an encysted state of loneliness, fear, and insecurity" (19). The same, I am arguing, could be said of Woolf, Joyce, Lawrence, and Conrad.

Comparing H. G. Wells, Arnold Bennett, and John Galsworthy with their major predecessors, Woolf wrote:

> *Tristram Shandy* or *Pride and Prejudice* is complete in itself; it is self-contained; it leaves one with no desire to do anything, except indeed to read the book again, and to understand it better. The difference perhaps is that both Sterne and Jane Austen were interested in things in themselves; in character in itself; in the book in itself. Therefore everything was inside the book, nothing outside. But the Edwardians were never interested in character in itself; or in the book in itself. They were interested in something outside. Their books, then, were incomplete as books, and required that the reader should finish them, actively and practically, for himself. ("Mr. Bennett and Mrs. Brown," 105)

But I think the major British twentieth-century figures under discussion, including Woolf herself, were interested in both "something inside" and "something outside." For these writers no longer accepted the traditional Christian beliefs that divine providence expresses itself in earthly matters or that this life is a necessary prelude to eternity. And the world outside could

no longer be limited and contained by authors whose own moral vision was tentative, incomplete, and lacking in conviction. We should not be surprised that the movement of *Nostromo, Women in Love,* or *Ulysses* enacts kinds of uneasiness and turbulence that are absent in, say, an Austen novel. Because the writer is striving to discover his moral and aesthetic values, this uneasiness and turbulence at times reflect unresolved social issues, characters whose motives the novelist does not understand, and inchoate form.

The social and historical milieu in which an artist writes determines the artistic problems that he must solve. Thus Conrad, Lawrence, Joyce, Forster, and Woolf had to discover an appropriate form with which to show (if I may baldly list the striking characteristics of the period) that motives could not be fully understood, that the world was not created and shaped by divine providence, that chance might determine human destiny, that human desires and aspirations were not likely to be fulfilled, that social institutions were ineffectual, and that materialism and industrialization were destroying the fabric of life. Consequently, they invented plots that at times reflect disorder, flux, discontinuity, fragmentations, and disruption without themselves having those qualities; they needed to use the *Odyssey, Hamlet,* the Bible, and, in *Ulysses* even such Jewish legends as "*The Just Men (The Lamed Vov)*" to give shape to seemingly random events. They had to invent means not only for rendering the inner life but for showing the unacknowledged private self that played such a large role in shaping behavior. Thus Conrad shows that Jim is the victim of compulsions, obsessions, and fixations that he cannot understand. They needed syntax and language to reveal the secret recesses of each psyche and the impact made upon it by experience, especially the kind of ordinary daily experience that was once thought to be insignificant. The unpunctuated, effervescent stream of consciousness of Molly fertilizes the presentation of both Stephen and Bloom by emphasiz-ing—in form and content—fecundity, sexuality, spontaneity, passion, and indifference to history and morality.

IV.

Let us think for a moment of some major Victorian novels—say *Bleak House, Vanity Fair,* or *Middlemarch.* Victorian fiction depends on the mastery of space and time in an unfolding narrative. It seeks to create an imagined world that both mirrors and exaggerates the external world. Its use of an omniscient, ubiquitous narrator implies the preeminence of the individual perceiver. Now let us think of *The Secret Agent* (like *Bleak House,* a novel of London),

Ulysses (like *Vanity Fair,* a satirical examination of relatively recent times), and *The Rainbow* (like *Middlemarch,* a panoramic novel about provincial life). Do not these examples of modern British fiction undermine the idea that space and time can be mastered by anyone, including the author? Like the subject matter, the setting resists the traditional patterns. The setting itself recoils from idealization, control, and order and expresses the turmoil and anxiety within each author's psyche. (By becoming foreground rather than background, setting plays a similar role in the Post-Impressionist works of Van Gogh, Matisse, and Picasso.) The setting—the physical conditions under which the imagined world functions—becomes not background but a moral labyrinth that the characters are unable to negotiate and that not only shapes their destiny but often subsumes them. Hardy's Wessex, Forster's India, Joyce's Dublin, and Conrad's London are manifestations of an amoral cosmos that preempts the characters' moral choices. By forging a web of social circumstances that encloses and limits characters, these settings displace the traditional role of individual will in shaping the lives of characters. Yet even as these settings often become coterminous with destiny and fate, they may also be a symptom or cause of a bankrupt social system, or a metaphor for the narrator's and his characters' own moral confusion.

In the nineteenth-century novel, characters are defined in terms of their moral choices in social situations. In *Vanity Fair* Becky Sharp consciously chooses to seek wealth and status, although we do not watch the processes of her mind; in *Bleak House* Esther Summerson's loyalty, sympathy, and integrity result mostly from conscious decisions. But Woolf, Joyce, Lawrence, Forster, and, quite frequently, Conrad perceive characters in terms of the honesty and integrity of their perceptions rather than in terms of the moral consequences of their behavior. What they *are* is more important than what they do. The integrity and purity of their souls are standards by which they are primarily judged. **Isness** (the quality and intensity of the soul and heart) replaces **Doesness** (the effects of behavior) as the norm for characters. Thus we value Bloom and Mrs Ramsay for their uniqueness rather than their effectiveness. And this corresponds to the shift in emphasis in the art of the novel from traditional effects upon the audience to self-dramatizing narrators in search of values and feelings.

The writers we are discussing saw that people no longer live together bound by common values and social purposes. Each person is his or her own secular sect, and the interaction of these sects creates a social Babel. The order of art becomes a substitute for the disorder of life, and the novel mimes a momentary unity in the novelist's mind rather than in the external world. Thus in Woolf and Joyce, a novel's lack of form may seem to have a

coherence that the subject of the novel lacks because the texture is reflexive and self-referential. Indeed, at times the writers under discussion try to replace, as Malcolm Bradbury has put it, "the linear logic of story, psychological progress, or history" with the "logic of metaphor, form, or symbol" (84). But do we not see that this effort has a compulsive quality and that Woolf and Joyce are as much committed to transforming their lives into art as to creating a symbolic alternative to realistic fiction?

In *The Form of Victorian Fiction*, J. Hillis Miller remarks that, for Victorian novelists, "the writing of fiction was an indirect way for them to reenter the social world from which they had been excluded or which they were afraid to enter directly" (63). By contrast, the great Modernists wrote fiction to define themselves outside the social world and to confirm their special status as artists. They did not want to reenter the social world but rather to leave it for islands (actual and imaginary) where life was more honest and true to the promptings of their hearts; these islands were often their novels. They could look at a society from which they felt excluded and criticize its values. Woolf's moments of enlightenment, Joyce's epiphanies, and Lawrence's states of passionate intensity emphasize the individual's life as separate from the community. Novels move not to a comprehensive vision of society but to unity within a character's imagination and perception. In *Heart of Darkness* and *Lord Jim* Marlow's experience and insight not only are his own but leave him, like the Ancient Mariner, separate from his fellows. If in Victorian fiction the narrator is, as in *Our Mutual Friend* or *Vanity Fair*, a detached outsider observing characters who often function successfully within the community, in modern British fiction, such as *Ulysses* and *Women in Love* the narrator and the protagonists are both separate from the community, and the community itself is corrupt and morally bankrupt. Woolf saw the problem. On the one hand, she knew that her novels give credence to various kinds of personal Crusoeism and raise the hope of solutions separate from the traditional community. But, on the other hand, she also understood the dangers of her fiction becoming self-indulgent and narcissistic: "I suppose the danger is the damned egotistical self. . . . Is one pliant and rich enough to provide a wall for the book from oneself without its becoming . . . narrowing and restricting?" (quoted in Bell, II. 73)

In *To the Lighthouse* the completion of Lily Briscoe's painting might serve as a metaphor for the hermetic nature of one strand of Modernism. She has her vision and completes her painting, but she turns her back on the opportunity for community in the form of marriage to Mr. Ramsay. Her art is at the expense of social life:

> Here she was again, she thought, stepping back to look at it, drawn
> out of gossip, out of living, out of community with people into the
> presence of this formidable ancient enemy of hers—this other thing,
> this truth, this reality, which suddenly laid hands on her, emerged stark
> at the back of appearances and commanded her attention. (Woolf, *To
> the Lighthouse*, 236)

And Mrs. Ramsay's victories are more aesthetic than moral; thinking of Mrs.
Ramsay, Lily realizes that her friend "[makes] of the moment something
permanent (as in another sphere Lily herself tried to make of the moment
something permanent)—this was of the nature of revelation. In the midst of
chaos there was shape: this eternal passing and flowing (she looked at the
clouds going and the leaves shaking) was struck into stability" (241). Life
struck into stability is what happens when pattern is imposed on life by art,
but it is also a foreshadowing of death. Lily is a version of her creator, and
her struggle with her painting mimes that of her author with the subject.
We realize that Woolf's quest for values in the "eternal passing and flowing"
continues through the novel.

V.

Lily's paintings are crucial to the meaning of *To the Lighthouse*. In this novel
painting and writing are metaphors for one another and for the creative
process. Painted ten years later than the first painting and after World War I,
Lily's second painting is Post-Impressionist. It defines the relationship between
lines and form, and is more abstract than the painting in Part One, which takes
its impulse from Impressionism. Isn't Woolf suggesting that aesthetic assump-
tions have changed and calling attention to the juxtapositions and non-
mimetic quality of her own writing? Lily completes the painting with the line
that is a metonymy for both the obsessive linearity of Mr. Ramsay and the
lighthouse; the line suggests Ramsay's focus on the vertical pronoun that, at
the age of forty-four and without supporting love relationships, Lily so
desperately needs ("I have had my vision"). She begins and ends her painting
with a single line, suggesting perhaps Japanese ink drawings: "One line placed
on the canvas committed her to innumerable risks, to frequent and irrevocable
decisions" (235). As she paints she loses herself in her vision but does not
completely lose touch with life: She wants to balance "two opposite forces;
Mr. Ramsay and the picture; which was necessary. There was something

perhaps wrong with the design? Was it, she wondered, that the line of the wall wanted breaking, was it that the mass of the trees was too heavy?" (287). In a sense the final line discovers for her—and for her creator—the relationship between art and life. For Woolf, the line also stands for the completion of the novel. Indeed, if the impulse for the first painting was what Lily sees, the impulse for the second is a dialogue between her imagination and experience, and between her sense of form and what she wants to include. The concern with mass and line shows the influence of Roger Fry's two London exhibits in 1910 to 1912 of Post-Impressionism, particularly Cézanne, who "drew" not only with line but with mass, with blocks of color.

An artist who relies on her inner vision, rather than anterior reality, Lily Briscoe paints what she knows, not what she sees. If her concept of form requires it, she paints a tree or a line although it may exist only in the mind's eye: "I shall put the tree further in the middle; then I shall avoid that awkward space" (128). Yet her artistic epiphany is created by human emotion—a vision that, notwithstanding Mrs. Ramsay's pity for William Bankes, he "is not in the least pitiable. He had his work, Lily said to herself. She remembered, all of a sudden as if she had found a treasure, that she had her work" (128). Thus the ground for Lily's epiphanic moment of wholeness depends on her personal, independent critique of Mrs. Ramsay's pity for Bankes. By showing that Lily's art requires the impetus of human feeling, Woolf urges the reader to see that nonrepresentational art is neither merely secondhand copying of the insights of others nor cold geometric forms. That Lily's formal non-realist's aesthetic depends on humanistic values helps us understand how we should read.

For Lily Briscoe the Post-Impressionist, "the question [is] one of the relations of masses, of lights and shadows"—as it is for Cézanne—but for her, art is much more than that (82). Art for Lily—as for Woolf—is "the deposit of each day's living mixed with something more secret than she had ever spoken or shown," and that deposit expresses her deepest feelings (81). One might say that Mrs. Ramsay influences or educates Lily's aesthetic values, as Lily educates the reader to respond to those of the narrative presence of the novel:

> Aren't things spoilt then, Mrs. Ramsay may have asked (it seemed to have happened so often, this silence by her side) by saying them? Aren't we more expressive thus? The moment at least seemed extraordinarily fertile. She rammed a little hole in the sand and covered it up, by way

> of burying in it the perfection of the moment. It was like a drop of silver
> in which one dipped and illumined the darkness of the past. (256)

Storing up the past serves as a metaphor not only for what Lily has done and
is doing now but for what Woolf's narrator is doing as she writes of Lily's
triumph. The view that saying too much can spoil things is not only Mrs.
Ramsay's but her creator's. Similarly, Woolf's presence shapes our reading.

Lily's impulse for the second painting is the intertextual memory of
the first painting:

> There was something . . . something she remembered in the relations of
> those lines cutting across, slicing down, and in the mass of the hedge
> with its green cave of blues and browns, which had stayed in her mind;
> which had tied a knot in her mind so that at odds and ends of time,
> involuntarily, as she walked along Brompton Road, as she brushed her
> hair, she found herself painting that picture, passing her eye over it, and
> untying the knot in imagination. But there was all the difference in the
> world between planning airily away from the canvas and actually taking
> her brush, and making the first mark. (234-5)

For her, colors—"its green cave of blues and browns"—are at least partially
freed from the morphology of representation. From her emphasis on spatial
relations, we can certainly assume that Woolf had seen the work of Cézanne,
Gauguin, and Matisse. We might think of what Elderfield wrote of Matisse's
style of the 1908 to 1912 period: "At times, he did not just adjust form as he
adjusted color, but drew everything in advance and then carefully filled in
the picture with colors appropriate to the size of the compartments they
occupied" (60). The stress in the second painting is on imbuing everyday
experience with the magic of meaning and form: "One wanted, she thought,
dipping her brush deliberately, to be on a level with ordinary experience, to
feel simply that's a chair, that's a table, and yet at the same time, It's a miracle,
it's an ecstasy" (*To the Lighthouse*, 299-300). She seeks an epiphany through
her art. Lily's creative imagination not only recalls Mrs. Ramsay from the
past but transforms her into a symbolic, if ambiguous, figure in the present.
As an artist she wants to achieve the kind of unity that Mrs. Ramsay achieves
in her life. To inform ordinary experience with meaning is a crucial goal of
Woolf's art—a goal that can be approached but never reached.

Woolf is embodied in Lily's quest for artistic values and Mrs. Ramsay's
quest for personal ones. The equation between Lily's painting and Woolf's

writing is crucial, but so is the equation between Mrs. Ramsay's effects on people and the goals that Woolf wants to achieve. Woolf establishes a relationship between Mrs. Ramsay's quest to achieve wholeness and unity in personal relationships and Lily's quest to complete her picture. Mrs. Ramsay is expected and expects herself to create the unity that will give her dinner party meaning: "And the whole of the effort of merging and flowing and creating rested on her" (126). And she thinks of her task in terms of the crucial image of sailing a ship: "[I]n pity for [William Bankes], life being now strong enough to bear her on again, she began all this business, as a sailor not without weariness sees the wind fill his sail and yet hardly wants to be off again and thinks how, had the ship sunk, he would have whirled round and round and found rest on the floor of the sea" (127). The image captures the continuing and finally futile quest to keep one's bearings in the cosmos—represented by the sea—which is indifferent toward both quest and goal.

Does not Lily's final vision emphasize its transitoriness, its consignment to the past?: "I have *had* my vision" (310, my emphasis). We know from the novel's narrative code—specifically, no sooner do we read of Mrs. Ramsay's epiphany than we learn both of her death and her failure to shape the relationship between Paul and Minta—that visions cannot wrench themselves from temporality. Since Mrs. Ramsay's triumphant vision had given "The Window" a similar closure and since Lily had conceived the resolving line at the end of that section, the narrative code warns us not to be seduced by Lily's epiphany or even the voice's visionary experience. Are not secular visions always ironized by what is missing: the deeply felt passionate relationship with God in which the seeker completes herself, or, in other terms, in which the world and word become one? That Lily's final thoughts ("It was done; it was finished") echo Christ's words on the cross (*"consummate est"*) emphasizes Woolf's awareness of this irony. The verticals—Lily's parodic line, the lighthouse (a man-made substitution for God's creation of light), Mr. Carmichael standing—are equated with the quest to discover meaning in a world where God is no longer a factor. As with all the major writers of this period, the concept of God is the absent signifier hovering both over the text and the imagined world created by the text. We recall Mrs. Ramsay's religious skepticism as she thinks, as her creator might, of death and suffering: "How could any Lord have made this world?" (98). As in *Mrs. Dalloway*, the absence of Christian belief is a striking fact in the novel. But unlike Hardy, Lawrence, Joyce, and Yeats, in Woolf disbelief really does not struggle with belief. When Mrs. Ramsay hears herself muttering the conventional Victorian shibboleth, "We are in the hands of the Lord," she dismisses it as a lie (97):

"With her mind she had always seized the fact that there is no reason, order, justice: but suffering, death, the poor. There was no treachery too base for the world to commit; she knew that" (98).

When she becomes like the artist surveying her creation, Mrs. Ramsay creates a kind of unity, a moment of *kairos*, a significance, of the kind that used to be associated with religion: "She looked at the window in which the candle flames burnt brighter now that the panes were black, and looking at that outside the voices came to her very strangely, as if they were voices at a service in a cathedral, for she did not listen to the words" (165-66). But verticals and linearity also are equated with the masculine need to progress, dominate, and conquer—with Mr. Ramsay's need to move "from start to finish" through the letters of the alphabet (55)—in contrast to the novel's intense effort to render somehow the dynamic, evanescent, shifting, interconnecting, and intersecting planes and spheres of reality. Thus the equation of the journey to the lighthouse with the completion of the painting is itself an acknowledgment of the paradox that completing a work—fixing an impression in time—belies the flux and hence the possibilities of reality. As with Lawrence, to be complete or finished is equated with death, while the flux of the quest for values is itself a value aligned with being fully alive. It is the movement toward the goal that gives life significance—reaching toward the lighthouse, pressing on in the attempt to solve the problem of the painting, trying to pull together the novel. Put another way, as in the series with which I concluded the prior sentence, the verb takes precedence over its object. Ultimately, the verticals of the lighthouse become ironized by temporality, by the inability of the characters or the narrator to close the gap between the signifier and the signified. Indeed, reaching the lighthouse and completing the painting is, like Mrs. Ramsay's vision, another poignant and very emphatic step toward death. Just as the second section, "Time Passes," dramatized how time preys on things human, the narrative shows us that not only Lily's painting but Woolf's writing is not immune to time. Yet, unlike a painting, the literary text, if and when published, can be repeated often enough so that it has the chance to survive time.

In Section V, Part II, "The Lighthouse," Woolf specifically equates the act of memory with the act of Lily's artistic creation: "And as she dipped into the blue paint, she dipped too into the past there. Now Mrs. Ramsay got up, she remembered" (256). But memories of Mrs. Ramsay *are* the catalyst for Lily's intense experience. The powerful presence of the past in human lives is a Woolf theme. Lily half expects Mrs. Ramsay to return from the past to the present:

> For the whole world seemed to have dissolved in this early morning hour
> into a pool of thought, a deep basin of reality, and one could almost
> fancy that had Mr. Carmichael spoken, for instance, a little tear would
> have rent the surface of the pool. And then? Something would emerge.
> A hand would be shoved up, a blade would be flashed. (266-67)

Lily wants to believe in the immortality of art—"How 'you' and 'I' and 'she'
pass and vanish; nothing stays; all changes; but not words, not paint" (267)—
but she fears that her paintings will be hung in attics and stored under a sofa.
Dissolving into tears for Mrs. Ramsay, for the immortality that she herself
will never achieve, and for her own realization that she, too, will die, she
silently asks Mr. Carmichael, who by his presence has become objectified
into the other she seeks now that Mrs. Ramsay and Bankes (we have no idea
if he is living or dead) are not here:

> What was it then? What did it mean? Could things thrust their hands
> up and grip one; could the blade cut; the fist grasp? Was there no safety?
> No learning by heart of the ways of the world? No guide, no shelter,
> but all was miracle, and leaping from the pinnacle of a tower into the
> air? Could it be, even for elderly people, that this was life—startling,
> unexpected, unknown? (268)

Is not this perception that the real significance of life is these moments that
contain the "startling," the "unexpected," and the "unknown" central to
Woolf's aesthetic? The text enacts this in Lily's tears and her desperate
insistence on meaning in a life "so short" and "so inexplicable." In the pathos
of Lily's quest, we feel Woolf's own:

> For one moment she felt that if they both got up, here, now on the lawn
> and demanded an explanation, why was it so short, why was it so
> inexplicable, said it with violence, as two fully equipped human beings
> from whom nothing should be hid might speak, then, beauty would roll
> itself up; the space would fill; those empty flourishes would form into
> shape; if they shouted loud enough Mrs. Ramsay would return. (268)

The beauty of art confers meaning by the filling of empty spaces, by
organizing unity among details, and by providing the coherence of epi-
phanic insight. But, as in many Modernist texts, moments of order and
beauty are temporary and not sufficient to provide plenitude.

We feel Woolf's identification with Lily when the latter thinks of literary responses in painterly terms: "[L]ike everything else this strange morning the words became symbols, wrote themselves all over the grey-green walls. If only she could put them together, she felt, write them out in some sentence, then she could have got at the truth of things" (219). Lily's mind works in terms of shapes and color. Her perceptions might be those of Woolf if we substitute writing for painting: "It was a miserable machine, an inefficient machine, she thought, the human apparatus for painting or for feeling; it always broke down at the critical moment; heroically, one must force it on" (287).

Woolf depicts acts of memory as kinds of narratives. The prototype for the way memory both recaptures and permanently loses experience is Mrs. Ramsay's recollection of the Mannings: "[N]ow she went among them like a ghost; and it fascinated her, as if, while she had changed, that particular day, now become very still and beautiful, had remained there, all these years" (132). This image describes not only the position of Lily, Mr. Ramsay, and his returning children in Part III, but also Woolf's position as she returned to the memories of her parents' home and relationship. In a reversal that privileges reading over living, imagination over results, the experience of memory is specifically equated with reading a book. Mrs. Ramsay, during the dinner party, wants to

> return to that dream land, that unreal but fascinating place, the Mannings' drawing-room at Marlow twenty years ago; where one moved about without haste or anxiety, for there was no future to worry about. She knew what happened to them, what to her. It was like reading a good book again, for she knew the end of the story, since it happened twenty years ago, and life, which shot down even from this dining-room table in cascades, heaven knows where, was sealed up there, and lay, like a lake, placidly between its banks. (140)

Yet, finally, Mrs. Ramsay censors the escapism of fantasy with the lesson of reason; she acknowledges that they have had a life beyond her consciousness and she had one beyond theirs, and finds the thought "strange and distasteful" (133).

In Part II, "Time Passes," the perspective becomes impersonal, detached, hawklike. Death is an insistent presence. At first the "airs"— Woolf's metaphor for indifferent, relentless time—have little effect on the house when it is uninhabited, but, after the family fails to return, the "airs"

begin to reclaim the house as their own, and the house and its contents decay. Part II responds to Mrs. Ramsay's allegorical question—"What was the value, the meaning of things?"—with an allegorical answer (183). To the detached perspective, Mrs. Ramsay's death and the deaths of Prue and Andrew are mere parentheses to the larger processes of life it records. The omniscient, distanced, and ironic voice is the antithesis of the personal, subjective presence that was something of a window into the consciousness of the characters, especially Mrs. Ramsay and Lily. But here the focus is on the house, from which human life is absent, and this is all the more moving and effective because of Part I.

In the face of insecurity, Lily holds on to what she sees: "The jacmanna was bright violet; the wall staring white. She would not have considered it honest to tamper with the bright violet and the staring white, since she saw them like that, fashionable though it was . . . to see everything pale, elegant, semitransparent" (31-32). At times it is as if she were influenced by Matisse's ethos but did not know how to soar from her positivist position on the ground. Yet she *is* able to draw upon her imagination: "In a flash she saw her picture, and thought, Yes, I shall put the tree further in the middle; then I shall avoid that awkward space. . . . She took up the salt cellar and put it down again on a flower in pattern in the table-cloth, so as to remind herself to move the tree" (128). *To the Lighthouse* is about the writing of itself, and a major trope is Lily's creation of a painting.

VI.

Let us conclude with some final observations about Modernism's focus on the consciousness of both the creator and his or her subjects. Even novels with an epic scope—*Ulysses, Nostromo, The Rainbow*—discover meaning in the isolated perceiving consciousness of such characters as Bloom, Mrs. Gould, and Ursula. Although these novels present an anatomy of social problems in the tradition of *Tom Jones* and *Bleak House*, they do not propose political and social solutions but personal ones—family ties (*Nostromo*); passion (*The Rainbow* and *Women in Love*); kindness, tolerance, and affection (*Ulysses*). Indeed, we should understand that the epic and romance strands in Conrad, Lawrence, Joyce, and Forster are part of the search for values of desperate men who seek to find in older traditions a continuity that evades the confusions of modern life. There is a reflexive quality in *Nostromo, Ulysses,* and *The Rainbow,* a self-consciousness, a personal urgency lacking in the eighteenth- and nineteenth-century novel. In *Nostromo* we sense Conrad's aware-

ness that he has very little to offer as an alternative to social and political chaos, an awareness that derives from his feeling that all social systems are "hollow at the core." As he searches for values in Costaguana, he proposes every major figure as heroic and every political program as redemptive, only to undermine them systematically and finally to discard them. Furthermore, in *Nostromo* and *Lord Jim* he charts the failure of modern man both by the realistic standards of the nineteenth century and the older standards of romance, epic, and legend. At the very center of *Lord Jim*, Conrad proposes Stein as an oracular figure before finally revealing him as uncertain and far from articulate in the gloom created by descending night. *Ulysses* and *The Rainbow*, in their reliance on Homer and the Bible for shape and significance, express their authors' nostalgia and enthusiasm for the simpler shapes of human experience and the narratives that rendered that experience. Perhaps this nostalgic enthusiasm is a reaction to the authors' own rather unheroic lives, which were punctuated by disappointment and frustration. What they sought was to retrieve their own feelings and attitudes, but, more than that, to convince themselves and their audiences that their feelings and attitudes typified those of others and had the kind of universality that realism had provided for the Victorians. To be sure, Joyce and Lawrence understood the need to invent a syntax and diction to render the flux of perceptual and sensory experience, the life of the subconscious, and the impulses of the unconscious life. But that experience, that life, and those impulses were also their own. When we respond to the presence of the author, when we feel his or her urgent pulsation within the novel, the focus of fiction is no more "narrow and restricting" than that of any other kind of mimesis.

The 1980 Picasso exhibit at the Museum of Modern Art made it clear that, as Hilton Kramer puts it, "any criticism that refuses to acknowledge the aesthetic reality of this autobiographical element in Picasso is doomed to be incomplete" (41). What distinguishes the movement in modern painting and sculpture from Impressionism onward through Abstract Expressionism, including Post-Impressionism, Cubism, and Fauvism, is its expressionist quality, its insistence on the validity of what the artist sees and feels, and this movement has its parallel in literature. The pressures of society had driven the artist from the world to the word. In painting, as the Picasso exhibit reminded us, the shift toward the more abstract, the spatial, and the chromatic was not so much a movement to objectivity but research into the possibilities of art in response to different conditions of life. Could we have *Guernica* without the enormity of modern warfare? Similarly, modern fiction's innovations are an effort to breathe new life into a world that seemed to have become inert and superfluous. Or, as Woolf puts it:

> The idea has come to me that what I want now to do is to saturate every
> atom. I mean to eliminate all waste, deadness, superfluity: to give the
> moment whole; whatever it includes. Say that the moment is a combi-
> nation of thought; sensation; the voice of the sea. Waste, deadness, come
> from the inclusion of things that don't belong to the moment; this
> appalling narrative business of the realist: getting on from lunch to
> dinner: it is false, unreal, merely conventional. Why admit anything to
> literature that is not poetry—by which I mean saturated? (Woolf, *Diary*,
> III, 209-10)

In *An Ordinary Evening in New Haven* (1949) Stevens—another great Modernist
who made his life the subject of his art—writes of the relationship between
the artist and his art in terms that I have been describing: "The poem is the
cry of its occasion/. . . . [The] words of the world are the life of the world"
(*Collected Poems*, XII, 473). The great British Modernists, I think, have said in
their fiction that their words are their life. Or as Lawrence puts it, "I must
write to live" (Lawrence, *Letters*, 180). We respond to those words and the
presence behind them because their words are also the life of our world.
They have transformed the novel from a realistic social document into a "cry
of its occasion" and affirmed that the act of telling is their paramount concern
as artists.

Two

Manet, James's The Turn of the Screw and the Voyeuristic Imagination

I.

Phoenix-like, the relationship between literature and its contexts has been reborn as the field of cultural studies—a field that stresses power relationships among genders, races, and classes. New historicism and its sibling, cultural studies, have been skeptical of the older historicism's positivistic stories of A influencing B and of reductive drawings of the boundaries that divide foreground and background. While both new historicism and cultural studies have sought to see literature as one of many cultural artifacts, the artifacts usually are understood in terms of socioeconomic production. But the stress on micropolitical and macropolitical relations should not prevent this welcome return to mimesis and to historical contexts from attending to other kinds of cultural frames. Specifically, the return from the formalism of deconstruction to mimesis should be a catalyst for examining and juxtaposing figures and movements without regard to simple patterns of influence.

I am interested in examining cultural figures in configurations that put new light on cultural history. My goal is to isolate essential ingredients of modernistic culture, ingredients that spill over the borderlands between genres and art forms. While we have learned in recent years to be wary of locating essential or transcendent themes, it is still necessary to understand the genealogy of Modernism and the figures who contributed to the modification of the cultural genetic code—particularly since these modifications live with us now in contemporary art and literature. Specifically, I am going to frame contextually an odd triptych: Edouard Manet, Henry James, and

Thomas Mann. As I weave a narrative from particular strands of similarities, I shall inquire into what cultural forces produced this configuration.

From our vantage point in 1997, we can understand that the cultural revolution known as Modernism originated as much with the paintings of Picasso and Matisse, and before that with Manet and Gauguin, as with literary figures. Modernism questioned the possibility of a homogeneous European culture even as it sought to propose diverse and contradictory alternatives. As John Elderfield puts it, "history was not always thought to be quite possibly a species of fiction but once comprised a form of order, and might still" (*Matisse in Morocco*, 203). We might recall James Clifford's comment that in 1900, "'Culture' referred to a single evolutionary process. The European bourgeois ideal of autonomous individuality was widely believed to be the natural outcome of a long development, a process that, although threatened by various disruptions, was assumed to be the basic, progressive movement of humanity" (92-93). The major Modernists felt estranged from orthodox political and historical assumptions and from the cultural values in which they were educated. Yet artists and writers paid homage to the very traditional ideas of art from which they were departing by their strong response to their predecessors and their need to modify and transform them.

Modernists often tried to insulate art from history and to apotheosize the aesthetic. Indeed, New Criticism was not only a response to Modernist texts; it originated in part from Modernist aesthetics, such as Eliot's objective correlative, Joyce's concept of epiphany, Lawrence's insistence that we believe the tale not the teller, and James's emphasis in his Prefaces on the inextricable relationship between the aesthetic and ethical. But the recent emphasis on historicism seems to be particularly apt for Modernism, which was shaped by World War I, the women's suffrage movement, the Depression, and the disappointments in the promise of industrialism and urbanization. English Modernism questions the mythical idealized Victorian family; European artists were also addressing bourgeois expectations and myths. As we shall see, in keeping with my hedgehoggy integrative spirit that eschews foxlike linearity, my account of the genealogy of Modernism will include such varied data as the sexual repression of the governess in *The Turn of the Screw* (1898), the paintings of Manet in the 1860s, 1870s, and early 1890s, and that strange bachelor novel of Thomas Mann, *Death in Venice* (1912), which owes much to Joris Karl Huysman. All address the question, "What shall we do about loneliness?" For the need to be noticed, seen, and read relates to a pervasive sense in the late nineteenth century that each human is a separate island, disconnected both from his or her fellow humans and any transcendent order or teleology. I shall focus on

how seeing and being seen is related not only to the cosmic loneliness of the modern world, but to the social and personal loneliness of bachelors and spinsters—and of governesses and prostitutes—who become metonymies in modern literature for all humankind. In other words, for otherwise insignificant humans, the act of seeing and being seen becomes a desperate part of the quest for meaning.

Modern literature and modern painting valorize what is represented as an intensified and illuminating version of reality. While self-consciously and knowingly using a web of signs, artists affirm that what they see is a version of the essential nature of things. Following Romantic antecedents, and compensating for the dissolution of shared beliefs and emptiness within themselves, artists respond to nature in a way that reflects the often desperate quest of an intuitive, powerful imagination. Modern artists deeply desire the capacity to see beyond the rest of us, but have difficulty convincing themselves and others that they have done so. This leads to the wearing of masques, ventriloquism, multiple ways of seeing the same phenomenon (i.e. Wallace Stevens's "Thirteen Ways of Looking at a Blackbird") and role-playing. Yet the very process of role-playing—experimenting with diverse styles while rapidly changing voices—was an essential part of Modernism. Role-playing was crucial to Manet, James, and Mann. In a world where a systematic world view is impossible, *inclusiveness of possibility*—of multiple ways of seeing—is an aesthetic and a value. Isn't the essence of Cubism the insistence that we need not restrict perspective and that reality depends on multiple angles of vision of the same object?

The invention of photography, the breakdown of accepted moral certainties in religion and politics, the Darwinian revolution, the beginnings of modern physics in the work of J. J. Thomson, Freud, Nietzsche—all these factors about which I and others have written—played a role in the shaping of new aesthetic assumptions. By the 1880s, we have Nietzsche's *Gay Science* (1882-87) with his contention that God is dead as well as Krafft-Ebing's revolutionary texts on sexuality. We need to understand and reconfigure the affinities between modern painting and sculpture and modern literature—affinities that at times take the form of influences, at times cultural parallels, at times unconscious responses. The experiments of Cézanne, Matisse, Picasso, and Klee in color, line, space, and abandonment of representation often provided a model for the experiments of James, Conrad, Joyce, Woolf, Eliot, and Stevens that challenged orderly narrative and consistent point of view. Juxtaposing disparate elements in collage certainly anticipated and was affected later by the disjunctions in modern narrative. The stress on form and style in Eliot, Woolf, Stevens, Joyce, and James is a correlative in literature

to Matisse's stress on patterning and the decorative. In *Dance* II (1910) and *Music* (1910), Matisse subordinates individuality and character to the purpose of design. His art is at once a triumph of self and form. Turning to modern literature, is there a more patterned book than *Ulysses* (1922), a more choreographed one than *Mrs. Dalloway* (1925) or James's *The Wings of the Dove* (1902)? In *Ulysses*, particularly in the later chapters, Joyce's experiments in style are a version of the decorative; indeed, his assigning colors to each chapter recalls Wassily Kandinsky's color theories and the relation of color to what he calls "spiritual values." Yet, as Joyce discovered in "Sirens" and "Oxen of the Sun," language resists the decorative because we recuperate it in terms of meaning.

Cézanne carried the revolution away from convention further when he deconstructed and undermined the idea of a single perspective. He subordinated details to the demands of a grand design without sacrificing the specificity of his eye. Cézanne knew that we see in context and that an object takes its meaning from that context. Like Joyce, he stressed that the identity and meaning of any given object or person depend upon its proximity to other given objects. Like Bergson, who wrote "we have to express ourselves in words, but more often we think in space," as well as like Conrad and James, Cézanne was concerned with the act of cognition and the perception of spatial-temporal relations (quoted in Russell, 31). We can see a direct line from Cézanne to Picasso and Matisse, both of whom reinvented the world according to their imagination.

In this chapter, I want to examine the importance of seeing and being seen. When Conrad wrote eloquently in the 1897 preface to *The Nigger of the "Narcissus"* about his purpose as a writer, he wrote with the fervor of a man who believed in the capacity of art to shape our responses to life: "My task which I am trying to achieve is, by the power of the written word, to make you hear, to make you feel—it is, before all, to make you *see*" (*The Portable Conrad*, 708). He was speaking of the power of the written word to create within the reader's mind an experience—a visual experience—that would be his own but still a version of Conrad's:

> Fiction—if it at all aspires to be art—appeals to temperament. And in truth it must be, like painting, like music, like all art, the appeal of one temperament to all the other innumerable temperaments whose subtle and resistless power endows passing events with their true meaning, and creates the moral, the emotional atmosphere of the place and time. (707)

In many ways, "To make you see" is the subject of James's *Turn of the Screw;* the governess learns how to see differently in part because of her need to be

seen; Douglas wants to be the center of attention as narrator, and James is using his tale to discuss the subjective nature of optics. James uses the governess as a paradigm of what happens when reality becomes subordinated to self-indulgence. It may be that for James the governess—the unreliable narrator whose perceptions are psychotic—is a self-parody of extreme and self-indulgent aestheticism. I want to discuss *The Turn of the Screw* among the mindscapes of Modernism, specifically in reference to a number of the novellas of the period—notably, *Heart of Darkness, Death in Venice, The Dead, The Secret Sharer,* and *Metamorphosis,* as well as the paintings of Edouard Manet. James published *The Turn of the Screw* in 1898, the year Conrad published *Heart of Darkness.* James's and Conrad's experiments with the dramatized narrator show how Modernism shifts the emphasis to the subject as interpreter, to the perceiver's mind in action, to the observer as subject as much as to *what* he or she observes. With some complaining irony, Woolf remarked in her essay "Mr. Bennett and Mrs. Brown," "where so much strength is spent on finding a way of telling the truth, the truth itself is bound to reach us in rather an exhausted and chaotic condition" (117). In the modern period, "finding a way"—the quest for values and the quest for the appropriate style and form—becomes the subject. And is not finding our way another version of seeing?

What James has done in *The Turn of the Screw* is provide an alternative to the spiritualized Victorian woman's narrative; as Beth Newman eloquently writes: "[I]t might be possible to hear in her willingness to endure such 'exposure' a disguised expression of her desire to be seen, a wish that she could best exercise her supervisory duties and prevent the children from seeing the ghosts by in some way 'exposing herself'" (61). The governess's desire to be seen, recognized, and validated runs throughout her narrative. Newman observes:

> Caught between two definitions of ideal femininity—one valuing the inconspicuous but vigilant woman, the other representing the desirable woman as an object of visual pleasure—she consciously chooses the former. But she cannot divest herself of her unconscious desire to be seen, which influences her insistent seeing and possibly—if the ghosts are hallucinations—the content of what she sees. (61)

The task set upon her by the master who hires her is a desexualizing one "denying her participation in the libidinal economy of seeing and being seen" (61)—the economy that, as we shall see, is so much a part of Manet's world. But she finds sublimated ways to participate in that economy.

II.

Manet is not only the great transitional figure from realism to Impressionism, but also, as Michael Fried has argued in *Manet's Modernism*, the first Modernist. In *Olympia* (1865) and *Déjeuner sur l'herbe* (1863), Manet broke with convention and painted what he *felt*; he painted what was disorderly, odd, and accidental, and in doing so anticipated Van Gogh and Degas. Do we not see affinities between the Impressionists and the naturalism and realism of Zola, Moore, and Bennett (who lived in Paris in the 1880s) and the exoticism of Wilde? As John Russell has stressed, Manet was saying "'No' to pictorial tradition." He and later the Impressionists whom he influenced saw truth in what their eyes saw and in the very act of painting on a canvas: "The all over flicker of Impressionism mimed the very act of putting paint on canvas, where the suaver, blander and, in intention, seamless procedures of earlier painting had tended to conceal it. Impressionism said 'No' to the mind, with its apparatus of received values, and put its trust in intuition" (Russell, 18). Indeed, Manet's belief in the power of art—in particular, of showing—also distinguishes him as a Modernist. Anticipating Cézanne, Matisse, and Picasso, and like Joyce and Eliot, he dispenses with rhetorical ploys to sentimentalize his subjects and with commentary to guide the viewer's ethical response; rather he leaves the viewer to interpret his work. Nor does he draw upon traditional iconography to shape the perceiver's response. To be sure, he provides clues as to his view, but most often he is serving us a smorgasbord and leaving us to put together our judgments. That is why the backgrounds often have an incomplete and inconclusive look, as if to urge the perceiver to *finish* the painting. In this respect, Japanese painting has influenced Manet as it will later influence Gauguin and Odilon Redon.

It was Renoir who wrote of Manet: "Manet was as important to us as [Impressionists] as Cimabue and Giotto were to the Italian Renaissance" (quoted in *Manet 1832-83*, 17). He was, as Françoise Cachin wrote in her introduction to the Manet catalogue, the first painter "to paint openly from paintings, almost to the point of parody, taking painting itself as the object of its own attention" (18). I think of him as central to the genealogy of Modernism; certainly he was a precursor of Modernism in understanding the independence of art from life. But for him subject matter is also important: He wanted to render Paris in its infinite variety and seething energy. He was self-consciously aware of his predecessors and knew that the subject of his paintings was the direction, subject matter, and techniques of painting. Just like Joyce enjoyed words—even reveled in creating pastiches of bad writing, as he did at times in "Oxen of the Sun," "Cyclops,"

and "Nausicaa"—Manet enjoyed the very action of painting and composing, enjoyed the physicality of paint, the medium of paint. In a sense he played the role that Joyce—with his self-conscious awareness that in reinventing or fathering his predecessors he was writing about writing— did for modern fiction. Just as Joyce loved words and the act of writing, so Manet loved paint and the act of painting. He would have agreed with Baudelaire, who said: "Poetry . . . has no object but itself; it can have no other, and no poem will be so great, so noble, so truly worthy of the name of poem as that which has been written solely for the pleasure of writing a poem" (from "Theophile Gautier," in Ellmann and Fiedelson, 101). As we saw in chapter 1, while Victorian art was primarily (with some notable exceptions in the 1890s), concerned with rendering truth to nature and, by implication, to God's creation and with whether the sentiment was appropriate, morally healthy, and therefore fit for consumption, modern art is concerned with expressing the artist's inner self—his or her imagination and feelings—to the world beyond.

Like Wilde, Manet understood that art did not imitate nature. "What art reveals to us," Wilde wrote in *The Decay of Lying* (1889), his version of the Socratic dialogues, "is Nature's lack of design, her curious crudities, her extraordinary monotony, her absolutely unfinished condition. . . . Art begins with abstract decoration, with purely imaginative and pleasurable work dealing with what is unreal and non-existent. . . . [Art] makes and unmakes many worlds" (Ellmann and Fiedelson, 17-20). Picasso concurred: "Art is a lie that makes us realize truth. . . . The artist must know the manner whereby to convince others of the truthfulness of his lies" (quoted in Ellmann and Fiedelson, 25). Manet was influenced by Eugène Chevreul's *Principles of Harmony and Contrast of Colors and Their Application to the Arts* (1839), which, as Stephen Adams puts it,

> held that colors in proximity influence and modify each other. This, plus his theories of negative after-image—the idea that any color on its own appears to be surrounded by a faint aureole of its complementary color—and optical mixture became central tenets of Impressionism. The last, for instance, led them to tinge shadows with colors complementary to those of the object casting the shadow and to juxtapose colors on the canvas that visually seem to fuse at a distance. (10)

Before Manet, artists drew upon other artists' subjects and inspiration. But Manet began to take what he saw more seriously. He emphasized the preeminence of the eye even while allowing a place for the transforming imagination

to heighten and transform what he observed. Later, the invention of easily portable paint enabled the Impressionist painters to work in the open air. Modernism's turn to intertextuality and metonymy relates to the loss of belief in the traditional Christian plot stretching from the Creation to the Apocalypse. The works of humans, like the world of humans, take on stature and importance once painters no longer feel compelled to render the high points of the teleological Christian plot such as the Incarnation, the birth of Christ, or the crucifixion, or to record the portraits or deeds of secular potentates.

That Manet's art originated in the factual is stressed by his interest in narrative and history; for example, he wrote, "the heroic image and the image of love can never hold their own with the image of pain. This is the essence of humanity, its poetry" (*Manet 1832-1883*, 275). It is not only in the historical report of Maxmillian's execution—in *The Execution of Emperor Maxmillian* (1867), where Maxmillian stands erect awaiting his fate—that he depicts pain. Indeed, Manet is more effective in rendering introspective, troubled figures, such as the portrait of Berthe Morisot on the right in *The Balcony* (1868) and in *Repose: Portrait of Berthe Morisot* (1870). In the latter, he depicts Morisot—with almost a touch of disillusionment—lost in thought, somewhat dejected but without the deeply anxious eyes and pensive, set mouth of the introspective figure of *The Balcony*.

Manet was extremely fond of Morisot and identified with her, too, as an artist. At the age of 30, she was still unmarried; she was also, as Cachin wrote, "poised between bourgeois comfort and the hazards of artistic experience" (*Manet 1832-1883*, 317). Did not Manet transfer some of his feelings onto her? Did he not paint her to exorcise his own feelings, just as Joyce depicted Molly as a version of Nora Barnacle? *The Balcony* is framed by green shutters as if to emphasize the classic composition. Did Manet know that in English, the "shutters" homophonically and metonymically suggest the shutter of a photograph? Does not the painting suggest photography in the catching of the figures at an unguarded moment when they all are attending to something different?

Manet learned from photographers such as Felix Nadar that no two people look alike and that there is no need to either idealize or diminish human subjects by making them coarse or indecent. Indeed, for his historical paintings, Manet probably used photographs of the actual events. From Nadar he may have learned to use a few simple props and a planned background for his portraits. As Adams notes:

> By the mid-19th century, photography had reached a high degree of technical skill; it was possible, for instance, to take photographs at shutter speeds of around one-fiftieth of a second. The convention

whereby an image of a fleeting moment could be caught on a glass plate
without the intervention of an intermediary was to have its effect upon
many of the 'naturalist' painters, who saw it as a means of capturing both
this fleeting moment and doing so in an objective manner. (56)

Both photography and the Japanese influence contributed to the foreshort-
ening of perspective.

The modernism of *The Balcony* comes from the isolated space the three
figures occupy even as they stand in a group; the relationship among the
figures recalls the isolated space and loneliness of figures in Hardy's novels
and poems, figures walking alone on Wessex paths and roads or separated
by walls, windows, and railroad cars. As in Arnold's or Hardy's poetry of this
period—Arnold's "Dover Beach" or Hardy's "The Darkling Thrush," for
example—we feel the emphasis on division, separateness, even when people
are together. Unlike Goya's *The Maja* on which *The Balcony* may have been
based, Manet's figures have nothing to do with each other's space. The eye
is the recording eye of history, portrait, photographs. The fixed image with
few clues of the context reduces narrative, even as the mystery of character
relationships evokes it. It is as if the figures wanted to strike a pose, determine
how they are regarded, control the very act of our looking. But it is as if the
photographic shot—taken a moment too late after the figures dropped their
guard or a moment too early before they composed themselves—revealed
their inner selves. The man in the center might be James's master in *The Turn
of the Screw*, so imposing, self-possessed, and yet caught in an awkward
moment. It is as if Manet's figures were separated by what Arnold called in
"To Marguerite," "the Unplumb'd, salt, estranging sea." In "Dover Beach,"
the English speaker and his beloved are looking toward France even as he
speaks of the breakdown of Victorian truths. We might think of the immense
emotional distance between the speaker and the former beloved in Hardy's
"Near Lanivet, 1872" or "Neutral Tones." Because Manet does not provide
us with the rhetoric to tell one story, the audience is called upon to complete
the painting. In other words, Manet requires a "reader-oriented" response
because the **doesness**—the structure of effects—is underdetermined.

Manet exalted in the energy of the modern city, even as he understood
it as both promise and problem. His understanding of the city is captured
by Walter Benjamin's observation: "The city is reflected in a thousand eyes,
a thousand lenses. . . . [M]irrors are the immaterial element of the city, her
emblem" (*Manet 1832-1883*, 481). This is the city of Manet and also of Jean
Rhys's 1920s novel *Quartet* (1929). Do we not think of *The Bar at the Folies-
Bergère* (1881-82) when Rhys describes the scene Marya observes in back of

the café *patron*: "The mirror at his back reflected his head, round as a bullet, covered with a coarse mane of hair, and the multi-coloured row of bottles. A hatless woman came in, drank a glass of white wine at the bar counter and inquired after a certain *beau blond*" (168). World War I has left its human debris of lost souls. In the previous passage the mirror no longer holds up an image to nature but, in a process of metaphoricity, distorts, controls, undermines, projects—and even blocks. In a sense the customer becomes, along with the reflected head, part of a still life with the bottles. The woman, a metonymy for Marya, *mirrors* her sexual desperation and chaotic, function-less life, just as each member of the quartet mirrors one another.

We recall the climactic passage in the "Ithaca" section of *Ulysses* where Stephen and Bloom look at each other: "Silent, each contemplating the other in both mirrors of the reciprocal flesh of their hisnothis fellowfaces" (XVII. 1183-84). In Stephen's striking metaphor about how the present will appear from a distance of time, the future is the mirror—the reflection of the past— because as he says elsewhere, "Coming events cast their shadow before" "So, in the future, the sister of the past, I may see myself as I sit here now but by reflection from that which then I shall be" (VIII. 527; IX. 384-86). The notion of mirror as self-expression—a window into self—rather than merely as object held up to external nature is an instance of how Modernism builds upon a romantic emphasis on a teleology of self—as in Wordsworth's *The Prelude* (1850)—as its subject. The frequency of Picasso's self-portraits and Stevens's selfconscious and reflective poems are, of course, instances of this. So is Matisse's continuing citing of his own prior work in such paintings as *Piano Lesson* (1916), which includes references to *Woman on a High Stool (Germain Raynal)* (1914) and *Seated Nude (Olga)* (1911?); for Matisse, "coming events cast their shadow before." As the work of Eliot, Stevens, Joyce, Lawrence, Picasso, and Matisse shows, the use of art to construct oneself is a feature of Modernism.

III.

I turn rather abruptly to Manet's *Déjeuner sur l'herbe* (1863; see p. 59), a parody of the pastoral as seen from an urban perspective. Two young urban males— the tasseled cap was worn by students—are picnicking with a naked woman. Meanwhile, in the background a woman emerges from a stream. But the background landscape might be another picture ironically commenting on the foregrounded picnic. Or we might say the middle-grounded picture, because foregrounded on the left is a still life. Isn't Manet calling attention

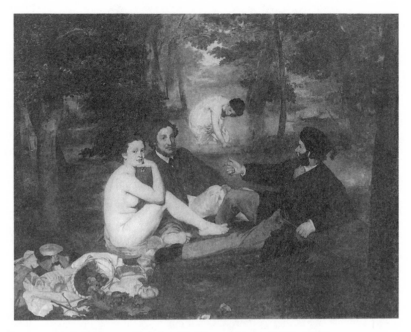

Le Déjeuner sur l'herbe (1863), Edouard Manet (1832–1883)

to his ability to mix genres however he pleases and to defy—like the naked woman—conventions of genre and perspective?

Neither woman—the one sitting on her wrap or the one emerging from the stream—pays attention to the men or to each other. Each is in her own space. Note how the naked woman is unselfconsciously looking away from her companions, perhaps to catch the attention of other men or women who are not within the scene. In a sense, we the audience are engaged frankly by her as voyeurs in a libidinal interchange in which she both looks and is looked at. If we think of *The Turn of the Screw*, the middle-grounded woman is the governess's suppressed libidinal self, while the self-absorbed and mysterious woman in the background is the embodiment of the governess's conscious level. We follow the phallic cane as it calls attention to her nakedness. As Françoise Cachin notes, "the still life accentuates the nudity of the woman, who becomes, in the presence of this heap of fashionable raiment, undressed rather than nude" (*Manet, 1832-1883*, 169). Yet the picnic lunch, with its cherries of June and figs of September, is not realistic. We

see the influence of Titian's *Concert Champêtre* and Raimondi's engraving—inspired by a Raphael composition—*The Judgment of Paris*. (Manet would have enjoyed the classical echo of his city's name.) But in Manet's realistic Paris, sexual frankness dominates.

In the woman emerging from the lake, Manet ironically refers to Botticelli's *Birth of Venus*; yet he reminds us that the current Venus in contemporary Paris is the middle-grounded nude woman—perhaps but not necessarily a prostitute—who can do with her body what she wishes. Indeed, from one perspective, the painting is gender-inscribed both as a masculine fantasy and as a text to show woman's control over her body, sexuality, and mood. She will *decide* on the sexual stakes and not tolerate abuse. By using his two brothers as models for the males, Manet shows his own participation in the fantasy. We are reminded of how Modernism's energy derives, in a time of moral and historical transition, from the artist's self-creating. In its deference to Old Masters, Manet's painting respects canon; in its provocativeness and parody, it opens the curtains to Modernism. Indeed, the background could be a stage backdrop for a Japanese screen. So unrealistic is the background, its very artificiality undermines the verisimilitude of a scene in open air; in fact, it was painted in a studio. The trees on the left and right suggest a framing curtain and anticipates Matisse's *Bonheur de Vivre* (1905-1906) and Picasso's *Demoiselles d'Avignon (1907)*.

Let us think about Manet's Modernism. In subject matter, he freed—to the dismay of many conservative critics of his day—the female nude from any pretensions of idealism and planted her squarely in the world of sexuality. Could Joyce have had this painting in mind when he created Molly's and Bloom's great moment of uninhibited intercourse during a picnic on the Howth in the "Lestrygonians" section of *Ulysses*? And Manet addressed the urban world of the city—from fashionable life (*Music in the Tuilieres, 1862*) and the life in cafés, to the outsiders such as the prostitute in *Olympia* (1867). He depicts women as sexual figures without sentimentalizing them. Manet explores various kinds of possibilities that thwart, offend, and undermine bourgeois family values. As in his pictures of Berthe Morisot, he also depicted women as coequal humans with a full range of emotions. And these two innovations—the focus on the painter and the perceiver and the opening up of subject matter—are related.

Not only *Déjeuner sur l'herbe*, but also *The Bar at the Folies-Bergère* (1881-82), *The Plum (1878)*, *Olympia*, and *Nana* (1877) are narratives of voyeurism. These narratives that anticipate Henry James's preoccupation in *The Turn of the Screw* with seeing and being seen. Just as James penetrated the gloss and style of English aristocracy to discover darker truths, so does Manet address

late nineteenth-century Parisian society. His *oeuvre* is like a novel; each painting is an episode or chapter in an unfolding saga of life in Paris. His city paintings remind us of Joyce's vignettes of the modern city in *Dubliners* and *Ulysses*, particularly the "Wandering Rocks" section. Just as episodes organize vignettes and pieces of dialogue and action, and chapters organize episodes into larger narrative elements, and, finally, parts or volumes of novels organize chapters, so single paintings form series that pertain to one subject, and several series of paintings might form larger organizing groups. Of course, what we organize into series and groups depends upon our perceptual interest. In this way we can regard Manet's paintings of Paris and its inhabitants as collectively forming a saga composed of a concatenation of narrative episodes: *Young Lady in 1866 (Woman with a Parrot)*, *Gypsy with Cigarette or Indian Woman Smoking* (1862), *Young Woman Reclining in Spanish Costume* (1862), *The Street Singer* (1862), *Masked Ball at the Opera* (1873-74), *Lola de Valence*, *Olympia*, and *Déjeuner sur l'herbe*. In one group, including *Déjeuner sur l'herbe*, *Woman with a Parrot*, *The Plum*, *Olympia*, and *Nana*, he is fascinated with changing sexual mores. For example, in *Woman with a Parrot*—which alludes to Courbet's *Woman with a Parrot*—the parrot is a metonymy for sexuality; the parrot sees its mistress undressing and knows her secrets, and perhaps could reveal fragments of them that it has overheard. Certainly the woman in the peignoir, who is holding a monocle that could be a man's—her lover's—combined with the discarded orange—image of her being used and discarded by the absent male, image of her open vagina—is not idealized. The orange anticipates the untouched plum, itself metonymic of sexuality, in *The Plum* (1878?). (Doesn't the plum suggest Joyce's use of the plum as a sexual and political symbol in *Ulysses*?) The woman is either a prostitute or a *griselle*, a working-class woman who often dressed above her station and visited places of public entertainment. In a world controlled by males, Manet understands that the way women are looked at and how they look at others creates their identity. Like James's governess, these women are often in their own space—on their own psychic island—and dependent on others to give them identity.

Manet is the painter of the contemporary life of his era. What Joyce did for Dublin and Damon Runyan did for New York, Manet did for Paris in painting. Manet's *oeuvre* displays his exuberant response to the variety of the city, its range of classes, its stories of seeming insignificance, its energy and complexity. He sees the spontaneity of human actions—including its ugliness and foolishness—of Paris's inhabitants, and he understands their impulse for self-survival in an indifferent environment. The very order, splendor, and glamour that Baron Haussmann brought to Paris had not

improved the lot of the working person. Beneath the glitter was another Paris; the high rents drove workers into the new slums that replaced those in the central city. Manet delights in the physical presence and quirks of his figures, and deftly balances empathy with objectivity. He enjoys the impudence of the *gavroche* in the *Masked Ball at the Opera*. Influenced by Ribera, he depicted the outsiders, disadvantaged, and lower classes with gusto and sympathy, and showed the way for Picasso to do the same. Indeed, Picasso's Paris—and Joyce's Dublin, which in the "Circe" section of *Ulysses* and in the bargirls snapping their garters in "Sirens" is often Paris mediated—owe much to the influence of Manet. Picasso's *Old Guitarist* (1903) might have been a response to Manet's *The Spanish Singer* (1860).

In *The Bar at the Folies-Bergère*, what is most striking about the bar is that the image in the mirror does not quite reflect the scene out front, but includes a customer omitted from the outside scene. Manet has two perspectives: (1) from the left where the customer would be standing; (2) and from the front of the painting where the viewer is standing. It is as if the viewer who is absent has taken the place of the man whom the barmaid is serving in the reflection. The painting calls attention to the viewer even while reminding us that the woman is more perceiver than participant. We should see something of the customer in front of her, but we do not. Her story is ambiguous; she is detached and something of an intermediary between the perceiver and the world of the Folies-Bergère, as if she were an artist watching the world in which she participates. Like James's governess, she is an insouciant outsider—reflective about her life but somewhat oblivious to the world she inhabits. It is as if Manet were stressing the double selves, the inward and outer selves both the man and woman have. The mirror— another glass plate—no longer holds up an image to nature but in a process of metaphoricity distorts, controls, undermines, and projects. We recall the epiphanic moment in "Circe" when Stephen and Bloom look into the mirror in the whorehouse and see Shakespeare. In "Asides on the Oboe," Stevens describes the poet "As a mirror with a voice, the man of glass, / Who in a million diamonds sums us up." The modern artist holds the mirror up to nature, but what he gets back is an illuminating distortion. The mirror in *The Bar at the Folies-Bergère* insists that art give us more than it sees. But ironically, the woman bartender withholds herself from the man and the viewer. The artificiality of the perspective stresses the importance of *art*.

Like Bakhtin, Manet understands the possibility of a multitude of voices in any discourse and visually represents them. He presents the spontaneity of human actions without pontificating or moralizing, and this includes *Woman in the Tub* (1878-79), *Olympia*, and *Nana*. Of course, Manet

paints in the context of the French naturalists. In 1877 Zola, his enthusiastic supporter, had introduced Nana in *L'Assommoir* but had not yet begun serializing *Nana* and would not do so until 1879. Later, when Degas and Toulouse-Lautrec became fascinated with the prostitute, not only would Degas's figures be of a lower class than Manet's, but both artists would be more judgmental and ironic than the accepting, detached Manet.

Manet's characterization of Nana dominates the space of the painting of that name—a departure from the expectations of genre painting—and the voyeuristic male client (like James's master in *The Turn of the Screw*) is reduced to a supernumerary who is treated mockingly, if not contemptuously. It is as if Manet conceived the two figures on a different scale. *Olympia* is also about the art of watching, in this case a naked woman who flaunts her sexuality. In *Olympia*—Manet's sly adoption of Titian's *Venus of Urbino*—he uses the black cat, the black servant, and the black ribbon. He uses eccentric details—illuminating distortions—to make his point. The huge bouquet, opened by the black servant, suggests a gift from an admirer but calls attention to her sexual parts and her propensity to make them available; the flowers—echoed in the blue trim of the slippers and the red and green of the embroidery—become a metonymy for her sexual mysteries within the wrappings (or vagina lips) that enclose them. The bold placement of the bed in the foreground emphasizes the subject figure's uninhibited boldness, and the details of the sheets and pillows recall the sumptuously dressed portraits of prior eras, including those of Van Dyke. Her head is hardly modeled, as if it were less important than her body, while the black ribbon and the blue slippers stress her eroticism. Finally, the viewer is complicit in the art of voyeuristic gazing. What Manet does is raise questions about bourgeois expectations and myths; he creates a link among desire, eroticism, and loneliness in a world where God's presence in a post-Darwinian cosmos is a matter of doubt and anxiety.

IV.

From Manet's Paris to James's London is not such a long journey. Governesses, life models, and prostitutes belong to no social class. What makes the governess uncomfortable is that she is being looked at by one man, Quint, as she herself fantasizes about being desired by another man, her employer. As Beth Newman puts it: "It is as though the governess's earnest, conscious desire to be the ideal domestic woman (the better to please her employer and perhaps gain his love) forces her into a sharper, more stringent

surveillance" (60). At all times the governess is most conscious of being watched by the master, the children, and the specters. Quint, like Tadzio in relationship to Aschenbach in *Death in Venice*, Mann's homoerotic version of *The Turn of the Screw*, represents, as Newman remarks, "the return of the repressed, with all the uncanniness—that combination of strangeness and familiarity—such a return implies" (53). The desire to be seen, recognized, validated, desired—the result of her isolation—runs through the governess's narrative.

The Turn of the Screw develops out of nineteenth-century obsessions about looking and being seen; it parodies the reductive dichotomy—inculcated by Victorian cultural conventions—between reason and passion, between id and superego, while examining how paralytic self-consciousness can result from repression and displacement. What I want to argue is that such erotically charged seeing is understood by studying Manet and that texts such as *The Dead* and *Death in Venice* partake of the same phenomenon. And it is Manet, I am contending, who is partly responsible for bringing the looking at unidealized sexual beings out into the open.

For the governess, Quint emerges as a sexual object in invidious form that challenges her fantasy as a wife; and perhaps she understands at some level that Quint is her rival for her master's affection. After all, she is "young and pretty," and, like the naked women in *Déjeuner sur l'herbe*, there to behold when she meets her master. She was "carried away" by her employer. Like those women Manet presents in *Olympia* and *Déjeuner*, the governess is an erotic and ironical comment about the sexualization of women. It is as if James—doubtless familiar with Manet's painting and with naturalism in literature—were trying to see if the genre of sexual intimacy could be put back in the box of Victorian conventions of sexual propriety. For the bachelor patron struck the governess as "gallant and splendid" (James, 631),[*] and she "saw him all in a glow of high fashion, of good looks, of expensive habits, of charming ways with women" (631). The amplitude of the country house contrasted with her "own scant home" (635). Her service is erotic and hints at the master-slave variety. Lonely, sublimated, and ingenuous—the very epitome of Modernist isolation—she feels joy in giving pleasure "to the person to whose pressure I had responded" (646).

[*] I have used the original 1898 edition reprinted in Philip Rahv's *The Great Short Novels of Henry James* (New York: Dial Press, Inc., 1965) rather than the more stylistically uniform New York edition. This edition reprints the original edition.

James's *The Turn of the Screw* is concerned with looking and being looked at. So is the tradition of still life, which plays such an important role in Impressionism and Post-Impressionism, and, which is a source of the miniature episodes that comprise *The Turn of the Screw*. As we have been noticing, *the act of observing* is a crucial point in Modernism; borrowing from astronomy, Joyce makes the theme of parallax—how the same phenomenon looks different from a different angle or perspective or how, by extension, human events look different to a different perceiver—central to *Ulysses*; Cubism is about the need to see from multiple perspectives.

Manet, like James, was interested in how the exceptional and diurnal rub against one another. And James's rendering of the governess is a rendering of a character in excruciating pain. For Quint is something of a rake, but more than that, a man of insidious vice, sexual insistence, putative perversion; moreover, in the economy of erotics, the governess has imagined herself as the object of his gaze. What the frame technique does is empower the reader's gaze by making the reader—through her/his metonymic relationship with both speaker and governess—a perceiver, a crucial figure.

What I am suggesting is that we should think of the governess's telling in *The Turn of the Screw* as a self-portrait. The governess sees herself as if she were a painting, an object or text requiring another to bring her to life. Thus her telling not only is part of a genre of nineteenth-century self-portraits in which the gaze of the perceiver completes and realizes the subject, but is also a repressed and displaced version of Manet's erotically charged gaze, a version shaped by the anxiety of the paralytic self-conscious speaker. We understand that her perspective results from an idealized, mysticized sexual culture where—unlike the world of Manet—passions and libido are denied. We might recall Jacques Lacan's insight about the painter's gaze as a way of linking our parallel between James and Manet:

> The painter gives something to the person who must stand in front of his painting which, in part, at least, of the painting, might be summed up thus—*You want to see? Well, take a look at this!* He gives something for the eye to feed on, but he invites the person to whom this picture is presented to lay down his gaze there as one lays down one's weapons. This is the pacifying, Apollonian effect of painting. Something is given not so much to the gaze as to the eye, something that involves the abandonment, the *laying down*, of the gaze. (101)

Like Gabriel Conroy in Joyce's *The Dead*, the governess often regards herself as strangely detached, the object of her own gaze, a kind of painting that

she might observe on the tastefully decorated walls of the house she inhabits. The governess speaks of her experience as if it were a series of paintings. She seeks to depict "a credible picture of my state of mind" (James, 664). She is both a fiction-maker and a participant in the fictions of others. If Quint is a spectator, is she creating her own viewer/narratee? The governess lives in a world of pictures; *The Turn of the Screw* is James's version of *Pictures at an Exhibition*. She wants to see allegorized, uplifting pictures and conceives herself in those terms—terms borrowed from nineteenth-century British representations of women in painting. Her mental pictures are the kind of misty allegorized pictures of the Pre-Raphaelites, such as John William Waterhouse's *Hylas and the Nymphs* (1896), Ford Madox Brown's *The Last of England* (1860), or the paintings of Dante Gabriel Rossetti or Edward Burne-Jones. But with her eyes she *sees* scandalous pictures produced by French lubricity.

Put another way, *The Turn of the Screw* is like a museum exhibit because the vignettes are visual. The governess arrests narrative moments and perceives them spatially as if they were museum pieces. Early on, Flora, the girl in the governess's charge, is compared with "one of Raphael's holy infants" (636). The children create a "spectacle" in which the governess participates as an active admirer: "I walked in a world of their invention" (665). Does not *The Turn of the Screw* call attention to the aesthetic, the fantastic, the romantic, the gothic, and the performative? To the governess, Quint looked "like an actor" (658). Her imagined reality refuses to be constrained or contained by day-to-day reality. The governess lives in a pictorial gallery of her own making: "Someone [the man who hired her] would appear there at the turn of a path and would stand before me and smile and approve" (647). For her, optative becomes indicative.

But what intrudes is a Modernist nightmare worthy of Edvard Munch: "[T]he man who looked at me over the battlements was as definite as a picture in a frame" (648). In her head is a dialogue between two pictures: the fantasy vision that the appealing bachelor who hired her will appear to sweep her away and the rakish corrupt figure that haunts her: "What arrested me on the spot— and with a shock much greater than any vision had allowed for—was the sense that my imagination had, in a flash, turned real. He did stand there!" (647). Of course to the figure staring at her, she is the aesthetic object. It is as if she were looking in the mirror, but like Stephen and Bloom in "Circe," what she sees is "other"—but *other* as a version of self: "[E]ven as he turned away [he] still markedly fixed me" (649); or: "I applied my face to the pane and looked, as he had looked, into the room" (654). In a sense, Quint and Miss Jessel represent the aesthetic and the fantastic, wooing the children from the world of doing.

To a resistant reader, the governess's sexual obsession and hysteria have undermined her capacity to take care of the children as surely as, in Conrad's *The Secret Sharer* (1911), the captain's obsession with Leggatt has undermined his capacity to command his ship. The governess lacks sexual self-confidence and thinks of women as the "inferior sex." She doesn't summon the master—Flora's and Miles's uncle—because she believes that he will think that she "had set in motion [machines] to attract his attention to [her] slighted charms" (695). She is loyal to the absent uncle—her chosen "master" to whom she submits her will—with whom she has an erotic obsession, and her judgment about his behavior is skewed:

> He never wrote to them—that may have been selfish, but it was a part of the flattery of his trust of me; for the way in which a man pays his highest tribute to a woman is apt to be but by the more festal celebration of one of the sacred laws of his comfort; and I held that I carried out the spirit of the pledge given not to appeal to him when I let my charges understand that their own letters were but charming literary exercises. (700)

Flora and Miles are in need of Social Services, and a contemporary reader might ask ironically why has not someone, perhaps Mrs. Grose, called the hotline to complain of a neglectful uncle as well as abusive servants. Is the governess paranoid? Sexually hysterical? She considers appearances of the dead to be "molestations" of her person; when they do not appear she says: "I continued unmolested" (698). But her real issue is a desperate need to be attended, objectified by the gaze of others, and filled with the plenitude of recognition. Without realizing it, she is one of what Herman Melville calls *Isolatóes*, those who "not acknowledging the common continent of men . . . [live] on a separate continent of his own" (118).

We think of Huysman and the aesthetes like Oscar Wilde and Aubrey Beardsley when the governess refers to her perceptions in aesthetic terms, as if they were pictures in a gallery: "This picture comes back to me in the general train" (James, 650). Her views of the apparition resemble the experience of coming upon disturbing paintings, for like paintings, the apparition does not do anything or respond or take part. That may be the reason, among others, that James spoke of the story in his preface as "a merely *pictorial* subject" (623). As in Conrad's *The Secret Sharer*—which also empha-sizes looking and seeing as a mode of perception that reveals the inner workings of character—loneliness half creates what the governess sees. Let us recall when she sees Miss Jessel: Miss Jessel is described as "a woman in

black, pale and dreadful—with such an air also, and such a face!—on the other side of the lake" (668). After *looking*—but not speaking or moving toward the female figure, her other self, a woman mysteriously and helplessly sexually corrupted by Quint *or* perhaps the initiator of corruption herself, she looks at the young girl in her charge. That her predecessor had been corrupted and seduced is both a source of fear and sexual hysteria that she displaces and projects onto the children; to be sure, she fears for them, but isn't the threat a projection of her own psyche? In her mind she paints still lifes, portraits, and fantastic landscapes.

Miles and Flora are desperate for love, for they are orphans, virtually abandoned by their uncle, who has consigned their upbringing to servants. What Quint and Miss Jessel offer apparently is initiation into sexual mysteries with a homosexual orientation. (That such an offer proffered by an older man is rejected by the young boy in Joyce's "An Encounter" shows that this theme recurs in the period; and James in *The Pupil* explores the homosexual undertones between mentor Pemberton and pupil Morgan.) Quint wears the master's clothes the way Leggatt wore the captain's. Here we have the governess as a third party who—repressed, lonely, and increasingly hysterical—must distinguish between the master and servant, the living and the dead, the innocent and the corrupt (in the matter of the children's complicity), the spectral appearance and the real. Are not the curses of Miles and Flora aestheticism, compulsive self-reflection, and narcissism? Like Tolstoy's Ivan Ilych, they can't feel and are caught in a web of their own selfishness. (Apparently the reason Miles was asked to leave school is that he spoke about sex to the fellows he "liked," but does he not often seem anesthetized? [746].) And the sexual undertones emphasize this; note how, after Flora and Mrs. Grose depart, Miles takes the place of a male companion when he and the governess sit together in the schoolroom "as silent, it whimsically occurred to me, as some young couple who, on their wedding-journey, at the inn, feel shy in the presence of the waiter" (738). After Flora leaves he no longer can see Quint, as if the charm depended upon her.

In a sense the apparitions, particularly Miss Jessel, become the governess's secret sharers, and she speaks of Quint as a stranger the way the captain-narrator spoke of Leggatt in *The Secret Sharer*. Particularly to a contemporary reader, does not the male bonding in Conrad's story have a homoerotic aspect? After all, they are in bed together and communicate like lovers: "And in the same whisper, as if we two whenever we talked had to say things to each other which were not fit for the world to hear, he added, 'It's very wonderful'" (Conrad, 688). Note the parallel between the unmarried governess when she encounters her predecessor—or, rather, her ghost—in

the schoolroom: "[S]he had looked at me long enough to appear to say that her right to sit at my table was as good as mine to sit at hers" (707).

I return to Benjamin's words, "The city is reflected in a thousand eyes, a thousand lenses . . . [M]irrors are the immaterial element of the city, her emblem" (quoted in *Manet 1832-1883*, 482). Mirrors always distort, for we see only what we, the perceivers, want to see; we only see the part of the body on which we focus. We might recall the mirror in *The Bar at the Folies-Bergère*. In *The Secret Sharer*, the captain observes: "The shadowy, dark head, like mine, seemed to nod imperceptibly above the ghostly gray of my sleeping suit. It was, in the night, as though I had been faced by my own reflection in the depths of a somber and immense mirror" (Conrad, 657-58). In *The Turn of the Screw*, the governess sees herself for the first time "from head to foot" in the mirror in the long, impressive room to which she is assigned (James, 635). Identity is dependent on what one sees, how one sees, and how one is seen. And does it not focus on ourselves creating what we see and so call attention both to the self-reflexivity of reading in the modern era and to the continuity between reading texts and reading lives? Are not Manet and James inviting us to ask questions about the way we see in mirrors—and texts, that is, what we bring to them? Do we not inadvertently, like the governess and Aschenbach and Manet's women, make texts into sites for our own constructions?

The Turn of the Screw's self-reflection and narcissism are troped in its style. The "I" not as a *subject* of ego but as the *object* of service becomes the subject:

> I used to wonder how my little charges could help guessing that I thought strange things about them; and the circumstance that these things only made them more interesting was not by itself a direct aid to keeping them in the dark. I trembled lest they should see that they *were* so immensely more interesting. Putting things at the worst, at all events, as in meditation I so often did, any clouding of their innocence could only be—blameless and foredoomed as they were—a reason the more for taking risks. There were moments when, by an irresistible impulse, I found myself catching them up and pressing them to my heart. As soon as I had done so I used to say to myself: "What will they think of that? Doesn't it betray too much?" It would have been easy to get into a sad, wild tangle about how much I might betray; but the real account, I feel, of the hours of peace that I could still enjoy was that the immediate charm of my companions was a beguilement still effective even under the shadow of the possibility that it was studied. For if it occurred to me that I might occasionally excite suspicion by the little outbreaks of my sharper passion for them, so too I remember wondering

if I mightn't see a queerness in the traceable increase of their own
demonstrations. (678-79)

The governess perceives herself as having a demonic post of service; a post
erotically defined by the act of seeing. Are Miles and Flora not both *fixed* by
the governess and the reader, and—as we shall see—Douglas, as objects of
voyeurism?

V.

Let us now examine *The Turn of the Screw* from another perspective. In James,
as in Huysman, a sometimes inverted bachelor needs to create his own
company and routines; as in *The Pupil*, we see lonely male figures reaching
out for empathetic others. Something of the kind is at work in the group—
men and women—at the country house scene in the opening of *The Turn of
the Screw*. As does Huysman, James depicts lonely, repressed, emotionally
stifled figures who create their own needs. (Kazuo Ishiguro draws upon this
tradition in *The Remains of the Day* [1989], a different kind of ghost story
narrated by a post–World War II Douglas.) The governess's story is told
within a predominantly male and apparently bachelor circle, although there
are a few ladies present. Douglas, the narrator, shares the governess's
manuscript with his friends, a manuscript entrusted to him after he had
earned her confidence because they shared a relationship one summer. She
had been his sister's governess; they had spent a summer together and clearly
enjoyed each other's company. The teller, the first narrator, is also a bachelor
who seems to find the presence of women a nuisance: "The departing ladies
who had said they would stay didn't, of course, thank heaven, stay" (James,
631). That Douglas leads his audience as if he were conducting a Socratic
dialogue implies a homoerotic dimension. Of course, given how many of
James's bachelors find confidence in a "safe" married woman—as in *The Aspern
Papers*—it is possible that the first narrator is a woman, or that James is
deliberately ambiguous about the sex of the frame narrator. Yet I hear a
voyeuristic male voice replicating not only Douglas's curiosity and sexual
interest, but also perhaps the master's.

 The governess's hysteria is related to the sexual excitement aroused
by the bachelor master who hired her to tutor his young charges. Why does
the master make such a misjudgment? Since Quint is described as the
master's "own man," is it not implied that those two bachelor figures were
lovers? Could the master, too, have been corrupted by Quint? Does that

explain his pathological need for distance? Quint, who appears as an apparition to the governess, is dissolute but "handsome," according to the housekeeper, the aptly named Mrs. Grose (658). He is a bachelor who preys on the innocence of his victims. As a bachelor he is as capable of corrupting her, as he did her predecessor. Quint seems to be a pederast, sexually corrupting Miles while Miss Jessel—with whom he apparently had a liaison—corrupts Flora. The second apparition—Miss Jessel, the governess's predecessor—is to her, "an alien object in view—a figure" (666). And she thinks that Miss Jessel looks at her in the same way. The governess is sexually attracted to Miles, whom she calls "my boy," and gives him far more attention than she gives Flora.

As Richard Sieburth notes, the bachelor has no place in a family-oriented culture:

> The bachelor cuts a somewhat pathetic figure in a nineteenth century given over to the ideological consolidation of the social and economic virtues of family life. Sexually, he is viewed with both condescension and trepidation, for while his legitimate recourse to prostitution is more or less condoned, he nonetheless threatens the social order as a possible agent of adultery, criminal seduction, or unnatural perversion. Economically, he is considered at most a marginal entity, for he plays no role in the transmission of property through inheritance or dowry. Civically, he is seen as an embarrassment to community values, a case of arrested development, narcissistically clinging to the prerogatives of his self-centered individualism. (5)

And of course the governess is a female counterpart to the bachelor. Is not this shift to self—this narcissism—on the part of master, governess, and Douglas appropriate for the self-contained unit of bachelorhood?

It is not accidental that Joyce's "Stately, plump Buck Mulligan" recalls Oscar Wilde, the ultimate bachelor figure although married. In Joyce, Stephen is a desperate young man who must resist homosexuality, and Bloom has been reduced to a caricature of a bachelor by his dysfunctional marriage. The bachelor motif plays a role in the sea tales of Conrad and in the male bonding between Marlow and Kurtz in *Heart of Darkness* and, in particular, between the Captain and Leggatt, where the word "secret"—which, as in *My Secret Life*, implied to the Victorians one's sexual life—gives the story a strong sexual implication.

Huysman's and Wilde's bachelors anticipate the frame narrator and Douglas of *The Turn of the Screw* and the Marlow who narrates to a fellow

group of males in "Youth," *Heart of Darkness*, and *Lord Jim* as well as, of course, Aschenbach and Kafka's bachelor in *Metamorphosis*. Sieburth notes "Huysman's aestheticism," his "encyclopedic compost," his interest in the occult, his rapid alternation between nightmare and reality—what Sieburth calls his "laconic montage technique" (5). And the qualities, I think, anticipate the techniques of Conrad—particularly in his Marlow tales where the discourse controls the story—and James. Marlow, like the governess, becomes imprisoned by Kurtz, the nightmare of his choice: Kurtz and Quint are demonic figures who destabilize the central narrators—Marlow and the governess—and undermine their assumptions.

The James tale, too, takes place in a world that challenges Western assumptions about reality and its concepts of order and logic: "The answer to my appeal was instantaneous, but it came in the form of an extraordinary blast and chill, a gust of frozen air and a shake of the room as great as if, in the wild wind, the casement had crashed in" (James, 715). The governess sees an "apparition" of the dead servant, Quint: "the thing was as human and hideous as a real interview: hideous just because it *was* human, as human as to have met alone, in the small hours, in a sleeping house, some enemy, some adventurer, some criminal," and her seeing derives from her paralytic self-consciousness about being seen (682). That the narrator of each tale tells the story of atavistic energy within a frame—the listeners on shipboard in the Conrad tale, the listeners to Douglas's reading in a drawing room—enacts the attempt of so-called civilization to control primitive energy (which takes the form of Kurtz's reversion to savagery and megalomania and Quint's and Miss Jessel's sexual license) and to understand it in terms of the culturally accepted norms.

One wonders if Gauguin's depictions of spirits—such as the relationship among the spirit, the girl, and the artist in *Manao tupapau*—influenced James, for in that painting, the ambiguity about who is imagining and gazing at whom is essential. Gauguin eulogized the primitive in the 1892 *Fatata te miti* (in the Washington National Gallery), which transforms the Golden Age of traditional painting—Titian, Fragonard, Courbet, Corot—to Tahiti. Since *The Turn of the Screw* is about obsessiveness, trauma, and catatonia, it is appropriate that time stands still. In that work, Miles and Flora—and the governess who is tutored, mentored, and metamorphosed by them—are condemned to a perpetual present haunted by ghosts of Quint and Miss Jessel—and the implication of initiation into sexual perversity—that will not fade; as with Franz Kafka's nightmare fable, "The Hunter Gracchus," past and present inhabit conterminous space. Time can be an imprisonment when obsessions intrude and arrest time, leaving the

obsessed in a perpetual present. Note how as the story moves from June to November—from late spring to approaching winter—the 24 chapters emphasize the ghostly claustrophobic ticking of a clock on a wall as the listeners hear Douglas's ghostly story. Like hours on a clock, the 24 short chapters emphasize the tick-tock of passing time and the logical progressive temperament of the Western reader as he or she—like the governess—faces challenges to the known.

VI.

Let us turn to our parallel text, *Death in Venice* (1912). Mann's text makes more explicit the underlying themes that we have been discussing in *The Turn of the Screw*: seeing and being seen as a function of loneliness, narcissism, and self-isolation. *Death in Venice*, like *The Turn of the Screw*, is about erotic aestheticism; Aschenbach's narcissism, paradoxically, is implicit in his ascetic denial of life, his obsession with control, and his conception of heroism—in such a work as his *The Abject*—as persevering in the face of exhaustion. Paradoxically, the governess's *service*—abject service—becomes a kind of narcissism, and her self-abnegation is a cause of a kind of nervous collapse. Mann suggests that asceticism and aestheticism share a narcissistic base (as does Kafka in *Metamorphosis*). When Aschenbach meets Tadzio, he transfers his passive-aggressive behavior from art to life. Just like Kurtz and the governess, Aschenbach erases the boundaries between self and other.

Fearing the bourgeois careerist in himself and knowing his own ambition and his own desire for a comfortable life focused on his work, Mann totemized his concerns in the figure of Aschenbach. Mann's narrator is an example of the vestigial omniscient narrator who, in the guise Mann gives him, seems to present an analysis derived from a particular point of view but who really presents a multi-layered perspective. His is a thick, rich reading of Aschenbach's behavior, an allegory of the impossibility of the univocal view. Like Conrad's Jim in Patusan, Aschenbach is enclosed in a self-created abyss from which his compulsions and fixations prevent his escaping. Yet the narrator does with Aschenbach what Aschenbach does with his own work: "With rage the author here rejects the rejected, casts out the outcast—and the measure of his fury is the measure of his condemnation of all moral shilly-shallying. Explicitly he renounces sympathy with the abyss, explicitly he refutes the flabby humanitarianism of the phrase: '*Tout comprendre c'est tout pardonner*'" (Mann, 13). Aschenbach's

pathological control is the quintessence of the European temperament that Mann associates with an enervated culture.

Aschenbach, Mann's fictional author, perceives Tadzio as a work of art in a medium different from the one in which he works:

> His face recalled the noblest moment of Greek sculpture—pale, with a sweet reserve, with clustering honey-coloured ringlets, the brow and nose descending in one line, the winning mouth, the expression of pure and godlike serenity. . . . It was the head of Eros, with the yellowish bloom of Parian marble, with fine serious brows, and dusky clustering ringlets standing out in soft plenteousness over temples and ears. (25, 29)

The irony is that the seemingly classical Apollonian statue intrudes the Dionysian element into Aschenbach's life. He also perceives Tadzio in terms of Botticelli's *Birth of Venus* (1480): "The sight of this living figure, virginally pure and austere, with dripping locks, beautiful as a tender young god, emerging from the depths of sea and sky, outrunning the element—it conjured up mythologies, it was like a primeval legend, handed down from the beginning of time, of the birth of form, of the origin of the gods" (33). That Aschenbach rejects Modernism—Futurism, Fauvism, Post-Impressionism, the Blue Rider school in Germany—for the classical tells us something about him and his art. His is a poignant effort to resist the juggernaut of Modernism, for has he not in Munich also tried to turn his back on contemporary urban life, industrialism, psychoanalysis, and modern science as well as sexuality and passion? Compare Aschenbach's world with that of Manet or Joyce. He imagines himself as an heir to the Platonists, including and especially their pederastic tendencies. He is as indifferent to Modernism as he is to contemporary politics and history; the narrator begins in 1912 with how "Europe sat upon the anxious seat beneath a menace that hung over its head for months" (3). Aschenbach embodies the spirit of Europe at a time when it has lost its sense of purpose, but we the audience respond with a polyauditory ear that hears other echoes. Aschenbach identifies with those who are exhausted and persevere in spite of enervation. Is Aschenbach not the "creator of that powerful narrative *The Abject*, which taught a whole grateful generation that a man can still be capable of moral resolution even after he has plumbed the depths of knowledge" (8)? Tadzio and Venice represents all that Aschenbach—and the rest of Europe—has repressed and excluded: Asia, the unknown, *other*, passion, and the insidious moral illness that is undermining its health. In art, Venice is color, decoration, diffused light, relaxation. For

Aschenbach in Venice, Tadzio's presence—his presence as Eros—becomes an inspiration, but the inspiration is libidinous and passionate, as the speaker ironically remarks: "Verily it is well for the world that it sees only the beauty of the completed work and not its origins nor the conditions whence it sprang; since knowledge of the artist's inspiration might often but confuse and alarm and so prevent the full effect of its excellence" (46-47).

The bachelor motif is central to Mann's *Death in Venice*, for Aschenbach has resisted and repressed his libido until it relentlessly emerges in the form of a catastrophic passion for Tadzio, a young boy at the edge of adolescence. Isn't *Death in Venice* not only about the dangers of the narcissism of art—the retreat into the self that makes the creator oblivious to history and morals— but the narcissism of bourgeois life? Kafka's *Metamorphosis* is about inversion caused by self-denial and self-effacement, about a kind of emotional mas- ochism, a starving of one's soul that is a not-too-distant cousin of narcissism. And this bachelor motif is applicable not only to Birkin and Gerald in *Women in Love* and Tom Brangwen in *The Rainbow* before he meets Lydia, but to single women, too, in the early twentieth century, including Ursula in *The Rainbow* and Lily in *To the Lighthouse*. Marriage is *supposed* to happen. Do we not see a kind of female counterpart to bachelorhood in Lawrence's Ursula, in Woolf's Lily, and in Gerty in *Ulysses* as well as in *Dubliners*—in the title character of "Eveline," in Maria in "Clay," and in the three spinsters and Molly Ivors in *The Dead*? In these texts the singleness of women of marriageable age is not simply an option but is an embarrassment to the women and is conceived by them as a problem to solve. In *The Turn of the Screw*, isn't "the spring of a beast" (646) that the governess feels in part originating in her psyche?

Aschenbach's relation to Tadzio has a strong affinity to the governess's relation to her master and the way it shapes her response to the children and to Bloom's relation with Stephen. Joyce's "Hades" section in particular recalls Mann's text. The carriage in which Bloom rides recalls Charon's boat—the gondola that takes Aschenbach through Venice to his house. Stephen Dedalus needs to eschew the Platonism that Aschenbach embraces; in the "Scylla and Charybdis" section in *Ulysses*, to imply the threat of Greek homosexual male bonding with his audience, Joyce has Stephen both echo and parody the Socratic dialogues and Wilde's version of those dialogues in *The Decay of Lying*. And so must the governess eschew Platonism, for are not the ghosts visitations of prior forms? Aschenbach's associations with the strangers he meets are examples of the double—the secret sharer—motif. Travel for Aschenbach is discovery of *other*, an area beyond his control, and once he leaves Munich he lives in no-man's land, on the margin along with Joyce's Bloom and James's governess.

Art has become service, control, a check on Aschenbach's feelings, and has exhausted him, in part because of the efforts of repression, displacement, and artistic discipline that have used up these libidinous energies:

> This yearning for new and distant scenes, this craving for freedom, release, forgetfulness—they were, he admitted to himself, an impulse towards flight, flight from the spot which was the daily theatre of a rigid, cold, and passionate service. . . . So now, perhaps, feeling, thus tyrannized, avenged itself by leaving him, refusing from now on to carry and wing his art and taking away with it all the ecstasy he had known in form and expression. (6-7)

Mann's Aschenbach looks forward to Kafka's Gregor, who, like the governess, has no way of escaping the service of a functionary; Gregor gradually surrenders his humanity, to insecthood, where he paradoxically finds his humanity and goes to another state than that of insect: death. In a word, art has become *resistant* to living passionately, fully, imaginatively. Cosmetically decorated—wearing red necktie and straw hat—Aschenbach becomes his *others*: those rakish, solipsistic hedonists who are indifferent to anything but their own feelings. As an object of art, he becomes a figure in a lush, decorative work of Guarino Veronese rather than a North European figure in a restrained work by Hans Memling or Cranach the Elder. In journeying from Germany to Italy—from Munich to Venice—he journeys from nineteenth-century emphasis on neoclassic and Apollonian virtues of control and reason to Modernist romantic and Dionysian possibilities, including color, decoration, and self-expression in which one's art reflects one's life. Passionately obsessed, he remains in Venice, notwithstanding his knowledge that the plague is abroad.

VII.

Where then does our inquiry take us? When the omniscient narrative perspective, based on measuring behavior against an assured perspective, breaks down, the reader becomes the one who gazes and literary works become, like modern paintings, dispersions of impressions for another perspective. Such openness is seductive and compelling and requires us to respond to the surface with our own narrative of meaning. When Hardy spoke of *Jude the Obscure* (1895) as a "series of seemings," he was acknowledging that neither mimesis nor point of view needs to be consistent. He uses

different modes of mimesis—Jude is a representative figure, Sue an idiosyncratic figure, Father Time an allegorical figure, and his omniscient narrator is a vestige of the objective ironic voice now transformed into an engaged partisan of Jude. Yet, notwithstanding the apparent single point of view, the novel contains multiple and contradictory explanations for its character's behavior until we realize that Jude's and, particularly, Sue's behavior is partially *obscure* to the narrator, whether intended or not. Such a technique—at once so sure of its conclusions, and yet so tentative—empowers the reader, makes the reader's odyssey part of the *agon* of the artistic work. I take this *agon* to be a principle feature of Modernism for visual artists such as Rodin, Picasso, and Matisse as well as for the modern authors that we have been discussing. Modernism is the story of the artist's quest more than it is of the finished work. As Barbara Rose notes of twentieth-century American painters, "usually, that subject was their own sense of self, their own intensely personal conception of the world and nature and their own feelings and responses to that world" (61).

Conrad thought of his technique of catching characters within the gaze of a narrative presence and rendering the perceiver's response as *Impressionism;* for him, dramatizing the reason for the narrator's interest—the psychic and moral reason for that interest—was more real than the tradition of filling in a character's appearance in a story with essential background information, such as "Jim was born in. . . he went to grammar school . . . he joined the merchant marine." Like *The Turn of the Screw*, *Lord Jim* is, among other things, a search for perspective; in Conrad's novel the omniscient narrator, Marlow, Stein, and Brierely—even Gentleman Brown, Doramin, and Dain Waris—all gaze at Jim, but we gaze at these characters trying to understand Jim, and we also, in part because of Conrad's efforts to undermine traditional linearity, spatially arrange the configurations of the figures in a cognitive pattern within our mind. That pattern of meaning, which our mind retains after our reading, is as much out of time as that of a painting. Much as in modern painting, the reader's gaze weaves her own pattern of meaning to complete the meaning. (Recall the pictorial view of Jim on the shore that Marlow describes as he leaves Jim after his visit on Patusan, which itself is more an aesthetic realm than a real one.)

I want to think of cultural criticism more as a verb than a noun. I want to stress the activity of inquiry, not announce the end of the inquiry before it begins. James's choice of narrator in *The Turn of the Screw* is an instance of the Modernist focus on the gaze. It not only resituates the governess's telling as subject but makes her an object—as much or more than her tale—of our gaze. For in the governess do we not see a model of the self-creating

narcissist who imagines forms of transference and courts transference with her observers, listeners, and readers? I believe that this has implications for the perceiver-reader who, released from the strong rhetorical control of the author or painter, reconfigures the subject as he or she chooses according to his or her own epistemology. And we readers, voyeurs like the governess, create in our reading our own self-portraits and doubles—whether of the governess as sexually hysterical or as the victim of ghosts; or whether (more indirectly) of those who play and parody the psychoanalyst's role for the governess: the master, Douglas, and Douglas's audience.

Our gaze is a way that we define ourselves as subject, give meaning to objects, and control the not-I world in which we live. Our gaze is shaped by our psyche and values, and our psyche and values are modified by it. Without a gazing observer, the painting does not live. But, just as when we read, we move beyond the gaze to cognition and to reflection on what we have seen and subsequently understood in terms of what we know. And when we reread we are gazers—voyeurs—and yet also we are in the position of being tempted to lay down our gaze and participate. And for this reason, too, we find not only a strong kinship between literature and the visual arts but in our response to these art forms. For Modernism depends not on a fixed perspective but on what Joyce calls parallax or what we might call polyper-spectivism—and so does its study, because we successors to Modernism are self-consciously aware of our place in a dynamic and temporal framework; and we, like the Modernists, know that fixed time, stable viewers, and an object that has only one meaning are no longer possible.

Three

The Influence of Gauguin on Conrad's Heart of Darkness

I.

My approach to establishing the dialogue between literature and the visual arts includes the study of sources and influences, intertextual relationships by which one art form illuminates the other, and cultural configurations that develop from diverse artistic and historical phenomena. In this chapter I want to use Conrad's reading of Gauguin's *Noa Noa* as a way of raising issues about race, gender, sexuality, colonialism, and nativity in *Heart of Darkness* (1898). Conrad, I shall suggest, knew Gauguin's journal, *Noa Noa*—based on his visit to Tahiti from 1891 to 1893—and probably wrote *Heart of Darkness* with that journal and Gauguin's Tahitian paintings in mind. When Conrad read *Noa Noa*—Noa Noa means "fragrance"—he would have been reminded of his 1890 journey into the Congo and his own even more sketchy Congo diary. I shall consider how Conrad supplemented his own journey to the Congo with Gauguin's texts and paintings.

Gauguin's process of disillusionment with European culture and his reversion to savagery as described in his 1897 version of *Noa Noa* was a model for Conrad's depiction of his character Kurtz. Conrad uses Kurtz's reversion to savagery as a model for examining how African and so-called primitive material is inscribed in Western work. By pursuing the response of both figures to primitivism, sexuality, and wilderness, I raise larger issues about how Western Modernism confronts and demonstrates *difference* and *other*.

Gauguin, and later Picasso and Fernand Léger, discovered the primitive at a time of growing *negrophilie*. As James Clifford puts it:

> Picasso, Léger, Apollinaire, and many others came to recognize the
> elemental, "magical" power of African sculptures in a period of growing
> *negrophilie*, a context that would see the irruption onto the European
> scene of other evocative black figures: the jazzman, the boxer (Al
> Brown), the *sauvage* Josephine Baker. . . . The discovery of things "nègré"
> by the European avant-garde was mediated by an imaginary America,
> a land of noble savages simultaneously standing for the past and future
> humanity—a perfect affinity of primitive and modern. (197-98)

Not only did Gauguin anticipate Picasso and Léger in his Tahitian paintings,
but in Conrad's *Heart of Darkness* and "An Outpost of Progress" (1896) we see
early claims for the nobility of the primitive and for the perception of the
innocent impulses of the black Africans. It is the Westerners, not the savages
who have the heart of darkness. Anticipating Conrad, Gauguin was inter-
ested in the *frisson* between Western European and other cultures. On his
Tahitian journeys, he brought along photographs of European paintings as
well as of the Dionysian sculptures in the Parthenon and the sensual
sculptures of Borobudur.

In Gauguin's paintings we see multiple uses of non-Western material;
to be sure, we see the kinds of distortions that we find in Polynesian
sculptures. Perhaps the bold expressive lines as well as negative space derive
from Japanese prints. Gauguin clearly influenced Picasso's primitive masks
in *Les Demoiselles d'Avignon* (1907). The three-dimensionality of Picasso's *Two
Nudes* (1906), *The Portrait of Gertrude Stein* (1906), and *Les Demoiselles d'Avignon*
owe something to African sculpture. So does the simplification of forms,
particularly facial features, and the disfigured faces. Matisse's *Two Negresses*
(1908) drew upon Gauguin's fascination with the primitive. Matisse's only
sculpture of more than one figure, *Two Negresses*, is an example of the African
influence; as Jack Flam puts it, "The anatomical articulation of the two figures
owes a good deal to African sculpture, especially in the relation between the
buttocks and torsos and in the breasts" (238). Based on a photograph of two
Tuareg women, the work overflows with sensuality.

As Griselda Pollack notes, Gauguin

> is usually perceived as having revolutionized Western art by rejecting the
> etiolated civilization of Europe and its cities by seeking to reconnect with
> basic human sensation, impulses and feelings in a rural paradise. . . .
> Personal liberation through an unfettered sexuality and aesthetic refresh-
> ment through an appropriate and exploitative multi-culturalism—what

the modernizing European termed "primitivism"—are part and parcel of
this nineteenth century myth of the tropical journey. (8)

Pierre Loti and Eugène Delacroix are sources for Gauguin's exoticism, but
so was the nineteenth-century Romantic myth of a Golden Age. As Nicholas
Wadley notes, "The nineteenth-century European view of the primitive life
contained a strong sense of rejuvenation, of return to the unspoilt infancy
of the human race. Gauguin shared this general view, but it also took on a
more personal meaning for him: he constantly associated his mature escape
from Europe with his own roots, his exotic ancestry, his childhood in Peru
and so on" (130). And didn't Conrad as a Slav see in himself something of
that primitivism in response to the decadent West? Isn't that one reason why
he is drawn to the primitive simplicity of the Bugi Malays?

Gauguin left France for the last time in 1895. In his second Tahitian
period, 1895 to 1903, he painted more mythic works such as *Where Do We
Come From? What Are We? Where Are We Going?* (1897), his last painting before
his 1897 suicide attempt. In this period he used the photographs from
Borobudur. In *Te arii vahine (The Noble Woman)* (1896), an important influence
is, according to Richard Brettell, "the reclining figure of a monk (*biksu*) from
the high-relief frieze on the second corridor of Borobudur" (399). While we
have no proof that Gauguin saw this frieze in the Exposition Universelle of
1889, "the physiognomy of the head, the swollen proportions of the limbs,
the softening of the contours, and the exaggeration of the feet that charac-
terize Gauguin's nude" are more evident in the Borobudur figures than in any
Western sources (399). While the scene is from early Buddhist tales called
The Awadenas and *The Jatakas*, Gauguin also wanted to place his painting
within the Western tradition. Manet's *Olympia* is an important influence on
Gauguin's South Pacific nudes of the 1890s, including *Manao tupapau* (1892)
and *Te arii vahine*. Not only had Gauguin copied *Olympia* in Paris, but he also
brought with him to Tahiti a photograph of the original.

Conrad was almost certainly indebted to *Noa Noa*, which was pub-
lished in 1897 in the avant-garde journal *La revue Blanche;* this version
contained the original 1893 draft plus some new material by Gauguin's
collaborator, the poet Charles Morice. Conrad surely would have heard of,
if not seen, the Tahitian paintings. My quotations are from the 1893 draft
published in Nicholas Wadley's 1985 edition because that draft is untouched
by Morice and gives us the best idea of the discontinuity, spontaneity,
improvisation, and fragmentariness of Gauguin's literary imagination. As a
narrative formed by his visual imagination, Gauguin's text of *Noa Noa*, like

his paintings, follows a Modernist tendency to equate the autobiographical with the universal. He thought of his writings as dreamscapes. *Noa Noa* is also influenced by Voltaire's *Candide*, a text Gauguin admired.

Gauguin read his 1893 draft in Paris salons when he returned from his first trip to Tahiti. His appearances were the equivalent of contemporary talk television, except the audiences were smaller. Given that the Maori, his subjects—often idealized into paradigms—had an oral culture and their history survived in oral renditions, Gauguin wanted to render his narrative orally; his illustrations speak of a desire to render a culture that used visual language. He created a public persona, a figure of fascination who had returned from an exotic experience. Until 1895 Conrad was in close corre-spondence with Marguerite Poradowski, a distant relative whom he called his aunt, a cultured woman to whom he felt very close; she maintained an apartment in Paris, and she would probably have known of, if not attended, Gauguin's readings and known his 1892 Tahitian paintings.

While *Noa Noa* also may have influenced Conrad's Malay novels and short stories—*Almayer's Folly* (1895), *An Outcast of the Islands* (1895), "Karain" (1897), "The Lagoon" (1897), and surely *Lord Jim*, which was published after the first version of *Noa Noa* appeared—my focus is on *Heart of Darkness*. To Conrad, fascinated by his own travels to exotic places, Gauguin must have been a kind of French Gulliver. Gauguin's escape to Tahiti parallels Jim's retreat to Patusan and his escape from the Western ethic after he fails on the *Patna* and no longer has a place in the maritime world. For Conrad, Jim's desire to eschew Home Service and to join the *Patna* in the first place is an indication of his flawed character. But Jim's Crusoeism is really the other side of his inability to meet the ethics and standards of the British Merchant Marine—to escape Home Service—as when he threw in his lot with decadent Europeans who savored the distinction of being white and were willing to serve "Chinamen, Arabs, half-castes" (Conrad, *Lord Jim*, 9).

At the outset, let me make clear that I am reading *Noa Noa* as a narrative that often reveals what it is meant to conceal. Gauguin's narrative is a kind of semiperceptive construct that is often evasive and contradictory. As if he were discovering the natural man within him, Gauguin speaks with pride about how each day he became a little more savage and primitive:

> Every day gets better for me, . . . my neighbours . . . regard me almost as one of themselves; my naked feet, from daily contact with the rock, have got used to the ground; my body, almost always naked, no longer fears the sun; civilization leaves me bit by bit and I begin to think simply, . . . and I function in an animal way, freely . . . every morning

the sun rises serene for me as for everyone, I become carefree and calm
and loving. (*Noa Noa*, 24-25)

(Soon, except for a loincloth, he is not wearing clothes.) In a note accom-
panying this page, he wrote: "The purity of thought associated with the
sight of naked bodies and the relaxed behavior between the two sexes" (*Noa,
Noa*, 74).

Gauguin wanted to preserve the naiveté of his narrator even while
preserving in the voice his own disdain for the rottenness of Europe. Perhaps
he had imagined in their putative collaboration that Charles Morice's voice
would be the sophisticated written part, but, as we can see when we read
the collaborated version, the better and more perspicacious written part is
Gauguin's. It is worth noting that the Tahiti Gauguin imagined no longer
existed, and that fact is a source of the narrator's occasional anger. Most of
what Gauguin knows about Tahitian legend and myth comes from J. A.
Moerenhout's two-volume *Voyages aux Iles du Grand Ocean* (1837). The text
for Gauguin's notebook *L'Ancien Culte Mahorie* comes from Moerenhout,
although he invented the fiction that Tehamana, his thirteen-year-old *vahine*,
taught him about Maori lore.

Yet, reading *Noa Noa*, we realize that Gauguin himself—far more than
he acknowledges—oscillated between seeing himself as a Parisian and a
born-again native. Ironically, Gauguin sees himself in the role of the inferior
and overcivilized European. That, while in Tahiti, he actively corresponded
with friends in France may have reinforced his sense that it was easier to cast
off his clothes than his European identity. Anticipating Conrad, Gauguin
used the journey to a primitive culture as an opportunity to ask central
philosophic questions as he does in the painting *Where Do We Come From?
What Are We? Where Are We Going?* As Wadley writes of the painting, "The
questions of its title are all posed in the visual form of an opposition. Its
extremes are the depressed introversion and self-awareness of the thinking
European on the one hand and on the other the unaffected and irresponsible
innocence of the primitive being, who lives, loves, sings and sleeps" (124).
Put another way, the painting dramatizes the epistemological journey Con-
rad's Marlow takes as he sifts through his experience in *Heart of Darkness*.

Gauguin's Tahitian paintings depend on a dialogue between East and
West, primitive art and the tradition of painting he knew. Gauguin's women
have a fuller emotional life than his myth of Paradise would suggest. As
Wadley remarks, "Gauguin's women have a brooding, inturned quality
somewhat at odds with descriptions of the lethargic but carefree, loving
children of a native paradise" (128). Beginning with the first one, they are

basically whores—as young as thirteen; as he acknowledges, "I well knew that all her [Titi, his first mistress] mercenary love was composed merely of things that, in our European eyes, make a *whore*, but to one observer there was more than this. Such eyes and such a mouth could not lie" (14). In *Te arii vahine*, the Tahitian woman is a mysterious seductress, confident in her body; the black dog on the ground suggests animality, sexuality, and mortality. Conrad's mysterious, sexual native women—Kurtz's savage mistress, Jewel (a half caste), and Aissa in *Almayer's Folly*—may owe something to Gauguin's Tahitian women, especially those from the first Tahitian phase. Except for his permissive sexual behavior, Gauguin's conversion to savagery was far less pronounced than that of Conrad's Kurtz.

Not only was Gauguin influenced by Egyptian, Assyrian, and Far Eastern sculpture that he had seen in the Louvre, but so, too, was Picasso. Anticipating Picasso, Gauguin used art to exorcise not only evil but fear of aging and death. He believed that hostile forces are all around us. His reaching back to the primitive anticipates not only Conrad but also D. H. Lawrence's use of Indian myth in *The Plumed Serpent* and Egyptian myth in "The Man Who Died," and E. M. Forster's use of the caves in *A Passage to India*.

The occasion of Gauguin's voyage between 1891 and 1893 was his appointment to an official mission with no real duties. Indeed, we might recall how Marlow got his appointment through his aunt's intervention. Like Conrad, Gauguin begins by describing the voyage out, his first sighting of the landscape, and the corrupting influence of Europeans; when he describes the indifference of the French, we think of Marlow's disillusionment at the outer station. On the very first page of his journal Gauguin writes, "Having only just arrived, rather disappointed as I was by things being so far from what I had longed for and (this was the point) imagined, disgusted as I was by all this European triviality, I was in some ways blind" (12-13). And the theme of awakening insight is important here, as it is in *Heart of Darkness*. When Gauguin paints, "It was a portrait resembling what my eyes *veiled by my heart* perceived" (20). The first of the Tahitian paintings is *Vahine no te Tiare* (*Woman with a Flower*) (1891). Gauguin sees the painting of a woman as a kind of seduction: "I realized that in my painter's scrutiny there was a sort of tacit demand for surrender, surrender for ever without any chance to withdraw, a perspicacious probing of what was within. . . . All her features had a raphaelesque harmony in their meeting curves, while her mouth, modelled by a sculptor, spoke all the tongues of speech and of the kiss, of joy and of suffering" (20). He inverts the expected meaning of what he calls "civilized people" and "savages" by showing us that the civilized French influence had undermined the savage innocence that he had expected and *imagined* existing

before the arrival of the French colonialists. He finds that the savages are the Europeans, the civilized are the savages.

Just as Marlow turns toward an alternative to the cynicism and greed of the manager and the manager's uncle, so in *Noa Noa* does Gauguin: "Shall I manage to recover any trace of that past, so remote and so mysterious? and the present had nothing worthwhile to say to me. To get back to the ancient hearth, revive the fire in the midst of all these ashes" (13). He wants "To leave Papeete as quickly as I could, to get away from the European centre. I had a sort of vague presentiment that, by living wholly in the bush with natives of Tahiti, I would manage with patience to overcome these people's mistrust, and that I would Know" (Gauguin capitalizes "Know" for emphasis; 14). Anticipating Conrad, he sees his voyage as one backward in time to the antecedents of civilization. When he goes inland, he does not know how to gather food: "So there I was, a civilized man, for the time being definitely inferior to the savage" (20).

Gauguin's text fiercely attacks the Western illusions of progress and civilization. Like Conrad, Gauguin stresses how Western culture has imported not only sickness—syphilis in particular (from other sources, we know that Gauguin himself seems not to have been exempt from trading in this export)—but alcoholism and moral decadence. Yet his experience contains many paradoxes. What he experienced was poverty, hunger, ill health, antagonism, and isolation; indeed, after a year he wanted to be repatriated, but it took two more years to get back to France.

Gauguin was fascinated with the uncorrupted innocence and sexuality of the Tahitians. In stressing the magnitude and purity of their emotions, whether anger, jealousy, or passion, he is an important source not only for Conrad but for Lawrence, who believed that civilization corrupted the passions and feelings and reduced them to a parody of themselves. In *No te aha oe riri* (*Why Are You Angry?*) (1896), the profiled standing woman at the right suggests the figure in Georges Seurat's *Sunday Afternoon on the Island of La Grand Jatte* (1894-96); as Griselda Pollack notes, Seurat's satire of upper-class pretensions and manners is striking: "Seurat's painting not only differed critically from the sunfilled gentility and simulated spontaneity of Renoir's *Luncheon of the Boating Party* but made it seem fanciful, romanticized and hopelessly out of date" (29). Here we see Tahitians at leisure, but the title and the expression of the standing woman, who seems—in relation to the sitting figure on the right who is looking away—angry and accusatory in her stance of modesty and quiet but righteous indignation, make us aware of how Gauguin is transforming and ironizing Western perspectives and assumptions. But as Brettell has noted, Gauguin hedges his bets: "The figures

have a quality of classic ease, innocence, and grace that would have been immediately acceptable to a French bourgeois public accustomed to nudes from the Salon" (424).

In *No te aha oe riri* the roosters to the right of the standing women imply male sexuality. They are a metonymy for the subject of female tension— that is, hormonal males—and as such are a comic version of the signified that is missing from the human drama; the hens standing in between the standing clothed woman and the front-facing bare-breasted woman stress this parabolic aspect of the painting. The figures in *Two Tahitian Women* (1891) recall the way Manet's nudes—say in *Déjeuner sur l'herbe* (1863) or *Olympia*—confront the viewer. The red mash of papaya and mango stresses Gauguin's emphasis on color for its own sake, free of the morphology of representational codes. In this regard Gauguin anticipates Matisse and the other Fauvists.

II.

Let us imagine Conrad's response to his reading of *Noa Noa*. Perhaps hearing about Gauguin's oral rendition, would he not have asked himself—thinking of his Congo and Malay experience—what if the European had become so disgusted with his fellow Europeans that he began, like Gauguin, to empathize with the primitive culture and then, like Gauguin at times, what if he lacked the moral and emotional tools to cope and became not only a sensualist but also a misanthrope and a cynic, and later a megalomaniac and a solipsist, namely a Kurtz? In *Heart of Darkness* Conrad responds to Gauguin's complex perspectives in *Noa Noa*: (1) Tahiti is Paradise—or rather it was before Western corruption; (2) Gauguin's speaker has discovered the *fragrance* of innocence within himself; (3) but he has also discovered a savage and atavistic potential when stripped of civilization. He understands that Gauguin has discovered not only an innocent primitive but darkness within himself as a savage who enjoys a certain amount of violent behavior, including rape. Isn't Kurtz a perverse and ironic version of Gauguin's idea that reversion to primitive life can bring about rejuvenation from decadent Western influence? Like Gauguin, Kurtz has a mixed and complex heritage. Kurtz has a German name but his mother is half English and his father half French: "All Europe contributed to the making of Kurtz" (561). Gauguin romanticized about Inca blood in his veins. In Conrad the savages have been Europeanized by westerners, even while Kurtz has become a self-proclaimed savage, a fate that Marlow resists in part because of his dedication to task,

specifically repairing the steamboat to go down the Congo. In *Noa Noa* Gauguin wants to dramatize himself as a European turned savage, but the self-dramatization, as Conrad would have seen, is more complex; in *Heart of Darkness* when Kurtz reverts to savagery, he becomes a demonic figure.

What Cleo McNelly wrote of Conrad is also true of Gauguin: "For Conrad (and for Baudelaire and Lévi-Strauss as well) home represents civilisation, but also order, constraint, sterility, pain and ennui, while native culture . . . represents nature, chaos, fecundity, power and joy" (9). It is the complex view of native life that gives both *Noa Noa* and the far richer narrative of Conrad much of their power. As Edward Said has noted in *Culture and Imperialism*: "Never the wholly incorporated and fully acculturated Englishman, Conrad therefore preserved an ironic distance in each of his works" (25). *Noa Noa* and Gauguin's Tahitian paintings resist the imperialistic discourse that stresses the superiority of the white man, but they do not propose their alternative—Tahitian paradise—as simply as it had once been thought. Yet by recognizing an alternative to materialism and acquisitiveness, by responding to passion, romance (or his version of it), intuition, imagination, and, yes, the essence or *fragrance* of experience, Gauguin does imply ways of resisting imperialism and finding interior and later external space for native cultures. And Conrad goes a step further, for *Heart of Darkness* speaks directly to the issues of colonialism and empire, to the corrupting influence of European culture on African customs and civilization. Conrad plays on the clichés and shibboleths of his era when Africa was the "dark continent"—the place of mystery and secrets—and the primitive continent where passions and emotions dominated reason and intellect. He asks us to consider whether we can cross cultural boundaries without transgressing them, for in situating himself in response to imperialistic exploitation, is Marlow able to separate himself from colonial domination?

I want to take partial issue with Said's view that "Marlow and Kurtz are also creatures of their time and cannot take the next step, which would be to recognize what they saw, disabling and disparagingly, as a non-European 'darkness' was in fact a non-European world *resisting* imperialism so as one day to regain sovereignty and independence, and not, as Conrad reductively says, to reestablish darkness" (30). Whether Malay or Africa, for Conrad Western colonialism in the name of civilization despoils the people and the land it touches. As Marlow puts it, "We were wanderers on prehistoric earth, on an earth that wore the aspect of an unknown planet. We could have fancied ourselves the first of men taking possession of an accursed inheritance, to be subdued at the cost of profound anguish and of excessive toil" (Conrad, *Heart of Darkness*, 539). Yet Conrad understands that the natives

are part of a common humanity: "They howled and leaped, and spun, and made horrid faces; but what thrilled you was just the thought of their humanity—like yours—the thought of your remote kinship with this wild and passionate uproar. . . . The mind of man is capable of anything—because everything is in it, all the past as well as all the future" (540). Conrad wants to propose the possibility of human continuity, even as he suggests that perhaps civilization *corrupts* native energy. *Heart of Darkness* debunks the concept of the white man's burden and shows how the concept of empire is a sham. It is the narrator, not Marlow, who speaks of "The dreams of men, the seed of commonwealths, the germs of empires" (492). Marlow speaks about European newspaper articles that made ethical claims for the trade mission, articles that spoke of "'weaning those ignorant millions from their horrid ways'" (504). In *Heart of Darkness*, Western man is imaged as the idiosyncratic Brussels doctor who measures crania, the cynical manager and his more cynical uncle, the chief accountant of the outer station, and, of course, Kurtz. Isn't imperialism figured as the pail with the hole in the bottom with which one of the white men at the central station tries to put out fires? Supposed emissaries of light, like Kurtz, become forces of exploitation.

Our multicultural perspective needs mention Conrad's use of Asian and Eastern contexts to comment on European behavior. A traveler who becomes transformed into a scathing critic of Western pretensions, Marlow is aligned by Conrad with the East: "He had sunken cheeks, a yellow complexion, a straight back, an ascetic aspect, and, with his arms dropped, the palms of hands outwards, resembled an idol" (491). A moment later the first narrator remarks on Marlow's lotus posture and contemplative demeanor: "[L]ifting one arm from the elbow, the palm of the hand outwards, so that, with his legs folded before him, he had the pose of a Buddha preaching in European clothes and without a lotus flower" (495). Marlow had returned from "six years in the East," the time presumably when *Lord Jim* took place. His familiarity with the East extends to Noh plays and puppet theater: the place-names in Africa, given by Europeans, "seemed to belong to some sordid farce acted in front of a sinister back-cloth" (505); perhaps such names as "Central Station" and "Inner Station" speak to the Japanese propensity to allegorize experience.

Let us return to *Noa Noa*, which is far from a panegyric of Tahitian life, and let us recall that Gauguin's paintings present a more complicated vision of Tahitian life than often has been supposed. For within Gauguin's written and visual paradisiacal lyric of Tahiti, too, is a strong overtone of discovering the forbidden, the atavistic, and the dimly acknowledged darker self. Readers of *Noa Noa* will recall that Gauguin's speaker's main pleasures seem to be

sexual license and sexual variety, even with adolescents as young as thirteen, the age of his child bride; at times it seems like the hormonal appeal is central to his embrace of Tahiti. The original draft manuscript of 1893 says little about Tahitian life, culture, setting, and values. *Noa Noa* is in the genre of a journal—like the anonymous Victorian text *My Secret Life*—in which the author discovers sexual freedom.

Like Kurtz, Gauguin left a European woman—he a wife, Kurtz an Intended—behind and took a savage mistress; indeed, Gauguin took several. In *Heart of Darkness*, the savage mistress becomes a metonymy for the atavistic and primitive, indeed, for Africa itself. For Gauguin, Tahiti represented *difference*—difference from the so-called civilized world he had known—and *other*. He loved the spontaneous sexuality and unselfconscious nudity of the Tahitians. Like Conrad's Marlow, Gauguin's narrative voice tries to convey a mysterious dream, a world beyond his comprehension. We might recall that the hypnotic effect of Kurtz's voice has a kinship with the incantations of the savages rather than the syntactical patterns of ordinary discourse. Kurtz's world takes shape from forbidden dreams of being worshipped and from libidinous needs that brook no restraint. In transforming his imaginative world into reality, Kurtz "had kicked himself loose of the earth. . . . He had kicked the very earth to pieces" (586).

After recalling his reading Kurtz's report to the International Society for the Suppression of Savage Customs and hearing Kurtz's eloquence, Marlow's telling radically changes. His narrative becomes more inclusive of the gestures of the savage mistress and the Intended, the beating of the drums, the shrill cry of the sorrowing savages, and the development of Kurtz into Marlow's own symbol of moral darkness and atavistic reversion. Marlow's recurring nightmare begins not only to compete with his effort to use language discursively and mimetically, but to establish a separate, more powerful telling. This more inclusive tale, not so much told as revealed by Marlow as he strains for the signs and symbols that will make his experience intelligible, transcends his more conventional discourse. Conrad shows that these instinctive and passionate outbursts—taking the form of gestures, chants, and litany—represent a tradition, a core of experience, that civilized man had debased. In a brilliant Surrealistic touch, Conrad makes Marlow's consciousness an echo chamber for the haunting sounds of his "culminating" experience. After recalling that Kurtz "was little more than a voice," the past rushes in to disrupt the present effort to give shape and meaning to his narrative: "And I heard him—it—this voice—other voices—all of them were so little more than voices—and the memory of that time itself lingers around me, impalpable, *like* a dying vibration of one immense jabber, silly, atrocious,

sordid, savage, or simply mean, without any kind of sense. Voices, voices—even the girl herself—now—" (558, my emphasis). The temporary break-down of Marlow's syntax in the passage dramatizes the resistance of his experience to ordinary discourse, even as the simile comparing Kurtz's voice to an "immense jabber" reveals the challenge of his nightmare to language.

For Gauguin, there is a world beyond utilitarianism, materialism, and empiricism. Just like Kurtz, Gauguin is attracted to a native woman, but he is also a pedophile who has sex with young pubescent women, eventually marrying a thirteen-year-old. We should be skeptical about the claims by Gauguin's defenders that a thirteen-year-old Maori is really an adult. As Pollack writes, "the bourgeois European's fascination with what he desires but cannot have is recouped by projection onto an infantalized and primi-tivized woman. She is made a sign of a culture which is distanced and subdued, put in its place like a native child—wild, primitive, superstitious, but desirable" (68). As his letters and *Noa Noa* make clear, Gauguin, like Conrad, creates from his own experience. He transforms his perceptions of innocent sexuality into a spectacle. Most unpleasantly, Gauguin's concept of sexual freedom from civilization's constraints includes violent fantasies. Indeed, he speaks of the desire to rape women: "I saw plenty of calm-eyed young women, I wanted them to be willing to be taken without a word: taken brutally. In a way a longing to rape" (23).

Tahiti awakened atavistic and forbidden impulses in Gauguin; he speaks not only of the desire to take women by force, but also he acknowl-edges homoerotic impulses. The diarist of *Noa Noa* reveals his presumably latent homoerotic impulses when he goes inland from Papeete. Gauguin writes of his powerful attraction to a young male who was "faultlessly handsome" and "who wants to know a lot of things about love in Europe, questions which often embarrassed me" (25). One day he and the young male go up a mountain to get some rosewood for Gauguin's sculptures; Gauguin writes: "From all this youth, from this perfect harmony with the nature which surrounded us, there emanated a beauty, a fragrance (*noa noa*) that enchanted my artist soul. From this friendship so well cemented by the mutual attraction between simple and composite, love took power to blossom in me" (25). Gauguin was fascinated with what he called the "androgynous nature of the savage"; to him the Maori men and women had much more in common physically with each other than Westerners do. We don't know what occurs, but it is characteristic of Gauguin to break off when he approaches the moment of sexual union. His next words reveal how his European values shadow his supposed liberation from conventions: "And we were only . . . the two of us—I had a sort of presentiment of crime, the

desire for the unknown, the awakening of evil—Then weariness of the male role, having always to be strong, protective; shoulders that are a heavy load. To be for a minute the weak being who loves and obeys" (25). It seems as if he were the passive figure in sexual intercourse between males. It is probably, but not certainly, only a fantasy experience, for Gauguin continues, "He had not understood. I alone carried the burden of an evil thought, a whole civilization had been before me in evil and had educated me" (28). Is this elision not an example of the hermeneutics of evasion, of narrative displacement?

Recently there has been a recognition of the importance of male bonding in Conrad and the realization that we need to examine what is going on between males. As Robert Ducharme has argued, male bonding in the Malay culture may well have included "explicit sexual behavior"; "[I]n warrior cultures, such bonds supercede all other attachments, including those to wives" (19). The homoeroticism of the warrior cults among the Bugi in Malaya is a way of understanding the commitment between Jim and Dain Waris. Marlow's attraction to Kurtz is not homosexual, but does it have an aspect of homoerotic fantasy at a time of great stress and the absence of available and culturally sanctioned—read *white*—women? As Conrad knew and hints on occasion, the homosexual acts and homoerotic feelings were more common on ships long absent from port or among men in remote outposts without women. Is it not possible Kurtz's lack of restraint in "the gratification of his various lusts" includes homosexuality? Do the "abominable practices" of which Marlow speaks include that kind of male bonding? Does it explain in part the odd behavior of the Russian harlequin figure and his ties to the charismatic Kurtz, who, he says, "has enlarged my mind" (568)? Does it explain Marlow's temptation to go ashore for "a howl and a dance"?

Does, we might ask, Gauguin equate violence and license with freedom? Often his words have a more aggressive edge, as when he speaks in violent terms of how he wields an ax to chop down trees: "Savages both of us, we attacked with the axe a magnificent tree. . . . I struck furiously and, my hands covered with blood, hacked away with the pleasure of sating one's brutality and of destroying something" (28). Is this deforestation, we might ask, any more politically correct than the ivory trade's inexcusable depopulation of elephants? Gauguin believed that he had left behind everything that was artificial and conventional and had escaped the disease of civilization to become one with nature. But much of the text and some of his Tahitian paintings reveal more complex emotions. For example, in Gauguin's *Two Nudes on a Tahitian Beach* (1891/1894), the women eye each other warily and with tension, as if bound by some hidden emotion of anger

or jealousy or a secret they share. They stare hostiley at each other. Is the woman on the left covering her breast out of sexual embarrassment, as if she were defending herself against a sexual accusation—whether it be spoken or unspoken—or is she provocatively answering the accusation by fondling herself? Is the painting unfinished to heighten the mysterious chasm between the two woman and to leave the text indeterminate, or did Gauguin simply fail to complete it? As we look at the painting, it is as if the savage mistress of *Heart of Darkness* and a native companion were standing on the shore of the Congo after Kurtz has departed with Marlow. Gauguin's two women could even be passionately attracted to one another. Perhaps the complexity of feeling hints at the *effects* of the colonial presence, most of which is ostentatiously absent from Gauguin's first Tahitian phase. Gauguin takes the expected symbolism of the dog representing obedience and implies that human life need obey the laws and rhythms of nature, but in the women's mysterious attraction—the passion and repulsion—he also suggests that we cannot control our emotional life or give it the direction we wish. It is the shared *knowing* between the two women that is both attractive and frightening.

III.

Gauguin, like Conrad, was fascinated by nightmares, dreamscapes, and the unconscious. Marlow speaks of Kurtz as the nightmare of his choice. In *Noa Noa*, Gauguin wrote: "[T]he night is loud with demons, evil spirits, and the spirit of the dead. Also there are tupapaus, with pale lips and phosphorescent eyes who loom in nightmares over the beds of young girls" (*The Art of Paul Gauguin*, 281). Gauguin frequently included the tupapaus—spirits of the dead—in paintings. A painting like *Manao tupapau* (or *Spirit of the Dead Watching*) (1892; see pg. 93) speaks to the Tahitian belief in the life beyond the natural world. Gauguin was fascinated by pagan forms of devotion. (We recall parenthetically how in *Lord Jim* the two Malay steersmen aboard the *Patna* are sustained by the belief that the white men are ghosts who will return as mysteriously as they left.) In *Heart of Darkness*, as we have seen, Conrad's Marlow learns about intuition, instinct, ritual, chants, and spectral forms of knowledge.

Manao tupapau is also an ironic version of Manet's *Olympia*, which Gauguin had copied before leaving Paris. He was married to the thirteen-year-old who is the model and subject. In an early draft of *Noa Noa* Gauguin makes clear that he based the painting on seeing the girl in the picture in the position depicted and with an expression of dread. It is not clear from

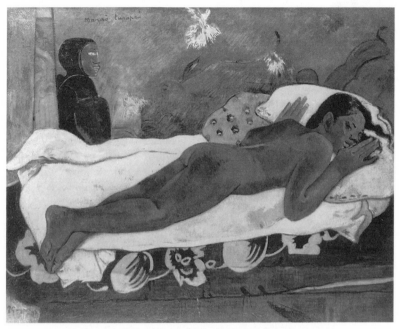

Manao Tupapau (Spirit of the Dead Watching), Paul Gauguin (1892)

the painting whether the girl thinks of the ghost, or whether the ghost voyeuristically watching the girl creates the kind of complex perspective that would have appealed to Conrad; this complexity is framed by another perspective, the painter's, who reinscribes both possibilities without resolving them. Like Conrad, Gauguin is in the position of trying to convey a mysterious dream, an experience beyond his comprehension. The yellows and violets and the *hoti* flowers "represent the [supposed] phosphorescent emanations of the spirits" (Bretell, 281) and suggest Marlow's ties to unseen devils; they also show Gauguin's dependence on form and color.

We note similarities between *Olympia* and Gauguin's *Manoa tupapau* in the juxtaposition of white and black. Discussing the similarities between the two paintings, Pollack writes, "the massive bed across the plane of the painting on which is spread a naked body served up on a sheet of dazzling white linen, set off by a patterned background. In both there are expressive hand gestures, and the composition is based on a contrast between a supine nude and a clothed but upright figure" (21). But in Gauguin's painting the

maid becomes the spirit of death. Rather vatically and without any supporting argument, Pollack comments, "the shift is possible only through a signifying chain in Eurocentric discourse which slides from Blackness to Darkness and Death" (23). In Manet we have two working-class women, maid and courtesan, black and white. Both paintings assume the gazing of a third party: "a viewer for the scene is invoked by the direction of the gaze of the woman on the bed" (25).

Gauguin's fascination with *tupapaus* recalls Marlow's fascination with spirits hovering over the land in *Lord Jim*, but perhaps more to our concern it recalls Kurtz's "taking a high seat among the devils of the land," and Marlow's commitment to Kurtz as "the nightmare of his choice." We recall Marlow's discussion of the various devils that haunt his imagination in *Heart of Darkness*: the ironic flabby devils of Western man and the incomprehensible devils and spirits of African life. After Kurtz's death, he says, "I remained to dream the nightmare out to the end" (592). While we can not be sure, Conrad might well have known of Gauguin's paintings, including those with dreamscapes, nightmares, and diabolical themes.

That both Conrad and Gauguin see art as a kind of mystical and spiritual experience derives in part from the aestheticism of the 1890s. Like Marlow, Gauguin, too, thought of his narration as a dream: He described his writings as "without sequence, like dreams, like all life, made of fragments" (Brettell, *The Art of Paul Gauguin*, 145). Marlow tells his audience, "It seems to me I am trying to tell you a dream" (526). The free association of Gauguin's narrative parallels the "segue" technique of Maori oral tradition and may be one source of Marlow's orally driven, complex reminiscence of his journey of self-discovery to the Congo. Marlow describes what he sees in a series of compelling images that can be thought of as cinematic or photographic, but resemble more the heightened and distorted images of Post-Impressionist painting and the particular images of Gauguin. Such images are the visual correlative of Conrad's adjectival rhetoric. Conrad may have been influenced by Gauguin or simply responded to the same desire to render memory visually and performatively through speaking voices— Marlow's and that of the frame narrator.

IV.

Kurtz's savage mistress might have been taken from Marlow's memory of a Gauguin painting or his imaginative reading of *Noa Noa*:

> And from right to left along the lighted shore moved a wild and gorgeous
> apparition of a woman. . . . She was savage and superb, wild-eyed and
> magnificent; there was something ominous and stately in her deliberate
> progress. And in the hush that had fallen suddenly upon the whole
> sorrowful land, the immense wilderness, the colossal body of the fecund
> and mysterious life seemed to look at her, pensive, as though it had been
> looking at the image of its own tenebrous and passionate soul . . .
> Suddenly she opened her bared arms and threw them up rigid above her
> head, as though in an uncontrollable desire to touch the sky, and at the
> same time the swift shadows darted out on the earth, swept around on
> the river, gathering the steamer into a shadowy embrace. A formidable
> silence hung over the scene. (Conrad, *Heart of Darkness*, 577-78)

The similarity to Gauguin's images can be seen in the visual tableaux.
Illustrating the ravages of imperialism, Conrad's visual images include the
French gunboat firing into the bush, black men chained together, and the
aimless blasting of the outer station. We see the grim images of starving
Africans that have intermittently invaded Western consciousness:

> Brought from all the recesses of the coast in all the legality of time
> contracts, lost in uncongenial surroundings, fed on unfamiliar food,
> they sickened, became inefficient, and were then allowed to crawl away
> and rest. . . . The black bones reclined at full length with one shoulder
> against the tree, and slowly the eyelids rose and the sunken eyes looked
> up at me, enormous and vacant, a kind of blind, white flicker in the
> depths of the orbs, which died out slowly. (511)

It is as if Conrad were imagining a Hieronymus Bosch or a macabre James
Ensor.

A crucial link between Gauguin and Conrad is that *Heart of Darkness*
also contains a painting, namely Kurtz's painting of his Intended, which
Marlow finds with Kurtz and expects to give back to the Intended: "I had
taken him for a painter who wrote for the papers, or else for a journalist who
could paint" (595). He had first seen the Intended's portrait at the Central
Station: "Then I noticed a small sketch in oils, on a panel, representing a
woman, draped and blindfolded, carrying a lighted torch. The background
was somber—almost black. The movement of the woman was stately, and
the effect of the torchlight on the face was sinister" (523). In its late-
Victorian—perhaps Pre-Raphaelite—mode of painting, the portrait ideal-
izes and allegorizes her: "She struck me as beautiful—I mean she had a

beautiful expression. I know that the sunlight can be made to lie, too, yet one felt that no manipulation of light and pose could have conveyed the delicate shade of truthfulness upon those features. She seemed ready to listen without mental reservation, without suspicion, without a thought for herself" (596). Thus *Heart of Darkness* creates a dialectic between the European ethos and the African one, between the assumptions of an art that emphasizes truth to nature and one that renders diverse perspectives, interiority of subject, and the painter's imagination. The grotesque image is almost Surrealistic; the visual depiction of the native women, the jungle, and Kurtz's comment on the aesthetic assumptions of the staid and conventional portrait, just as Kurtz's moral devolution ("Exterminate all the brutes") and reversion to savagery have commented on the civilized moral assumptions.

The idealized portrait of the Intended influences Marlow's behavior in the final scene. What is striking is the difference between the conventional and stereotypical late-Victorian portrait and the modernity and metaphoricity of Marlow's visual imagination. But can we be sure that Marlow can be trusted as a perceiver here? By depicting women in graphic visual terms, as if they were paintings on which to gaze—from the Manet-like depiction of the knitting women in Brussels ("Two women, one fat and the other slim, sat on straw-bottomed chairs, knitting black wool" [500]) to the Savage Mistress to the allegorized Pre-Raphaelite Intended—isn't Marlow revealing something about himself? Isn't he too a kind of painter? Marlow's visual memory of Kurtz is the kind of illuminating distortion that we associate with Modernism: "He looked at least seven feet long. His covering had fallen off, and his body emerged from it pitiful and appalling as from a winding sheet. I could see the cage of his ribs all astir, the bones of his arm waving" (576). The figure of Kurtz occupies the entire canvas. Conrad anticipates the Surrealistic distortions of Ernst and Dalí and the powerful images of *Guernica*. Conveying elaborate ritual patterns of his story, the image of Kurtz might be an African statue embodying spiritual insight and demonic transcendence. More important, Conrad's visual images are free from the mid-nineteenth-century's morphology of representation and give the experience the form and perspective—even the lines and color—of Post-Impressionism.

Marlow's images reflect the movement in late nineteenth- and early twentieth-century painting away from realism to illuminating distortion, to the grotesque, and to the abstract. His experience in the Congo is, among other things, about the challenge to his visual expectations, particularly to his sight. Notice the *metaphoricity* with which Marlow's imagination transforms what he sees: "I came upon a boiler wallowing in the grass, then found a path leading up the hill. It turned aside for the boulders, and also for an

undersized railway truck lying there on its back with its wheels in the air. One was off. The thing looked as dead as the carcass of some animal" (508). Or, note how the Post-Impressionist perspective—with its stress on light and shadow—of Marlow's response to the natives mixes foreground and background and focuses on sharply drawn physical shapes: "Black shapes crouched, lay, sat between the trees leaning against the trunks, clinging to the earth, half coming out, half effaced within the dim light, in all the attitudes of pain, abandonment, and despair" (510). Like Gauguin's paintings, these passages reveal as much as they conceal and depend on the perceiver's gaze to recompose them into significance.

V.

A final word: As westerners, we might ask, How can we teach a story like *Heart of Darkness* with its non-Western setting without reinscribing ourselves as colonialists? When we teach *Heart of Darkness*, are we in the same position as Western museums displaying non-Western art, that is, are we invading a different culture with our texts about the colonialism? But not so fast. Conrad was avant-garde for his time in acknowledging that, on occasion, Africans were more controlled and ethically advanced than Westerners; he, like Gauguin, knew that African cultural practices and art—chants, dance, drumming—were alien to Western concepts of display, that African art was religious in function and linked daily experience to abstract beliefs, and that African art was used performatively in funerals, weddings, and initiation rites. While Western history is preserved as literature, isn't Maori oral tradition preserved as memory and artistic objects? Memory, as Conrad and Gauguin stress in their oral narratives, is personal, selective, amorphous, and emotionally charged, while Western history is more objective, verified, and sorted out. Memory and history are intertwined not only in nonwhite cultures, but even—as Conrad understood—in Western culture. Has not Conrad's perspective seemed to have found confirmation in postmodern theory and the history and criticism it shapes?

Four

Cézanne and Eliot: The Classical Temper and the Unity of Eliot's Gerontion

The man of letters expresses himself in abstractions whereas a painter,
by means of drawing and color, gives concrete form to his sensations
and perceptions—Cézanne, May 26, 1904

I.

T.S. Eliot and Paul Cézanne represent the formalist and classical im-
pulse of Modernism. Eliot would have been aware of Cézanne from the
Armory Show, from his sojourn in Paris (1910-11) where Cézanne had long
been recognized as a major figure, and from the effects of the 1910 and
1912 London shows of Post-Impressionists. Both Cézanne and Eliot insisted
that the function of art was to look at the world with fresh eyes and to cast
aside assumptions about how the world was supposed to look. In that sense,
they are revolutionaries. What Maurice Merleau-Ponty wrote of Cézanne
is equally true of Eliot: "Cézanne did not think he had to chose between
feeling and thought, between order and chaos. He did not want to separate
the stable things which we see, and the shifting way in which they appear;
he wanted to depict matter as it takes on form, the birth of order through
spontaneous organization" (quoted in *Cézanne*, 69).

Eliot would have seen a parallel between his own developing aesthetic
theory and Cézanne's formalism and classicism. Cézanne was praised for
restoring classicism in painting. As Maurice Denis puts it, "The painting of
Cézanne . . . imitates objects without any exactitude and without any

accessory interest of sentiment or thought" (quoted in *Cézanne* 48). Cézanne saw himself as a formalist: "All discourse is misunderstanding. The only insight is in the work itself" (quoted in *Cézanne*, 46). Eliot wrote in his 1919 essay, "Tradition and the Individual Talent": "The progress of an artist is a continual self-sacrifice, a continual extinction of personality . . . [T]he mind of the mature poet differs from that of the immature one not precisely in any valuation of 'personality', not being necessarily more interesting, or having 'more to say', but rather by being a more finely perfected medium in which special, or very varied, feelings are at liberty to enter into new combinations" (*Selected Essays*, 7).

Like Cézanne, who was deeply influenced by Poussin and Chardin— in particular their ordered composition—Eliot was most conscious of writing within a period of transition and the need for the stability of tradition:

> No poet, no artist of any art, has his complete meaning alone. His significance, his appreciation is the appreciation of his relation to the dead poets and artists. You cannot value him alone; you must set him, for contrast and comparison, among the dead. I mean this as a principle of aesthetic, not merely historical, criticism. The necessity that he shall conform, that he shall cohere, is not one-sided; what happens when a new work of art is created is something that happens simultaneously to all the works of art which preceded it. (*Selected Essays*, 4)

Both Cézanne and Eliot construct forms by means of allusion to prior works; as Jed Perl notes:

> When Cézanne, in what was to become one of his two or three most famous remarks, announced his desire to "revive Poussin through contact with nature," he may well have been aware that Poussin himself had lived in a period in which the old ideals—the ideals of Raphael— were enfeebled. By Cézanne's time the French Academy that had been based on Poussin's discoveries had rotted to the core. But the situation had already been dire in 1765, when Chardin, Cézanne's great predecessor in the art of still life, stood before the Academy and spoke of the hopelessness of the young artists, who "withered for days and nights" before the casts of classical sculpture, which he called "immobile and inanimate nature." (Perl, 29)

What Eliot learned from Cézanne was composition, particularly resolution—at least tentative and provisionally—of disparate images, inclusive-

ness of multiple viewpoints (as when Cézanne paints fruit in his still life from several focal points), and startling placement and cropping of figures and natural objects. Even when Cézanne's detachment is ironic, his is not a fixed stance but rather a stance dynamically growing out of and reflecting at times a personal struggle with his subject and materials. For Cézanne's sensibility at times resisted his formalism; in his work he often left traces of bare canvases. And Eliot's ironic detachment to his monologuistics Gerontion and Prufrock is similar. In *Gerontion* (1920) and *The Love Song of J. Alfred Prufrock* (1917), he looks at his characters from multiple perspectives; and while his speakers indict themselves with their myopic perspectives, he observes from an ironic distance. Cézanne viewed the experiential world as an important base, but expected the finished works to become an illuminating distortion of what he had observed. He loved color and volume, loved the line and the brush, yet never wasted his energy on the purely decorative.

While Manet was the central figure in the 1910-11 London exhibit organized by the Bloomsbury figures Roger Fry and Clive Bell, Cézanne was the central figure in the second London exhibit organized in 1912. Both exhibits created the occasion to expose England to the formalist art criticism of Fry and Bell, especially to Bell's concept of significant form. Fry, whose ideas occupied a prominent place in the London to which Eliot emigrated, transformed Denis's ideas about Cézanne's classicism into a formalist and Modernist mode; when Cézanne suppressed the subjective, according to Fry, he achieved his genius. Bell saw Cézanne as a Modernist who had liberated "painting from a mass of conventions which, useful once had grown old and stiff and were now no more than so many impediments to expression" (quoted in *Cézanne*, 57). This was the view that Eliot had of himself. In Cézanne's last phase, according to Bell, "We get, in fact, a kind of abstract system of plastic rhythms, from which we can no doubt build up the separate volumes for ourselves, but in which these are not clearly enforced on us" (quoted in *Cézanne*, 55).

Imagism in its effort to catch the response to experience at an intense moment parallels Impressionism—recall that Monet was painting his water lilies in the 1912 to 1914 period—but in its formal rigor, precision, and effort to achieve objectivity, parallels Post-Impressionism, particularly that of Cézanne. In his 1913 manifesto, Pound called for hardness ("Direct treatment of the 'thing,' whether subjective or objective"), exactness ("To use absolutely no word that does not contribute to the presentation"), and cadence ("As regarding rhythm; to compose in sequence of the musical phrase, not in sequence of the metronome") (Pound, quoted in Ellmann and Fiedelson, *Modern Tradition*, 145). He might have been describing the

Cézanne paintings he had seen at the Post-Impressionist exhibit. In Pound's two-line poem "In a Station of the Metro," he juxtaposes his response to an experience with an image that renders it:

> The apparition of these faces in the crowd;
> Petals on a wet, black bough.

The poem evaluates and structures the experience as an epiphanic moment of revelation for the speaker. In the characteristic Modernist way, it is a poem about looking. Even if we read from left to right the first time, we can choose in such a short poem to follow the eye the next time—choose to, as when we are looking at paintings, start any place we please. Our memories of texts, particularly short texts, are rarely in narrative order but usually partly visual, even if the visual may have the distortions of dreamscapes. In *Gerontion, The Love Song of J. Alfred Prufrock,* and *The Waste Land,* Eliot's verse paragraphs often have the visual quality of paintings.

As the epigraph at the beginning of this chapter shows, Cézanne, like Eliot, sought to objectify his personal responses, to find in concrete images the reality he wanted to convey. We could think of Cézanne's work as a painterly model for Eliot's objective correlative. For Cézanne, painting from nature was not copying the object, but giving shape to his material sensations: "Knowledge of the means of expressing our emotion is . . . essential . . . I become more lucid in front of nature. . . . I believe in the logical development of what we see and feel through the study of nature, and concern myself with method only later; method being for us but the simple means by which we manage to make the public feel what we ourselves feel and so accept us" (quoted in *Cézanne,* 17, 18). Is this not reminiscent of Eliot's definition of objective correlative, which is as much a definition of what Eliot was attempting as it was a description of Shakespeare's technique in *Hamlet?* "The only way of expressing emotion in the form of art is by finding an 'objective correlative;' in other words, a set of objects, a situation, a chain of events which shall be the formula of that *particular* emotion; such that when external facts, which must terminate in sensory experience, are given, the emotion is immediately evoked" (Eliot, *Selected Essays,* 124-25). Doesn't this quotation also apply to Cézanne's classical formalism? Eliot's goal was to move beyond the abstractions that he felt had seeped into English poetry and to seek objective correlatives for experience. For him Cézanne would have been the model of an objective artist, a paradigm of a figure who examined basic tenets of realism to find an inner reality.

Cézanne does not have a linear imagination but one that holds a multiplicity of perspectives and disparate elements suspended like constellations in his imagination. Forms blur into one another, suggesting Eliot's transitions without breaks or explanation. Let us look at *Millstone in the Park of the Chateau Noir* (1898-1900) and see how Cézanne creates solidity and materiality in a flat plane: "Cézanne did not seek to represent forms by means of line. Contour existed for him only as the place where one form ended and another began" (Riviere and Schnerb, quoted in *Cézanne*, 1996, 384). Cézanne's *Millstone in the Park of the Chateau Noir* (1898-1900; see p. 104) anticipates Eliot's wasteland setting in *Gerontion* and *The Waste Land*. By evoking and transforming Poussin's classical landscapes in *Millstone in the Park of the Chateau Noir*, he, like Eliot, is bringing into present focus an absent, idyllic world. Unlike Poussin, Cézanne builds depth not by traditional perspectives toward a vanishing point but by weaving and overlapping.

In *Millstone in the Park of the Chateau Noir*, the bleak, dark mood is created by piles of loose stones, other rocks cut into rectangle shapes (the rectangles might possibly be of wood), and the large stark unused millstone in the front left-hand corner. Apparently what Cézanne saw was the debris of a planned mill that was subsequently abandoned, although it could be construction material for the building of a mill. The four foregrounded trees, which provide a stark vertical, almost lack leaves except for one slim branch, which paradoxically emphasizes the baldness of the other trees. When the viewer looks for possible passages out of the clearing in which the building material lies, she finds none. The viewer experiences something of a psychological blockade, as if she were on a trip to nowhere; her eye wanders in circles seeking a way out. We recall the epigraph to *Prufrock* from Canto 27 of Dante's *Inferno*, in which Guido da Montefeltro, whom Dante and Virgil have encountered among the False Counselors, where each spirit is concealed within a flame that moves as the spirit speaks:

> If I thought my answers were given
> to anyone who would ever return to the world,
> this flame would stand still without moving any further.
> But since never from this abyss
> has anyone ever returned alive, if what I hear is true,
> without fear of infamy I answer thee.

Cézanne's *Millstone in the Park of the Chateau Noir* is claustrophobic, as if the eye were trapped from escaping. Instead of moving to the background, our attention is redeflected clearly across the picture plane. How does he do this?

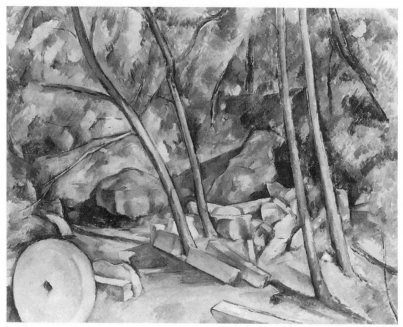

Millstone in the Park of the Chateau Noir (Le Meule), Paul Cézanne (1839-1906)

Viewers of the 1995-96 Vermeer exhibit at the National Gallery in Washington understand how artists used all orthogonals—parallel lines that are perpendicular to the picture—to recede to a single point or vanishing point; but two of Cézanne's four trees are at an angle while the other two are perpendicular. There is no exit from the clearing containing the rocks—grim gray rocks that suggest an abandoned cemetery or the detritus of volcanoes, rocks that seem to fall from left to right—and the foregrounded millstone. Eliot, too, creates this sense of hopeless passivity. We think of Gerontion's seeing himself as the gull against the wind and Prufrock's identifying himself with the sideways movement of a crab. What light there is in *Millstone in the Park of the Chateau Noir* is provided by the painter's ocher earth color, a color echoed in flecks in the background green trees. That the painter, not the sun, provides the light emphasizes the fictionality of painting. While the background bushes are green, he is painting with a limited palette. Humans are absent, and the green—unexpectedly—does not give the scene life but rather emphasizes the irony of the missing human emotions and activity. Perhaps, more than in literature, what is *missing* is crucial in reading paintings. That

Cézanne's landscape or mindscape has the three dimensionality of geometric shapes underlines the foreboding quality of the scene. No humans are present, no hustle and bustle, no goals, desires, hopes outside the painter's own. Stones and rocks are metaphors for a desiccated life, Cézanne often painted rock formations and quarries. It is as if as representatives of nature, they precede and will outlast human plans and human life.

Let us turn to his still lifes. By suggesting several possible outlines of an object—as Cézanne does in *Curtain, Jug and Compotier* (1893-94) and *Still Life with Curtain and Flowered Pitcher* (c. 1899)—he mirrors what happens in perception. As Jed Perl writes of the latter:

> That this is a painting full of complex inequalities is signaled by the baker's dozen of apples and oranges, which are arranged in groups of five and four and three and one, so that the eye is offered no rest, only a continual weighing of sum against sum. And then there are the two kinds of cloths—or is it three?—for there are actually two white cloths on the table to balance the curtain hanging on the wall. The white cloth on the left is arranged in soft curves, the one to the right in more angled folds. The figured curtain is darkly intricate, with the geometry of the leaf pattern rearranged in thick folds to achieve an effect as complex as a scene by Breughel. And then, as if to mediate between all these conflicting forces, there is the decorated pitcher, white with bits of green and orange and purple—but Cézanne is far too intent on asserting the dazzling autonomy of each part to permit an easy resolution. It's a mysteriously radiant canvas, with the purplish dusk of the upper regions descending on a tabletop as full of colorful whites as newly fallen snow. (30)

Perl reminds us of the crucial role of optics in Cézanne's formalism, and how we as perceivers have a far more substantial role to play than we do in the works of Poussin or Chardin.

In 1908 Maurice Denis suggested how imagination re-creates reality in its illuminating distortions: "Art is a creation of our imagination of which nature is only occasion. . . . Art instead of being a copy, becomes the subject of deformation of nature" (quoted in Adams, 145). Cézanne questioned realistic convention when he undermined the idea of a single perspective. Just as Cézanne's still lifes are more abstract alternatives to *Millstone in the Park of the Chateau Noir*, the various versions of *The Bathers* are a development of his interest in pure form. His bathing scenes move toward abstraction; by the turn of the century, as his Philadelphia *Great Bathers* (1906, #219; numbers

refer to *Cézanne*) demonstrates, Cézanne's women have become featureless shapes; indeed their bodies are not only interchangeable with the surrounding tree trunks, but seem to be painted with the same brushstrokes. His bathers, as Gottfried Boehm notes, "seem dull, ugly, isolated, lacking in spirit. They are constructed, not natural, the components of a pictorial structure, not the representatives of physical beauty" (13). He plays down the figures and integrates them into a formal arrangement: "This result is achieved by multiple contours and ambivalent body masses, which simultaneously direct the eye toward the surface" (13). Bodies do not call attention to themselves but are structural elements in the composition. He is not interested in the characters of his figure in the various *Bathers*, but the juxtaposition of shapes; the trees and bodies become interchangeable. Unlike Picasso's *Les Demoiselles d'Avignon* or Manet's *Déjeuner sur l'herbe*, Cézanne, as Boehm writes, "instead of modelling them plastically in light and shadow . . . he 'modulates' them according to structure and color tone" (20).

Cézanne used geometric strokes to build up compositions. His art is poetic rather than mimetic. He creates sculptural illusion. Bathers do not form a group through behavior such as sexual play, dancing, or music. Interestingly, in the Philadelphia version of *The Great Bathers*, the small figure of an observer—the artist?—stands at the center of the background and watches from a distance. As Cézanne's career progressed, he became interested more and more in form, including color relations; not only did he use still life to examine perspective and visual possibilities, but his landscapes lack either humans or details of modern life. Cézanne stopped using naked models; rather, he used as his models paintings in the Louvre and at times poor reproductions of them. For Cézanne, the body is not a preexistent fact but "the *outcome* of a pictorial process" (Boehm, 22).

Let us turn to Eliot. Like Cézanne, Eliot does not necessarily separate figure from ground, subject from context; his characters are illustrative of the world in which they live. What Eliot would have noticed in Cézanne was not only the use of vernacular and personal subject matter but the ironic and objective perspective on the personal and subjective; Eliot's solution was to transform his emotions to those of the dramatic monologist. Cézanne's three dimensionality, his departures from traditional realism achieved by means of distortion, his building up paintings with multiple surfaces and contours with broad arrays of colors might well have influenced the way Eliot uses shifting, discontinuous, discrete vignettes in *Prufrock* or *Gerontion*. The characters Prufrock and Gerontion are self-conscious of themselves as bodies on which others gaze; their process of telling reveals aging, diminishing bodies. Gerontion is "an old man in a dry month . . . among windy

spaces: . . . [a] gull against the wind;" Prufrock sees himself as a ludicrous
disembodied figure, his nerves exposed for all to see: "They will say: 'But
how his arms and legs are thin! But as if a magic lantern threw the nerves in
patterns on a screen. Would it have been worthwhile.'" Eliot's characters
Prufrock and Gerontion are also objects of their own gaze; they see them-
selves as *objects*:

> And I have known the eyes already, known them all—
> The eyes that fix you in a formulated phrase,
> And when I am formulated, sprawling on a pin,
> When I am pinned and wriggling on the wall,
> Then how should I begin
> To spit out all the butt-ends of my days and ways?
> And how should I presume?

In Robert Browning's "My Last Duchess"—one of Eliot's paradigms—the
Duke turns the Duchess into an object of art; Eliot's Gerontion, as we shall
see, does that to himself.

Cézanne subordinated details to the demands of a grand design
without sacrificing specificity of his eye. A Cézanne painting begins as a
self-reflexive meditation and becomes a radical departure from representa-
tional aesthetics. Cézanne knew that we see in context and that an object
takes its meaning from that context. Like Joyce and Eliot, he stressed that
"the identity of any given object is often most subtly varied and adjusted by
the fact of its proximity to other given objects" (Russell, 23). Perhaps the
clearest explication of Cézanne's technique is articulated in the following
letter to Emile Bernard: "[T]reat nature by means of the cylinder, the sphere,
the cone, with everything put in perspective so that each side of an object
or a plane is directed toward a central point. . . . Now nature, for us men, is
more depth than surface, hence the need to introduce into our vibration of
light, represented by reds and yellows, a sufficient amount of blue, to make
the air palpable" (quoted in Cézanne, April 15, 1904, 18). Bergson wrote,
"we have to express ourselves in words, but more often we think in space"
(*Les Donnes immediates de la conscience* [1889] quoted in Russell, 31); like Conrad
and James, Cézanne was concerned with the act of cognition by imagined
characters—such as the imagined perceiver within his landscape or the card
players in the painting of that name—*and* by his audience.

Maurice Merleau-Ponty's phenomenological reading emphasizes how
the viewer becomes a participant in Cézanne's art: "His painting was para-
doxical; he was pursuing reality without giving up the sensuous surface, with

no other guide than the immediate impression of nature, without following the contours, with no outline to enclose the color, with no perspectival or pictorial arrangement," (quoted in *Cézanne*, 69). While I would argue that in Cézanne there is always a "perspective or pictorial arrangement," even if it is elusive and ambiguous, Eliot's readers find the same paradox between the pursuit of reality and the shifting discontinuous narrative form. Cézanne plays down the figures and integrates them into a formal arrangement. Isn't that what Eliot does in *The Waste Land*, where no one figure comes into focus—in part because he looks from a steep and icy peak at his lower-class subjects? From Cézanne, who undoubtedly knew of Eadweard Muybridge's photographic experiment with motion, Eliot also may have learned the dynamic quality of apparently static scenes; for example, in *Curtain, Jug and Compotier* (#159), the tablecloth looks as if it might get up and leave.

The influential art historian Meyer Schapiro has written of Cézanne:

> Compared with the normal broken line of an interrupted and re-emerging edge, Cézanne's shifting form is more varied and interesting; by multiplying discontinuities and asymmetry, it increases the effect of freedom and randomness in the whole. . . . We see the object in the painting as formed by strokes, each of which corresponds to a distinct perception and operation. It is as if there is no independent, closed, pre-existing object, given once and for all to the painter's eye for representation, but only a multiplicity of successively probed sensations—sources and points of reference for a constructed form which possesses in a remarkable way the object-traits of the thing represented: its local color, weight, solidity, and extension. (9-10)

As my analysis of *Gerontion* will show, Eliot uses shifting forms, discontinuities and asymmetry. His vignettes correspond to the distinct perception and operation of Cézanne's strokes.

Cézanne, like Eliot, launched a formalist revolution. Yet although Cézanne never deviates from a strong focus on form, his portraits, like Eliot's, are often subtle psychological studies. Cézanne's color and drawings write the text of Modernism, not merely in his focus on exploring the formal possibilities of painting but in his developing Manet's use of vernacular subjects in his various versions of *The Card Players* and in his psychological realism. Cézanne's color and drawing are crucial, even when he "draws" with blocks, swathes, and shapes of color. His drawings emphatically show us how he begins *before* his formal and abstract solutions. Cézanne is the paradigm of an artist who finds profundity without recourse to myth,

religion, or social and political aims—unlike Lawrence, Joyce, and, indeed, Eliot he is a figure of secular culture. Both Picasso, not withstanding *Guernica*, and Matisse sat at his feet in this regard.

Yet, as his portraits of self and family show, he was not so much a formalist that the personal and human were neglected. In these portraits Cézanne uses the smallest touches of paint and touches of brush as if he were a poet finding the *bon mot*. As in modern literature, we find attention to minute details that change the shape of the whole. Take *Uncle Dominique (Man in a Cotton Cap* 1865-67). It is the circle of thick, black facial hair balancing the painting's other blacks, the slightly unkempt raised, skeptical left eyebrow, the linear tassle, and the V of the eater's neckline that give the painting an odd geometry and whimsy. While *The Large Bather* (1885; #104) lacks both historical or contemporary contexts, its mysterious expression calls out for a reading and a response. Here Cézanne turns the conventional male nude into what Joseph Rishel calls "a series of an intensely isolated and introspective images" (*Cézanne*, 81); so, too, does Eliot with his monologues . The face looking down is vulnerable in its thoughtful isolation. *Portrait of Madame Cézanne* (1888-90; #125) is passive, stolid, calm, pessimistic. Rishel speaks of "the calmly determined rectitude of her straight-backed posture" (318). Can we imagine a poet like Eliot or Stevens wondering what these figures would say if they could speak? While Cézanne never finished his *Portrait of Gustave Geffroy* (#172), the portrait conveys the artist's ambiguous attitude. As Françoise Cachin puts it, "the sitter comes across as an opaque and mysterious presence, powerful, even a bit menacing" (*Cézanne*, 412).

II.

Gerontion is a poem that owes much to visual allusions. By having a speaker refer to Titians here and Michelangelo in *Prufrock*, Eliot is locating a cultural tradition to which he wants one to juxtapose his portrait. In one sense, the character of Gerontion is culturally obsolete, casting blame on everyone but himself. We understand Gerontion's self-portrait in reference to the substantial Titians where the figure dominates the space and is the picture of poise and confidence. Titians represents a world of Renaissance confidence, single perspective, artistic and temperamental control. By contrast, we don't really know what Gerontion, whose name means "little old man," looks like, but we know how he lives and the kind of place he lives in, the cultural milieu in which he lives. His references to a past religious tradition—to Christ the tiger—evoke also the great Renaissance seventeenth-century biblical paint-

ings, often on the grand scale of Rubens. *Gerontion*—like *Prufrock*—substitutes different optics. Renaissance portraits placed figures in their upper-class social milieu and relied on traditional representation. But Eliot's monologues are Cubist portraits in the mode of synthetic Cubism, and the spectator must interpret the disparate impressions. To be sure they have a narrative structure as they move from beginning to end. But they also have a spatial dimension.

Eliot's fragmentation, disrupted narrative, alternation of background and foreground, and, finally, disparate picture planes resolved into one plane owe much to the Cubist collage. The verse paragraphs in *Prufrock* and *Gerontion* are like pictures at an art exhibition, a set of visual tableaus or imagined paintings. In *Prufrock* Eliot could well have Manet's *Olympia* in mind when he wrote of being rebuked by "one settling a pillow by her head / Should say, 'That is not what I meant at all.'" We might compare Eliot's stanzas with disparate planes. In *Gerontion* the first stanza is a pathetic picture of a figure living in a decayed house on wasteland mindscape while being waited on by an anonymous woman of indeterminate age and being read to by a boy. From his expectations of service, we can imagine that once he was in different circumstances. He represents European civilization in decline. The visual vignettes of *The Waste Land* intersperse figure and ground on the same plane in a collage technique; note the shifting perspective, the fore-shortening, abrupt cropping of scene, and visual quality of the opening:

> April is the cruelest month, breeding
> Lilacs out of the dead land, mixing
> Memory and desire, stirring
> Dull roots with spring rain.
> Winter kept us warm, covering
> Earth in forgetful snow, feeding
> A little life with dried tubers.
> Summer surprised us, coming over the Starnbergersee
> With a shower of rain; we stopped in the colonnade,
> And went on in sunlight, into the Hofgarten,
> And drank coffee, and talked for an hour.
> Bin gar keine Russin, stamm' aus Litauen, echt deutsch.
> And when we were children, staying at the archduke's,
> My cousin's, he took me out on a sled,
> And I was frightened. He said, Marie,
> Marie, hold on tight. And down we went.
> In the mountains, there you feel free.
> I read, much of the night, and go south in the winter.

The reader is able to recompose the images, to find a focal point.

What has puzzled most readers of *Gerontion* is the apparently incoherent structure of the old man's monologue. But if it can be established that Eliot is dramatizing the process of unsuccessful meditation, the speaker's imprecision and incongruous combinations of sensual and spiritual images become explicable.* I am arguing that *Gerontion* is about the title character's desperate attempt to place his life within an eschatological context and to achieve the humility and passionate commitment to Christ on which his salvation depends. By having Gerontion consciously quote Lancelot Andrewes's and unconsciously parody a passage from John Donne's *Second Anniversary*, Eliot implicitly juxtaposes his character's monologue to the spiritual unity and concomitant rhetorical control of successful meditations within the tradition of *contemptus mundi*. Relying upon reason and logic to explain his inability to believe, while desperately groping for the faith on which salvation and apocalyptic vision depend, Gerontion's meditation poignantly dissolves into self-deprecation.

While Cézanne's classicism is secular, Eliot's often depends on a traditional Christian perspective to shape his values. Because most of us are indebted to Louis Martz for showing us how the continental meditative treatises of the Counter-Reformation influence the structure and content of seventeenth-century religious poetry, it may be difficult for us to appreciate Eliot's immersion in the tradition of meditation. Yet only a man who felt a passionate epistemological empathy with this tradition could have written of Andrewes:

> It is only when we have saturated ourselves in his prose, followed the movement of his thought, that we find his examination of words terminating in the ecstasy of assent. Andrewes takes a word and derives the world from it; squeezing and squeezing the word until it yields a full juice of meaning which we should never have supposed any word to possess. (Eliot, *Selected Essays*, 305)

*If I were to select a paradigmatic statement of the view of the poem that I wish to refute, it would probably be the following comment from Grover Smith's excellent source study, *T. S. Eliot's Poetry & Plays: A Study in Source and Meanings* (Chicago, 1956): "Because Gerontion, though primarily a symbol, is still dramatic enough to remain a person, the poem tends to split between the personality, which nevertheless is undefined, and the argument, which is not intimately enough related to the old man's feelings" (64-65).

Or,

> When Andrewes begins his sermon, from beginning to end you are sure
> that he is wholly in his subject, unaware of anything else, that his
> emotion grows as he penetrates more deeply into his subject, that he
> is finally "alone with the Alone," with the mystery which he is seeking
> to grasp more and more firmly. (308)

By having Gerontion quote Andrewes as he recoils from the initial self-
deprecation of the first verse paragraph, Eliot calls attention to the tradition
of religious meditation in which his character is trying to participate. But
the very qualities that Eliot praises in Andrewes's style—"ordonnance, or
arrangement and structure, precision in the use of words, and relevant
intensity"—are conspicuously lacking in Gerontion's monologue. In the
same essay, Eliot goes on to compare Donne's sermons with those of
Andrewes:

> Of the two men, it may be said that Andrewes is the more medieval,
> because he is the more pure, and because his bond was with the Church,
> with tradition. His intellect was satisfied by theology and his sensibility
> by prayer and liturgy. Donne is the more modern—if we are careful to
> take this word exactly without any implication of value, or any sugges-
> tion that we must have more sympathy with Donne than with An-
> drewes. Donne is much less mystic; he is primarily interested in man.
> He is much less traditional. (309)

If we recall Eliot's remark that Donne "belonged to that class of persons . . .
who seek refuge in religion from the tumults of a strong emotional temper-
ament which can find no complete satisfaction elsewhere" (309), it is hardly
surprising that Eliot, himself involved in a lifelong spiritual quest, used
Donne's *Anniversaries* as a paradigm of the successful meditation.

III.

If Cézanne's paintings are a version of a successful quest for Modernist order,
Gerontion's monologue is an example of Eliot deliberately dramatizing a
failed quest. At first Gerontion attempts to place himself in a sociological
and historical context and to attribute his disillusionment and despair to a
civilization that does not offer opportunities for heroism or dignity. Geron-

tion sees himself not only as the victim but as a symbol of a civilization that he believes has deprived its best men of the opportunity to distinguish themselves in their actions. But the reader soon understands that Gerontion's negatives and circumlocutions thinly disguise his self-indulgent and narcissistic sensibility:

> I was neither at the hot gates
> Nor fought in the warm rain
> Nor knee deep in the salt marsh, heaving a cutlass,
> Bitten by flies, fought.

If the opening two lines seem to indicate self-control and precision, this impression is quickly dispelled by the old man's savoring of the world of action that has passed him by. Rather than offering incisive self-analysis or a pointed indictment of his *Zeitgeist*, he fastidiously evokes the minor discomforts that he takes for the self-sacrifice accompanying the heroic life. Although Gerontion begins the next sentence by teasing the reader into expecting a controlled analysis ("house" suggests both the physical body in which his soul dwells and the social and political world he inhabits), the syntactical precision is undercut by the vituperative substance:

> My house is a decayed house,
> And the jew squats on the window sill, the owner,
> Spawned in some estaminet of Antwerp,
> Blistered in Brussels, patched and peeled in London.

Devoting three lines to derogate the landlord with onomatopoeic verbs and participles—"squats," "spawned," "blistered," "patched," and "peeled"—is a gross example of the rhetoric of insult, prejudice, and defamation. For Eliot, Jews were a metonymy for a rootless, deracinated people who embraced material rather than spiritual values. That his use of "jew"—derogated to the lower case—draws on an equation of the Jew with a predatory toad-like figure reflects Eliot's pervasive anti-Semitism. Jews are associated with cities—cities huge, drab, ugly, and impersonal. Not only are Jews associated in the passage above with disease and decay, but in the next lines, they are linked with lust and defection. As Anthony Julius persuasively writes:

> Gerontion's "jew" is ugly in full measure. Spawned, blistered, patched and
> peeled, he emerges as if from the swamp, diseased and disfigured. Jews
> are swamp-life, breeding in uncontrollable numbers. . . The "jew" is an

> intruder. He hovers outside the house, making unwelcome proprietary
> claims over it. . . . Eliot's anti-Semitic imagination also responded to a
> turn-of-the-century preoccupation with the threat posed by Jewish ref-
> ugees to the nation's health. The "jew" is on the window sill both because
> he has been denied any more secure resting place and because he himself
> may thus deny his tenant peaceable possession of his house. (45, 47)

Eliot, like Cézanne, invites the reader to recompose his separate images and
vignettes. Note how visual, despite the negatives, the opening self-portrait
of *Gerontion* is and how cities are evoked in pejorative visual images, as if their
filth were metonymically related to Jews. Yet the very fragmentation of cities
is enacted in the forms on Modernism. When Eliot writes in *The Love Song of
J. Alfred Prufrock* of

> half-deserted streets,
> The muttering retreats
> Of restless nights in one-night cheap hotels
> And sawdust restaurants with oyster shells,

he asks us to recompose the city's fragments into our mental neighborhood.
The vast interconnections of Cézanne's elaborate canvases with their sepa-
rate neighborhoods like *The Card Players, Still Life with Apples* (1893-94; #160),
and various versions of *The Bathers*—or Eliot's *Prufrock* and *The Waste Land*—
may be the result of his living in cities or his imagining the city as a labyrinth.
Such large canvases and texts are pulled together by a willful and often
visionary overview.

Gerontion suggests that his era has witnessed the corruption of
sexuality, symbolized by the sickly goat Capricorn, and of family relations,
represented by the infirmity of the anonymous woman who is reduced to a
mere instrument for providing food and tea:

> The goat coughs at night in the field overhead;
> Rocks, moss, stonecrop, iron, merds.
> The woman keeps the kitchen, makes tea,
> Sneezes at evening, poking the peevish gutter.

But in view of his later self-consciousness about his declining capacity to
feel ("I have lost my sight, smell, hearing, taste and touch"), it seems clear
that these statements are functions of Gerontion's psychic need to imag-
ine himself as an archetype of a civilization that deprives men of a chance

to distinguish themselves in action or to fulfill their emotional and spiritual needs. The concluding lines of the first verse paragraph indicate that his meditation is back at its self-pitying starting point. Julius aptly concludes:

> *Gerontion*, a condensed instance of all these anti-Semitic themes, economically renders them in the image of the squatting Jew, perched on a window sill, in a state of precarious quarantine ("mankind has put the Jewish race in quarantine" said Chateaubriand), kept apart because he is unclean, unwelcome even in the house that he owns, wretched yet monied. These lines are a horror picture, drawn with loathing. One recoils from them. (49)

After noting the effects on a Jewish reader, Julius seeks, as I also do, to rescue the poem by its genre of dramatic monologue. Yet I want to argue for a vacillating distance between Eliot and the passive old man who, at the least, objectifies a self Eliot feared becoming; I want also to contend that *Gerontion* is damaged by its embracing prejudices. Eliot could have dramatized Gerontion's parallel soul without this extended discourse. Julius argues: "He does not dwell on him, dwelling in his property. . . . Gerontion does not need Jews to explain his present condition, it is enough that they are part of it" (61); yet Julius's own version of the ramifications of the first verse paragraph gives the lie to this explanation.

The movement of Gerontion's mind suggests Cézanne's shifting forms. The abrupt evocation of Andrewes's sermon on the Nativity, stating the essence of Gerontion's dilemma, represents the character's desperate attempt to leave what he realizes to be a bankrupt path of introspection:

> Signs are taken for wonders. "We would see a sign!"
> The word within a word, unable to speak a word,
> Swaddled with darkness. In the juvenescence of the year
> Came Christ the tiger.[*]

At the same time that he recalls Christ's rebuke to those Scribes and Pharisees who would wish for a demonstrable sign, he voices his own desperate hope

[*] The context for the sermon is taken from *Matthew* xii. 39-40; the sermon may be found in *Seventeen Sermons on the Nativity* (London, n.d.) with the passage that Eliot uses on pp. 200-201.

for empirical evidence of grace. The "we" of the quotation enables him to distance his anxiety by generalizing it. That Gerontion cannot meditate upon the significance of Christ's Nativity and cannot translate the retelling of the event into insight is indicated simultaneously by the abrupt interruption of his sentence and by the implied pause before he begins again. The tiger not only suggests Blake's tiger, itself defined by antithesis to the Lamb, symbol of innocence, mercy, and humility, but also indicates that Christ is now a menacing image to Gerontion. Although Christ came at the appropriate time, "in the juvenescence of the year," the response to him is inappropriate and degraded, coming as it does at the wrong time, "in depraved May," and accompanied by the icons of betrayal: dogwood and flowering Judas. Rather than accepted in Christian humility and in the form of the traditional communion, Christ's presence is perverted by an assortment of aesthetes whose behavior is anticipated by the increasingly suspect series of words: "to be eaten, to be divided, to be drunk among whispers." The description of those who eat the Lord's supper gives these phrases a perverted and sordid import. Mr. Silvero, whose name hardly suggests an interest in spiritual values, apparently finds his spiritual satisfaction among his porcelain objects, and Hakagawa genuflects to his sensual Titians. While Madame de Tornquist perverts the communion by indulging in a seance, Fraulein Von Kulp—whose name suggests *culpa*, or guilt—is conducting activities that seem to have more to do with the sexual than the religious realm. Gerontion's bitterly pejorative epithet for these people, "Vacant shuttles weave the wind," ironically recalls the self-deprecatory phrase "A dull head among windy spaces" and thus unintentionally forges a link between himself and the people he despises.

IV.

Like Cézanne, Eliot uses references to prior works "as a way of controlling, of ordering, of giving shape and a significance to the immense panorama of futility and anarchy which is contemporary history" (Eliot, "*Ulysses*, Order, and Myth" reprinted as "Myth and Literary Classicism," in Ellmann and Fiedelson, 681). Before discussing how Eliot draws upon *The Second Anniversary*, perhaps I should make clear how I view *The Anniversaries*. We might think of how Cézanne reinterpreted the orderly universe of Renaissance paintings—for example, his *Boy Resting* (1890) reconfigures Poussin's *Echo and Narcissus*, and *Old Woman with a Rosary* (1895-96) evokes Rembrandt as well as Courbet. Rather than viewing these remarkable religious poems as

Donne's personal religious statement, I believe that Donne is dramatizing the process of discovering spiritual certainties amid excruciating and agonizing doubts that his *Zeitgeist* presented to him. Certainly Donne, like Eliot, draws upon his own epistemological experience, but the very fact that he chooses to meditate upon the significance of the death of a young girl that he barely knew indicates that he is concerned with understanding the meaning of death rather than with presenting an outpouring of private grief. In 1920 Eliot would have approved of Donne's division between the man who suffers and the mind that creates, of his "continual surrender of himself as he is at the moment to something which is more valuable" (*Selected Essays*, 7). Indeed, Donne's persona sets out to perform a vatic role, to sing Elizabeth Drury's praises, because "none/ Offers to tell us who it is that's gone" (I. 42). It soon becomes apparent that the speaker does not mean to discuss her specific virtues, or even her significance as the platonic symbol of goodness on earth, but the relationship of this life to the next and the possibilities of salvation for those remaining on earth. The subject of the poem, then, is at once anonymous, since the deceased is barely mentioned except in terms of what she symbolizes, and highly personalized, because the significance of her death to the speaker is the poem's subject.

At the beginning of *The First Anniversary*, the persona's confused despair is reflected by hyperbolic statements about the world's decay. But the speaker pulls himself together and begins his anatomy of the world. As he becomes more specific in his indictment and begins to recount man's limitations and the shortcomings of life on earth, he gains emotional and rhetorical control. This is illustrated by the movement from the commonplace figure that the world is senile—lacking "sense," "memory," and "speech"—to an intricate and controlled analysis. For our purposes, the important part of *The First Anniversary* comes when, after dissecting the world by means of logical analysis and reason, the poem turns on itself and rejects its own empiricism and logical methodology. In his famous indictment of the new sciences, Donne has his persona attack man's attempts to understand by reason and observation:

> Man hath weav'd out a net, and this net throwne
> Upon the Heavens, and now they are his owne,
> Loth to goe up the hill, or labour thus
> To goe to heaven, we make heaven come to us.
> We spur, we raine the starres, and in their race
> They're diversly content t'obey our pace. (I. 279-84)

As *The Second Anniversary* makes clear, the empirical method has undercut the old cosmology without providing a substitute. What the speaker of *The First Anniversary* saw as a lack of "interchange" between heaven and earth is revealed by *The Second Anniversary* as his own inability, now overcome, to discover something other than a physical relationship between earth and the heavens.

The Second Anniversary builds upon the insights of *The First Anniversary*: namely, the speaker's discovery of the ineffectuality of reason and empirical method; and the lack of correspondence between heaven and earth. That the speaker can explain for the first time the Christian paradox that death is birth (I. 451-54) is evidence of his readiness for the meditations of *The Second Anniversary* and shows us how far he has come since the confusion of the introduction and the despair of the first meditation of *The First Anniversary*. The realization that death is eternal birth, a discovery made possible by the preparations of *The First Anniversary*, provides the basis for the upward journey climaxed by the wonderfully ingenuous yet incredibly compelling repetition of the word "up." In *The Second Anniversary*, the speaker's rhetorical control reflects his increased spiritual control. As the dialectic of *The First Anniversary* is replaced by intense personal experience, his imagination becomes more dramatic and visual. Where in *The First Anniversary* is there anything like the trope of the beheaded body twitching after death to illustrate that "There is motion in corruption" (II. 222)? And the gradual disappearance of the clear-cut schematic divisions between meditation and eulogy is a structural metaphor for the speaker's spiritual integration.

In *The Second Anniversary* the persona engages in an intense dialogue with his soul in which he prepares himself for the spiritual epiphany of the later sections. To ready his soul to meet death, he exhorts, implores, and commands it as he imagines his soul as a finite object meeting death, depicted as another anthropomorphic body. The dramatic images—of death as a groom bringing light, of life as a prison from which death releases one's soul, of the body as a gun that ejects the soul—show how death restores the harmony and correspondence between earth and heaven:

> Thinke then, My soule, that death is but a Groome,
> Which brings a Taper to the outward roome,
> Whence thou spiest first a little glimmering light,
> And after brings it nearer to thy sight:
> For such approaches doth Heaven make in death. (II. 85-89)

Thinke in how poore a prison thou didst lie
After, enabled but to sucke, and crie.
Thinke, when t'was growne to most, t'was a poore Inne,
A province Pack'd up in two yeards of skinne,
And that usurped, or threatened with the rage
Of sickness, or their true mother, Age.
But thinke that Death hath now enfranchis'd thee,
Thou hast thy'expansion now and libertee;
Thinke that a rusty Peece, discharg'd is flowen
In peeces, and the bullet is his owne,
And freely flies: This to thy soule allow,
Thinke thy sheell broke; thinke thy Soule hatch'd but now.
And thinke this slow-pac'd soule, which late did cleave,
To'a body, and went but by the bodies leave,
Twenty, perchance, or thirty mile a day,
Dispatches in a minute all the way,
Twixt Heaven, and Earth. . . . (II. 173-89)

The repetition of the imperative "think" implies a disciplined persona who is intensely engaged in meditation to the neglect of all other concerns. That the speaker implores his soul to *think* in these terms is itself preparation for death. As if to dramatize this point, *The Second Anniversary's* third meditation places the soul in relation to the body. The speaker realizes that the flight of his soul—which he imagines following Elizabeth Drury's—is the proto-type for the flight of all souls. In this sense, death is a creative force correcting the lack of communication between heaven and earth caused by the Fall. After discussing the limitations of a soul's earthly life, the persona begins to question what kind of knowledge the soul will obtain in heaven:

In this low forme, poore soule, what wilt thou doe?
When wilt thou shake off this Pedantary,
Of being taught by sense, and Fantasy? (II. 290-92)

The process of *knowing* loses its complexity in heaven, because the soul's intelligence intuitively grasps true knowledge as opposed to the false knowledge of men's sensory perceptions:

In heaven thou straight know'st all, concerning it,
And what concerns it not, shalt straight forget (II. 299-300)

Contemplating her and realizing that death has taken her there makes him "strive/ The more, because shee'is there" (II. 381). He can speak of those who have enjoyed "the sight of God, in fulnesse" because in a very real sense he is one of those who had the grace to have this perception (II. 441). To comprehend the essential joy is to be prepared for salvation. That he can speak of the "sight of God" shows he has attained salvation and grace.

V.

Cézanne's impulses are secular and his focus is on the here and now—the Aristotelean "ineluctable modality of the visible"—while Eliot follows in the tradition of classical humanism and focuses on the Platonic body/spirit dicthotomy. *The Anniversaries* are the dramatization of a man who, by coming to understand the implications of the death of a young girl, discovers an inclusive system of spiritual values. They evoke the high Renaissance, a time when classical and religious values dominated, and free-thinking Jews of whom Eliot wrote in *After Strange Gods* were not a problem: "[We must discover] . . . what conditions, within our power to bring about, would foster the society that we desire. . . . [R]easons of race and religion combine to make any large number of free-thinking Jews undesirable" (quoted in Julius, 1). Like the persona of *The Anniversaries*, Gerontion contemplates the problem of belief at a time when he feels an inadequacy in his faith. While Elizabeth Drury's death makes Donne's speaker think of the world as "fragmentary rubbidge," Gerontion's dissatisfaction with his *own* plight leads him to indict the world. While in *The Anniversaries* the speaker moves from despair to faith and finally to a point where he imagines himself having a vision of God; in *Gerontion* the speaker cannot reconcile himself to death because he cannot meditate effectively. Gerontion intellectually knows that he lacks the faith on which salvation depends, but knowledge of his plight is not enough.

That Gerontion meditates upon history—now fragmented, disingenuous, hostile to humankind—in the passage whose structure echoes Donne's is fraught with ironic implication. In the passage that Eliot has his speaker parody, Donne's persona meditates upon the significance of Elizabeth Drury in an intense dialogue between self and soul. The pronoun "she," which in *Gerontion* denotes the secular abstraction "history" and which is the object of sexual innuendoes, refers in *The Anniversaries* to Elizabeth Drury, who as we have seen becomes a symbol of the possibility of achieving the promise of

salvation that is the goal of the spiritual quest of Donne's persona. Ironically and poignantly, Gerontion returns to the temporal and geographical framework of his opening remarks. After demonstrating that he understands how Christ's meaning has been made a sham by the aesthetes and self-conceived spiritualists, he displays his own spiritual hollowness by meditating upon history. Rather than meditate upon the significance of the Christian mystery, such as the inexplicable death of a young girl or the meaning of some of Christ's words to the Scribes and Pharisees, Gerontion turns to the very discipline that provides a logical explanation for his present plight. He would try to explain his inadequacy by placing himself in the context of a concatenation of events over which he has no control:

> Think now
> History has many cunning passages, contrived corridors
> And issues, deceives with whispering ambitions,
> Guides us by vanities. Think now
> She gives when our attention is distracted
> And what she gives, gives with such supple confusions
> That the giving famishes the craving. Gives too late
> What's not believed in, or if still believed,
> In memory only, reconsidered passion. Gives too soon
> Into weak hands, what's thought can be dispensed with
> Till the refusal propagates a fear. Think
> Neither fear nor courage saves us. Unnatural vices
> Are fathered by our heroism. Virtues
> Are forced upon us by our impudent crimes.

The claustrophobic image of history recalls the trapped gaze in Cézanne's historical meditation, *Millstone in the Park of the Chateau Noir*. But in *The Second Anniversary*, which is the model of successful meditation against which Eliot is intentionally juxtaposing Gerontion's ineffectual attempts at meditation, Donne's persona counsels his soul to ignore the study of this world:

> Forget this rotten world; And unto thee
> Let thine owne times as an old storie bee.
> Be not concern'd: studie not why, nor when;
> Doe not so much as not beleeve a man.
> For though to erre, be worst, to try truths forth,
> Is far more business, then this world is worth. (ll. 49-54)

Eliot's later *Four Quartets* provides an illuminating critique on Gerontion's meditative process.* The persona, finding through his meditations the passionate faith that eludes Gerontion, is Gerontion's antithesis. The essential themes of *Gerontion* are reconsidered: the use of history as a method of understanding oneself, the necessity of being prepared for death, and the process of evaluating our past to prepare for our ending. What Eliot's persona, at this stage of his career virtually inseparable from the man who suffers, says in "East Coker" is relevant to Gerontion's mistaken epistemology and his dialogue with history:

> There is, it seems to us,
> At best, only a limited value
> In the knowledge derived from experience.
> The knowledge imposes a pattern, and falsifies,
> For the pattern is new in every moment
> And every moment is a new and shocking
> Valuation of all we have been. ("East Coker," II)

The rejection of empirical knowledge is an important spiritual step, but even more significant is the understanding that an essential part of the quest for salvation is the entering into a passionate dialogue between self and soul:

> I said to my soul, be still, and let the dark come upon you
> Which shall be the darkness of God. . . .
> I said to my soul, be still, and wait without hope
> For hope would be hope for the wrong thing; wait without love
> For love would be love of the wrong thing; there is yet faith
> But the faith and the love and the hope are all in the waiting.
> Wait without thought, for you are not ready for thought:
> So the darkness shall be the light, and the stillness the
> dancing. ("East Coker," III)

In *Four Quartets* Eliot distinguishes between history as *chronos* and history as *kairos*, between, as Frank Kermode puts it, "passing time" or "waiting time" and "historical moments of intemporal significance" (147). History as *kairos*,

* While Eliot published *Four Quartets* as a unit in 1943, "Burnt Norton" appeared in 1935 in *Collected Poems 1909-1935*. "East Coker" was published in 1940, "The Dry Salvages" in 1941, and "Little Gidding" in 1942.

as "a pattern of timeless moments," provides paradigms and symbols for the memory to contemplate:

> A people without history
> Is not redeemed from time, for history is a pattern
> Of timeless moments. So, while the light fails
> On a winter's afternoon, in a secluded chapel
> History is now and England. ("Little Gidding," V)

The massacre of those who visited Little Gidding is a release from the demands of time because it provides a symbol of faith for the speaker:

> We have taken from the defeated
> What they had to leave us—a symbol:
> A symbol perfected in death.
> And all shall be well and
> All manner of thing shall be well
> By the purification of the motive
> In the ground of our beseeching. ("Little Gidding," III)

Gerontion's conception of history is unilinear and dialectic; it is the accumulation of causes that explain his *personal* dilemma at a certain spatial-temporal locus. Speaking in a slightly different context, Kermode discusses the concept of history to which Gerontion adheres: "History . . . is a fictive substitute for authority and tradition, a maker of concords between past, present, and future, a provider of significance to mere chronicity" (56). If in *Gerontion* Eliot indicts his character for meditation on the subject of history, the later Eliot realizes that, as he says in "Little Gidding": "History may be servitude,/ History may be freedom." Eliot wants us to understand Gerontion's conception of history as merely a concatenation of events tested by empirical knowledge and formulated into causes is servitude. Eliot, however, believes that history transfigured into patterns of significance—into still points in the turning world—is freedom:

> This is the use of memory:
> For liberation—not less of love but expanding
> Of love beyond desire, and so liberation
> From the future as well as the past. ("Little Gidding," III)

We should realize that Gerontion's imperatives are not directed to his soul but to *himself.* His inability to perceive the soul as a separate entity is itself

symptomatic of a lack of grace. He precedes his meditation with the despairing question "After such knowledge, what forgiveness?" a question that follows his reiteration that he is an "old man . . . under a windy knob." Obviously, despite his having evoked Christ and quoted Andrewes and his insight that his contemporaries have perverted the meaning of the communion, his continual lapses into self-pity and ennui are indicative of his failure to believe passionately. In *The Anniversaries* the speaker imagines himself performing a vatic role for all who have a soul, while Gerontion seeks the *comfort* of generalizing his plight to include his generation. If history is at fault and we are all the inevitable effects of causes beyond our control, then it follows for Gerontion that his plight is not personal but representative and that he can speak of "us" and "our." The pathetic need to generalize the spiritual drought, to move from the first-person singular to the first-person plural, is in stark contrast to the intense introspective dialogue of *The Second Anniversary*, which increasingly proceeds as if the immediate and intuitive relationship with God were the only reality and that nothing else could possibly affect this relationship.

VI.

That Gerontion recognizes the futility of his meditation on history is indicated by his awareness that his tears are not the result of penitence: "These tears are shaken from the wrath-bearing tree." He has emphasized the necessity for moisture to allay his spiritual drought. But these are tears resulting from indignation and anger with a world that has made him what he is. The "wrath-bearing tree" recalls William Blake's poem "A Poison Tree," where the tree of wrath is watered by fears and sunned by "soft deceitful wiles" until it becomes capable of deadly evil. Gerontion is operating within the post-Enlightenment Blakean cosmos without being *consciously* aware of doing so. The very next words after "wrath-bearing tree" are "the tiger"; the Blakean tiger of "The Tyger" and *The Marriage of Heaven and Hell* is antithetical to the meaning of the Lamb and suggests punishment for, rather than forgiveness of, sins. Gerontion's allusions emphasize his distance from the spirit of Bishop Andrewes and Donne's persona. It is useful to recall Eliot's condescending remarks about Blake's system of beliefs, remarks that were made at about the same time that *Gerontion* was first published:

> We have the same respect for Blake's philosophy . . . that we have for
> an ingenious piece of home-made furniture: we admire the man who

has put it together out of the odds and ends about the house. England
has produced a fair number of these resourceful Robinson Crusoes; but
we are not really so remote from the Continent, or from our own past,
as to be deprived of the advantages of culture if we wish them. . . . And
about Blake's supernatural territories, as about the supposed ideas that
dwell there, we cannot help commenting on a certain meanness of
culture. . . . What his genius required, and what it sadly lacked, was a
framework of accepted and traditional ideas which would have prevent-
ed him from indulging in a philosophy of his own. . . . (Eliot, *Selected
Essays*, 279)[*]

The statement of renewal—"The tiger springs in the new year. Us he
devours"—is an optative statement that loses its significance in the face of
Gerontion's failure to meditate on the meaning of this posited resurrection.
Christ's rebirth, properly understood, is the end of the Tiger of Wrath and
the Old Dispensation. But the very word "devours" implies that for him,
Christ is a threat that terrifies because his notion of Christ is as a punishing
Tiger of Wrath.

The sexual innuendoes with which Gerontion discusses history
become more and more obtrusive and finally culminate with the crude pun
on "stiffening": "Think at last/ We have not reached conclusion, when I/
Stiffen in a rented house." The passage echoing the most intense and
passionate moments of *The Second Anniversary* has degenerated into an elegy
for an old man's sexual prowess. As if to show Gerontion's inherent crude-
ness, Eliot has his character speak in double entendres. History is conceived
of as a temptress who "deceives with whispered ambitions,/ Guides us by
vanities." More explicitly, this Cleopatra figure "gives with such supple
confusions/ That the giving famishes the craving." At one level he is rebuking
history for using her "cunning passages" to deceive men into committing
deeds in spite of themselves. That Gerontion speaks in sexual terms places
him within the crude Zeitgeist that he would separate himself from; it also
bathetically undercuts the very concept that he takes seriously.

The movement of the meditative passage containing the imperative
"think" is away from the discovery of faith and toward self-pity. It is ironic
that the last imperative "think" alludes to the devils in Dante's inferno that

[*] The Blake essay, anthologized in the *Selected Essays* as "William Blake," appeared as
a review in 1920, the year that *Gerontion* was first published in the volume *Ara Vos Prec*.

run backward. For Gerontion has become another of those devils that run backward, since his rhetoric moves further and further from the Word and its contingent mysteries and towards the secular and sensual concerns that continue to intrude upon his meditative efforts. Finally abandoning the specific meditative pattern that echoes Donne, Gerontion attempts to vindicate himself to God with the pathetic plea, "I would meet you upon this honestly." But his new approach to Christ is yet another way of avoiding prayer and repentance, for now he would speak to Christ logically and coherently, would attempt again to explain and extenuate his plight. The reason, he explains, for his loss of passion is that his senses have failed him:

> I that was near your heart was removed therefrom
> To lose beauty in terror, terror in inquisition.
> I have lost my passion: why should I need to keep it
> Since what is kept must be adulterated?
> I have lost my sight, smell, hearing, taste and touch:
> How should I use them for your closer contact?

Yet I think Eliot wishes us to see that Gerontion's optics are still wrong. Sense experience is not the way to discover the essential faith for salvation. The decline of the senses, a natural result of old age, is not the cause of Gerontion's failure to achieve the "closer contact" that he knows is essential. The example of Hakagawa, Mr. Silvero, and the rest of the participants in the ineffectual communion should have made clear to Gerontion that it is not his atrophied senses that prevent him from finding the faith with which to experience Christ. In the next sentence, when he borrows images from the material world to describe his plight, he ironically locates himself within the Zeitgeist that he had taken pains to reject in the first, third, and fourth verse paragraphs:

> These with a thousand small deliberations
> Protract the profit of their chilled delirium,
> Excite the membrane, when the sense has cooled,
> With pungent sauces, multiply variety
> In a wilderness of mirrors.

Now he realizes that his meditation is no more than a "thousand small deliberations" providing intellectual and emotional titillation and that he is caught in a psychic house of mirrors from which there is no escape. While *The Anniversaries* move toward a unified vision, Gerontion's deliberations are a self-indulgent attempt—as he puts it in another of those damning phrases

where his sensuality baldly interferes with his efforts to discover faith—to "excite the membrane."

VII.

Gerontion finds it increasingly difficult to follow through on his ideas or even to make syntactical sense. As Louis Martz has pointed out, the meditations of *The Anniversaries* move to greater and more intense unity and certainty as the tripartite structure of each meditation gradually dissolves into the harmonious integration of "meditation," "eulogy," and "refrain," with which *The Second Anniversary* concludes. But Gerontion's meditation moves in the opposite direction, toward fragmentation and dubiety. At an obvious level, Gerontion partakes of the parasitic nature of the weevil and the spider that he inquires about: "What will the spider do,/ Suspend its operations, will the weevil/ Delay?" Like the spider and the weevil, Gerontion himself is caught up in the processes of mutability and mortality which he lacks the faith to transcend. Thoughts of mortality evoke the vision of bodies, presumably belonging to the decadent spatial-temporal locus that he seeks to escape, "whirled/ Beyond the circuit of the shuddering Bear/ In fractured atoms." His entire epistemology at this point is non-Christian, indicative of the failure of his attempts to find faith. His reference to the Big Dipper, "the shuddering Bear," recalls his earlier reference to the lecherous Capricorn. And he believes that the dead will become mere particles of matter rather than taking their place as souls within a Christian framework containing heaven, hell, and limbo.

Gerontion's monologue, like some of Cézanne's selectively incomplete canvases, does not really end. Ironically, Gerontion has earned his right to be identified with those passive creatures who are the helpless victims of natural process. As he is caught up in the processes of history because he lacks the faith to escape, the gull is caught in the wind:

> Gull against the wind, in the windy straits
> Of Belle Isle, or running on the Horn,
> White feathers in the snow, the Gulf claims,
> And an old man driven by the Trades
> To a sleepy corner.

The image of the gull swept, in spite of itself, to Belle Isle (perhaps a parody of Ulysses' destination of the "happy Isles," a destination that Tennyson's

heroic figure consciously reaches for) or the gulf (perhaps, as John Crowe Ransom suggests, the Abyss in the bottom of the world) again places Gerontion's cosmology in a non-Christian framework. The references to weather and to the literal geography, such as Cape Horn and the Gulf of Mexico, show how far he has strayed from his original quest of coming to terms with death and preparing his soul for salvation. Ironically, the speaker is a gull in the traditional sense, a foolish victim of his own winds, and he will die, like the bird, isolated and without consequence. In this sentence, "an old man driven by the Trades" is in virtual apposition to the gull, and the phrase "White feathers in the snow" becomes almost a metonymy for the speaker, who conflates his vision of the gull's death with that of his own. The general term, "an old man" thinly disguises Gerontion's admission that he is equal to the gull in his impotence to resist a meaningless death.[*]

In contrast to the ecstasy that Donne's speaker attains in his comments on accidental and essential joys of earth and heaven, Gerontion lapses into ineffectual despair at the failure of his attempts to reach Christ and finally drifts into a self-pitying silence. The final crystallizing image of the "old man" driven into a corner from which there is no escape is underlined by

[*] What Reuben Brower has said about the importance of allusion in Dryden and Pope is equally applicable to Eliot and Cézanne: "Allusion, especially as ironic contexts, is a resource equivalent to symbolic metaphor and elaborate imagery in other poets" (viii). The complexity of the allusive technique in *Gerontion* extends to the epigraph taken from the Duke's advice to Claudio in *Measure for Measure* to "Be absolute for death." The Duke's secular version of the *contemptus mundi* tradition only momentarily provides Claudio with an epistemology with which to face death. Gerontion's attempt for positional assurance is implicitly contrasted with the Duke's avowal that death is a trifle. But Gerontion resembles Claudio, whose original acceptance of the Duke's advice gives way to doubt and fear and whose vision of death anticipates Gerontion's image of dead bodies whirled through space:

> Ay, but to die, and go we know not where,
> To lie in cold obstruction and to rot,
> This sensible warm motion to become
> A kneaded clod; and the delightful spirit
> To bathe in fiery floods, or to reside
> In thrilling region of thick-ribbed ice,
> To be imprisoned in the viewless winds

the final dreary refrain: "Tenants of the house,/ Thoughts of a dry brain in a dry season." These lines bring together two image patterns that allude persistently to Donne's poem. Gerontion's emphasis on dryness and on living in a "decayed house" take on renewed significance if we recall *The Anniversaries*. The persona of Donne's poem advises his soul to continually thirst for the Eucharist:

> Thirst for that time, O my insatiate soule,
> And serve thy thirst, with Gods safe-sealing Bowle.
> Bee thirsty still, and drinke still till thou goe;
> 'Tis th' onely Health, to be Hydropique so. (II. 45-58)

Gerontion recognizes the need for life-giving water but concludes significantly as "a dry brain in a dry season," knowing he is further from the "warm rain" than ever. In both Eliot and Donne, the house becomes a metaphor for both the body and the physical world. Donne's speaker welcomes death as a release because man is poorly "housed" in his "living Tombe":

> Shee, shee, thus richly and largely hous'd, is gone:
> And chides us slow-pac'd snailes who crawle upon
> Our prisons prison, earth, nor thinke us well,
> Longer, then whil'st wee beare our brittle shell.
> But 'twere but little to have chang'd our roome,
> If, as we were in this our living Tombe
> Oppress'd with ignorance, wee still were so. (II. 247-53)

Gerontion does not realize the irrelevance of his complaints about his decayed house, an image that expands to imply contemporary Europe and

> And blown with restless violence round about
> The pendent world (*Measure for Measure*, ed. R. C. Bald [Baltimore, 1956], III. i. 118-26)

Not only is Gerontion's fear of continual physical atrophy that will culminate in complete stasis anticipated in the first lines; also suggested by Claudio's terror are some details of Gerontion's vision. Claudio's image of the dead's domain as a "thrilling region of thick-ribbed ice" is evoked by Gerontion's depicting the feathers of the gull—with the bitterly self-conscious meaning of fool and dupe—strewn on the snow.

contracts to imply his physical body. Were he able to believe passionately in Christ as the Lamb of mercy and salvation, the declining physical condition of his body and the decaying civilization of Europe would not be of any importance.

VIII.

For Eliot, poetry is a creative art, "a way of putting it" for his audience, but poetry is also the means of working out his most compelling personal dilemmas. While it can be said that every poem contains part of the poet, it is especially true of Eliot. As Allen Austin has persuasively argued, "Eliot does not deny that the work of any poet may express personality but contends that the work of a mature poet possesses 'a greater expression of personality' and that this expression increases esthetic value" (62). Despite his public language and allusions, Eliot's is a far more private poetry than is generally realized, a private poetry in the way that George Herbert's poetry is private, dramatizing a personal religious quest involving crises of conscience and agonies of doubt. Eliot isolates tendencies within himself and creates a distinct personality from attitudes and emotions that he recognizes as part of his own personality. Eliot wrote that a "dramatic poet cannot create characters of the greatest intensity of life unless his personages, in their reciprocal action and behavior in their story, are somehow dramatizing, but in no obvious form, an action or struggle for harmony in the soul of the poet" (*On Poetry and Poets*, 172-73). Beginning with Prufrock's insistence on asking cosmic questions, Eliot is increasingly concerned with the problem of religious belief in a secular age when, as he remarks in the Andrewes essay, "all dogma is in doubt except the dogmas of science of which we have read in newspapers, when the language of theology itself, under the influence of an undisciplined mysticism of popular philosophy, tends to become a language of tergiversation" (*Selected Essays*, 305). In Eliot's major works, there is a progressive narrowing of distance between speaker and poet until, in *Four Quartets*, the persona and the poet are well-nigh indistinguishable. Perhaps dramatizing the unsuccessful struggle for spiritual conviction in *Gerontion* and *The Love Song of J. Alfred Prufrock* was part of Eliot's own religious quest and helped to prepare his spiritual and poetic energies for the great religious poetry of *Ash Wednesday* and *Four Quartets*.

IX.

For Wallace Stevens, Cézanne was the example of someone whose integrity, as Stevens puts it, "sent him onward to new discoveries of technique, new realisations of the motive" (*Commonplace Book*, 53). But I think he meant even more to Eliot. Not only his career but his individual paintings often defy rest and stasis. Cézanne's comprehensiveness was a paradigm for Eliot. Cézanne balances line and resolves color; he balances his romantic sensibility with an aesthetic devoted to classicism. The paradox of Cézanne: he is the painter of volume and yet he does it on a flat surface resolving foreground and background on one plane; he is a draftsman who draws with blocks and swathes; and he is a formalist and a classicist who evokes feelings from his audience. The paradox of Eliot: he is a formalist, a classicist, an Anglo-Catholic, and a royalist; yet he creates characters who expose their inner lives, and he becomes the voice of a disillusioned Modernism.

Five

Painting Texts, Authoring Paintings: The Dance of Modernism

I. Introduction

Goya, the great Spanish painter and social observer, remarked that if a man fell out of a third-story window, a true artist would have finished drawing him by the time he hit the sidewalk. He meant that the artist would conceive according to his own vision the importance of what was happening, as he himself did in *Disasters of War*, his wonderful allegorical drawings on the ravages of the Peninsular war. He was speaking of the role of the artist not only as prophetic witness but as a perceiver and recording eye—a function replaced in the nineteenth century by photography and now supplemented, often, by the electronic eye of television.

Art is metaphorical. It is analogical because it suggests that our cognitive processes refer to something beyond themselves—and all analogues have an ingredient of distortion. There is a fundamental awkwardness about our using analogies to see, for there is a gap between our metaphors and objective truth. Art Spiegelman, who has cast the Holocaust in cartoons with Jews as mice and the Germans as cats in *Maus I: My Father Bleeds History* (1986) and *Maus II: A Survivor's Tale: And Here My Troubles Began* (1991), acknowledges how all metaphors are flawed if the goal is objectivity: "All metaphors are a kind of lying. As soon as you make a correspondence, it only highlights the gaps. Nothing thoroughly interlocks" (*New York Times*, December 10, 1991, National Edition, B12). Yet Spiegelman endows his cartoons with authentic human personalities, and the mice become metonymies for the concentration camp victims of the German cats and the Polish pigs. His point of departure is a newspaper article in Germany in the mid-1930s that

read in part: "Mickey Mouse is the most miserable ideal ever revealed. . . . Healthy emotions tell every independent young man and every honorable youth that the dirty and filth-covered vermin, the greatest bacteria carrier in the animal kingdom, cannot be the ideal type of animal. . . . Away with Jewish brutalization of the people! Down with Mickey Mouse! Wear the Swastika Cross!" (Quoted in *Maus I*) At first we resist Spiegelman's cartoons as narratives of a subject of such intensity and for such an extended period, but, in part because of the *human* behavior, we become engaged and simultaneously keep in mind the image (Jews) and thing imaged (mice); indeed, in *Maus II*— the sequel—Spiegelman shows the Jews *wearing* the mouse mask, as if to make readers aware of the process of metaphoricity and the active movement between signifier and signified. Depending on their experience, viewers and readers will respond differently to analogy and will fill differently the space between the painter's or author's image and what the image signifies. In Aesop's fable, the fox who walks away from the grapes that he cannot reach and declares them sour is a traditional example of someone who cannot gracefully accept disappointment. In modern interpretations, he is also an example of the compensating ego taking care of himself as well as an example of the gracelessness of a megalomaniac who cannot come to terms with what he cannot control. Language—and line and color—signifies differently, but visual art creates a meaningful and purposeful structure of affects to shape the viewer's response and narrow the space or distance between image and thing imaged, between signifier and signified.

I have been urging in prior chapters that we think of cultural criticism more as a verb—as in the process of inquiring, teaching, reading, practicing, or approaching culture—than as a noun embraced by groups defining themselves ideologically in reference to, if not direct opposition to, other groups. I want to stress the activity of inquiry, not announce the ends of the inquiry before it begins.

What is the potential of cultural criticism? As it extends its boundaries, it needs to think about cultural configurations that transcend simple stories of influence and clear distinctions between background and foreground. For example, we need to ask what Picasso and Matisse have in common with major Modernist authors such as Joyce, Conrad, Yeats, and Stevens and how we can locate the genealogy of Modernism in cultural developments that transcend literatures, art forms, and nationalities. The categories of national literature all too often create arbitrary dividing lines.

How do we recapture the genealogy of a period? If we abandon simple stories of how A influences B, what takes their place? We can speak of common phenomena recurring in diverse places. Thus, Modernism seems

to be a response to the perception, on one hand, that people's lives lack a lasting and higher significance; yet, on the other, that they are granted the curse of consciousness to be aware of this. The geologist Charles Lyell, Charles Darwin, the higher criticism of the Bible, challenges to political authority (in England represented by Chartism), agrarian displacement and urban poverty, Bergson's work on the complexity of time, the realization that the world was what Joseph Conrad called "a remorseless process" rather than a teleologically ordered movement—all these ideas left human beings without bearings. As Conrad's Marlow puts it in *Heart of Darkness*, "we live, as we dream—alone." Under the influence of psychoanalysis, we became more self-conscious and more aware of our fixations, obsessions, and dimly acknowledged needs.

How can we speak about the relationship between modern painting and literature? Can we propose cultural configurations that throw light on the individual components? In our discussion we need to break down the border lines between national literatures and between literature and other arts. We need to think about how painting works metaphorically. In the following pages, I shall insist on the narrativity of painting in a number of ways, including a narrative of how paintings relate to one another, how they tell a story within their imagined ontology, and how, because they are part of a story of Modernism, they necessarily have a narrative component.

Stephen Dedalus, looking at visual data in the "Proteus" section of *Ulysses*, remarks, "Signatures of all things I am here to read." We need to read paintings in several ways, as the accumulations of the signs that form an aggregate signature—the figure of the painter inscribing a story in paint but also as the visualization of event or story. I want to discuss the parallels between the kinds of narratives that paintings enact and relate those stories to the kinds of images literature presents. Even if at first we are struck by the juxtaposition of colors and forms, do we not domesticate and narrativize the paintings because they are about us humans? Coming from literature, and coming with a humanistic and narratological bent, I *want* the visual arts to tell a story. It may be, too, that as an obsessive reader, my eye moves from left to right and sees the chronological and narrative aspect of painting. Yet just as modern novelists no longer believe that there is an objective reality to imitate, modern painters no longer see the material world as solid and unchanging. Indeed, what Stephen Dedalus calls in the opening of "Proteus" "the ineluctable modality of the visible" no longer existed; Max Plank considered that the "essential factor in the development of theoretical physics" was "a certain emancipation from anthropomorphic elements, and especially from sense impressions" (quoted in Russell, 102).

Narrative is both the representation of external events and the telling of those events, including commentary and interpretation. My interest in narrative derives from my belief that we each make sense of our own life by ordering it and giving it shape. The stories we tell ourselves provide continuity among the concatenation of diverse episodes in our lives, even if our stories inevitably distort and falsify. Each of us is continually changing the text of our lives, revising our memories and hopes, proposing plans, filtering disappointments through our defenses and rationalizations, making adjustments in the way we present ourselves to ourselves and others. To the degree that we are self-conscious, we live in our narratives—our discourse— about our actions, thoughts, and feelings. While there is a gulf between imagined worlds and real ones, does not the continuity between reading lives and reading texts depend on understanding reading as a means of sharpening our perceptions, cultivating discriminations, and deepening our insights about ourselves? For reading is a process of cognition that depends on actively organizing the phenomena of language both in the moment of perception and in the fuller understanding that develops as well as in our retrospective view of our completed reading.

Painting includes elements of story—dramatic events that imply a sequence—and discourse—the presentation of events in an organizing discourse. The gaze of the audience requires us to make links between them and to provide a hypothesis—an *as if* of temporally structuring, an *as if* beginning and end to give shape to the middle. Certainly such sequences as Matisse's *Dance II* (1910) and *Music* (1910) insist on relating the paintings as if they were two scenes in a story; so do two versions of the same painting, such as Picasso's *Three Musicians* or Matisse's *Dance I* (1909) and *Dance II*. By focusing on the related paintings of Picasso and Matisse, I shall show that paintings are not restricted to a single moment. The story within the painting and its presentation imply a looking back, a looking forward, and a move- ment within the present. I shall propose a narrative about the relationship between Matisse and Picasso and about the importance of both to the genealogy of Modernism. I shall also explore the multicultural influences on Modernism. Finally, I shall show how the various strands of Modernism respond to one another in exploring, dramatizing, and rendering *dance*.

We need to examine the shibboleth, derived from Gotthold Ephraim Lessing, that painting is a transcendent object out of time and that literary works exist only within chronological time; because literature unfolds as one thing after another to the reader, we perceive literature within a linear framework. In *Laocoon* (1766), Lessing differentiated between subjects appro- priate to the visual arts and literature: "In the one case the action is visible and

progressive, its different parts occurring one after the other (*nacheinander*) in a sequence of time, and in the other the action is visible and stationary, its different parts developing in co-existence (*nebeneinander*) in space." Yet, as Joyce understands, we cannot separate spatial and temporal dimensions from one another. A characteristic of modern painting is that it strives to render temporality and movement, even while modern literature seeks a spatial configuration. Muybridge had made painters aware of the possibilities of dramatizing motion. Do we not always seek to place our perceptions within a temporal framework, even if only to link and connect them with our other knowledge? We do domesticate our perceptions in terms of our understanding of ourselves and our world, and temporality—unfolding continuity through space—is an essential ingredient of that understanding.[*] The grammar of a painting implies a past and a future, implies a continuity of identity, and invites us to domesticate it within a hermeneutics of mimesis. Nor is it quite true that in Modernist painting, as Wendy Steiner claims, "Fixing of time, viewer, and represented object becomes a curiosity of the past" (123). Just as literary Modernism commented, ironized, and undermined nineteenth-century realism, so modern painting responded to and transformed Renaissance concepts of pictorial realism—what Steiner defines as "a two-dimensional plane meant as the equivalent of a moment of vision, with the perceiver's position vis-à-vis the represented scene organizing the relative size, prominence, and placement of the elements within it" (122). Modernism depends on what Joyce calls parallax or what we might call polyperspectivism.

At the same time that Conrad, Joyce, and other Modernists were making similar experiments in fiction, Picasso was embarking on Cubism, on scrambling the distinction between foreground and background, on freeing color from the morphology of representation, and on including multiple perspectives on the same subject. In a sense, color provided the kind of energy and differentiation in painting that Conrad's adjectives provided in his fiction. And Gauguin, Picasso, and Matisse, among others, were exploring human's primitive and atavistic antecedents during the approximate decade that Conrad was writing *Heart of Darkness* (1899), *Lord Jim* (1900), his Malay novels (including *The Rescue*, which he did not publish until 1919), *Nostromo* (1904), and *The Secret Sharer* (1911).

[*] Wendy Steiner has argued that narrativity in painting depends upon "the temporal unfolding of events, the continuity of identity over time, and spatio-temporal assumptions about reality that we normally take for granted." (2).

For modern painters the discovery of the possibilities of color is akin to the stress on adjectives in modern literature; Gauguin is the Hopkins or Conrad of Modernism in his rediscovery of color as the means for differentiating things and emotions and as the source of energy in a painting. Similarly, what has been called pejoratively by F. R. Leavis in *The Great Tradition* Conrad's "adjectival insistence" is the energy of distinguishing that creates the structure of effects, particularly in a world where realities are no longer shared. When Conrad's describes in *Heart of Darkness* how "the memory of that time lingers around me, impalpable, like a dying vibration of one immense jabber, silly, atrocious, sordid, safe, or simply mean without any kind of sense", he uses adjectives to differentiate further levels of specifics (558). But adjectives in *Heart of Darkness* such as "abominable," "inconceivable," "savage," "devilish," and "inscrutable" give the illusion of specifics when in fact they invite the reader to create his own meaning, just as painters invite the viewer to respond to color or a drawn image when it no longer pretends to be a realistic facsimile.

Hopkins is indebted to Impressionism and Post-Impressionism. A poem like "The Windhover" owes much to the Impressionists catching a moment in nature as it appears to the perceiver and creating a visual image of that epiphanic realization. Isn't the bird caught at a moment in the morning's light the way Monet would capture water lilies? Hopkins breaks through the morphology of representation with his adjectives, just as the Fauvists abandon morphology of representation in their nonrepresentational use of color. Hopkins's adjectival neologisms, such as "dapple-dawn-drawn Falcon," substitute, for the expected image of the windhover, the differentiating energy that crosses our field of perception and commands our attention.

II. Opening the Drapes of Modernism

Les Demoiselles d'Avignon (1907; see p. 140), Picasso's huge canvas now hanging in the Museum of Modern Art, is a pivotal moment for Modernism. Unselfconsciously, five brazen naked women of diverse ethnicities display themselves. Open sexuality is one subject of literary Modernism in Joyce and Lawrence. Picasso in *Les Demoiselles* is reordering the visible world into what Alfred Barr has called a "semi-abstract all-over design of tilting, shifting planes compressed into a shallow space" (56). Picasso was influenced by visits to the ethnographical museum at Trocadero, where he saw primitive African sculpture. The large sculptural figures command our attention as observers as if we were customers at the brothel. If Joyce's fascination with

the primitive takes him back to *The Odyssey*, Picasso's takes him back to African sources. The distortion of bodily proportion suggests tribal art. African art, like Picasso's, is based less on what the artist sees than on conceptual image-making. Picasso's art uses the extreme distortions of bodily parts that he saw in primitive art, but doesn't Joyce do something akin to this in the illuminating distortions of "Circe"? Notice the difference between the African masks on the left and the more natural figures on the right. At first, to the observer accustomed to realism, the faces repel rather than attract and the prostitutes display a cool, dispassionate indifference. The women on the left wear primitive masks.

The painting recalls Conrad's insistence in *Heart of Darkness* on the simultaneity of savagery and barbaric impulse in modern European behavior. It is very much part of the agon of *Lord Jim* and *Heart of Darkness* that, according to Conrad, every person has the potential to do what any person can; we never leave humankind's anthropological past behind. The left foregrounded head faces forward and backward, as if inviting the spectator to enter into the world of the painting. As we move from left to right, there is a narrative that moves toward savage forms and Cubist shapes, as if Picasso were writing a narrative of painterly history. Yet the upper head is no longer flat and the bottom figure has a flattened African mask—with a profiled nose on the front-facing figure—on a rounder, more contoured figure. In early drawing versions of the painting, two clients, a medical student and a sailor, are with the nudes. For example, in the recently purchased seven-and-a-half-by-eight-inch sketch at the Museum of Modern Art, we can see two men: the medical student on the left and the undressed sailor in the middle front; the sailor is a figure that in the final version merges with the foregrounded female who is opening the curtain to reveal the scene. In a still earlier version, the medical student at the left carried a skull, as if to suggest mortality. In terms of narrative, Avignon refers to a street in Barcelona that Picasso knew well, not to the city in France. The pink and cream sketch provides a link to Picasso's rose period.

The medical student's head becomes fused with the squatting foreground figure, which once was far more suggestive with her legs spread wide to display her vulva. She is holding back the drapes for the putative onlooker, as if she were, like Conrad's Marlow, both character and impressario. And, like Marlow, the uncovered world is atavistic and frightening. We think of the sexual explicitness of the "Circe" section of *Ulysses* when Stephen visits the brothel. Isn't Stephen metonymically the medical student and aren't the Parisian brothels of 1906-7 a source for both Joyce and Picasso? With massive legs, the figure on the left is unusually large and heavy, recalling the

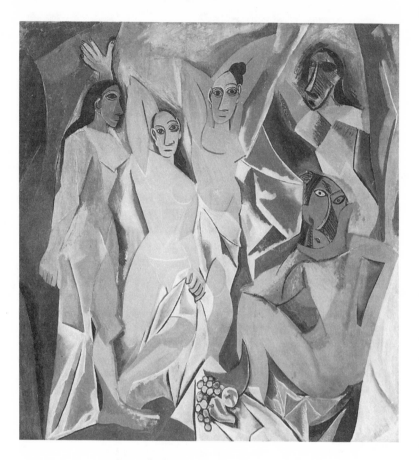

Les Demoiselles d'Avignon, Pablo Picasso (1907)

Two Nudes of 1906 as well as the work of Reubens. The foregrounded primitive head could be male, giving this figure an androgynous quality.

The same artist who sees himself as a prophet and genius also sees himself as *flaneur*, prostituting himself for the public. In its echoes of the apple Paris awarded to Venus as the most beautiful of the Three Graces, Picasso is also commenting on the artists' dependence on a fickle public *and* fickle patrons for prosperity. The crescent slice of melon and the phallic pear and apple—suggesting both Paris' choice of the most beautiful goddess and the story of Eve—emphasize the sexuality of the foregrounded fruit, fruit that is also raw material for a still life. As if to stress the kinship between painter and whore, the ingredients—melon, pear, and apple—of a still life are

displayed in the front of that foregrounded figure. It is as if that figure were guarding the fruit, as if he or she were the artist to whom they belonged. And we, of course, see references to Cézanne's *Great Bathers* and *Five Bathers* (1877-78). In the background is El Grecoesque drapery fabric.

Just as in the late nineteenth and early twentieth century, novelists and poets could no longer feel comfortable with one perspective as an organizing principle, neither could painters; the composition of intersecting planes that intrude on one another enables painters to achieve multiple perspectives. Stevens's "Thirteen Ways of Looking at a Blackbird" and Joyce's *Ulysses*, with its 18 separate episodes in diverse ways of telling, are literary examples of this. For Picasso, as for Joyce and Stevens, another reality coexisted with the visual surface of things. The distinction between foreground and background is partially dissolved into these intersecting planes. Picasso also builds on the Fauvist example of freeing color from the morphology of representation. The violent distortions are themselves part of the narrative about the relationship between sexuality and savagery, passion and violence. Yet the point of view is neither moralistic nor dehumanizing to its subjects.

As in the "Nausicaa" section of *Ulysses*, where Gerty and Bloom become the voyeuristic subject of the other's fantasies, the women in *Les Demoiselles* are the focus of the gaze of the imaginary audience and perhaps the creators in their fantasies of the audience for whom they display themselves. Manet's *Déjeuner sur l'herbe* (1863) displays brazen nude and unselfconscious woman with more subdued, cosmopolitan men. From his first visit in 1902, Joyce would have known that Paris was alive with innovation in painting and sculpture. In Joyce's "Araby," the narrator's reference to mariolotry summons images of medieval and Renaissance paintings; his view of Mangan's sister with the "light of the lamp opposite our door catching the white curve of her neck" suggests a halo. We see Joyce's visual imagination in rendering both Stephen and Bloom. In "Telemachus," when Stephen leaves the tower, he perceives the bathing Mulligan as part of a seascape and responds oedipally: "Usurper." In "Calypso," Bloom's fantasy of the woman whom he imagines running toward him might be a Matisse. Writing of *Ulysses* under Joyce's influence, Frank Budgen comments, "If there is a parallel in the art of painting for Joyce's swift, instantaneous shots of life it is in the art of Matisse or . . . the draughtsman, Rodin, watching, ready pencil in hand, the model doing whatever it pleased in his studio" (211). That Joyce uses his omniscient narrator to render ironically the synchronicity of the two perspectives— Stephen's and Bloom's—parallels Picasso's *Les Demoiselles d'Avignon*. *Ulysses*, like *Les Demoiselles*, is an epic of the body. After the first three chapters, Joyce

begins to draw the body by assigning "organs" to each chapter. While Picasso's original depiction of a whorehouse in 1906-7 could have been an inspiration for "Circe," Joyce's familiarity with the French bordello, more than the Dublin night town, is the main source for the scene's Dionysian fantasies and bizarre sexuality.

According to Joyce's schema, the technique of the "Nausicaa" section of *Ulysses* is "painting." As Wendy Steiner writes, "Gerty, totally engrossed in her role as Bloom's voyeuristic object, imagines herself in the third person and composes Bloom's response to that objectified self as we listen in on her thoughts" (125). She becomes the painter of herself. Bloom, turning to Molly, wishes that "he had a full length oil painting of her" (130). Depicted by sentimental, stereotypical language, as if on a flat plane, as if it were a medical painting, Gerty recalls the many blue figures in Cimabue and Giotto. Blue is the color of chastity; her face is not really modeled; the strained look and the "waxen pallor" suggest the elongated faces of medieval Virgin Mary figures. Bloom and Gerty are functions of the other's gaze. In the second half of "Nausicaa," Bloom returns to the real world. Manet's *Olympia* (1863) and Cézanne's various *Bathers* pictures are other possible sources. Indeed, Molly in bed comically recalls Manet's *Olympia* and other paintings that Joyce would have known. We see that the gaze of the observer supersedes the perspective and that Bloom and Gerty in themselves are captured by Joyce's perspective. In Gerty's orgasm, we see echoes of Bernini's *The Ecstasy of St. Theresa*, where angels look like cupid.

III. Picasso's Transformation of Still Life

As we have been noticing, *the act of observing* is a crucial point in Modernism; Joyce makes the theme of parallax—how the same phenomena looks different from a different angle or perspective or by extension how human events look different to a different perceiver—central to *Ulysses*. Parallax has a kinship with Cubism and is the technique of the first six chapters, which look at the same day from Stephen's and Bloom's perspectives. As we have seen, not only is James's *The Turn of the Screw* about optics, but so also is the tradition of still life, which plays such an important role in Impressionism and Post-Impressionism.

As Norman Bryson notes, "Still life . . . opposes . . . the idea of the canvas as a window on the world, leading to a distant view. . . . [I]t proposes a much closer space, centered on the body" (quoted in Boggs, 14). The 1992

Philadelphia Picasso still-life exhibit entitled *Picasso and Things* underlined how the images in still lifes become metaphors for his feelings and attitudes, and how collectively they provide a grammar of the artist's personal life as well as his evolving aesthetic and political views. So often his still lifes are the mirror of his soul. Like Joyce and Stevens ("Anecdote of the Jar," "Local Objects"), Picasso was obsessively fascinated with things; that fascination was the underpinning of his still lifes. Picasso's lapsed Catholicism may have been a catalyst for the focus on how art transforms—*transubstantiates*—object into meaning. Picasso was indebted to Zubaran, Chardin, Cézanne, and Henri Rousseau. As much as Joyce and Eliot, Picasso conceived his art as a response to tradition and understood that the originality and power of art come from breaking down the barriers.

Picasso's focus on interior space and the physical nature of the body is part of Modernism. In 1937 he was fascinated with the rotting skull of a bull, an animal Picasso associates with Spain; given the year of the painting and the triumph of Franco's fascism, it is a metaphor of the impending demise of Spanish democracy. In many of his still lifes of the period, Picasso uses such traditional images of the ephemeral quality of life as human skulls, mirrors, and snuffed-out candles. Thus the shades of gray in his 1941 *Still Life with Sausage* reflect the joylessness of working under the Occupation, and the forks and knives rising from the drawer give us a sense, along with the gray artichoke and coiled sausage, of an intimidating environment and of the transubstantiation of every element of life into a fearful, claustrophobic world. As Roland Penrose wrote:

> The same sinister background of war and privation makes itself felt in many of the still-lives of this period. Just as music in the form of guitar-playing and songs had been the theme of many Cubist paintings in the days before the First World War, so food in its more humble forms, such as sausages and leeks, together with the skulls of animals and the dim lights of candles and shaded lamps recur throughout Picasso's wartime paintings. Even the cutlery, sharp-pointed gleaming knives and hungry forks, repeats the same uneasy theme. (Quoted in Boggs, *Picasso and Things*, 268)

It is as if the cutlery were trying to free itself from the drawer; perhaps the dark, claustrophobic atmosphere implies Picasso's sense of confinement. Like Joyce—particularly in the "Circe" section of *Ulysses*—Picasso anthropomorphizes things.

Indeed, Picasso's fascination with the vernacular, the substance and materiality of everyday life, derived in part from his animistic sense that everything expressed feelings in some way. As Marie-Laure Bernadec writes:

> Picasso was particularly attentive to the domestic and utilitarian aspect of objects, their familiar beauty, their humble yet necessary existence. In his view, things participated in their own way in the universal laws, the biological processes of life and death, the circulation of energy between objects and beings. . . . It was as if Picasso identified himself with everything that was around him, transmitting an inner part of himself to a multitude of fragments of the external world, while receiving part of their own identity in exchange. (Quoted in Boggs, 25-26)

But Picasso, like Joyce and Rabelais, reveled in the materiality, the physicality of the body. He was very attentive to the process of digestion and excretion; like Joyce he was aware of what Bernadec has called "isomorphism of these three orifices—mouth, vulva, anus" (27).

While much has been made of the negative space of Modernism, Picasso fills his wartime still lifes almost to excess with grim images. For Modernism, still life is a way of controlling space and time. Unlike Chardin, Picasso's interest in form and his denial of representation are always in a tension with his fascination with the whatness of his world. The dance of things in his gaze is the subject of his still lifes. On the one hand, Picasso's objects resolve themselves into formal coherence; on the other, each object speaks for cacophony and irresolution. Still lifes cut off objects from history and context and speak for tunnel vision, a tunnel vision that is often the result of the self-immersion and narcissism—the other side of political engagement and historical perspective—that characterizes Modernism. At times, his lines holding together the diverse objects—as well as bent brushes and books—speak for an aesthetic alternative to violence; the lines suggest sexuality, passion, appetite.

Juxtaposing Picasso with Conrad is instructive. The artist's still lifes recall the heightened graphic mélange of death heads (including shrunken heads set on posts), carcasses and enslaved humans in Conrad's *Heart of Darkness*. From one perspective, *Heart of Darkness* is a sequence of still lifes—fully realized objects against a dark background—that reflect Marlow's feelings. The 1938 composition *Palette, Candlestick and Head of Minotaur* and the 1921 *Dog and Cock* illustrate also the rich metaferocity of Picasso's still lifes and the expressive quality of his imagination. In the former painting, the purple suggests "something of the violence of the common root that the

word *violet* shares with the French word *viol* for rape" (Boggs, 254). This may be a reflection of Picasso's disturbance at the thought of the impending Republican defeat in the Spanish Civil War. In the latter the cock symbolizes betrayal—the cock that will crow three times at Christ's betrayal—as it sticks out its tongue and its hair sticks out like white flames, while the dog represents life; the blue is a positive image, as are the embryonic eggs. The painting is decorative, perhaps reflecting Matisse's influence. Like Japanese paintings, it encompasses and compresses images of life and death. Note the austerity of Picasso's table and the cowering dog. In the same year as he painted the two versions of *The Three Musicians* (1921), Picasso painted this austere late-synthetic Cubist meditation on life and death. The cock— masculine image—hangs dead over a corner of the table. The five (the catalog says "four") forms are eggs, images of life or regeneration; we wonder whether the objects are to be devoured by the dog or an absent person. *Pitcher, Bowl of Fruit and Leaves* (1931), inspired by Picasso's love affair with Marie Walter, shows joy and life. The painting's wonderful dominating yellow pitcher shouts out its exuberance, its "Yes." The sexual implications of the phallic brown form in the middle are obvious. Clearly, still lifes are the hieroglyphs of Picasso's life.

IV. Modernism and the East

The Modernists look to the East for abstraction, exoticism, and tropes of spiritual unity. Just as in *Heart of Darkness* the jungle—containing the Diony- sian African woman—becomes a metonymy for perverse sexual activity, so in *Death in Venice* the Ganges becomes a metonymy for disease. Thus in Thomas Mann's *Death in Venice*, the Asiatic is associated with libido and disease, creating an interesting zeugma that informs the story. "Asiatic cholera" plagues Venice: "For the past several years Asiatic cholera had shown a strong tendency to spread. Its source was the hot swamps of the delta of the Ganges, where it bred in the mephitic air of that primeval island- jungle, among whose bamboo thickets the tiger crouches, where life of every sort flourishes in rankest abundance, and only man avoids the spot" (Mann, 63). But "orientalism" meant to early modernists any cultural experience beyond the Eurocentric one. The Japanese influence on Western painting— as we see in Manet's *The Bar at the Folies-Bergère* (1881-1882)—includes the diagonal picture plane, the asymmetrical, sometimes seemingly slightly askew, off-centered composition; the reversal of expectations in determining background and foreground (so that a large tree might be in front of a bird

that is the seeming subject). The Japanese influence extends to emphasis on a decorative and stylized and often symbolic rather than a representational view of the nominal subject. The negative or empty space invites the perceiver to complete the artistic experience; perhaps it is the relatively crowded nature of Japan that makes negatively defined space a *value*. Finally, narrative elements in Chinese and Japanese are read vertically from right to left. Chinese landscape painting includes in elegant vertical brush-stroked calligraphy—or ink in pen-and-ink drawing—the words of the poem that inspired it. The range of colors is often limited, and the ink drawings depend exclusively on shades of black and gray; could they have influenced Franz Klein, Yves Klein, or Pierre Soulages? In Redon's *Lady of the Flowers* (1900; in Honolulu Academy Collection), the Japanese influence is in the asymmetrical but balanced composition, the negative space, and the decorative and patterned flat surface. In the Redon painting the figure's floral dress echoes the color of the flowers and the subject seems to be falling off the canvas; influenced by Japanese ink drawings, a few spare lines render the emotion of the figure's face. But we also see in the Redon work a North African touch in the costume and architecture.

Matisse uses kimonos, women with fans, decorative patterns. The abstraction of *haboku*, broken ink landscape in which brushstrokes move in a spontaneous manner with strong contrasts in tonality, may have influenced him. So did the tendency to leave out the details of facial features and to depict them with a few strong lines. For Matisse, like his Japanese sources, used minimal lines to create facial expressions. (In a painting like *Fan, Pipe, Glass* [1911], we see the Japanese influence on Picasso.)

Matisse's Fauvist paintings, such as *Les Toits de Collioure* (1906), are vibrant dances of color. In that work we see the restlessness of the Fauves but also the controlled formalized movement of Japanese works, such as *Tsubaki Chinzan* (*Landscape with Fisherman*, 1850; Honolulu Academy catalog, 104) of the Edo period. But usually the Japanese influence is in the harmony and stasis of a painting such as *Ogata Korin* (*Plum Blossoms*, 1702, Edo period; Honolulu Academy catalog, 102). Matisse sought life and light by juxtaposing color with color—often red and green—and, as Lawrence Gowing puts it, "revealing an inherent light in the interval and the interplay between them" (51). Matisse's work denies depth and insists on the patterned surface; it recalls Chinese and Japanese painting. Sometimes it looks as if Matisse paints from a higher perspective and tilts receding planes diagonally (as in Japanese and Chinese prints) from that higher perspective: "the perspective diminution and convergence are flattened to form areas in which color can tell for its own sake" (49).

Orientalism was a form of exoticism in the nineteenth century; as Pierre Schneider remarks, "exoticism is the artistic version of colonialism" (25). Exoticism insisted on novelty of subject matter. Even though he developed an "aesthetic of decoration," Matisse never abandoned his interest in subject matter and was influenced by Moroccan exoticism: "Gauguin alone had dared, both in his writings and in his works, to claim that the artisan was equal, if not superior, to the artist. Matisse unquestionably paid great attention to his message" (Schneider, 25). During his Moroccan stage, Matisse was deeply influenced by Pierre Loti's *Au Maroc* (1889). In Tangier, Matisse painted flowers. With flowers, nature and decorative art are one; as Schneider writes, "To paint flowers is to oblige oneself to paint florally. The Moroccan pictures are not so much painted as stained" (38). By proposing the decorative—under the aegis of Moslem art—in *Dance I* and *Dance II, Music* and *La Desserte* (also known as *Harmony in Red*), Matisse was making a strong counterstatement to the Cubists who held sway in 1912-13. Gauguin had remarked: "O painters who are looking for a color technique, study rugs. You will find all the necessary knowledge there" (quoted in Schneider, 26). But rugs, with their colorful, never completely symmetrical patterns, deemphasized volume, while Cézanne had taught Matisse to conceive three-dimensionality. That Matisse never rested in a style, that he was always questing at the frontier of painting, that he continually kept pushing limits of color, form, and line, is testimony to his magnitude as artist. Of *Moroccans* (1916), Gowing writes: "He compelled the picture to take on a new form, a structure of analogy and interplay for which there was essentially no precedent" (128). Matisse's use of different size figures without any pretense of realistic receding planes or perspective is a movement away from mimesis as realism. *Bonheur de Vivre* (1905-1906) not only suggests the curtain of Modernism parting in Picasso's *Les Demoiselles d'Avignon*, but also echoes Manet's *Déjeuner sur l'herbe* and Cézanne's *Bathers* series.

We can see a direct line from Manet and Cézanne to Picasso and Matisse, both of whom reinvented the world according to their imagination. In *Dance* (1909) and *Music*, Matisse subordinated individuality and character to the purposes of design. Later, as his work became more and more idealized to the point of self-indulgence, he subordinated story and narrative to design. His art is at once a triumph of self and form. Whenever Matisse seemed to be turning toward abstraction, as in *La Leçon du Piano* (1916), he seemed to recoil to a more mimetic painting, as if he did not want to let go of the human subject. Matisse insisted on the place of the personal in his work. Figurative painting was a kind of action in which he discovered principles of color and composition. From 1906 to 1908 and periodically

thereafter he sought harmony and quiet, sought to create a mask and leave life behind; as Gowing puts it, "His ideal not only excluded what was momentary and transitory; it avoided equally anything that was energetic" (57). Often in this fin de siecle Matisse, expressiveness took the form of defining a masque along the lines of Wilde and Yeats or seeking self-effacement, along the lines of Eliot's objective correlative. Yet the Matisse of this period also extemporized what Gowing calls his "extravagant interplay of colours with a naturalness that made any other content or purpose in painting seem, for the moment, irrelevant" (53).

Matisse's flowers recall Bloom's and Molly's great moment on the Howth, the scene where she and Bloom are having intercourse for the first time amidst flowers. In Joyce we see orientalism—or a parody—in the boy's destination in "Araby," a destination that turns out to be an English bazaar or carnival—and in Stephen's, Bloom's, and Molly's thoughts of the East. Stephen thinks of the Arabic culture and the East in terms of abstract numbers, the Christ story, and the Adam and Eve myth. Bloom thinks of the renewal of Israel, his ethnic homeland, as a metaphor for the renewal of his home on Eccles Street ("Agendeth Netaim"), of the Zionist greeting "Next Year in Jerusalem," and of Gibraltar, where Molly was born. Molly thinks of Gibraltar, where she was raised and where she reached sexual maturity. In Conrad, the East plays a prominent role; the Malay culture, like the Congo, is depicted as mysterious, passionate, libidinous, intuitive, and passive-aggressive. Conrad's *Under Western Eyes*, written in 1910-11, juxtaposes East and West, using Russia as an example of *difference*, exoticism, mysticism, and passion.

V. Matisse's Contribution to the Modernist Aesthetic

Matisse's painting, like Eliot's poetry, is responding to excesses in romanticism and realism, but the richness of his decorative canvases are hardly the stuff of spare classicism. Comparing Matisse to Eugène Delacroix, who had also journeyed to Morocco, Schneider writes: "In Delacroix, all is motion, turmoil, dynamic disequilibrium, striving for extremes—for rumbling crowds or fierce solitude. Matisse, on the other hand, favors calmness, repose, immobility" (23). Matisse emphasized the artist as maker, as re-creating what he sees. As Schneider writes, *Café Marocains* represents "not the abolition of reality in favor of abstraction, but the conversion of reality into abstraction" (46). Matisse's Moroccan stage has a Conradian aspect and could be called "Under Oriental or Moslem Eyes," rather than *Under Western Eyes*. Matisse brought Dickens (Dickens, we recall, was Conrad's exemplum for depicting

angst in the modern city in *The Secret Agent*) to read even as he sought to escape the modern city. Matisse had the kind of historical sense that Eliot had and knew that art took its meaning from prior art and convention; even as he gradually supplemented Western influences with Eastern ones, he never ceased struggling with examples and paradigms. Just as Joyce needed Europe to understand Ireland, and Conrad needed England to understand Poland and his sea years, so Matisse needed Morocco to understand Paris. In each case, a place encountered late—a new ontology—enabled the artist to define subjects embedded in his psyche by prior experience.

Let us return to the East or orientalism from a different perspective. To be sure, in *Death in Venice*, the plague originates in India, but Mann gives a Modernist spin to the notion that travel frees the imagination, unlocks the libido, and provides necessary space for creativity. He is playing with the late nineteenth-century concept of exoticism; while seemingly providing new stimuli for Aschenbach, Tadzio really brings out Aschenbach's essential if repressed character. But isn't that the meaning of exoticism? As Stevens wrote in "Tea at the Palaz of Hoon," we find ourselves "more truly and more strange" in our own world. Morocco became Matisse's Arcadia but also an imagined space within his psyche: "This is why he had to avoid detail: because Arcadia is an imaginary location and cannot be specified. This is why he purged [Moroccan] figures of expression: because he was painting not contemporary individuals but atemporal, representative types" (Elderfield, 228). When he painted *Moroccans* in 1916, his golden age had passed; he was back in France and the Great War raged. Disjunction exists among the three parts. The black background suggests war, and the painting has three separate groups or stories tied together by the discourse of flat abstract forms and black background. In *Moroccans* "we look at its separate parts as dislocated in space as well as on the surface" (Elderfield, 65). John Elderfield reminds us that Matisse admired the philosopher Henri-Louis Bergson, who wrote in *Creative Evolution*, of separate temporal incidents with a duration: "Discontinuous though they appear . . . they stand out against the continuity of a background on which they are designed, and to which indeed they owe the intervals that separate them" (quoted in Elderfield, 65). Matisse paints to define painting, as when he makes 50 images of Lorette in his later work and alternates abstract and naturalistic versions of the same subject.

To the extent that Matisse's art is more concerned with costume, decoration, and surface, it challenges our traditional ways of recuperating signs into hermeneutical patterns: "In Matisse's drawings of his models, the fabric woven by the web of signs is a kind of costume, a decorative surface that conceals the image of the model, to reveal the sensual pleasure provoked

by the model. (Hence, representation of models who actually wear costumes—always of Matisse's choosing—form an important theme in his art as a whole)" (Elderfield, *Matisse: A Retrospective*, 27). By implying in his still lifes an emptiness or vacancy of features in place of the expected substance in a container, Matisse paradoxically calls attention to the very act of representation in which he is engaged. The same kind of statement would apply to Stevens's women in "The Paltry Nude" or "Mrs. Alfred Uruguay" or the figures evoked in his *Notes towards a Supreme Fiction*. We might recall Matisse's "Notes of a Painter on His Drawing," in which he uses such terms as "plastic writing" (*l'écriture plastique*), "plastic signs" (*signes plastiques*), "the page is written" (*la page est écrite*) (in Elderfield, *Matisse: A Retrospective*, 27). What characterizes Modernism is a self-conscious search for signs even when recognizing the futility of finding an absolute formula of signs that might imitate reality. We need to recall that Matisse wrote: "The truly original artist invents his own signs. . . . The importance of an artist is to be measured by the number of new signs he has introduced into the language of art" (27). Matisse, much more intellectual than Picasso, was in word and deed theorizing art, and saw himself engaged in the search for the appropriate sign.

For Matisse and Picasso, Cézanne's emphasis on form is the model of the painter who achieved unity. It is worth recalling that Matisse's sexually charged *Bathers with a Turtle* (1908) was painted a year after Picasso's *Les Demoiselles d'Avignon*. Elderfield writes, "This is Matisse's very first painting wherein the figural elements are isolated from each other, separately placed against the color field" (59). Matisse, like many Modernists including Stevens, Joyce, and Eliot, uses ellipses and invites us to piece together the disparate parts; *Moroccans* (1915-16) is such a case.

According to Elderfield, "[F]or all the variety within [Matisse's] oeuvre, his presence in each work is unmistakable once we have come to recognize its different guises" (13). For Matisse color is as formative as words are to Joyce. Matisse, like Joyce, sometimes seems to be preoccupied with the doing and the formal. But, like Joyce, his highly wrought structures are compositions that transcend the parts and become an intervention in the real world. As Elderfield puts it, "The mental image Matisse is painting is not a pre-formed idea, in the sense of something separate from the means of its pictorial realization, but, rather, an idea whose form will finally be discovered within those means" (26). So with recent theory—more Modernist than postmodern in its quest for odd kinds of unity that transcend parts—the discourse relies in its telling upon principles of meaning and order, only to discover they are provisional and to discard them. Matisse, like most of the major Modernists, found his home in his work: "Matisse reenacts the fall

from innocence of realistic representation. He confirms for himself that meaning can be produced only in the material of painting. Thus, each painting is an individual struggle, uncertain of its outcome, to a far greater extent than ever before. He is a prisoner of painting and will never escape except by abandoning painting at the very end" (ibid, 66). Modern artists, I am stressing, are imprisoned by their art, and yet paradoxically art gives them freedom. Aschenbach and Prufrock are self-imprisoned in their worlds, but creating them—totemizing that enclosure—frees Mann and Eliot.

Let us pursue the Matisse-Joyce parallel. Matisse's ellipses, like those of Joyce, leave the perceiver to complete them. Both Matisse and Joyce revel in the decorative. Recall that Joyce spent 1902-3 in France, and Molly was imaged as a heavy, large-breasted, beautifully ugly woman in the fictive world of 1904. Matisse's women are not idealized women, any more than Joyce's are. According to Adam Gopnick, "Matisse's women are a particular French type—the jolie laide, the beautifully ugly. Heavy, thick-torsoed, square-jawed, they are like Gothic Eves, with curving stomachs and short, strong legs" (107). Gopnick might be describing Molly. Finally, just as Joyce displaced his descriptive language from the characters' thoughts to the world around them—so that in *The Dead* as the description of Gabriel's mind "bleeds" into that of the narrator's presentation of the physical setting or vice versa—so Matisse does the same with color: "[Matisse displaces] energy from still and plaintive human figures to the objects surrounding them. . . . All the emotion in the picture is transferred from the people to the room" (109).

Interestingly, when Matisse painted *Dance I* and *II* and *Music*, he was afraid of losing his eyesight. Joyce, too, had problems with his vision, problems that may have skewed his perspective and taken him further and further away from representation in *Finnegans Wake*. Like Matisse's paintings, Joyce's texts call attention to their medium—in this case language, not paint; in *Finnegans Wake* and in *Ulysses* (chapters 11-18, especially chapters 11-14), the language calls attention to itself as a plastic medium with its own colors, patterns, and sounds. Joyce called the "art" of "Nausicaa" *painting* in part because of the parody of Renaissance Madonna figures in the presentation of Gerty and in part because of the stress on optics: how Bloom sees Gerty, how Gerty sees Bloom, how we see them against a traditional Boudin seascape.

VI. Rendering Dance: Matisse's *Dance* and *Music*

If, as Wendy Steiner claims, for the visual arts to have narrative, "an identical subject must be repeated in the differential context of realist space and time

in order for a design to give birth to a story," then *Dance I*, *Dance II*, and *Music* are narratives (144). When we think of narrative in painting we think of how a group of paintings forms a sequel. Thus Elderfield argues that *Blue Nude* is "the third picture of a sequence begun by *Luxe, calme et volupté* and developed by *Le bonheur de vivre*" (57). That books and readers appear in Matisse's paintings, such as in *Girl Reading* (1905-6), may reflect his interest in narrative and story. By their very titles, which allude to a cultural tradition that they evoke if only by comparison, *Dance*—both I and II—and *Music* are narratives. As Elderfield writes, echoing T. S. Eliot in "Tradition and the Individual Talent":

> Narrative continuity with the past having been lost for Modernism, to paint imperative pictures that gave narration a commanding role (however much the traditional forms of narration must be modified to allow it that role) would be to rejoin modern art to the loftiest products of Western tradition. To make unquestionably modern paintings, but works that invite our reading as traditional history paintings did, and give them subjects that tell of ancestry, was to suggest a sense of the wholeness of past and present as expressed in unified history. The theme of remembrance is placed in the center of our reading of these works; the vividness of its realization makes the distant seem near and the past genuinely new. We have seen nothing quite like what Matisse shows us, yet it is familiar to us and we recognize it. (60)

Matisse turned modern painting toward the decorative and was obsessed with conveying light. Influenced by the designs of oriental rugs, he called paintings such as *Dance II* and *Music* "decorative panels" (Schneider, 26). I shall be focusing on *Dance II* (1910), located in the Hermitage rather than *Dance I*, in the Museum of Modern Art. The two versions of *Dance* are also in a narrative relationship to one another. In the second version, the physical effort of dancing is emphasized and the red gives it what Jack Flam calls a "dionysian energy" (78). In the first version, effortless dancers float through space. In *Dance II*, the figures are closer to the edge and the painting seems more expansive, yet more nervous and anxious. Rosamund Bernier notes, "The cheerful round dance had turned into a test of endurance. Bodies were convulsed and frantic, with every twist and turn spelled out. It was almost a foretaste of Stravinsky's *Rite of Spring*, where the dance ends in death" (80). Pierre Schneider has remarked, "He constructed his picture *by* color, but *for* light" (30). According to Schneider, "at the time he was working on these two canvases, Matisse, perhaps because he unconsciously remembered Saint

Paul's experience on the road to Damascus, was afraid of losing his eyesight. Numen, Lumen: for a painter more than anyone, light and the sacred are apt to be synonymous" (34). Matisse notes, "The expression came from the coloured surface, which struck the spectator as a whole" (quoted in Gowing, 105). The light is fierce, as if a spotlight had uncovered the actions in both paintings. While the spectator is at once dazzled by the colors and decoration, the artist wants us to understand the presence of meaning in these primitive paintings. Joyce, too—perhaps influenced by *The Book of Kells*— was fascinated with art as decoration and played with words as if they were colors or abstract shapes in the "Oxen of the Sun" section of *Ulysses* and *Finnegans Wake*. In *Ulysses*, not only are Joyce's experiments in style in the later chapters versions of the decorative, but, as we have noted, his assigning *colors* to each chapter recalls Kandinsky's elaborate color theories.

It is a paradox that Cubism contains narrative even while displacing the fixed gaze of the perceiver, the momentary tension of an action within a dramatized setting or situation, or the psychology of individuals. Let us take Matisse's 1910 painting *Dance II*, a painting that Picasso might have had in mind when he painted *The Dance* (sometimes called *The Three Dancers*), and Matisse's *Music*, which Picasso may have had in mind when he painted *The Three Musicians*. By their very titles, *Dance II* and *Music*, Matisse is trying to make a claim for the importance of painting in response to the view expressed by Walter Pater and tested by Joyce in "Sirens" that music is the highest art form. In both paintings Matisse restricts himself to the same three colors: blue, red, and green. (The Museum of Modern Art version entitled *Dance I* is, finally, less joyous and more of a dance of death than the version in St. Petersburg). These are large paintings (8 feet 6 1/2 inches by 12 feet 9 1/2 inches) and the characters are lifesize according to the perspective of the foreground. We can enter into the circle between the outstretched hands, but we are reluctant to do so because of the ominous tone. In each we have large-scale figures and no point of perspective from which the painter or spectator is encouraged to look.

Dance I and *Dance II* are crucial in the development of modern painting. Barr writes, "Its extreme flatness, totally nonatmospheric space, and highly abstracted and schematic manner of representation mark a more complete break with Renaissance illusionism than is produced by any previous painting. The surface is opened and expanded to give color its own visibility and own voice in a way virtually unknown in the West since Byzantine art" (quoted in Elderfield, *Matisse in the Collection of the Museum of Modern Art*, 5). In *Dance II* Matisse uses the earth color brown for the hair, the generic and generalized facial features, and the outline of the bodies, and in *Music* he

uses black for the same purpose. *Dance II* is a symphony of colors, which Matisse describes as "a beautiful blue for the sky, the bluest of blues (the surface was colored to saturation, that is to say, up to a point where the blue, the idea of absolute blue, appeared conclusively) and a like green for the earth, and the vibrant vermilion for the bodies" (quoted in Russell, 66). The naked dancers float on the top of a hill—itself an image of separation—as if they were Chagallian figures making their way across the heavens; yet their leader has his foot firmly planted on the ground in an anatomically correct position, a carefully studied foot that reminds us of Matisse's sculptural work. Like figures in early Yeats—or in Stevens (we might think of "Domination of Black" or even "Thirteen Ways of Looking at a Blackbird")—they are poised between the real and the aesthetic world.

Scholars have speculated on Matisse's sources. For our purposes, what is interesting is that he created a system of allusions, much like Joyce and Eliot, to give what Eliot calls in his 1923 review essay of *Ulysses*, "shape and significance to the immense panorama of futility and anarchy which is contemporary history" (Ellmann and Fiedelson, 68). As with *Ulysses*, Matisse's references to prior works create a synchronicity and context. His immediate source is the ring of dancers in his own *Bonheur de Vivre*, but he also refers to a wide range of paintings by Poussin and Mantegna, a tapestry by Goya, and Carpeaux's sculpture on the facade of the French opera. He was no doubt also influenced by oriental rug design and Japanese woodcuts. And he may have had in mind Manet's *Déjeuner sur l'herbe* (1863), where a nude woman is accompanied by two dressed urban males and awkwardness puts a damper on spontaneity; the background landscape would have overwhelmed the front figures were it not for the provocative front-facing nude.

We may be jaded regarding how unique a subject Matisse has chosen for his versions of *Dance*. Matisse wants to move sensuality into the context of the primitive and ritualistic, and away from the mannered display in Manet's provocative revision of Titian's *Concert Champêtre*. Indeed he wants to reinscribe the original Titian painting with pagan energy by means of color. We might think of the pagan dances in *Tess of the d'Urbervilles* and, especially, the dancing under the moon between Anna and Will and Ursula and Skrebensky; for Lawrence, too, the dance was an image of Dionysian Modernism. In *The Rainbow*, dance is part of a cyclical rhythm, the seasonal process that culminates in harvest, and Anna and Will are realized within that cosmic rhythm:

> Into the rhythm of his work there came a pulse and a steadied purpose.
> He stopped, he lifted the weight, he heaved it towards her, setting it

as in her, under the moonlight space. And he went back for more. Ever with increasing closeness he lifted the sheaves and swung striding to the centre with them, ever he drove her more nearly to the meeting, ever he did his share, and drew towards her, overtaking her. There was only the moving to and fro in the moonlight, engrossed, the swinging in the silence, that was marked only by the splash of sheaves, and silence, and a splash of sheaves. And ever the splash of his sheaves broke swifter, beating up to hers, and ever the splash of sheaves recurred monotonously, unchanging, and ever the splash of his sheaves beat nearer. . . . (Lawrence, *The Rainbow*, 119)

Lawrence renders unrestrained, unselfconscious dancing when the will is suspended. Not only here but in Anna's dance in front of the mirror when she is pregnant (with Will notably absent) as well as in the moonlight scene between Ursula and Skrebensky, the dance motif becomes an image of passion and spontaneity—although it can devolve into something mechanical and onerous:

She wanted to let go. She wanted to reach and be amongst the flashing stars, she wanted to race with her feet and be beyond the confines of this earth. She was mad to be gone. . . .

The music began, and the bonds began to slip. Tom Brangwen was dancing with the bride, quick and fluid and as if in another element, inaccessible as the creatures that move in the water. . . .

There was a wonderful rocking of the darkness, slowly, a great, slow swinging of the whole night, with the music playing lightly on the surface, making the strange, ecstatic, rippling on the surface of the dance, but underneath only one great flood heaving slowly backwards to the verge of oblivion, slowly forward to the other verge, the heart sweeping along each time, and tightening with anguish as the limit was reached, and the movement, at crises, turned and swept back.

As the dance surged heavily on, Ursula was aware of some influence looking in upon her. Something was looking at her. Some powerful, glowing sight was looking right into her, not upon her, but right at her. Out of the great distance, and yet imminent, the powerful, overwhelming watch was kept upon her. And she danced on and on with Skrebensky, while the great, white watching continued, balancing all in its revelation. . . .

But her naked self was away there beating upon the moonlight, dashing the moonlight with her breasts and her knees, in meeting, in

communion. She half started, to go in actuality, to fling away her clothing and flee away, away from this dark confusion and chaos of people to the hill and the moon. But the people stood round her like stones, like magnetic stones, and she could not go, in actuality. Skrebensky like a loadstone weighed on her, the weight of his presence detained her. She felt the burden of him, the blind persistent, inert burden. He was inert, and he weighed upon her. She sighed in pain. . . .

The music began again and the dance. He appropriated her. There was a fierce, white, cold passion in her heart. But he held her close, and danced with her. Always present, like a soft weight upon her, bearing her down, was his body against her as they danced. He held her very close, so that she could feel his body, the weight of him sinking, settling upon her, overcoming her life and energy, making her inert along with him, she felt his hands pressing behind her, upon her. But still in her body was the subdued, cold, indomitable passion. (Lawrence, *The Rainbow*, 315-8)

We might recall that in the East, dancing is an ancient form of magic. The dancer becomes amplified into a being endowed with supernatural personality. Like yoga in Hinduism, dance is an activity of the gods, a form of celestial entertainment. Dance induces trance, ecstasy, the experience of the divine, the realization of one's secret nature and divine essence. Similarly, Lawrence's rendering of dance in *The Rainbow* dramatizes the potential of dance as a way out of time, as way to transcendence, particularly for Lawrence's women. Yet, even while one's body becomes a release from what Lawrence called mind consciousness, it is also, when the dance ceases, an anxiety-producing threat to the daytime self because it is a journey to a different place and state of being.

Stevens's dance in *Sunday Morning*, Yeats's dance image in the closing lines of "Among School Children," and the wild gyrations of the savage mistress in Conrad's *Heart of Darkness* are all Western instances of primitive and magical dance that are influenced by Asian and African sources. Indeed, as we have seen, when Marlow speaks of his temptation to go ashore for "a howl and a dance," dance is in this context associated with the libidinous, the primitive, and, the unconscious. In *Heart of Darkness* dance is a metaphor for letting go, instinct, feelings, for Dionysian behavior. Marlow asks of his audience, "You wonder I didn't go ashore for a howl and a dance?" (540), and that becomes his metaphor for reverting to savagery. Of the fireman who stuck to his work, Marlow says, "He ought to have been clapping his hands and stamping his feet on the bank" (541). The gyrations of the savage

mistress as Kurtz departs are a kind of dance. The savage woman has become a metonymy for the land. For Marlow she embodies Africa: "And in the hush that had fallen suddenly upon the whole sorrowful land, the immense wilderness, the colossal body of the fecund and mysterious life seemed to look at her, pensive, as though it had been looking at the image of its own tenebrous and passionate soul" (578). To a first reader "colossal body" might be the woman. In a sense the woman and Africa—both Dionysian, atavistic, incomprehensible, fecund, uncontrollable—become in the process of reading metonymies for one another.

Once the teleological view of history that dominated Western art came into question—responding to Lyell, Charles Darwin, and the historical criticism of the Bible—Western art looked to Eastern concepts of cyclical time: The power inherent in Shiva's furious yet blissful dance represents his role as the creator-destroyer of the universe. His dance becomes not merely the catalyst but the representation for the destruction of one time period and the creation of a new cosmos. Shiva's metamorphosis into different forms reminds us of Joyce's metempsychosis, by which his Bloom is a counterpart to Homer's Odysseus.

Let us turn to the wonderful 29 1/2-inch-late-tenth century sculpture *Shiva: The Lord of the Dance*, in the collection of the Asian Society in New York, in which we see the sculptor's full pleasure in the human physique and in the details of jewelry and clothing. Rodin was influenced by the unity, grace, and power of statues of Shiva. What he must have loved in such statues is the anthropomorphic quality of Indian Gods, their elegant physicality. For Rodin, Shiva is a vision of the artist. Also, Rodin would have liked the tension inherent in Shiva's controlling a snake, a tiger, and a dwarf demon. In the Asian Society statue, Shiva wears the snake-belt and animal loincloth (representing the tiger) and stands on the dwarf-demon: "The three creatures symbolize the untamed minds, egoism and ignorance that Shiva has to destroy in order to guide the sages to a more developed spiritual state" (Leidy, 5). According to Stella Kramrisch: "Shiva's dance is the dance of the cosmos, the rhythm of the movement of the sun and the moon, of the earth and the wind. All pulsate in his body, and man—the microcosm who shares in and is conscious of them—is also part of Shiva's body, the total creation" (quoted in Little, 4). Shiva is male and female, motion and calm, light and dark; indeed, he embodies everything and its opposite. Shiva embodies the structure of the whole universe; as its potent, all-pervasive energy, as a radial force that appears in many forms—light, fire, the heat of sexual passion, ascetic discipline—he has the capacity to create, maintain, and destroy, that is, to release every being in this universe.

The great Hindu temples in Indonesia, collectively known as Pramba-
nan, testify to Shiva's multiple identities. In Indonesia Shiva is known as
Siwa, and the central surviving temple is called Candi Siwa or Siwa's temple.
Brahma, Vishnu, and Shiva are a trinity; all have their own magnificent
temple. The Hindu epic *The Ramayana*—depicted in 41 frames on the walls
of the temple—has parallels to the incarnation of the Christian story and
the Homeric epic. When later in the epic Ramachandra slays the giants, we
think of Odysseus slaying Polyphemus, the leader of the Cyclops, and David
slaying Goliath.

In *Ulysses* Bloom's multiple identities might have been suggested by
Shiva: "Shiva is revered both as a wandering ascetic, totally devoid of any
social obligations, and as the consummate lover and husband of the goddess
Parvati and the devoted father of two sons, Ganesha and Kumara" (Leidy,
8). Just as Joyce retold and embellished an old story, *The Odyssey*, and other
moderns look back to archetypes, so Indian artists reinvigorated Hindu
myths: "Much of the pleasure of viewing a dance performance and looking
at a sculpture derives from identifying the tale that is being recounted and
recognizing the subtle ways in which an artist has made the old tale alive
again, either by changing the emphasis in the story, embellishing its details
or creating an entirely new variant" (15). Although Shiva in his absolute state
is beyond form, he is, like Joyce's voice, capable of appearing in many forms.
In his universality and chameleonic form, he suggests Bloom, but in his
capacity for metamorphosis, he suggests the Irish god Cuchulain. Like
Bloom, Shiva appears in many guises: husband, father, the female aspect of
himself. Shiva's wife Parvata is not only the female aspect of Shiva but an
idealized manifestation of female beauty. The physicality of the statues of
Parvati suggests Molly. Like Bloom—and like the Hasidic legend of the Just
Man (*Lamid Vov*) on which Bloom is modeled—Shiva often conceals his real
identity and value. Does not Joyce attribute the kind of universality to Bloom
and to his narrative voice—the prophetic voice of the Irish epic that will
raise the consciousness of his people and introduce the new pacifistic
Masonic and Jewish successor to Parnell—that the Hindus attribute to
Shiva?

That dance itself, a form that oscillates between mimesis and styliza-
tion, is appropriate for paintings that have the *process* of life, of creation, of
objectifying experience as a subject. In a sense, the dancers here and in
Picasso's *The Dance*, which we will examine later, become metaphors or
metonyms for the artist; that is, they are object and subject—dancers and
dance—in their inseparable form. Keep in mind that dance itself was
important in Paris in 1909; Diaghilev arrived then and Isadora Duncan

danced in Paris in that year. As Lynn Garafola has written, "Just as many writers of the (modern) period sought to identify a living literary tradition, so these choreographers struggled to redefine the vital inheritance of classicism for the twentieth century" (Garafola, viii). Diaghilev's Ballets Russes was formed in St. Petersburg in 1911 and continued until 1929. He fused dance, music, and art, and used elaborate costumes and scenery. (Olga Kokhlova, one of his dancers, married Picasso.)

Diaghilev brought a new audience to ballet between 1909 and 1929. While prominent political figures and members of the Russian aristocracy in Paris frequented his performances, most of the audience was made up of music aficionados as well as professional musicians. Diaghilev captured the "cultured, cosmopolitan, and knowledgeable audience" that had earlier been drawn to Wagner's operas and his theater at Beyreuth in the 1890s and early 1900s (Garafola, 277). The audience differed from city to city and included "the wealthy, powerful, cultivated, celebrated, and talented. . . . their presence in the audience shaped the company's public image, while their influence behind the scenes left an imprint on the repertory: at any given moment, the identity of the Ballets Russes at least partly reflected that of its public" (Garafola, 273). Diaghilev paved the way for his triumphant 1909 Paris season with appearances the prior few years during which time he "acquired a growing legion of partisans" and "assembled a band of influential critics, publicists, and patrons" (Garafola, 274).

Ballet was at a low ebb in France when Diaghilev came on the scene. Edgar Degas's paintings capture the fragility of the dance world. The performers, mostly female, were despised as being low and debased. Their bodies were taken at the age of eight and molded into instruments of dance. Degas depicts them in awkward positions and postures. He captures them in moments of stasis. Yet the diverse figures create the illusion of motion, in part because of their similarity and blurred facial features. Their bodies become sites of motion but they lack distinct characters. For the viewer, dance is a joyous liberation, an opportunity to watch voyeuristically the bodies of others. Degas uses clothing to suggest, but not fully reveal, the body; it is as if these brief costumes were like the lines of a painter. Paul Valery wrote: "The dancers are transfixed in poses quite remote from those that human body can maintain by its own strength . . . while thinking of something else. Consequently, there is a wonderful impression: that in the Universe of Dance, rest has no place; immobility is a thing compelled, constrained, a state of passage and almost of violence while the leaps, the counted steps, the poses on point, the entrechats or the dizzying turns are quite natural ways of being and doing" (quoted in Degas, 38).

In the 1870s the ballet became popular entertainment. A ballerina performing on point was a new style on the Paris stage then; Degas's *L'Etoile: Dancer on Point* (1878) renders this image from a backstage perspective. In his *The Entrance of the Masked Dancers* (1879), the constricting ribbons—playing on Manet's *Olympia*—emphasize how these dancers are constrained by circumstances. We look from the wings and it seems as if the dancer on the left is stepping off the stage into our world. Degas depicted dancers in performance, at rehearsal, and in a state of exhausted rest. The sculpture *Little Dancer of 14 Years* (1880) incorporates real elements: human hair, the dancer's tulle tutu and silk hair ribbon. The dancer shows pride in her posture and her basic position step.

Degas's *The Ballet Class* (1880) reminds us how Degas shows not only the elegance but the pathos and exploitation of dance. Wealthy men went to the ballet to select women for brief dalliances as potential mistresses; as Garafola reminds us:

> In the early twentieth century, ballet in France was socially and artisti-
> cally déclassé; isolated from the cultural mainstream and patronized by
> the most philistine stratum of the male upper class. That this was no
> longer the case in 1914 is a measure of Diaghilev's genius and the
> extraordinary changes he brought about in the audience for his chosen
> art. (274)

In *Dealing with Degas*, Anthea Callen notes that "The gaze of the lower classes, like their touch, was experienced as an act of aggression. The paradigmatic bourgeois gaze, on the other hand, was the gaze of surveillance deployed to master the aggresive gaze of the lower classes. . . . The shock of Manet's *Olympia* lay precisely in the artist's explicit reference to the touch of the *déclassé*, as signified by the Olympia's gaze" (quoted in Allen, 167). Irony, even a kind of cool anger, is as much a part of Degas's perspective as sympathy and empathy. Parents took girls of modest expectations to ballet school at the age of seven or eight and relentlessly pushed their children to dance. In *Ballet Class* (1878-9) is the foregrounded, drably dressed woman, who is sitting in a chair reading, the mother of one of the girls? The male instructor observes three preadolecescent girls taking a lesson. The spare rehearsal room emphasizes the dancers' isolation. Their postures are quite awkward. They are dressed for performance of some kind, yet the girl in the mirror seems barely able to hold her balance. Actually, the mirror image is an artistic distortion of what would have been reflected. The legs and back of one are reflected in a mirror; two other dancers are behind the instructor. The dancers are at once

desexualized and the object of voyeurism. We *watch* the instructor *watching* them. The instructor almost merges in our view of the girl practicing in back of him. And the fifth dancer directly in back of him is cropped Japanese fashion. The five dancers' facial expressions are barely delineated, as if to emphasize their anonymity, an anonymity stressed by the confusion of limbs created by the reflection; we hardly know whose limbs belong to whom. These dancers are working-class girls without distinguishing physiognomy. Doesn't their very anonymity emphasize a movement within the stasis of painting, as if one person were in the various postures?

What Lincoln Kirsten says about classical ballet is relevant to all forms of dance. "Our Western ballet is a clear if complex blending of human anatomy, solid geometry and acrobatics offered as a symbolic demonstration of manners—the morality of consideration for one human being moving in *time* with another" (226). Kirsten defines classic ballet as: "A style of the academic theatrical dance employing pure movements of the traditional school apart from character dancing or associative or mimetic gesture. The impression of the body in movement or repose is essentially linear, with the line of the silhouette, clean, sustained and noble, brilliant, but measured, deliberate but never dead" (quoted in Kisselgoff, 6). In modern literature and painting, dance is a metonymy for *always alive*—the antithesis of death, infertility, willed control. In Matisse's *Dance I* and *II*, Picasso's *Three Dancers*, Lawrence's *The Rainbow*, Stevens's *Sunday Morning*, and Yeats's "Among School Children," dance is imaged in terms of both pure movement and mimetic gesture, as something out of time between the tick and the tock. Dance is a metaphor for asymmetry within symmetry, disorder resolved as order, spontaneity resolved as control; dance frees the self from interior shackles to take one's place in a larger meaningful pattern.

The dynamic visual and tactile qualities of dance make it mediate among several art forms: sculpture, painting, music, and literature. Dance visualizes the capacity—the physical capability—of the human body for controlled and patterned movement; for that reason it is an apt way of representing ritual, of various iterations within the human experience. Dance is about stretching the limits of the body; it is about the language of movement, the visualization of the body's potential for poetic movement within a form. African masks, we might recall, are intended to be seen in the movement of dance; they are meant to be seen—as Yoruba masks are—as part of the costume: "[T]o isolate the mask is to take it out of its meaningful context, for the mask itself is regarded merely as part of a complex—part of a costume which is danced in to music—and it is only when all these elements are present that the mask comes to life, becomes inhabited by the

spirit" (Frank Willet, 173). And this reference to African masks is another reason Picasso's *Les Demoiselles d'Avignon* is a precursor to Matisse's *Dance* and many of the other examples that we are discussing.

Matisse's *Dance II* (1910) and *Music* (1910) were painted as the influence of Diaghilev took hold. The artists who created the sets and costumes "reiterated the blend of sumptuousness, decorative harmony, and historical veracity so appealing to audiences of *Boris [Godunov]*. Visually as well as musically, Diaghilev aligned his earliest ballet ventures with the aesthetic of his lyric theater" (Garafola, 276). Mondrian, too, sought to integrate music, dance, and painting; witness such paintings as *Broadway Boogie Woogie* (1942-43). As Michael Kimmelman observes, "The paradox of Mondrian's art is that it combines sophisticated nuance of color and line with what appears to be the most childlike simplicity of form" (12). Mondrian learned from Cubism to break from naturalistic representation. He adopted Cubists' imagery but not their volume. His work does not resolve diverse planes, but presents them "frontal and flat." Whereas Picasso returns to subject, Mondrian moves on to pure abstraction: "He strips away elements in his art until all that is left are primary colors plus black and white, and the barest arrangements of lines. Then, methodically, he fills his art back up again with colors in syncopated combinations, reaching his ecstatic climax in the final pictures" (Kimmelman, 12).

Matisse was interested in popular dance—perhaps influenced, as he claimed, by specific memories of a Catalan *sardana* or Montmartre *farandole*— and wished to focus on the dance as "an expression of purely physical abandonment of lusty forms and sense intoxication" (Barr, 56). For Matisse, himself sometimes a formal Edwardian, the dance was, as Rosamund Bernier puts it, "the embodiment of the Dionysian element in life that he liked to watch on Sunday afternoons at the Moulin de le Galette in Paris, where young people would join hands and fling themselves around to the music of the farandole" (80). In a sense, he was like Yeats, who used the image of the dance in "Among School Children" to enact the inseparability of the dancer from the dance, "O body swayed to music," as a figure for the organic nature of art. Yeats is idealizing dance as an image of spontaneity and organic unity, but dance, we realize, is also a self-fashioning escape from the daily self. Given his familiarity with modern painting, Stevens's image in *Sunday Morning* (1915) of a "supple and turbulent" chanting group of men in orgy on a summer morn might have derived from Matisse's painting of the dance, if not specifically *Dance II*: the men's lyricism, energy, and passion are devoted to singing of physical life in contrast to "the tomb in Palestine" in the following stanza. The quoted stanza, which was part of the 1915 version

published in *Poetry*, affirms the primacy of human life in tune with nature. The poem's primitivism and atavistic energy recall *Dance II*. In dance, for Matisse and for Yeats, form and content are inseparable. Both are trying to capture nonverbal and ritualized art forms in visual terms. In *The Dead*, quadrilles and lancers are a respite for Gabriel and an oasis for the reader from his paralytic self-consciousness. If we think of Mrs. Ramsay's role as a choreographer of souls, we see that Lily's painting in *To the Lighthouse* takes its energy from The Dance. And the libidinous sexual energy of Molly and Bloom's shared sexual memory of a picnic on the Howth is rendered in lively, Impressionistic colors as if it were a Monet or Bonnard. Indeed, isn't their recollection a version of *Déjeuner sur l'herbe*? (I am doubtful, as Jack Flam argues, that all the dancers in *Dance II* are female, although *Dance I* could be read that way [see Flam, 288].)

Like figures in *Lord Jim*, Matisse's figures are poised between a realistic and an aesthetic world. *Dance II* enacts the primitive fantasy that informs Conrad's Congo and Patusan, including the female figures of the savage mistress and Jewel. In *Heart of Darkness*, Marlow speaks about how he was tempted to go ashore for a howl and a dance with savages; Matisse and Picasso would have endorsed Marlow's words, "The mind of man is capable of anything—because everything is in it, all the past as well as the future" (540). Just as Matisse's reflective *Music* and libidinous and fantastic *Dance II* inform one another, so in *Lord Jim* do the realist perspective—of both the *Patna* collision and Jim's subsequent trial after the officers desert—and the romantic perspective of Patusan inform one another. Similarly, in *Heart of Darkness*, Kurtz's reversion to savagery and Marlow's often reflective (and, later, retrospective) psychological response are counterparts to one another.

Much like Yeats's "Who Goes with Fergus" (1892), *Dance II* is about the effort to escape from the turmoil—the hopes and fears—of this world to an idealized one and, finally, about the failure of the effort. It is a story of movement, primitive ritualized movement, and of escape from the diurnal world to an aesthetic realm where dancing is perpetual, and sensuality and passions renew themselves in their very enactment. *Dance II* is also a story of the preeminence of design, decoration, color, and form over theme, proportion, and relevance. Matisse actually thought of his paintings as emitting light (Gowing, 107). Like Yeats's 1914 companion poems "The Magi" and "The Dolls," his *Dance II* is a story of both movement and suspended animation, passionate sensuality and detached perspective; as Gowing writes, "The whole vision of the picture is in a sense contradictory, the indications of movement counteract each other; even the cursive slant of the foregrounded figure is held in check" (Gowing, 87). Gowing has suggested

the echo of Dante's seventh circle of hell where those who have committed violence against nature are condemned to perpetual motion; perhaps the "Hades" section of *Ulysses* recalls this, too.

Dance II is a story about the search for lines—curved lines—and color. It seems as if the circle were revolving in both directions—or neither. The vibrant lobster-color vermilion takes us outside the morphology of representation; it also suggests humankind's precrustacean antecedents. It is as if the sunlight that is absent reappears in the bodies—the sensuous bodies of the dancers. The broad brown lines with which the figures are drawn reinforce the sensuality of the figures. The green grass for the hill suggests fecundity— reinforced by the obvious pregnancy of the top figure whose legs are spread as if she were either receiving seed (or expected to, perhaps from a god) or were about to give birth; the deep blue sky suggests life, health. While Matisse wanted spring colors for symbolic association, he wanted to undermine the colors with the action and with the ominous quality of the coloring. Yet, as decoration, Matisse wanted "all my colours [to] sing together like a chord in music" (quoted in Elderfield, 56). Matisse had depicted six dancers in *The Joy of Life* (1905-6), but here he discarded one female and intensified the dynamic energy of the dance. In an earlier *Music* (1907) he had depicted a violinist, a sitting woman, and a couple embracing while dancing; this suggests that the musicians may be standing embarrassedly in front of the dancers with their backs turned. The contours of the figures dancing are conveyed with precision. One model for the pagan energy might be the decoration of Grecian red-figured vases. What makes the painting so appealing to the gaze is that all the figures have their own stories.

But perhaps the shadows—shadows far more pronounced than those that could be thrown by the figures in the painting—along with the darkness of the blue suggest something ominous and threatening; could it be death, temporality, or the specter of history lurking over the shoulder of primitive and libidinous rites? The darkened blue at the top seems to be increasingly intruding on the dance. And, in another intrusion of reality into the romance world, even the dancers seem to be dancing different kinds of steps. It is as if they were dancing together but not hearing the same music; that they are separate even in their moment of togetherness is underlined by the darkening patterns within the blue, as if a stormy disruption were ominously hovering above the unsuspecting dancers. And they are dancing more in the blue than in the green.

The energy and spontaneity of the dance are somewhat undermined by the lifelessness of the dancers' expressions; perhaps this is the price of journeying to the aesthetic realm where Yeat's Fergus rules the brazen cars

and Kubla Khan decrees stately pleasure domes. In *Dance II*, the left, apparently male, figure is positioned in an elegant bow from his left leg to his left arm, and he seems to be leading or trying to lead the dancers in a clockwise pattern while doing a classical ballet; the pregnant figure is dancing in frenzy—exposing her sexual organs, which are emphasized by the shadow—as if she were doing a fertility rite; the figure on the right with legs widely spread is skipping or perhaps kicking up her leg toward the center as if in a square dance, and she uninhibitedly is looking toward the androgynous (or perhaps male) figure to her right, who is slightly turned toward her and who was female in *Dance I*. The eternal circle is broken by the hands that do not touch—the hands of the elegant muscular male on the right and the desperately reaching, heavy-thighed woman in the foreground. And the hands of the pregnant figure are also disconnected from the apparent male leader as if he were narcisstically and erotically in his own space. Meanwhile, the foregrounded figure is falling forward on her knees, perhaps because she cannot keep up; she has lost touch with the male figure to her left and may be losing her hold with the figure to the right. Perhaps the foregrounded figure leaning in is falling down; indeed, her body is not only on the earth but almost in it, as if the hill were opening up to be her grave. She is the only one whose toes are not in frantic motion. Matisse may be ironically recalling Michelangelo's *Creation of Adam* in the Sistine Chapel, where the hands do not touch. It is possible to imagine a terrible moment when she has fallen ill in the frenzy of the Dionysian moment.

In *Music* (1910) the five musical figures are male or androgynous—certainly the two on the left seem to be eunuchs—and static, and not in connection with one another. We think of the epigraph to E. M. Forster's *Howards End* (1910): "Only Connect." The zombielike figures recall Matisse's *Game of Bowls* (1909). Certainly the relationships—such as they are—are joyless. What could be more eloquent than the space between the characters: their different placement on the slope of the hill and their indifference to one another? The three male figures are in a kind of triangle, and each covers up his nakedness in a different way. The figures are all male. The genitals of the double fife player were visible, but Sergei Shchukin—who commissioned the painting for his Moscow town house staircase—had them painted out. The figure on the right is oddly out of proportion; notice the immense distance from foot to navel. Could their embarrassment be postlapsarian or related to what they have seen or participated in? Is there a hint of orgy and dissipation? That the original double fife player had his genitals exposed would have created a linear narrative tension as the perceiver's eye moved from left to right. As if this were a later and ironic sequel to *Dance II*,

spontaneity and joy turn to embarrassment and humiliation; this is a post-lapsarian vision of the Garden. These figures have eaten from the tree of knowledge. (Is that perhaps why we see the navels of two of the musicians?)

Yet could the musicians be facing the dancers and even playing for them? Or are they embarrassedly playing for and simultaneously watching the dancers? The painting is immobile and the characters are enervated, as if anesthetized; the figures are in repose, almost as if they were lotus-eating. Isn't there in *Music* a calmness approaching passivity? All the figures' feet are ostentatiously on the ground. What, we ask, has happened to the Arcadian dance? Yet we recall that *Dance II* was *not* so innocent. For we remember the descending shadows from the dance; if anything, the blue is brighter, and the purple shadows are still present. Because the darker, shadowy blue at the top is less intrusive than in *Dance II*, the blue *seems* lighter. Here we have music—music that was absent from the visual depiction of *Dance II*, but the musicians seem to be playing alone and without joy. According to an ingenious suggestion of Flam's, the picture embodies music: "The standing violinist on the left . . . acts as a G clef at the beginning of the bar of music in which the other four figures embody musical notes. The line of the hilltop acts as a kind of figured bass (or violin melody?) against which the other notes are set" (283); Flam believes the three figures on the left are singers, but if so, their lyrical wings have been clipped. In any case, the dense brushwork and bright colors create much of whatever energy the five passive figures have, especially the three on the left.

That the figures are sculpturally chiseled almost like a Massacio or even a Mantegna is emphasized by the thin black lines outlining them. They recall Matisse's sculptures of the period. The figures sit on a green hill that occupies a much larger proportion of the space in relation to the blue, but the darkening shadow of the green also has an ominous aspect. Perhaps because the painting is static, it seems more removed from time and the figures more timeless and less vulnerable to mortality. Yet the embarrassed, covered-up figures remind us of the ephemerality of life; their seeming awareness of an audience places them at a later stage of civilization than the dancers. The primitive and libidinous energy that characterized *Dance II* has been undermined by the tightly closed legs of the left three figures, who not only play no instruments but are constrained by embarrassment. Indeed, even the two figures on the right playing their instruments—the Chagallian fiddle and the primitive double whistle or twin pipes—look stilted, constrained, self-conscious, stifled, and joyless and do not seem to be playing together as a duet. Perhaps Matisse's darker vision in *Dance II* was influenced by Degas.

Matisse, we recall, was an enthusiastic amateur violinist; he may be ironically putting himself on the right as the elongated leading player, as if he were conducting his own composition. As we move—or read—from left to right, the figures lose their distinguishing features; moreover, as we move from left to right, the distance between them seems accentuated. The one on the left is a far more pronounced and developed figure; the second one has some distinction to his nose, a navel, and is unselfconscious. Paradoxically, the light is generated from the sitting, expressionless figures because they contain no distinguishing features. The third figure has his knees over his legs and his right hand buried in his private parts. The fourth figure has a different way to cover himself, and the fifth, with his knees together, has a quizzical if not comic aspect, and his hands between his knees.

All the figures are primitive forms but lack primitive energy; except for the unnaturally tall and elongated fiddler, they do not have necks. Their nondescript features nullify their humanity. As if they were rag dolls or doughboys, they have no features, gestures, or teleology. They each look out of place and out of proportion, for they are not drawn to scale; they are as deracinated in their psychic and moral space as they are unrooted to their physical space. If anything holds the painting together, it is a unity of decoration, which is deliberately antithetical to the characters disunity of purpose. That unity recalls the simplicity and energy of primitive art but enacts Matisse's insistence on subordinating subjects and themes to the art of painting. Just as there is something obsessive about Eliot's insistence on form in *The Waste Land* (1922) and Joyce's in *Ulysses*, so is Matisse obsessed with formal resolution, which deflects him from psychological precision. Yet isn't *Music*, as much as Mann's *Death in Venice* (1911), a comment on the breakdown of an organic community—the ennui, hopelessness, and power-lessness—with which artists responded to the gathering storm of world war that hung over Europe and the world?

Both paintings are ritualistic, primitive, and pagan. They have nothing and yet everything to do with Europe in 1909-10. We recall, do we not, how the women's suffragette movement seemed to add to the strains of liberal democracy? In a sense, the desire to escape the here and now motivates Matisse's—and Modernism's—interest in the cosmic and the mythic. Yet the darkening shadows and the falling women imply incipient disaster, as if to say the escape to form and decoration is finally impossible. *Music* enacts a terrifying image of isolation. Yet if music is the most ethereal and spiritual of the arts—the music of the heavenly spheres—it is in this painting diminished and ironized. The males are separate and incomplete, in part

because of the absence of the women who are in the ontology of the companion piece, *Dance II*.

Paradoxically, these objective, detached formalist paintings become narratives to which we respond in terms of hermeneutics. And it is characteristic of the difficulty of Modernism—even when it proposes a narrative of forms, a narrative of semiotics and of rhetoricity—to evoke from the spectator a hermeneutics that insists upon meaning. For narratives are both within art and the stories we tell about art. The American Modernist Stuart Davis thought that rather than abstraction, modern art employed *extraction* and that *extraction* was not the music of the ears but the music of the eyes. With his odd nude figures, hidden suggestions of dissipation and orgy, and bizarre color, Matisse's paintings invite and play upon the gazer's curiosity. Let us recall Lacan's insight: "The painter gives something to the person who must stand in front of his painting which, in part, at least, of the painting, might be summed up thus—*You want to see? Well, take a look at this!* He gives something for the eye to feed on, but he invites the person to whom this picture is presented to lay down his gaze there as one lays down one's weapons" (101). But, I believe, our response to the invitation elicits—indeed demands—a more attentive gaze, an engagement of attention; as our attention becomes aroused, the gaze becomes intensified—becomes a *need*, a desire, an enactment of our necessity to control—and reads the text of paintings with the same kind of visual acumen as we read a text. The gaze is a way that we define ourselves as subject, give meaning to object, and control the not-I world in which we live. It is shaped by our psyche and values and our psyche and values are modified by it. For those who are not blind, the gaze is an essential part of our identity. Without a gazing observer, the painting does not live. But, just as when we read, we move beyond the gaze to cognition and to reflection on what we have seen and subsequently understood in terms of what we know. And when we reread we are gazers—voyeurs—and yet also we are in the position of being tempted to lay down our gaze and participate. Isn't that tension the very essence of Marlow's role as dramatized perceiver in *Heart of Darkness* and *Lord Jim*?

VII. Picasso's Response: *The Dance* and *The Three Musicians*

Picasso's *The Dance* and his two versions of *The Three Musicians* are not only in a narrative relation to one another much like Matisse's *Dance I, Dance II,* and *Music* are, but they also comment on Matisse's work. Thus the plenitude of

Matisse's two paintings depends on Picasso's reworking of them and vice versa. In terms of our narrative, the Matisses prefigure the Picassos, which fulfill them. Matisse's *Dance II* and *Music* are often the embodiment of controlled, reserved, and balanced aesthetics, while Picasso's companion pieces—like most of his work—are passionate, intuitive, and expressionistic. Matisse and Picasso's differences are not unlike the differences between Conrad, James, and Joyce, on the one hand, and Hardy and Lawrence, on the other.

As if to stress his independence from Matisse, Picasso turned to music before dance. Preserving the Matisse contrast between *Dance II* and *Music*, both versions of *The Three Musicians* (Zervos IV 332 in Philadelphia and Zervos IV in New York) are far more static and immobile than Picasso's later *The Dance*. The clown's costume itself suggests Matisse's decorative quality. But the Philadelphia painting (see page 170) is more controlled than the New York one (see page 171). The Philadelphia version is 80 by 74 inches, and the New York version is 79 by 87 $^3/_4$ inches. Both versions echo the Holy Trinity from Renaissance painting and they remind us, as Russell notes, of a "trio of judges—robed, remote and yet with power over life and death—who gaze back at us in Daumier, and later in Rouault" (262). The Picassos under discussion also owe something to Renaissance triptychs and Renaissance compositions that take the eye to the middle. Russell also calls attention to the Cubist echoes: the clarinet, the sheet music, the guitar, and the study table; in the Philadelphia version, the harlequin, somewhat surprisingly, is playing the violin. In the New York version, the figure on the right is tearing the paper of the sheet music.

The *Three Musicians* is a Cubist response to Matisse. As in the later *The Dance* (which at times has been called *The Three Dancers* but which Picasso called *The Dance*, I suspect, to deliberately echo Matisse and focus on the parallels)* the musicians are squeezed into a claustrophobic indoor space; their tiny hands are way too small for these figures, as if Picasso were trying to revivify the life of Matisse's anesthetized figures in *Music*. The figures are taken from the *commedia dell'arte* tradition, specifically the Pierrot, harlequin, and Pulcinella, who is an absurd, grotesque, barrel-bodied intriguer who gets in and out of scrapes. In the New York version, Pulcinella is disguised as the

* John Russell, for example, calls the painting *The Three Dancers*, but since the authoritative catalog for the 1980 exhibit refers to it as *The Dance*, I shall refer to the painting by that title. The catalog is entitled *Pablo Picasso: A Retrospective*, edited by William Rubin.

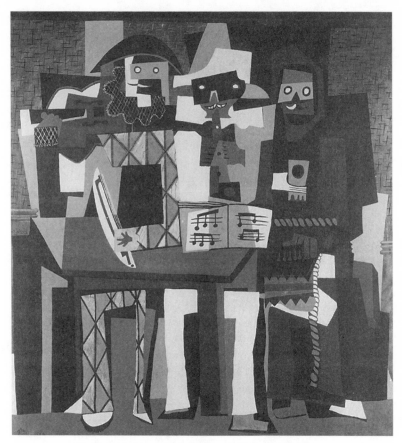

The Three Musicians, Pablo Picasso (1921); Philadelphia

grim reaper, *mori*, but we see his quixotic face beneath the masque. Pierrot usually wears the white costume and has a whitened face. It is a more coherent group than the figures in Matisse's *Dance II.* All the figures are masqueraded. By contrast, the Philadelphia version is more joyful; all the players seem to be smiling; the frayed lace on the front of the clown who is on the right seems less ominous; brown, not black, is the dominant color, and white is more prevalent throughout, although nothing is as pure white as the first figure in the New York version.

In the Philadelphia version, we have a sense of musicians playing— practicing but not performing—in a room, and we can see an elaborate

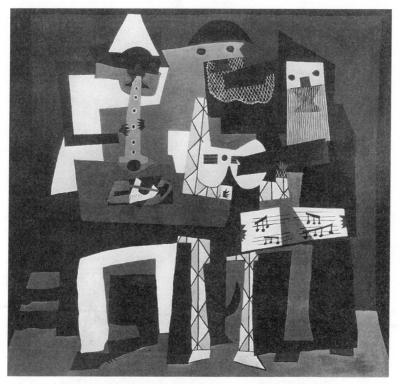

Three Musicians, Pablo Picasso (1921); New York, MOMA

molding in the background of the first two figures on the right. The red flower recalls the red of Matisse, and the whole painting is far more decorative than the New York version. By contrast, the New York version is framed on three sides by a very dark brown—approaching black—box; we have a sense of the players in a small enclosed room like the hotel room Gretta and Gabriel inhabit at the end of Joyce's *The Dead*. The prominence of the yellow guitar recalls the Fauvist influence in which color was freed from the morphology of representation. And the player wearing white is holding a phallic-looking clarinet with a ball, perhaps suggesting the scrotum. On the left of the much sparser New York version is a black figure suggesting death. It is almost as if he wore a monk's robe; he is a grim figure geometrically defined, cold and detached. That the robe is indeed a monk's frock is emphasized by the elaborate hanging rope of the figure on the left

in the Philadelphia version. Notice how the black on both sides intrudes onto the clown's outside legs and how even on the inside of his right leg the ominous animal's tail seems to be inside another black intrusion. In what might be called a narrative of color and space, black is coming forward from the background. In the New York version, the movement from white to black through the multicolor clown figure playing the guitar suggests the inevitable movement from life to death. The black figure is not only separated into two vertical pieces but holds a torn version of the score; in contrast, in the Philadelphia version, the middle figure holds an untorn score and the clown is on the right.

Stretching from the middle—notice its black tail—to the right is a black wolflike animal; while a dog suggests loyalty, the wolf is more ominous. Indeed, is it an animal or a shadow? William Rubin has noted how the static and immobile quality—its severity of structure—gives the painting an almost Byzantine quality.[+] And while the paws might belong to the same animal as the wolf, it is possible that the wolf's head is a different animal from the creature lying on the floor, its tail pointing out. The clown's body gives way to the black figure or plane that includes the head—as if the black were intruding, even preying—upon the clown's music. Only the mostly white Pierrot figure is smiling; the others are faceless except for anonymous eyes and geometric features that make them look more like ominous death heads. Notice how the small carnival masque of the Philadelphia figures have been replaced in the New York version by frightening face covers that blot the former joy of their features. The disintegrating, frayed lace covering the middle figure also suggests mortality. Indeed, the receding planes seem to end in black for all three figures. Each version defines the other. It is almost as if in the New York version the colors—the purple plane (anticipating the purple between the windows in the later *The Dance*), the black, and the brown background—are contending for space and control. Like Stevens's poem *The Man with the Blue Guitar*, the New York version is also a narrative of the metamorphosis of color. The blue-purple could be seen as a guitarist who would displace the two commedia dell'arte figures. The clawlike feet on the figure in black also likens him to the animal on the right. Nor is the black absent from the first figure's

[+] "In compositional terms the New York version has a severity which," as William Rubin says, "might seem more appropriate to a Byzantine *maesta* than a group of maskers from the commedia dell'arte; but it is precisely this structuring that informs the monumentality of *Three Musicians* and endows it with a mysterious, otherworldly air" (*Picasso in the Collection of the Museum of Modern Art*, 263).

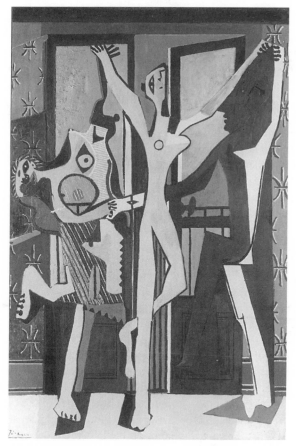

The Three Dancers (also known as *The Dance*), Pablo Picasso (1925)

neck and arm or from the outline of the table on which his music rests. And the triangular hat on the Pierrot figure—recalling Picasso's 1918 *Pierrot and Harlequin*—also suggests the garb of a clown or a street performer.

The Dance (see above) provides a narrative comment that gives the earlier works a place in a narrative sequence. *The Dance*, like so many of Picasso's works, has a strong autobiographical element and reflects his increasing unhappiness with his marriage to Olga. According to Jane Fluegel, the figure "in profile in the window at right" commemorates "the death of his friend Ramon Pichot" (quoted in Rubin, 252). Indeed, Pichot was something of a father figure to Picasso. In 1965 Picasso said the painting

ought to be called *Death of Pichot*; however, like most of his retrospective comments, we need to consider them without letting them dominate our perspective. Yet Pichot's death seemed to remind Picasso of Carlos Casegemas's 1901 suicide; Casegemas had become depressed over his obsession with a woman named Germaine, who was to become Pichot's wife. Notice how metaphorically and autobiographically Picasso, like Stevens and Joyce, thinks; in terms of this biographical metaphor, the woman, Germaine, could be the woman on the left, Casegemas the crucified figure, and Pichot the figure on the right. The woman crucified owes something to the woman falling down in Matisse's *Dance I* and *II*. If, as the Tate catalog (1979) claims, Picasso's starting point was three dancers rehearsing in front of French windows, the painting moves a long way from its donnée. John Richardson calls this painting "the great balletic organization" (I, 139).

We read paintings spatially—letting our initial reading intensify as we perceive the elements in configuration—and temporally. Picasso's *The Dance* is expressionist in character and passionate in intensity. On the left, we see a kind of willful decomposition of the body, and in the center is the crucifixion. As we read from left to right—not the only way, but a way of reading narrative in painting because it is a mode of reading to which we are accustomed—on the right is the larger-than-life black head as if doom were enclosed within the space of the room. With hands outstretched against a column, the middle figure of *The Dance* suggests the crucified Christ—the kind of Baroque and mannerist Christ that young Picasso would have seen in statues and paintings in Spanish churches. But her outstretched arms also recall the characteristic pose—captured in photographs of the period—of the dancer Isadora Duncan. The brown and white sitting figure on the right could be the artist drawing the figure on the left, while the middle figure recalls the crucified figure of traditional paintings; indeed, the middle figure is transformed from the joy and energy of the first figure, and soon goes with the ominous tricolored third figure. Also, the three figures are, from left to right, Picasso's conceptions of the diverse roles of the artist—the artist as performer, the artist as victim, and the artist as onlooker; all are shadowed by the huge black profile on the left, suggesting mortality lurking behind them and the onlooker. Furthermore, the three aspects—white, brown, and black—of the third figure are, in a sense, another subtle reason for the painting's alternate title, *Three Dancers*, although as the right figure recedes, so does the motif of dancing. Finally, from another perspective, as we move from left to right, we move from a primitive dance to a baroque version of the classical to the geometry of the modern dance. Did Picasso, who knew Wilde's work, have Wilde's *Salomé* in mind?

The deep blue background of *The Dance* suggests Matisse; so does the highly textured wall decoration and the red floor mat. With their out-stretched hands touching one another, the figures suggest the Matisse painting, especially its ritualistic circle. Picasso's painting has a point of view and a highly regulated and controlled sense of space in which the Christ-like figure is the organizing principle. Nor should we ignore the decorative nature of the colors in tension with the blatant sexuality of the first figure's upturned nipple, the breasts of the second figure, or the arresting and resistant motion of the figure on the left. The tone is bizarre, suggesting an odd cacophony of life and death, of solemnity and grotesque. We might think of the final party in Woolf's *Mrs. Dalloway* and Septimus Smith's role in the organization of that novel as a way of pointing out the way society takes its toll on individuals, saps their energies, regulates their talents and, more important, their needs, and organizes itself in a way that is indifferent to the needs not only of outsiders but of apparent insiders like Mrs. Dalloway. As in the Picasso painting, self-consciousness and death are crucial issues.

Let us return to *The Dance*. From one perspective the frenzied dancers recall Matisse's broken circle in *Dance II*. The back railing suggests limits and control, as does the formal design of the wood underneath. It is an odd and tense juxtaposition of, on the one hand, the control of a Dutch interior with, on the other hand, wild emotional abandonment. Is the protrusion on the top of the second vertical on the left a bird? The jagged edges of the woman on the right—in her foot, her crotch, and her left side—are reinforced by the enclosing railing as if to signify punishment and imprisonment. The ominous red on the floor and the black windows reinforce the crucifixion suggestion of the central figure's hands. The female figure on the left dances in a way that flaunts her sexuality. Her facial features—the eyes on her head and chest—become metonymies for bodily apertures. The shape of the openings in which the blue sky penetrates are sexual. The primitive head suggests an African mask; the crescent itself, in part because it recalls the melon slice in the foreground of *Les Demoiselles*, is sexually suggestive. The eye goes then to the right to the complex abstract figure—or figures—on four planes: brown, white, black, and, indeed, red. Notice, too, how the figures dominate the space unlike in Matisse's painting *Dance II*. It is as if the brown figure were the shadow of the white one, the red the outrageous reflection of the brown and white, and the black the shadow of the other three. The kind of doubling in which each figure is replicated by another is central to the reflexive structure of *Lord Jim*, a structure that is part of Modernism's obsession with doubling and mirroring; there, too, as in the

two versions of *The Three Musicians*—which echo and comment upon one another—each figure becomes a metonymy for the other, and by doing so, calls attention to the fictionality of the works of art.

John Russell emphasizes the pain of *The Dance;* to be sure, the distorted figure at the left suggests both the upturned head on the left in *Guernica* and the figure on the right in the same painting holding the dead child. But to say, as Russell does, that the painting "speaks for a grief that is violent, destructive, and disorderly" (270) misses the sensual abandon, the insidious sexuality of the other two figures holding hands behind the back of the central figure. According to Russell, the figure on the left is a re-creation of the "Maenad as Bacchante, a motif first known to us in Greek reliefs and later taken up by Donatello when he grouped the three Marys at the foot of the cross" (270). It brings together the combination of grief, mourning, sensuality, hyperbole, and frenzy. In her disorderliness, grimace—contorting face, bodily convolutions—she stands in stark contrast to the more passive crucified figure. And Picasso, like modern writers, lives in a system in which prior artists—in this case, Donatello and Matisse, among others—are always synchronically present as ordering principles and as strong father figures who *need* to be redefined and transformed.

The tone of *The Dance* is frantic to the point of being terrifying; the figures are asunder and do not fit together. It is as if both in form and in content the looming third figure on the right were a parody or deconstruction of the rest of the painting. Black overwhelms the third figure. In the form of the profile of the giant black primitive head—a head in silhouette, which seems to belong to an intruding figure of prey, death stalks the vitality of the dance and reconfirms the ominous nature of the androgynous Christ-like figure, the Christ-figure with its spiderlike fingers or perhaps right-hand nailed. Yet the dance has vestiges of civilized life as befits its setting in Monte Carlo: the decorative Matisse-like patterned wallpaper, the tall French windows opening to the Mediterranean blue sky, and the suggestion of the women on the right playing a blue guitar. Does the bluish purple layer allude to Matisse's blue sky? The room's designed woodwork and wallpaper are highly decorative and create a tension between the formality of the room and the libidinous and frightening behavior of the dancers. The dancers' uplifted feet have a more controlled and civilized dimension; indeed, the man on the right is doing a kind of restrained step, a minuet, with the frenzied women as if he—a metonymy for the artist?—is trying to bring her under control. Do the apertures of the middle and left figures suggest a kinship? What about the left figure's probing white object touching the black aperture of the brown figure? The shadow of the frenzied dancer with her huge

outstretched nipple is what the shadowy black figure is watching; indeed, the third figure joins hands with the first behind the second as if in lust and in some conspiracy at the expense of the victimized second figure. Black overwhelms the third figure. Note how his white hand is divided by a line that could be a decoration in his glove or a fracture to remind us of the unjoined hands in Matisse's *Dance I* and *II*. Even the monochromatic middle figure is shadowed by the black frames of the windows. These frames, like the purple that divides the windows, remind us gazers that Picasso's *The Dance* is indeed a *painting;* the hands of the other two figures that join behind the central woman figure bring their respective colors into her ken. And we realize that the first figure has three components: flesh, brown, and black, although her flesh dominates. So suggestive of the sexuality of naked feet in traditional paintings, the dramatic feet provide an enclosed narrative within the larger painting; the right foot of the first figure is pikelike, as if anticipating the mock crucified figure in the middle; the toes are still present in the right foot of the central figure before disappearing in that figure's left foot; toes are absent from the third figure, as if the story were a narrative of the diminishment of passion and the libido—recalling the feet of the falling-down figure in Matisse's *The Dance.*

Six

Searching for Modernism's Genetic Code: Picasso, Joyce, and Stevens as a Cultural Configuration

I.

In this chapter I am going to consider three figures—Picasso, Stevens, and Joyce—and inquire into what cultural forces produce their common bonds. John Richardson's biography of Picasso—the first two volumes of a contemplated four-part study were published in 1991 and 1996—establishes the artist's importance to the history of Modernism and his stature as the predominant figure in twentieth-century painting. While the culture in which any artist creates depends in part on extant cultural assumptions, including symbolic structures, Picasso, as much as any artist, contributed originally to the reservoir of available symbols his successors inherited. In his major works, such as *The Old Guitarist* (1903), *Les Demoiselles d'Avignon* (1907), *The Three Musicians* (1921), *The Dance* (1925), and *Guernica* (1937), he left images for his successors to wrestle with. These paintings became the texts that more than any other œuvre created our understanding of modern painting and became the standards by which subsequent painters measured themselves.

James Joyce, Wallace Stevens, Pablo Picasso—great Modernist figures: Joyce, perhaps the most important twentieth-century novelist; Stevens, the American poet who best captured the American sensibility in the twentieth century; and Picasso, undoubtedly the preeminent modern painter. They were born within a few years of one another—Stevens in 1879, Picasso in 1881, Joyce in 1882—and were deeply affected by the

crisis of belief, the explorations of modern science and technology, the development of the modern city, and the changing perceptions of reality. More than any other Modernists, Picasso, Stevens, and Joyce invented forms, techniques, and modes of perception that became part of the cultural genetic code. Yet each of these three figures revitalized the forms in which he worked and became a paradigm for successors.[*]

All three knew that they were auditioning for the role of major artist, the successor to the giants who preceded them. All three were deeply influenced by the canon that preceded them and needed to be understood in terms of the traditions and contexts in which they wrote and painted. All three were haunted by personal and cultural memory—for Joyce, the Irish experience; for Stevens, the democratic and transcendental traditions of the American mind; for Picasso, the Andalusian, Catalan, and Castillian traditions fertilized by the world of Paris. In the work of all three, the dead— particularly dead artists—live as if they were alive, and all three—unbelievers in God—are haunted by the specter of their own death. (We need to maintain a healthy skepticism about Stevens's alleged deathbed conversion to Catholicism.)

Just as Joyce saw himself as the successor to Homer, Dante, Shakespeare, and Milton, so Stevens saw himself as the heir to Emerson and the English romantics. Picasso, Joyce, and Stevens are in a continuing dialogue with the past from which they take much of their meaning. They are consciously creating a modern tradition by reinterpreting the tradition that precedes them. For example, *Les Demoiselles d'Avignon* comments on El Greco's *Apocalyptic Vision* and Cézanne's various *Bathers* as surely as *Ulysses* comments on *The Odyssey* and other prior works, and as Stevens comments on Emerson, Whitman, Keats, and Shelley. Picasso, Joyce, and Stevens sought archetypes as the common denominators of human experience. They wished to create modern symbols. They sought to create imagined worlds that would reinvigorate the nominalism of modern experience and enrich the day-to-day tedium of what Stevens calls in "The Man Whose Pharynx Was Bad" "the malady of the quotidian." Each wished to balance romanticism with classicism.

[*] At the outset, I want to make clear that this story of *male* artists is one component of Modernism's genetic code. I have discussed Virginia Woolf's work and importance in *The Transformation of the English Novel, 1890-1930: Studies in Hardy, Conrad, Joyce, Lawrence, Forster, Woolf,* 2nd ed. (New York: St. Martin's, 1995) and understand that she could and should be part of a different cultural configuration.

As I have been arguing, the very process of role-playing—experimenting with diverse styles while rapidly changing styles and voices—is an essential part of Modernism. Role-playing is crucial to all three of these towering Modernist figures. In a world where a systematic worldview is impossible, *inclusiveness of possibility*—of multiple ways of seeing—is an aesthetic and a value. Isn't the essence of Cubism the insistence that we need not restrict perspective and that reality depends on the angle of vision? Borrowing from astronomy, Joyce used the concept of parallax in *Ulysses*. In *Les Demoiselles d'Avignon*—we recall from chapter 5—the frontmost naked figure, a whore, is simultaneously looking forward and backward and has the body of the *female;* her African mask with its wild libidinous energy mocks the restrained and repressed world of conventions and commerce. But the figure's mask also could suggest the *male* artist looking outward and inviting his audience to see the still life of fruit in the foreground, which he is exhibiting for a commercial audience to whom he is desperate to sell pictures. The position of the modern artist—like himself—who lacks patrons and wealth, Picasso implies, is not so different from the way that the whores are offering themselves to clients; indeed, perhaps the distorted facial expression owes something to Picasso's discomfort with the *role* of the artist as salesman peddling his wares.

Picasso, Stevens, and Joyce all knew how the specific underlies the universal; each had a remarkable eye for detail. What John Richardson writes of Picasso is true of Stevens and Joyce: "[H]e had learned how to exploit his inherent gifts for caricature in depth as a means of dramatizing psychological as well as physiognomical traits" (285). Each of our three figures combines in his work, "sacred and profane, demonic and angelic, mystic and matter-of-fact" (270). Each employs an element of magical realism to intensify and give mystery—and comedy—to the world he observes. Painting on his Barcelona studio wall "the half-naked body of a Moor with an erection, suspended from a tree," Picasso anticipates Joyce's morbid yet hilarious equation of orgasm and death in "Cyclops," when the alleged perpetrator has an erection as a result of being hanged *before* his trial (I, 287).

Picasso thought of his works as a diary and the history of his art as his autobiography: "My work is like a diary. . . . It's even dated like a diary" (John Richardson, 3). His work is deeply and profoundly autobiographical. For Picasso, like Joyce—to quote what Stephen Dedalus said about Shakespeare as the prototypical man of genius—"found in the world without as actual what was in his world within as possible." He used his paintings not simply to reflect his feelings but to create his identity. Picasso's art was exorcism of his feelings, but is that not equally true of Joyce and Stevens? Picasso, we

are told, "said that his sculptures were vials filled with his own blood" (John
Richardson, 461), yet when he depicted himself in self-portraits, he wanted
to move beyond the lyrical to the dramatic and epical—as Joyce did in
Ulysses—and see himself as other. For example, in the famous 1906 *Self-
Portrait*, which was indebted to Manet's *Portrait of a Man* (1860), "He also
switched his gaze away from the beholder, to demonstrate that this is no
mirror image, but a detached view of himself" (472). For Picasso, the artist's
creative imagination has the power to recast the world, but he does not
ignore the world beyond that imagination.

In *The Necessary Angel*, Wallace Stevens wrote, "It is said of a man that
his work is autobiographical in spite of every subterfuge. It cannot be
otherwise" (121). Yet the coherent self of a major artist is a myriad of selves,
roles, voices, and positions. John Richardson shows how deeply personal
and autobiographical Picasso's work is. Not only does he stress the impor-
tance of Picasso's self-portraits, but he interprets many of the masterworks
from, among others, an autobiographical perspective. Beginning with trac-
ing Picasso's Andalusian roots, Richardson shows us the folly of separating
an artist's life from his work and shows that the dialogue between the
individual experience and the cultural experience is necessary to answer
questions about an artist's themes and styles:

> [B]eing Andalusian, he was apt to be at the mercy of this obsession
> [with mortality], just as he was apt to be at the mercy of that Andalusian
> obsession, the *mirada fuerte* (literally, "strong gazing")
> . . . The *mirada fuerte* is the key—the Andalusian key—that helps
> unlock the mysteries of Picasso's late work, and of his work as a whole.
> It helps us understand his recurrent references to voyeurism; the way
> he uses art and sex—painting and making love—as metaphors for each
> other; and his fascination with genitalia—all those ocular penises, those
> vaginal eyes. (10)

Picasso found his metaphors in biography. Just as Joyce showed how one
figure could become a synchronic and diachronic metonymy for another—
synchronically: "Jewgreek is Greekjew," "Blephen and Stoom"; diachronically:
Bloom as Odysseus, Moses, Shakespeare; Stephen as Telemachus, Christ, and
also Shakespeare—Picasso used figures metonymically in his imagination.
Thus in *The Poet Sabartes* (1901), he is recalling Carles Casagemas, a friend who
had recently committed suicide; by envisioning Jaime Sabartès's likeness to

Casagemas, a not very promising poet, Picasso is using the technique of summoning something absent for means of comparison, as Joyce did with *The Odyssey* in *Ulysses* and as Stevens did in his great 1921 lyric sequence, "The Man whose Pharynx was Bad," "The Snow Man," and "Tea at the Palaz of Hoon," a sequence in which he refers to Shakespeare's seventy-third sonnet, "That time of year thou mayest in me behold," and Shelley's "Ode to the West Wind." In three of his 1901 self-portraits, we see Picasso testing different versions of himself. In one signed, "Yo Picasso" (I Picasso), he is the cocky solipsist of "Hoon," full of bravura, staring boldly at the audience, daring his audience to challenge his charisma; in the second, he gazes powerfully, as if able to overcome circumstances. We think of the poet who felt the shadow of time and death in "The Man whose Pharynx was Bad." In the third self-portrait, we see the chameleonic figure—the figure of negative capability in the guise of an El Greco masque; the artist shows how he can become the figure of capable imagination who, as Stevens put it in "The Snow Man," "[beholds] nothing that is not there / And the nothing that is." In *A Portrait of the Artist as a Young Man*, Joyce uses Stephen as a thinly disguised version of himself, and in *Ulysses* he creates another version—the humane other he sought to become—in the form of the unappreciated Jewish exile, Bloom, who lives in the here and now (Aristotle's "ineluctable modality of the visible") and who increasingly displaces Stephen—now perceived as an intransigent Platonist and a jejune aesthete—as the center of his attention.

Each artist was fascinated by the role of mirrors and glass, not surprising for writers who could say, as Stevens put it in "Tea at the Palaz of Hoon" (1921), "I was the world in which I walked." While Picasso is known for his compelling and revealing self-portraits, Joyce and Stevens uniquely write about their psyche and imaginative life in their self-portraits. The crucial scene in *Ulysses* is when Stephen and Bloom look into the mirror and see together an image of Shakespeare—an image of him as a comic figure wearing a "reindeer antlered hatrack" to signify his being cuckolded. Among other things, it is a time when in *Ulysses* diachronic metaferocity and synchronic metonymy are interchangeable. For even as Stephen and Bloom take their identity from the past, they also take it from each other. In "Asides on the Oboe," Stevens describes Major Man as a "mirror with a voice, the man of glass, / Who in a million diamonds sums us up"—a man who presumably looks into his own glass to discover his capacity for responding to feelings and images in the external world: "There was nothing he did not suffer, no; nor we." The artist's soul is more encompassing and capable of greater feeling; so, too, are his creations.

At times Picasso, like Stevens, was more interested in variations on a theme in a particular idiom—multiple self-portraits, bullfighters, a plethora of paintings in blue or rose—than in the great work. Yet at other times Stevens and Picasso, like Joyce, become obsessed with the idea of the masterwork. Unlike, say, *Paradise Lost*, a great modern poem such as *Notes Toward a Supreme Fiction* or a novel like *Ulysses* is composed of variations on motifs, probes, qualifications, and even riffs that do not hold together organically. (In that way Modernism is a prelude to Postmodernism.) And that kind of ventriloquism—where the poet or novelist within a work does not speak from one sustained monologic point of view but, rather, dialogically enacts multiple points of view—is a strong feature of Modernism, what might be called the *metamorphosis* of Modernism. In "Circe" the metamorphosis of Bloom into a dog and into successive species of dogs is a trope for this process; for Picasso, it was often the metamorphosis of humans into bulls; and for Stevens, in "Thirteen Ways of Looking at a Blackbird," it was not only the various ways a blackbird could be perceived but the metamorphosis of the persona in poems such as *The Man with the Blue Guitar* (1937) and *Notes toward a Supreme Fiction* (1942).

Stevens was fascinated, knowledgeable, and deeply influenced by modern painting, and by Picasso in particular. For Stevens, Picasso was the very model of the modern artist. *Les Demoiselles d'Avignon* established Picasso as the most innovative painter of his era and opened the door to Cubism. For Stevens, Picasso was not only the towering figure of modern painting but the archetype of the kind of stature and recognition as the preeminent artist in his medium that Stevens craved. In *The Man with the Blue Guitar*, Stevens wrestles with Picasso's paintings—not merely *The Old Guitarist*, but *The Three Musicians*, *The Dance*, and a number of the major paintings and collages of guitars—as he uses the speaker to define his aesthetic. Like Joyce and Picasso, Stevens, too, employs multiple points of view not only from poem to poem but within his major works, such as *The Man with the Blue Guitar* and *Notes toward a Supreme Fiction*. Stevens owned a copy of *Ulysses* (1922) and in his 1936 lecture, "The Irrational Element in Poetry," referred to Joyce as one of those who explored the unconscious.

If Stevens's *The Man with the Blue Guitar* is a reference to Picasso's *The Old Guitarist* (1903) of the blue period, it is an ironic, subtle one. While the next chapter will discuss in detail Stevens's use of Picasso's paintings in *The Man with the Blue Guitar*, let us observe here that the passionate singer of Stevens's poem is not the blind and probably deaf figure of Picasso's blue period. He is not lifeless or sentimental, self-pitying and deflated; if the guitarist has his

blue melancholy mood, Stevens's guitarist finally triumphs over it. He is not in need of pity or charity. He is full of himself, has a period of depression and recovers, but never loses the high spirits of his song. He is proactive, not reactive. Stevens's speaker is a man of indomitable will, the painter rather than the subject. Where in Stevens's poem is the old guitarist's image of "old age, destitution, and blindness" that John Richardson ascribes to that painting (I, 277)? No, the man with the blue guitar is more like the Picasso who created the old guitarist, the artist who, as Joyce puts it in the "Scylla and Charybdis" section of *Ulysses*, puts the "allinall" in his vision, the figure for whom, as Stephen Dedalus puts it, "his errors are volitional and the portals of discovery" (IX. 228-29).

II.

Let me begin this section with the "Ithaca" section of *Ulysses*. In a curious passage illustrating the "irreparability of the past," the narrator comments:

> [O]nce at a performance of Albert Hengler's circus in the Rotunda, Rutland square, Dublin, an intuitive particoloured clown in quest of paternity had penetrated from the ring to a place in the auditorium where Bloom, solitary, was seated and had publicly declared to an exhilarated audience that he (Bloom) was his (the clown's) papa. The imprevidibility of the future: once in the summer of 1898 he (Bloom) had marked a florin (2/-) with three notches on the milled edge and tendered it in payment of an account due to and received by J. and T. Davy, family grocers, 1 Charlemont Mall, Grand Canal, for circulation on the waters of civic finance, for possible, circuitous or direct, return. (XVII. 975-84)

I want to take this passage as a point of departure for examining parallels among Joyce, Stevens, and Picasso. In a sense, each of these figures conceived the artist as a clown, but more than that, they each understood the issue of paternity in terms of a post-Christian world where God the Father was no longer a working myth.

In this farcical version of search in *Ulysses*, the clown is a metonym for Stephen Dedalus's search for a father and for Bloom's search for a son. He is the anonymous, androgynous, marginalized outsider charged with amusing the bourgeois. All of us—or at least all males—Joyce is suggesting, are

fathers and sons of clowns. The clown's quest for a surrogate approving father and for an audience is appropriate to Picasso, Stevens, and Joyce. And where is this quest for a father carried on? Isn't it in the circus of the modern city—which is so often the subject of our three writers? Thus, writing of one of the great triumphs of the rose period, *Family of Saltimbanques* (1905; see p. 188), John Richardson remarks: "Like Manet [in *The Old Musician*], Picasso has appropriated Baudelaire's metaphor of vagabonds as artists; and he has set his wanderers in a metaphysical wasteland, where they confront each other, not to speak of ourselves, with the coolness that Manet (primed by Baudelaire) used to such telling effect" (I, 385).

The previous passage from "Ithaca" points to the modern novel's awareness of popular culture and its function as a source of metaphors in a world where, as Stevens puts it, the gods have "come to an end" (*Opus Posthumous*, 262). The intuitive particolored clown in the human comedy is Joyce, who is, in fact, the father of Bloom and the grandfather of the clown and who can be, like Shakespeare in Stephen Dedalus's monologue in "Scylla and Charybdis," the father of his own grandfather. The clown is also Picasso and Stevens, the artist as wanderer, as outsider, as performer, as confidence man, as *flaneur*. Picasso depicted clowns to mock the traditional bourgeois complacency; clowns were for him figures who mocked pretension and hypocrisy even while suffering within; they were marginal figures—like circus performers or figures in arcades—living by their wits. The title figure in *The Man with the Blue Guitar* is a version of the popular performer as troubadour and picaro. Are we not, Stevens implies, all picaros in a system that lacks a supreme fiction?

All three artists found high culture stultifying and turned for inspiration and stimulation both to the middle class of the impersonal and indifferent urban culture and to the classless culture of music halls, circuses, and street and arcade performers. Picasso and Joyce populated their worlds with the tumultuous, sensuous, and sometimes bawdy life of the modern city. While Picasso sought the society of cafés and brothels in Paris, Joyce knew the life of music halls (we might think of figures such as Tom Rochford and Maria Kendall in "Wandering Rocks"), brothels, and the bars—from which women were excluded—in Dublin and cafés in Paris. While Stevens as an insurance company lawyer and executive sought refuge in the comforts of upper-middle-class and socially elite life, he often held himself aloof from this life and thus kept ties both to the socially elite and to artistic, bohemian communities. He was a member of the group of artists known as the "Others," whose hero was the artist Marcel Duchamp; Duchamp focused on eros as the way humans felt oneness with the universe.

Circus performers, entertainers, and clowns depend finally on the economic support of those they satirize and set themselves apart from. And there is always the possibility that finally the joke is on themselves and no one hears. The clown is a solitary. And what is the clown's quest; isn't the clown everyman and everywoman with a painted face? Isn't Bloom a clown to those in Dublin who do not recognize his *quality?* The second sentence in the previous passage from *Ulysses* is about the serendipitous nature of reality; the image is of a coin marked by Bloom, but a coin that never returns.

We think, too, of Stevens's use of the speaker as harlequin, as mocker, and as picaro. The clown suggests the Chaplinesque figure in pantaloons in *Notes* and the man on the dump in the poem of that name; both figures are derived from the dispossessed and hobo of the depression. In Stevens's *Harmonium* (1923), which owes its title to an instrument particular to American middle-class culture, churches, and music halls, are not both Berserk and the prince of peacocks in "Anecdote of the Prince of Peacocks" (1923)—as well as the speaker in "A High-Toned Old Christian Woman"—versions of clowns? Isn't the speaker of "Anecdote of the Prince of Peacocks" a clown in motley, a figure dressed as the prince of peacocks when he meets a figure dressed as Berserk? The capable man in "Mrs. Alfred Uruguay" (1940) is a man of cap and bells, an image of the traditional jester—a version of Stevens's poet as clown—even as he is the heroic figure who creates in his mind the ultimate elegance. As in Picasso's works, the clown is often in Stevens's not only a harlequin and picaro but also an androgynous figure: "For all their coarseness, [clowns] struck Picasso as true artists, like himself: wanderers who led a picturesquely marginal existence when they were not, like him, performing feats of prodigious skill" (John Richardson, I, 371). Like them, Picasso felt he was performing for an audience that saw only the mask of an artist and did not wish to and could not understand the man within. Because of this, he sought refuge in secret codes to convey his feelings even while publicly *performing* a painting for prospective buyers.

At times, Joyce, Stevens, and Picasso sought masks to hide their real feelings, and Picasso and Stevens were drawn to the masques of the *commedia dell'Arte.* In Stevens's *The Man with the Blue Guitar,* the poet is a figure from *commedia dell'Arte*—a clown and juggler, a circus performer and picaro; dressed in motley, playing a blue guitar, he flouts standards and mocks his audience and subject. Borrowing from the *commedia dell'Arte,* Stevens mocks the nose, the most prominent part of the masque, which was often a metonym for penis. In *Notes toward a Supreme Fiction,* Stevens's poet is a solitary figure, a rabbi, "walking by himself," who is seen as a vagabond, namely "the man /

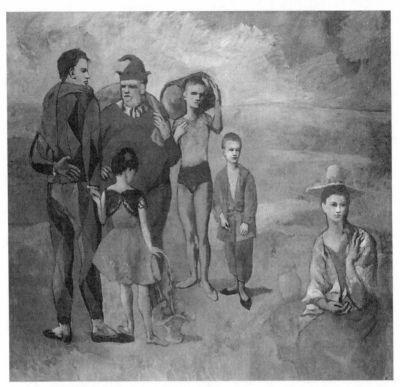

Family of Saltimbanques, Pablo Picasso (1905)

In that old coat, those sagging pantaloons"; "A bench was his catalepsy, Theatre / Of Trope. He sat in the park" (I, x; II, x).

III.

Part of the genetic code of Modernism is the specter of the modern city, oedipal image of hope and rescue, but also anonymous, indifferent, paternal juggernaut. For each artist the city had to be naturalized, domesticated, brought into the ken of understanding. For all three artists, Paris was libidinous, bohemian, anarchial *Other*. Abroad—and specifically Paris—for Joyce and Picasso was voluntary exile to a place where intellectual excite-

ment, personal freedom, and artistic innovation could be found. It is perhaps easier to see some parallels between the Andalusian painter who thought of himself as a Catalan and lived in exile in Paris and the Irish novelist who disdained Irish glorification of Celtic culture and language and thought of himself as a European novelist and lived and wrote in Paris. Indeed, did not Picasso live in the Paris that Joyce first visited in 1902 to 1903 and to which he alludes in *Ulysses*? The thinly disguised Joyce figure, Stephen Dedalus of *Ulysses*, was visiting the same sordid neighborhood where Picasso lived. In sections of *Ulysses*, Dublin is Paris mediated. Within *Ulysses*, specifically in the "Proteus" section, Stephen thinks frequently of his Paris experiences; they inform Joyce's rendering of Stephen's and Bloom's fantasies in "Circe." Isn't the vision in "Circe" of sexual experimentation and outrageous behavior in Bella Cohen's whorehouse—Joyce's version of *Les Demoiselles d'Avignon*— overlaid with his Parisian memories? "Wandering Rocks" is the arcade of Dublin, but its book stalls and eccentricities derive as much from Joyce's memory of Paris as of Dublin.

Living in Trieste from 1904 to 1915 and immersed in its intellectual life, Joyce was more influenced by Futurism than Vorticism, its English counterpart. Although Richard Ellmann acknowledges that Joyce attended "the most important exhibition of Futurism" held in Trieste in 1908, he does not take seriously the influence of Futurism on Joyce because he thinks of it as a movement in painting, not literature. Yet, as Ellmann himself notes, Joyce asked his first biographer, Frank Budgen, whether the "Cyclops" episode was not Futuristic (430). That, of course, is not to deny that Joyce was influenced by Ezra Pound's call for objectivity in art and Pound's doctrine that art could provide order and stasis to a chaotic world. After all, Pound had placed *Portrait* in the *Egoist*.

To be sure, we can plausibly argue that Joyce's juxtaposition of scenes from the modern city, his alternation between close-up and distanced views, and his effort to dramatize both the physical motion of his characters as well as the rapid movement from one scene to another, particularly in "Wandering Rocks" and "Circe," all owe as much to the influence of cinematic montage as to that of Futurism. But in celebrating the excitement and bustle of modern life (although at the same time characteristically undermining it with his customary irony and bathos), Joyce, I suspect, was very much influenced by Marinetti's 1909 "Futurist Manifesto." Indeed, the Futurists' experiments in dramatizing motion—the most notable of which is Marcel Duchamp's *Nude Descending the Staircase* (1912)—were influenced by Eadweard Muybridge's stop-action photography; he had illustrated Paul Souriau's 1889

scientific study of motion, *The Aesthetics of Movement.* We should remember that, unlike Cubism, Futurism began as a literary enterprise. Futurism insisted on the need for capturing bodily sensations as well as physical motion and the simultaneity of diverse aspects of contemporary life.

Depending on the idea that each perception is a function of the position of the perceiver, Joyce's idea of parallax owes something to Futurism and Cubism. For the "position" of the perceiver is not merely a function of his present temporal-spatial location, but of the entire past experience he brings to his perception. Not only did Cubist painting try to do justice to the multiple perspectives of any given perception, but it employed the collage to juxtapose seemingly incongruous experiences within one aesthetic form. Marinetti, the prophet of Futurism, believed that art must express the fact that we simultaneously register many perceptual experiences; he believed that techniques had to be invented to do justice to the disparate elements that comprise our mental and emotional lives at any given moment. As Jane Rye has written, "the Futurist poets sought to convey the 'simultaneity' of impressions which characterized modern life. The stylistic devices by which they sought to achieve this aim were the abolition of traditional syntax, metre and punctuation and the introduction of mathematical and musical symbols, onomatopoeia and 'free expressive orthography'" (104).

Futurism also sought to emphasize the visual potential of literature and stressed the importance of, as Grace Glueck has put it, "combining of onomatopoeic fragments, numbers, symbols and typographical effects in a format that stormed the viewer's eye" (29). Marinetti's phrase for this orthographic mode, "parole in liberta," or "words in freedom," would have appealed to Joyce, who clearly uses similar orthographic techniques. Drawing upon the example of abstraction in painting, the literary Futurists wished to stress the spatial arrangement of language—what they thought of as a "supraconscious" verbal art, and what recent criticism has been calling a "subtext"—that superimposed itself on our linear reading process and our desires for chronological order and representation of a prior reality. In his famous article "Futurism" (1919), Roman Jakobson linked the defense of Cubism with the theory of relativity. As Joseph Frank has put it, "Since time and space no longer had fixed determinants, and the category of substance had lost all meaning, reality could only be represented, as the Cubists were showing it, from multiple points of view simultaneously" (30). Once we no longer believe it is possible to designate reality and once we believe that the arrangement of elements on a page itself becomes its own ontology, the focus shifts to the sounds and texture of the language itself.

Using the giant letters of Irish illuminated manuscripts, the best known of which is *The Book of Kells*, was another way of Joyce announcing the significance of his *New* New Testament. (Given that these giant letters appeared in every edition in his lifetime and, as far as I know, there is no evidence that Joyce objected to them, I am skeptical that Joyce would have approved of their omission in the Gabler edition.) The narrator in "Ithaca" specifically mentions *The Book of Kells* as one of the "points of contact" between the Jews and Irish (XVII. 755). We see the influence of Futurism's *parole in liberta* in the musical score in "Scylla and Charybdis" (lx, 499) as well as, most notably, in the headlines of "Aeolus." We also see its influence in Joyce's effort to fuse words and music in "Sirens," particularly the opening overture, in the dramatic interludes of "Scylla and Charybdis," in the play format of "Circe," especially the elaborate and often Surrealistic stage directions, in the ironic scientific catechism in "Ithaca," and in the punctuation and syntax of Molly's stream of consciousness in "Penelope."

To understand better the influence of Futurism in Joyce's technique, let us look briefly at a few passages in "Aelous." When Joyce describes the movement of beer barrels in Dublin, a movement that becomes a metonym for the way Bloom is buffeted in the chapter, we should see the influence of Futurism's insistence on capturing motion itself and on celebrating the hustle and bustle of twentieth-century life: "Grossbooted draymen rolled barrels dullthudding out of Prince's stores and bumped them up on the brewery float. On the brewery float bumped dullthudding barrels rolled by grossbooted drayment out of Prince's stores" (VII. 21-24). For the Futurists, the bodily smells and sounds of a modern city were, as Grace Glueck puts it, "fit subjects for poetic and visual exploration" (30). In this passage from "Aeolus," we also might note how Joyce, by using chiasmas to reverse the syntax, orthographically implies Bloom's unique position as an Irish Jew since the left-to-right movement of English iterates the right to left movement of Hebrew.

In the section of "Aeolus" entitled "ORTHOGRAPHICAL," the word "sllt," made by the newspaper presses, recurs in Bloom's mind; but that word is also an orthographic prolepsis of the merging of Stephen and Bloom because the double "l" between "s" and "t," the first two letters of Stephen's name, signifies the recurring "l" in the names of "Leopold Bloom" as well as the two l's in "Leopold," and the "l" that is the second letter of both "Bloom" and "Ulysses" (VII. 164, 174-77). That *Stephen* thinks of a "sallust," the name of a Roman historian whose name is composed of these very same consonants a few pages later, is another powerful manifestation to the reader of the transpersonal presence who is illustrating the parallel thoughts of these

seemingly different men who, although in the same place at virtually the same time, manage not to meet.

Even if Joyce never met him, was not Picasso a gigantic figure in Paris from 1920 to 1922, where Joyce finished *Ulysses*? But what about Stevens, who lived abroad only in his imagination and for whom abroad was of necessity a state of mind, inculcated from his reading, from the European influence of the 1913 Armory Show, and from a lifetime of seeing artistic exhibits and reading French literature and literary journals as well as from his foreign correspondence? Stevens was acutely aware of the European intellectual and artistic ferment. Although maintaining a strong interest in French culture, corresponding widely beyond the United States, and thinking of himself as a cosmopolitan figure, he never visited Europe. Wallace Stevens was born in Reading, Pennsylvania, from German-Dutch stock, and lived as a prosperous New England insurance executive. Joan Richardson reminds us that in 1912-1913, "It was as though Paris had come to New York" (Joan Richardson, *Wallace Stevens: The Early Years*, 412). For Stevens, Key West was his Paris, a city that for him had associations of artistic and sexual experimentation and bohemian behavior. Although the landscape of *Notes toward a Supreme Fiction* is a kind of cinematic montage of a dreamscape, it is fitfully anchored in Paris. Doesn't the ephebe have to overcome the "celestial ennui" of Parisian apartments? Does he not speak directly to the ephebe of his habitat that gives him a view from "your attic window, / Your mansard with a rented piano" (I, v)? But Stevens has an ironic attitude to the cosmopolitanism and erudition of the city, which are contrasted with his epiphanic immersion in the natural cycle of the here and now at the poem's climax: "[T]hey will get it straight one day at the Sorbonne" (III, x). He addresses the reader as "monsieur and comrade"— not without a hint of admonition, if not iconoclastic disdain, that links him (especially if the reader will not heed the lessons of the prior stanzas) with the ephebe in the epigraph.

Let us continue with the parallels among Picasso, Joyce, and Stevens. In their early lives, the three were all educated in varieties of an ascetic tradition: Joyce—and, yes, Picasso, too—in the Catholic tradition, which saw this world as a prelude to a better one and understood death as the birth of the eternal soul or as eternal damnation. Stevens's Pennsylvania Dutch Protestantism saw this world as an individual moral test of worthiness for the next. Each was educated in something of a Platonic tradition—Joyce in parochial schools and at University College in Dublin; Stevens at Harvard under Santayana; and, as John Richardson carefully shows us, Picasso under the influence of his father was nurtured on a diet of paradigmatic classical

Spanish painters—Velásquez, Murillo, and Goya—even while admiring the figure who was being rehabilitated into the Spanish canon, El Greco.

Before fully encountering the Aristotelian "ineluctable modality of the visible"—what Stephen in *Ulysses* calls "what you damn well have to see"— each figure flirted with aestheticism, androgyny, escapism, exoticism. These temptations conflicted with their desire to encounter reality. Picasso, Joyce, and Stevens were overtly attracted to aestheticism; the work of each was for a time shadowed by symbolism. All three were touched by the symbolist movement in art, which embodied codes to unlock reality and depended upon a hermetic system of correspondence between self and the universe and/or nature. The Stevens of *Harmonium* and, in particular, of the early poems in that volume such as "Domination of Black" and *Sunday Morning*, was strongly influenced by the aesthetic movement. Like Picasso and Joyce, he was attracted by the concept of pure art but later sought "to get to the center . . . to share the common life" (Stevens, *Letters*, #327, #397).[*] Like Joyce, Stevens used the Eucharist—the transformation of blood into wine— as an image of the word into the world and of the world into the word: "After one has abandoned a belief in God, poetry is that essence which takes its place in life's redemption" (*Opus Posthumous*, 185). Like Picasso and Joyce, Stevens saw the artist as God creating a Genesis, a new ontology—and sometimes saw the artist as a victim, as Christ crucified.

That Oscar Wilde and the aesthetic and decadent movement influenced all three shows their common cultural heritage. As John Richardson has shown, Picasso knew Wilde's work as well as Aubrey Beardsley's drawings in *Yellow Book*. Picasso was deeply influenced by the decadent movement from Guillaume Apollinaire to Alfred Jarry. Picasso actually had literary aspirations and wrote poetry and plays. Moreover, his painting was deeply informed by the poetry he knew; as Richardson argues, "Max Jacob is the one we associate with Picasso's earliest years in Paris, Guillaume Apollinaire with the rose period and Cubism. Jean Cocteau was the catalyst for the neoclassical period" (John Richardson, I, 5). Picasso's literary judgments were taken seriously by the poets he knew. In different ways, all three of our figures were influenced by Gertrude Stein. In Joyce's *A Portrait*, we see a strong influence of Wilde's art for art's sake and the religion of art. Such a stance puts the artist in the position of observer and voyeur, someone who is like God paring his fingernails.

[*] The numbers in parentheses for the *Letters* of Stevens refer to letter numbers, not page numbers.

But Picasso, Stevens, and Joyce all turn their backs on—or at least modify—the aesthetic tradition in their later years. Joyce discovered a political voice in *Ulysses* and Picasso did in *Guernica* (1937). Stevens found a kinship with Walt Whitman and Ralph Waldo Emerson and also with the democratic tradition in America. In *The Man with the Blue Guitar*, he wrote, "I am a native in this world / And think in it as a native thinks." In his later lyrics, such as "Not Ideas About the Thing but the Thing Itself," he emphasizes the need to communicate with the audience and to move beyond abstruse poetry.

Each of these artists struggled with his father before reinventing his father by discovering *artistic* patrimony. As a very young man, Picasso was said to have remarked, "In art one must kill one's own father" (John Richardson, I, 95). Each had father figures whose personality, character, and value systems were deeply troubling. Each needed to surpass a father who was perceived as weak, ineffectual, or wrongheaded. Each sought father figures in male friends. Joyce's father was a heavy drinker who had let his family's fortune slip away and who, in Joyce's mind, was responsible for the illness and death of his beloved mother; Picasso's father had artistic pretensions that far surpassed his ability; and Stevens's father was a strong puritanical presence who insisted that his son pursue a practical career, even while writing to him, "Paint truth but not always in drab clothes" (Joan Richardson, *The Early Years*, 49). Finally, each endured and was haunted by the loss of a younger sibling: Joyce's brother George died at fourteen when he was twenty, Picasso lost his sister Conchita when she was eight years old and he was thirteen, and Stevens's sister Mary Katherine died in 1919 when she was in her mid-twenties.

All three had to function as economic men in a bourgeois society, had to market their work and become something of *flaneurs* to sell in the arcade of the bourgeois. Yet Stevens carved out for himself another life and was part of the world on which he economically depended, even while having another self who was an artist. John Richardson wrote of Picasso: "How often he would echo Goya's dictum, 'Ugliness is beautiful'" (182). Stevens and Joyce were also attracted to the unattractive in life. For each, art was self-expression. For Picasso, his blue period was the reflection of his feelings at the time. Each felt that he was ostracized and victimized by an unappreciative public, although Stevens was characteristically more reticent about such feelings. All suffered painful nonrecognition and disappointment and felt despair about whether their talents would be recognized.

Picasso said of his own style: "I'm never fixed" (I, 83). He was always seeking new styles, new visions; Richardson's words about Picasso are also applicable to Joyce and Stevens : "[H]e wanted to . . . fantasize and dramatize

himself and manipulate his own identity and appearance. . . . This self-dramatizing, chameleon-like sense would remain with him all his life" (I, 83). Picasso, Joyce, and Stevens all focused on perspectivism as central to their technique; indeed, for each the technique for presenting perspectives often became the subject. Each used multiple and often contradictory perspectives—witness not only Picasso's Cubism, but Stevens's "Thirteen Ways of Looking at a Blackbird" (1917) and *Notes toward a Supreme Fiction*, and Joyce's *Ulysses*, which depends on ventriloquy of styles, particularly "Oxen of the Sun," where Joyce *performs* a historical anatomy of how the changing of styles *is* the changing of perspectives.

IV.

Joyce, Picasso, and Stevens all broke up the surface into several planes and destroyed the distinction between foreground and background; they all decentered the subject and recontextualized it by odd juxtapositions and unique forms. They all saw human characters in perspectives that included prior experience and association. Stevens's poems, like Cubist paintings, are brash attacks on traditional ideas of representation. Like Cubist paintings, his poems focus on local objects that the reader needs to put together. Like Cubist collages, they highlight some details at the expense of others and often break up a surface into several intersecting planes. Like both Cubist paintings and collages, they depend on (1) playfulness that often begins with the title and continues throughout in an attitude of vacillating but pervasive irony; (2) rapid oscillation between abstraction and nominalistic specificity; (3) odd juxtapositions of shapes and colors; and (4) fragments of vignettes and objects, often displaced from their historical origins but with a hint of their original context.

When we read "Thirteen Ways of Looking at a Blackbird" as a visual entity, we notice that the imposing empty space on the page calls attention to and provides demarcation for the dearth of words, almost the way frames define and mark the space outside and inside paintings. And isn't this part of Modernism's genetic code? Modern art depends less on what is perceived than on how we think about and render what we perceive. And the same can be said for the perception of art. The modern artist does not expect a closed hermeneutical circle where he communicates what he has seen to the perceiver. No, the perceiver must parse together a reading depending on the dialogue between, on one hand, hints, shards, and clues, and, on the other, his own experience.

In *Adagio*, Stevens quotes Braque's emphasis on the doing as crucial to art: "Usage is everything. (*Les idées sont destinées á etre deformées á l'usage. Reconnâitre ce fait est une preuve de désinteressment* [Georges Braque, Verve, No. 2])" (*Opus Posthumous*, 159). According to William Rubin, Cubists made "the very process of image formation virtually the subject of their pictures" (Rubin, *Picasso and Braque*, 16). From Cubism Stevens derived his sensitivity to light and shade, his experiments with layered textures, his presentation of images in several pictorial planes, his wit and playfulness, and his abstractions oddly intermingled with the embrace of daily life. Such poems as "The Emperor of Ice Cream" and "The Man on the Dump" recall Picasso's and Braque's passion for the vernacular material, particularly their sensory appreciation of objects and interaction of the gregarious and classless world of the café. Wasn't Stevens's idea of Florida, especially Key West, based on experiences and fantasies of this kind? Wasn't Key West his version of bohemian life in Paris? Poems like "The Snow Man" and "Tea at the Palaz of Hoon" follow the Cubist tendency to dissolve the distinction between figure and ground, eliminate a single point of perspective, and also eliminate what Emily Bardace Kies has called "a comprehensible recession in space." Stevens, like Braque, focuses on the connection between things, the total composition; but like Picasso, he is riveted by the peculiarities of individual things, the specificity.

Like Picasso, Stevens took odd combinations of man-made and natural forms and fused them into a homogeneity, but a homogeneity that was tentative and disjunctive. We could say that *The Man with the Blue Guitar* and *Notes toward a Supreme Fiction* are elaborate collages. Also, Stevens's nonmimetic use of color—as, say, in "Anecdote of the Prince of Peacocks"—recalls the Cubists' use of color as "an autonomous sign disengaged from the morphological depiction of an object" (Rubin, 40). Like Picasso, Stevens liberated color from mimesis and freed color from the boundaries of drawn objects and denoted space. Stevens followed Braque and Picasso in taking art outside the mimetic system of representation with which we are familiar and making a new system based upon new juxtapositions, odd assemblies of objects, and discontinuous relations that barely held together—a system that each perceiver had to resolve into her own hypothesis of unity, an hypothesis always challenged by the anarchy of disunity. Yet the flight from verisimilitude was accompanied by a desire to fuse familiar perceptions into odd and striking combinations. Stevens, like Picasso, depended upon the visible world of immediate experience for his donnée, but created a teasing balance between abstraction and representation.

All three artists were fascinated by colors and were alternately attracted and repelled by black, which they equated with death, evil,

nullification, and sexuality. Picasso wrote, "the only real color is black" (John Richardson, I, 417). For all three, black is the alpha and omega of colors. Stephen and Bloom—like Hamlet—wear black all day; "Ithaca" concludes in the darkness with Molly's soliloquy; Penelope unweaves by night what she has woven by day. "Ithaca" ends with the orthographic black dot, suggesting, among other things, the womb; in some editions of *Ulysses*, the black dot is egg shaped. Mourning and death hover over Joyce's work from *The Dead*, to the "Hades" section of *Ulysses*, to *Finnegans Wake*. "Thirteen Ways of Looking at a Blackbird" speaks to Stevens's fascination with the equation of black with death, nullification, mystery, and evil.

V.

Such works as Joyce's *A Portrait of the Artist as a Young Man*—particularly Stephen's voyeuristic fascination with Davin's tale of the Irish woman who invites him in while her husband is away—Picasso's *Family of Saltimbanques*, and Stevens's "Anecdote of the Prince of Peacocks" show how the aesthetic, mystical, naturalistic, and boldly sexual aspects of Modernist art struggle dialogically for space in the same work and thus speak to the contradictory impulses with which their creators struggled throughout their lives. For all three artists, sexuality not only bridges the gap between the aesthetic and ascetic, between word and world, but is the catalyst for imagined worlds that reflect reality. As Richardson wrote, "Picasso's Blue period subjects could only be conceived by someone who had been brought up on the agonized martyrs, lachrymose Magdelans and flagellated Christs—waxen faces stained with tears, livid bodies streaked with blood—to be found in Andalusian churches . . . such as the *Pietà* in Málaga Cathedral" (John Richardson, I, 277). Sexual subjects are also a way of offending bourgeois sensibilities; isn't "Anecdote of the Prince of Peacocks," among other things, a phallic emblem poem about the male libido? In art and in life, when he found a new woman, Picasso "fantasized he was God creating a new Eve" (I, 445). Joyce and Stevens, too, felt they were Pygmalions to the female Galatea.

None of our three figures were paralyzed by paroxysms of false modesty about their own talents in relationship to others. Each believed in the exalted view of the artist as prophet and superman. Picasso's 1901 self-portrait signed "Yo, Picasso" (I, Picasso), "dare[s] us to question his right to be the new messiah of art" (John Richardson, I, 228). In one sketch book, he wrote, "Yo el Roy" (I, the king) across the page (ibid., 171). Joyce was convinced he was the major writer of his era and half believed that his genius

was a dramatic historical sign of a new cultural and historical Viconian cycle about to begin. Stevens's idea of Major Man owes something to Nietzsche:

> For the moment the philosopher of the superhuman served well as a reference point for Stevens's own ambivalent feelings: wanting to be God-like but knowing the notion of God to be bankrupt; wanting to feel himself free, strong, rid of the shadow of his father but still obviously tied to it. He conceived his voyaging to be an up and down between two elements. (Joan Richardson, *Stevens: The Early Years*, 488)

Indeed, Picasso, Stevens, and Joyce were all influenced by Nietzsche.

Each of our three figures imaged the artist as a god figure creating and re-creating the universe. Both Stevens and Picasso would understand how, for Joyce, to paraphrase Stephen in the "Scylla and Charybdis" section of *Ulysses*, the artist could become the father of his own grandfather. The very title of Stevens's *Notes toward a Supreme Fiction* pays homage to the concept of God—even as he declares it a fiction—and he speaks in *The Necessary Angel* of the work the imagination must do now that the gods have disappeared. Stevens's subject is what to do in a world of unbelief. In *Notes*, the poet speaker is engaged in a quest for value, for the need to find a surrogate for religion, a working hypothesis for a world in which, as Conrad puts it, "We live, as we dream—alone." Further, each of our three artists stresses the relationship between the creative and the procreative and uses sexual intercourse as a metaphor for the way the artist's imagination must have intercourse with the world—creates the condition, as Joyce puts it, of "[finding] in the world without as actual what was in his world within as possible." It might be said that all three spiritualized sexuality, made it something of a supreme fiction; we might think of Stevens's title "Final Soliloquy of the Interior Paramour" (1950). Stevens found in the concept of muse and interior paramour and, in his feminized "fluent mundo" of *Notes toward a Supreme Fiction*, compensation for what he lacked in a wife, namely a responsive, empathetic other with whom he could share his imaginative world. Just as Molly's monologue gathers together and comments upon the women figures who preceded her in *Ulysses* (the old milkwoman as "The Old Women of Ireland" who only appears young to a true believer, Bella Cohen, Gerty, Martha Clifford, Ms. Douce, and Ms. Kennedy), so does Stevens's "fat lady" do the same for the women in *Notes*, including Bawda, who marries the great captain on Catawba; Nanzia Nunzio, who strips herself naked before Ozymandias; Canon Aspirin's sister; and the blue lady.

Picasso appropriated what John Richardson calls the "sacred fire" of Christianity for his art. In *The Two Sisters* (1902), Picasso drew upon his "apprenticeship as a devotional painter" "to endow whores with an air of universal relevance and mystic power" (John Richardson, I, 224). Picasso knew Cátalan, Romanesque, and Gothic art and architecture; he was in Barcelona in 1902 when the great exhibit of ancient Spanish art opened and knew Spanish religious paintings well. His work often retains the trappings and apparatus of religion; as Richardson shows, Picasso's early treatment of sacred subjects "lingered on in the artist's memory, and re-emerged in the tear-filled eyes and scream-filled mouths of *Guernica*, not to speak of Picasso's harrowing portrayals of his own personal martyrs—Dora Maar, and his wives, Olga and Jacqueline" (I, 72).

The metonymical interrelationship among the sexual, religious, and aesthetic are at the center of the art of all three figures. Like Joyce with Molly and Stevens with his "fat lady"—herself a version of the earlier blue lady and an echo of Joyce's Molly—Picasso celebrated experienced, intensely sexual women as Madonnas. Joyce was fascinated by the systems of religion that he spent his life protesting; does not the very term "epiphany" come from the Catholic tradition in which he had been immersed as a child and adolescent? Isn't *A Portrait of the Artist as a Young Man* about the aestheticizing of the sacred and of religious tradition? Note the painterly title, playing on Wilde's title *The Picture of Dorian Gray* (a book about the corrupting effects of a decadent life and about the power of art to transcend life in revealing truth). On one hand, Stephen Dedalus refuses to pray at his mother's funeral; on the other hand, his frame of reference for imagining the search for a father takes place in terms of arcane Trinitarian heresies of Arius and Sabellius. Joyce in his early work created a religion of art to replace the religion he had left behind.

Each of these male figures uses his art to self-fashion his relationships with women. For each the aesthetic and the sexual, art and desire, are inextricably linked and that link derives from the imagination. As John Richardson notes, Picasso "[charges] the portraits of women in his life with hidden messages and manipulative devices; sometimes calculated to warn or punish or tease; sometimes to seduce or entrap" (I, 237). Joyce with Molly and Stevens with his idealized women as muse in poems such as "The Idea of Order at Key West" (1934) and *Notes toward a Supreme Fiction* also use their art to work out issues with the women in their lives. Each has a need for women both as aestheticized muse and as a sexually accessible object. Yet, by the contemporary standards of 1997, perhaps all three male figures are somewhat limited, if not misogynistic, in their

perception of women. At times Picasso, Joyce, and Stevens see women in blatant sexual roles and do not seem to credit them with powers of intellect equivalent to their own. And this, too, is something of the legacy of the male genetic code of Modernism.

VI.

To conclude: In this chapter, I am suggesting that cultural criticism need not be confined only to Marxist perspectives and stories of power relationships. What I am suggesting is that we might extend cultural criticism beyond ideology and abstractions and refocus it in humanistic terms. By imaginatively responding to similarities among Picasso, Stevens, and Joyce and tracing patterns within their lives and works, we may create a cultural context that locates the genealogy of Modernism, even while that context transcends geographical boundaries as well as simplified stories of influence or hegemony.

Seven

"Spiritually Inquisitive Images":
Stevens's Reading of Modern Painting

I.

I want to look at Wallace Stevens's understanding of modern painting as a way of defining crucial issues in reading his poetry, including the need to understand his concept of narrative and representation. We shall see how Stevens is culturally defined, how his signs are framed, but also how he is unique—that is, how he signs his frames. I shall show how in painting Stevens found a story, a narrative; although that narrative is often a story about how to achieve plenitude and multiple perspectives and simultaneity, it is still a narrative.

In my 1993 book on Stevens entitled *Narrative and Representation in the Poetry of Wallace Stevens: "A Tune Beyond Us, Yet Ourselves,"* I argue for the importance of narrative and representation in his poetry. I try to restore a balance between deconstructive readings of Stevens that stress rhetoricity and hermeneutical readings that stress what poems signify not only within a text, but what they signify about the person and world that produced that text. I argue that understanding the cultural contexts of Stevens depends upon hearing the heteroglossic voices of diverse traditions, including that of High Romanticism in the tradition of Wordsworth, Keats, and Shelley; the American tradition of Emerson and Whitman; the symbolic experiments proposed by Pound; and, finally, the visual examples of modern painting, sculpture, and cinema.

Perhaps in Stevens's poetry we have neglected the storytelling of traditional narrative; perhaps we have not heard the dramatized voice of a speaker who is at times frustrated with the modern world and in personal

pain. Paradoxically, Stevens's secret codes and apparent lack of narrative distance become both an enabling and an essential condition to the reader's weaving a narrative in which the words can be understood in a referential context. It is not so much that their openness to interpretation invites the reader in, but that the reader is enclosed in a room from which his desire for narrative becomes the exit to understanding.

I want to stress Stevens as a high Modernist not only among Joyce, Eliot, Lawrence, and Yeats but among such painters as Duchamp, Picasso, Matisse, and Klee. We might contrast Modernism to nineteenth-century representation, particularly the Victorian period. In chapter 1 I described how the 1978 London exhibition, *Great Victorian Pictures*, made clear, I think, the revolutionary character of Roger Fry's Post-Impressionist London exhibitions of 1910 to 1912. Victorian painting often told a story, either of history or of contemporary life. Let us recall Rosemary Treble's comments, "The constant refrain in all the writing of the period and the touchstone of every judgment was whether the work attained 'truth' generally to nature and therefore, by implication, to God's creation, whether its sentiment was appropriate and whether it was morally healthy and therefore fit for consumption" (*Great Victorian Pictures*, 7). Thus, a painting like William Powell Frith's *The Railroad Station* (1862) was considered a national epic because it included every class. And the values by which Victorian fiction writers were evaluated were not too different.

Like Joyce, Woolf, Lawrence, Yeats, and Eliot—and also like Picasso, Matisse, and Klee—Stevens used his work to define himself. For these aforementioned writers, telling is an *agon*, just as the act of painting is the subject of the Modernist painters' art. Like these other Modernists, Stevens drew upon prior myths and prior poetry to give shape to his narratives. While he is surely an American figure deriving from Emerson, it is worth noting that Stevens speaks far less often in his letters of such American figures as Emerson and Whitman—who have been rightly claimed as his major influences—than he does of expatriates such as Eliot and Pound as well as continental figures such as Mallarme, Rimbaud, and Verlaine, and less of American painters than he does of such European painters as Picasso, Braque, and Klee.

II.

A crucial strand of my argument will be to establish the importance of the relationship between Stevens the man and Stevens the poet. We might recall

Stevens's own lines in "Tea at the Palaz of Hoon" (1921)—"I was the world in which I walked, . . . And there I found myself more truly and more strange"—as our point of departure for the relationship between text and author that I shall suggest. For Stevens, the work is the ultimate metaphor for the author, painter, or composer who creates. We cannot, Stevens believed, disconnect the threads of his poetry from the warp and the woof of the life and the historical period that shaped that life. As Stevens put it in *The Necessary Angel*, "It is often said of a man that his work is autobiographical in spite of every subterfuge. It cannot be otherwise. Certainly, from the point of view from which we are now regarding it, it cannot be otherwise, even though it may be totally without reference to himself" (121).

Stevens's evidence for the autobiographical in art often comes from the plastic arts. As he perceived modern painters, they were using their art to define themselves, or at least to acknowledge their multiple, subjective, and diverse authentic selves. In 1937 Stevens noted in his *Commonplace Book* a passage from a piece by Graham Bell entitled "Cézanne at the Lefevre," concluding: "[The quoted passage] adds to subject and manner the thing that is incessantly overlooked: the artist, the presence of the determining personality. Without that reality no amount of other things matter much" (54-55). Stevens would have liked someone to say of him what Bell said of Cézanne: "With Cézanne integrity was the thing, and integrity never allowed him to become fixed at any one point in his development, but sent him onward toward new discoveries of technique, new realisations of the motive" (*Commonplace Book*, 53). In an omitted section of *The Necessary Angel* entitled "The Figure of the Youth as a Virile Poet," he insisted upon the presence in the work of the artist, in this case Picasso:

> What we have under observation, however, is the creative process, the personality of the poet, his individuality, as an element in the creative process; and by process of the personality of the poet we mean, to select what may seem to be a curious particular, the incidence of the nervous sensitiveness of the poet in the act of creating the poem and, generally speaking, the physical and mental factors that condition him as an individual. . . . We take a man like Picasso, for instance, and assume here is Picasso and there is his work. This is nonsense, where the one is, the other is, this son of an intellectual and antiquarian, with his early imaginative periods, as inevitable in such a case as puberty, may sit in his studio, half-a-dozen men at once conversing together. They reach a conclusion and all of them go back into one of them who seats himself and begins to paint. Is it one of them within him that dominates and

makes the design or rather could it be? Can Picasso choose? Free will does not go so far. (Quoted in Joan Richardson, *Wallace Stevens: The Later Years*, 103)

Stevens himself imagined the act of creation as a dialogue between various personae, including those that he had created in prior poems.

Reading his letters, we hear the voice of a man who is the successor to a Victorian tradition—epitomized by Arnold—that wanted to hold the Philistines at arm's length while providing a cultural enclave for themselves and their followers; yet we also hear a Modernist dazzled by the motion, energy, and excitement of the modern city and the possibilities offered for art by new circumstances. Stevens oscillates between the world of fact, symbolized by his career as an insurance lawyer, and a world of imagination. We hear the voice of a man drawn by iconoclastic, aesthetic, ascetic, and contemplative impulses and one who desperately wishes to feel a kinship with his fellows. Stevens wished to avoid the poles of realism and the aesthetic and write a poetry of negotiating and crossing back and forth between the two: "[A] real poetry, that is to say, a poetry that is not poetical or that is merely the notation of objects in themselves poetic is a poetry divested of poetry" (#685). Writing of a distinction between the "ascetic" Courbet—"He was an ascetic by virtue of all his rejections and also by virtue of his devotion to the real" (#685)—and the "humanistic" Giorgione, he observed: "What I am thinking of is that the ascetic is negative and the humanistic affirmative, and that though they face in two different ways which would bring them together ultimately at the other side of the world, face to face" (#685).

III.

We need to be reminded how important mimesis and representation are to Stevens. The extent to which he is not only dramatic but visual needs to be stressed. Because of the abstract nature of our interpretations of his themes, we forget that Stevens is one of our most visual poets, a man whose landscapes and mindscapes remain in our memory as if they were miniature paintings or drawings.

In New York, the group of artists in the later years of the second decade of the twentieth century that called itself the "Others" regarded Stevens "as their herald and hero" (Joan Richardson, *Wallace Stevens: The Early Years*, 412). Marcel Duchamp, who preached the importance of sex, was a

model to the "Others" of the avant-garde artist who flouted convention as an artist and a man and lived his life as he pleased. Stevens's Puritanism made it essential that he find an alternative to eros for his energy and sensuality. Although he regarded Duchamp as an oddity, "an intense neurotic" whose "life was not explicable in any other terms," Stevens was attracted to his concept of the "Great Work" that had to reveal itself gradually to an elite audience as the audience carefully studied it (#880). What John Russell has written of Duchamp—and, in particular, of *With Hidden Noise* (1916)—is appropriate for Stevens's poems, particularly the ones of *Harmonium*: "[In Duchamp,] Objects of everyday use are combined in a completely irrational or nonutilitarian way to produce something that we recognize as having a strange power and a presence all its own. That strangeness is compounded by the addition of a further, hidden element: a secret from which even the artist himself is excluded"(178). Wouldn't Stevens have found in Duchamp's work—say, in a title like *Nude Descending the Staircase*—an exploitation of the ironic incongruity between title and subject that he himself uses in his titles? In "Tea at the Palaz of Hoon" and "The Snow Man," isn't Stevens, like Duchamp and Klee, fascinated by the possibility of being both protagonist and ironic spectator? Just as Duchamp and Klee composed works that were both artworks and criticism of the very concept of aesthetic objects, so did Stevens write poems that were a criticism of poetry.

Stevens was fascinated with the revolutionary 1913 Armory Show, and it deeply influenced him. In that show, as Joan Richardson puts it:

> The primary understanding concerning time was that no subject or object could be experienced fully if the subject or object were separated from past knowledge of it. The representation of reality was "truer" . . . when the thing known was presented incorporating some record of previous experience. The various intersecting and juxta- posed forms depicted on a Cubist canvas were intended to mirror this constant movement of consciousness, aware of itself, as it observed something external; that temporarily focused attention. (*Wallace Stevens: The Early Years*, 403)

In the Armory Show and elsewhere, Stevens would have been exposed to the technique—notable in the works of Georgia O'Keeffe—of relating small elements to larger forms, causing the latter to seem even larger. We see this in "Tea at the Palaz of Hoon" (1921) and "Thirteen Ways of Looking at a Blackbird" (1917).

Stevens's poems, like Cubist paintings or Paul Klee's works, undermine traditional ideas of representation. Art depends less on what is perceived than on how we think about and render what we perceive. And the same can be said for the perception of art. The modern artist does not expect a closed hermeneutical circle where he communicates what he has seen to the perceiver. No, the perceiver must parse together a reading depending on the dialogue between, on one hand, hints, shards, and clues, and, on the other, his own experience. In the last chapter, I mentioned important similarities that bear repeating. Like Cubist collages, Stevens poems often highlight some details at the expense of others and often break up a surface into several intersecting planes and rely upon the reader to recompose these planes. Like both Cubist paintings and collages, Stevens's poems depend on: (1) playfulness that often begins with the title and continues throughout in an attitude of vacillating but pervasive irony; (2) rapid oscillation between abstraction and nominalistic specifity; (3) odd juxtaposition of shapes and colors; and (4) fragments of vignettes and objects, often displaced from their historical origins but with a hint of their original context.

Yet, like the Cubists, Stevens also had a paradoxical sense that, on one hand, human figures cannot be separated from their surroundings, while on the other, in a post-Christian universe humans suffer an unbridgeable gap between consciousness and the objective world they inhabit. At times, Stevens seeks refuge in geometric forms, obscure objects, and self-created symbols. But at other times, his persona sees that his created objects are blocking and his symbolic system is reductive, and the persona seeks to undo them, to move them away, or to bring them into the ken of a more inclusive understanding. Often underneath the surface, in a kind of pentimento, is a story needing to be told. The reader must construct a narrative from obscure clues. Like Duchamp, Stevens did not believe that the work of art needed to be understood instantaneously.

Because Stevens worked in both modes, it is worth recalling Emily Bardace Kies's distinctions between *papier collé* and collage: "*Papier collé* indicates a specific kind of pasted image whose elements are consistent, governed by the classical principle of design that insists on unity of material, in this case all paper. Collage, on the other hand, mixes different materials, modes of representation, and styles; it welcomes the clash of the alien and unexpected" (Kies, n.p.). Stevens's work is influenced by both modes. Often, as in *Notes toward a Supreme Fiction*, both the synthesizing and juxtaposing odd elements appear at the same time. Like Georges Braque and Picasso, his references touch on personal and political matters, often in elusive ways. In the first guise, Stevens is drawn to the set configurations—the ordering

abstractions—of Braque's Cubism: "Working to synthesize individual things from a general sense of their overall relations, [Braque] is finally less interested in the thing represented than in the way it relates to the composition as a whole. Less a generalizer, Picasso is riveted by the thing itself, and its very peculiarities are his stimulus" (Rubin, *Picasso and Braque*, 2).

Undoubtedly Stevens was influenced by imagism and its stress on the visual. It is well to recall Ezra Pound's definition of an imagist poem in his 1914 essay "Vorticism": "In a poem of this sort one is trying to record the precise instant when a thing outward and objective transforms itself, or darts into a thing inward and subjective" (Eilman and Feidelson, 150). We might recall Pound's famous haikulike example of an imagist poem, "In a Station of the Metro": "The apparitions of these faces in the crowd: / Petals on a wet, black bough." Pound used free-verse forms to render an impression in a single metaphor or to juxtapose an object with several objects, each standing as a metonymy for the other. "Thirteen Ways of Looking at a Blackbird" varies the haiku form; the poem is also indebted to Japanese prints in which a single setting is rendered from different viewpoints and at different seasons of the weather or mind. (See Litz, 66). Without dialogue, the stanzas are not only deeply indebted to the cryptic form of haiku, an unrhymed form limited to 17 syllables, divided rigorously into three lines of five, seven, and five syllables; its usual topic is a brief evocation of something in nature. In its highly stylized presentation and its use of folk and religious references, "Thirteen Ways of Looking at a Blackbird" also suggests a sequence of scenes from a Noh play.

The series of 13 stanzas in "Thirteen Ways of Looking at a Blackbird" is like pictures at an exhibition—we might even recall Moussorgsky's musical composition of that name; it is also like a Cubist painting where disparate elements are combined into one flat surface. In a sense, the poem has a radial center—the blackbird or the perception of it—around which concentric circles of impressions revolve. Indeed, are not the 13 stanzas like still lifes, a form that minimizes the presence of the human subject, narrative, and storytelling? As if each stanza were a still life in a room, the reader stands at the center and chooses which to observe. At the same time, each stanza is a cinematic scene progressing to greater if tentative revelation. Perceiving the poem as a visual entity, we notice that the imposing empty space on the page calls attention to and provides demarcation for the dearth of words, almost the way frames define and mark the space outside and inside paintings.

Certainly the influence of Impressionism and Cubism is strong in "Thirteen Ways of Looking at a Blackbird." As Michael Brenson notes,

"Cubism shattered the autonomy of the individual subject and integrated it with its environment. It made instability, indeterminacy and multiple points of view staples of modern art. It was more comfortable with metamorphosis and change than with permanence"(Brenson, 1). Ever since the 1913 Armory Show Stevens had been fascinated by Cubism:

> Were [Cubists] not attempting to get at not the invisible but the visible? They assumed that back of the peculiar reality that we see, there lay a more prismatic one of many facets. Apparently deviating from reality, they were trying to fix on it. . . . [T]he momentum toward abstraction exerts a greater force on the poet than on the painter. I imagine that the tendency of all thinking is toward the abstract. . . . (#655)

If we substitute "writing" for "painting," what William Rubin says of Braque is true of the early Stevens: "Braque's reverence for the language and the craft of painting distances him from his subject" (*Picasso and Braque*, 22). Like the Cubists, Stevens took odd combinations of man-made and natural forms and fused them into a homogeneity, but a homogeneity that was tentative and disjunctive. Stevens fulfills Rubin's definition of the collage: "The essence of collage . . . is the insertion into a given context of an alien entity—not only of a different medium but of a different style or, as the Surrealists would later insist, even of a motif drawn from a different context of experience or level of consciousness" (38).

Stevens found in collage not only a lyrical impulse but also a model for narrative possibilities. Moreover, he adopted the Cubists' example of playing upon, within one work, a continuum stretching from the most recognizable—say a "blackbird" in "Thirteen Ways of Looking at a Black-bird"—to the most abstruse abstractions: "I was of three minds, / Like a tree / In which there are three blackbirds." For Picasso, as Rubin puts it, "collage, construction, and *papier collé* . . . were about alternate ways of *imaging* reality. . . . The collage principle, we recall, is by definition conflictual and subversive, and sorts well Picasso's anarchic tendencies, his personification of the *agent provocateur*" (37-38). Writing of Picasso's May 1912 collage, *Still Life with Chair Caning*, Kies notes, "Such an unpredictable, playful, and provocative combination of objects, illusions, and paint exemplifies Picasso's acrobatic imagination and subversive spirit" (Kies, n.p.). Like Picasso, Stevens enjoyed the role of aesthetic joker. Stevens, for all of his respectability and desire for order and control, had another self in his poetry that gave voice to his libidinous, anarchic side, a side that flouted bourgeois values and expecta-

tions; the sexual playfulness of "Anecdote of the Prince of Peacocks" (1923) is an example.

IV.

Although many years later Stevens claimed that he confined his focus in *The Man with the Blue Guitar* (1937) to "the area of poetry" (#873), this brilliantly concise poem—or perhaps we should say sequence of 33 poems—explores the necessary preconditions to creativity: self-knowledge and knowledge of man. Among other things, Stevens is auditioning for the crucial roles of the major Modernist poet—the poetic counterpart of Picasso—and the major American poet in the tradition of Emerson and Whitman.

By using painting in this poem as a model and metaphor for poetry— a painting that evokes music—Stevens was taking issue with Walter Pater's claim that music was the highest art form and that all art aspires to the purity of music. By seeking to "resolve" other art forms on the plane of poetry, he was making a claim for poetry's centrality. What he liked about modern painting was its engagement with reality:

> Thinking about poetry is the same thing as thinking about painting. . . . [The painters Camille Pissaro and Pierre Bonnard] attach one to real things: closely, actually, without the interventions or excitements of metaphor. One wonders sometimes whether this is not exactly what the whole effort of modern art has been about: the attachment to real things. . . . While one thinks about poetry as one thinks about painting, the momentum toward abstraction exerts a greater force on the poet than on the painter. (#655)

The poet is conceived as a painter—"The world washed in his imagina- tion"—trying to find the appropriate forms and colors with which to render man (Stevens's *The Man with the Blue Guitar*, section XXVI). It may be helpful to think of the blue guitarist as a painter painting a series of canvases, a set of frescoes for the palace of his and our minds. Indeed, the poem is a kind of mural in which various ideas about the poet and imagination are depicted. The poem has the illogic of a Surrealistic dreamscape: "The color like a thought that grows / Out of a mood" (IX). Some of the paintings are self- portraits. The blue guitar is an image of the imagination; it is also a sexual trope ("And I am merely a shadow hunched / Above arrowy, still strings" or

"Raise reddest columns"[ix, x]). As the poem proceeds, it enacts a number of conflicts, including the one between concept and sensory perception, or what Stevens calls thesis and instinct: "Life cannot be based on a thesis, since by nature, it is based on instinct. A thesis, however, is usually present and living in the struggle between thesis and instinct" (*Adagio*, 160). Finally, as we shall see, the crescendo—section XXXIII—casts aside the concept of thesis and enters into the world of imaginative play.

Stevens is a poet of middles, and his poems begin as if we were entering into a situation where something has been said or happened about which we know nothing. For one thing, words do not have their customary definition. *The Man with the Blue Guitar* enacts the transformation of language into something both familiar and foreign. It needs to be thought of as a poem with several voices, a kind of roundelay where each voice takes its turn; rather than a narrative of linear continuity and a consistent voice, the stanzas respond to one another in a dialogic mode. This helps us understand the radical break between, say, sections XVI and XVII.

In the opening section, the blue guitar is proposed as an image of both the creative imagination and the poet. But Stevens immediately extends the dialogue between the man with the guitar and his listeners into a dialogue between poet and audience. To those who object that he does not play things as they are, the guitar player says that the blue guitar cannot help but change things. That is, the act of creating by definition transforms the literal to the metaphorical, the bread and wine of life into something different. But the audience drastically raises the stakes and asks for "a tune beyond us, yet ourselves," "exactly as they are," as if they expected simultaneously an intensified version of themselves and the larger world beyond them, as if they wished to be measured in their own self-defined heroic potential or self-apotheosis. They wish to be projected as bigger than life and to have that projection called "things exactly as they are." The shearsman is a collagist who cuts and patches; he also carries resonances of the three classic Fates, or Parcae who control the destinies of humans. And Stevens knew how the Cubists exploited the sexual potential of the guitar and would have expected us to see how the bent man was having intercourse with his imagination.

That is why the guitarist-speaker steps back and glosses the exchange of section I—provides a kind of explanatory midrash—by rejecting the view that he can create a sufficient cosmology: "I cannot bring a world quite round, although I patch it as I can." Nor can he quite find the essence of man, even if he were to abstract him from the heroic vision that man would like to have of himself. The word "patch" reminds us of a central Emersonian distinction:

NATURE. In enumerating the values of nature and casting up their sum, I shall use the word in both senses;—in its common and in its philosophical import. In inquiries so general as our present one, the inaccuracy is not material; no confusion of thought will occur. *Nature*, in the common sense, refers to essences unchanged by man; space, the air, the river, the leaf. *Art* is applied to the mixture of his will with the same things, as in a house, a canal, a statue, a picture. But his operations taken together are so insignificant, a little chipping, baking, patching, and washing, that in an impression so grand as that of the world on the human mind, they do not vary the result. (Emerson, 8)

The subject of the poem includes the essence of nature: sun, sea, earth, and air.

In stanza 2 of section I, when he writes of "a hero's head, large eye / And bearded bronze, but not a man," Stevens may have in mind the figure of the artist that Rodin proposed in his magnificent *Balzac*, a figure of the artist as hero and seer that had more to do with Rodin's concept of the artist and of Balzac than Balzac's self-concept. With its emphasis on form and on the artist as seer and iconoclast, Rodin's *Balzac* is a crystallizing image of Modernism. Isn't Stevens also rejecting the view of the artist as hero by choosing the metaphor of the guitarist serenading his listeners and then in turn imaging the guitarist as humble tailor patching as he can, which in turn evokes the clown in motley?

Stevens admired the power and assurance of Picasso's execution and composition. In section XV, the very middle of the poem, Stevens invokes the spirit of Picasso, he asks if "this picture of Picasso's, this 'hoard of destructions,'" is "a picture of ourselves"? The relationship between the speaker and his readers is troped by the relationship between the audience and the man with the blue guitar, a man whose blue guitar would have suggested Cubism and Fauvism to Stevens's audience. Stevens was in awe of the space that Picasso occupied in the modern imagination and yearned to be a figure of similar stature in poetry. Does he not invoke Picasso as an invocation of the Modernist ambiguity toward coherent reality? In a remark to his friend Christian Zeves, Picasso had described his paintings as a "sum of destructions;" by this he meant that, unlike his predecessors who proceeded incrementally, he stripped away until he reached the essence. Borrowing a term from Simone Weil, Stevens spoke of the process of his writing as "decreation."

Although Stevens claimed he had no specific Picasso in mind, it seems possible that he was thinking of the version of *Three Musicians* (1921) in the Museum of Modern Art. In that painting, as H. W. Janson writes, "The

separate pieces are fitted together as firmly as architectural blocks, yet the artist's primary concern is not with surface pattern . . . but with the image of three musicians, traditional figures of the comedy stage" (523). As we read from left to right, the ominous black suggesting death becomes more prominent, even as the white—image of life—recedes. And is not death a motivation of representation, a catalyst for using paint, music, and words, to define and secure life, to evade death? While the first figure is sexual and the middle one has clown pants, the third is death's shadow.

Stevens also had in mind Picasso's *Guitar* (1913), which relies on word play and exploits the words in the newspaper cuttings that are part of the collage. Does not the synthesis of objects in a Cubist collage suggest Stevens's technique, for the collage presented a system of formal notation that would allow the painter to build a picture in terms of discrete elements and eventually to reassemble the subject matter in all its aspects? Stevens plays on the Cubist trope of guitar as an emblem of a man and woman making love; like Picasso, he appreciates the dissemination of meaning from complex allusions and insinuations.

Stevens also may have seen pictures of Picasso's *The Dance* (1925), a painting with a blue background, in which the female figure on the right is a frenzied, dancing guitarist with a profile that suggests a crescent moon and in which the middle dancer suggests a Christ-like pose of crucifixion; the third dancer's tiny helmet head—perhaps the hero's head earlier in Stevens's poem—is surrounded and engulfed by a larger-than-life black head which evokes the presence of death. The high-spirited comic nature of the early stanzas may owe something to this painting, but the trappings of death on the figure at the right intrudes into the painting just as despair intrudes into Stevens's poem. Stevens, like Picasso, saw the musicians and dancers as figures for the comic artist, comic in the sense of awareness of what it is to live in an absurd cosmos. Isn't Picasso present not only in the image of the collagist—"patching" and "pick[ing] the acrid colors out" and "bang[ing] it from a savage blue"—but in the exuberant beginning of both section XXV, where the poet is a juggler ("he held the world upon his nose"), and section XXX, where the poet conceives himself as a puppeteer manipulating his "fantoche" or "puppets"? Given the poem's poignance and visceral pain, "blue" may carry a suggestion of the American blues as well as the implication of sexually daring material. Stevens also may have had in mind *Guitar* (1919), which is more concerned with the guitarist than the guitar; according to John Russell, "The diamond-shape [which lies behind the guitar painted on torn paper] represents . . . an immensely simplified human figure, with just one or two very discreet clues as to its pose and location (123)."

It is worth noting that notwithstanding assertions in Stevens scholarship to the contrary, there is no Picasso painting entitled *The Man with the Blue Guitar* and also that the dominant motif of Stevens's poem is not the gloom and melancholy of Picasso's blue period. While the critics have *The Old Guitarist* in mind, it is obvious that some have not looked carefully at the painting. According to Stevens, "The great poem is the disengaging of [a] reality" (*Adagio*, 169). The stripping down to essentials that Stevens is trying to imitate was characteristic of Picasso's technique in *The Old Guitarist* (1903), a painting of his blue period that implies some of the melancholy aspects of Stevens's poem; indeed, it is a painting in which the guitar is brown. The elongated El Grecoesque figure is—if his head bent to an unnatural angle, his shoeless feet and ragged garb, and his nearly frozen facial features are criteria—depressed and weary, but indomitable in his effort to survive. Even as he dominates his space, does not that figure refuse to bow with resignation to age and death? Stevens, I think, would have been responsive to such an aesthetic that emphasizes reduction and simplicity; certainly *The Man with the Blue Guitar*, with its spare, stark form, sharp contrasts, rapid movements, distortions, and brief vignettes alternating with concise theorizing, *enacts* such an aesthetic.

The leitmotif of section XV is destruction and dissolution, even if the hope of coherence is held out by the reference to Picasso. If Stevens's speaker has found an artistic paradigm, he has not found an antidote to his gloom and fragmentation. Does he not have *Hamlet* in mind when he thinks of himself at a table where the food is cold? "Stone" is an image of death, reality, and the depth of imagination; it is the ground from which the imagination must depart and the pole of reality to which the imagination must, in its endless oscillations—its warp and woof—return. Are not the gloomy infinitives of section XVI an ironic response to those in III? Does not XVI devolve into bitterness: "Place honey on the altars and die, / You lovers that are bitter at heart"? In section XVI *things*, on the one hand, are bitterly resolved into stone and death: war, religion, progress ("To improve the sewers in Jerusalem"—the Roman sewers made of stone); on the other hand, passions—including love—are proposed and rejected: "Place honey on the altars and die, / You lovers that are bitter at heart." In Poem XVII, the speaker imagines the guitar played upon by "claws" and "fangs," for man is conceived in his animalistic dimension. Instead of the West Wind trumpeting life, the north wind announces death: "the north wind blows / A horn, on which its victory / Is a worm composing on a straw."

Notwithstanding my placing Stevens in the Modernist movement, he is also an American artist. Indeed, *The Man with the Blue Guitar* concludes in

his Americanist voice, but does so without discarding the persona of one immersed in the Western tradition, including the Bible, Shakespeare, the Romantics, other Modernists—painters and authors—and *commedia dell'arte.* Stevens was raised in the America idealized by the Hudson River School. Shaped by his Reading, Pennsylvania, boyhood, his vision of nineteenth-century America is a version of the pastoral unspoiled by pollution and industrialism, an America where plenitude rather than want prevails. It is an America awaiting man's energy to fill its spaces, as if it were a blank page awaiting the marks of the poet. Part of Stevens longs to recapture this Edenic America and elegizes its loss to "Oxidia, banal suburb." Stevens remembered a Pennsylvania of his boyhood with slow-moving sylvan streams, lucid, lighted skies—often with a diaphanous light—lush green fields in the summer, set against imposing but accessible mountains, rural activities of domesticity, and bucolic winter landscape. Indeed, in his journal he wrote as if he were a literary member of the Hudson River School: "the light is perfect—absolute—one sees the bark of trees high up on the hills, the seams of rocks, the color + compass of things . . . I made a map of the river. . . . What a thing blue is!" (#89).

We recall Emerson's essay "Nature":

> The eye is the best of artists. By the mutual action of its structure and of the laws of light, perspective is produced, which integrates every mass of objects, of what character soever, into a well colored and shaded globe, so that where the particular objects are mean and unaffecting, the landscape which they compose is round and symmetrical. And as the eye is the best composer, so light is the first of painters. There is no object so foul that intense light will not make beautiful. (13-14)

Light for Stevens, as for Emerson, is metaphorical: "The production of a work of art throws a light upon the mystery of humanity. A work of art is an abstract or epitome of the world" (Emerson, 18). It is part of the poignance of Stevens that nature has been despoiled and transformed into things so that "the earth is alive with creeping men, mechanical beetles never quite warm" (section VII), the halls are filled with "shuffling men," the guitarist feels that his music is a "leaden twang," and "the fields entrap the children, brick / Is a weed" (section IX). We think of Gloucester's words in *King Lear:* "as flies to wanton boys are we to the gods, they kill us for their sport." That the world is in dissolution requires the artist to give it meaning. The poem is a response to the Depression, to the blighted hopes of the League of Nations, to the failure of Emerson's dream.

Writing of the paintings of Thomas Cole, Stevens remarked: "I like to hold on to anything that seems to have a definite American past. . . . One is so homeless over here in such things and something really American is like meeting a beautiful cousin, or for that matter, even one's mother for the first time" (#677). The nostalgia for the past intermixes with a longing for an indigenous American culture, as Stevens proclaims in section XXVIII: "I am a native in this world / And think in it as a native thinks."

V.

Let us return to "Thirteen Ways of Looking at a Blackbird." The title invites us away from the world of doing into the world of beholding. Stevens wished to emphasize the contemplation of reality, not reality itself. The blackbird is something of an X factor whose identity changes in relation to the speaker's mood and context. As the title and insistence on verbs of looking, knowing, and seeing stress, the poem is about what we know and how we know it. Each stanza brings the blackbird into relation with the mind. The speaker is like a surveyor using the blackbird as an instrument to measure the geography of the mind. From the outset, the play on "eye" and "I"— introduced in the last line of stanza I and the first line of stanza II— emphasizes the stress on one person *looking*.

Isn't Stevens stressing that the blackbird—like a metaphor—is whatever and wherever one wants it to be? And although it flies from the circle of visual perception, as in stanza IX, it returns or—mysteriously—is still there in stanzas X, XI, XII, and XIII as an object of contemplation and as a catalyst for meditation and creativity. Indeed, the speaker's rhyme in stanzas IX and X emphasizes that when the blackbird is "out of [his] sight," it is still hypothetically possible to evoke it in his mental "light." Thus the poem stresses that sight has little to do with seeing. The "insight" of memory and fantasy—both indispensable for the creative process—is just as real. As in "The Snow Man" (1921), for the imaginative "listener" what is there and what is not there are both real.

The text defines the essential Emersonian distinction between Me and not-Me, between freedom of the observer to perceive and the world on which his mind acts. In "The American Scholar," Emerson writes: "The one thing in the world, of value, is the active soul. . . . The soul active sees absolute truth and utters truth or creates. In this action it is genius" (56). Yet at the end of Stevens's poem, as we shall see, the distinction is blurred and the blackbird is depicted as a function of the speaker. Similarly, the poem itself

begins in an *I/not-I* relationship with the reader and collapses by its very tautological structure into a function of the I-reader. While Stevens wrote that "This group of poems is not meant to be a collection of epigrams or of ideas, but of sensations," the effect of such a group is to insist upon recuperation in terms of something we can understand (#279). That is, as the poet comes to terms with a difficult, abstruse and resistant subject, so the reader comes to terms with—brings into the ken of her understanding— a complex, abstract, seemingly arcane, and resistant poem. But because the poem is as much about the exploration—the quest—for innovative form as it is about its nominal subject, the reader experiences the creative process— the dialogue between the formal ingredients (the abstract discourse) and the story that always like an underground stream threatens to emerge above the surface as the *agon*.

While the spare diction and syntax look forward to the later lyrics, "Thirteen Ways of Looking at a Blackbird" has a much harder, flatter surface, one that not only puzzles and distances the reader but makes her uneasy. Stevens is obliterating conventional expectations of narrative and three-dimensionality. One is struck by what is absent from the poem: politics, relationships, the presence of the speaker's psyche—although that, as we shall see, is revealed obliquely by the speaker's choice of scenes and his development of metaphors. Rereading, we realize how often the speaker is outrageously importing nonempirical and unconventional assumptions. At such a distance, as implied by "twenty snowy mountains," how could the speaker see the moving eye of the blackbird? What does it mean in stanza II to be of three minds? Is it an intensification of the ambivalence of being of two minds, while introducing a poem that stresses the multiplicity of perspectives? If—to pursue the logic of Stevens's metaphoricity—one is like a tree, is it to be capable of growth, or does it mean to be wooden or to be rigid in one's responses (stanza II)?

Stevens conceived of poetry as a performance for an audience, but one that required the reader's participation; in "Thirteen Ways of Looking at a Blackbird," he is stressing the visual element and inviting his reader to see a poem as if it were a visual performance, a kind of modern dance or a series of paintings. Yet the very need for utterance—of articulating in the first and third person the responses to the blackbird—shows the impossibility of his attempt to write a kind of visual silkscreen where abstract detachment from reality takes the place of mimesis. For Stevens, like Joyce—particularly in *Ulysses* and *Finnegans Wake*—language takes precedence over ways of conveying feeling and emotions; the mimetic code triumphs over the pure and abstract within the work; and themes and values emerge about how people

live and die, create and desire. Just as Joyce in the "Sirens" episode of *Ulysses* goes as far as he can go in exploring the possible fusion of music and language, Stevens in "Thirteen Ways of Looking at a Blackbird" explores the possibility of visual poetry.

By its flat plane, sense of story, and reductive, almost hawklike overview, "Thirteen Ways of Looking at a Blackbird" places the reader at a distance and situates her far from the expected intimacy of lyrical poetry. We take for granted conventions of sense and meaning, Stevens implies, but his rhetoric—as a structure of tropes that generates a structure of affects— invites us to create an alternative group of assumptions and see where that takes us. As wittily and playfully as Paul Klee and other Surrealists, Stevens turns our expectations upside down and proposes observations on the relationship between the linguistic and the visual. The "eye" in the first stanza is the objective world—the not-I world—that exists beyond the perception of self. So, too, is the mark on the page, the disruption of blankness, the notation that makes meaning.

The empty space on the pages on which the poem appears is a visual metonym for the limitless spaces of the mountains. Among other things, the print or signs left by words are not only the tracks that a bird might leave in the snow, but the print on the page. The typography of the poem—the spare stanzas, each with its own demarcation of a Roman numeral—empha- sizes the presence of occasional black marks on a white page. Just as the 20 mountains in stanza I provide a vast space for the perception of the birds and their potential activity, so the pages offer the promise of meaningful signs. Does not the generous space surrounding the rather scant typography on the page visually mime the blackbird against the sky, particularly against the 20 mountains?

The striking presence of black within diverse scenes—black often set against the white of snowy mountains (stanza I) or within a snowscape (stanza XIII)—climaxes in its juxtaposition with the astonishing appear- ance of green light into the black-and-white mindscape in stanza X: "At the sight of blackbirds / Flying in a green light, / Even the bawds of euphony / Would cry out sharply." Does not Stevens have in mind the *ersatz* order proposed by those upholding the moral law in his 1922 poem, "A High-Toned Old Christian Woman"? But, as he makes clear in a letter to Henry Church, he also had in mind rigorous academics who were reluctant to admit the diversity of the universe; "What was intended by [stanza] X," wrote Stevens, "was that the bawds of euphony would suddenly cease to be academic and express themselves sharply: naturally, with pleasure, etc" (#387).

The sequence of 13 related poems recalls Pointillist paintings that fix one moment in space and isolate it from a temporal process. Isn't each miniature poem like a collection of pointillist dots that cohere on the surface? The poems may owe something to pointillism's freezing moments in time and place by applying dots or tiny strokes of color elements to a surface so that, when seen from a distance, the dots or strokes blend luminously together. Indeed, like the tracks of the print covering the white page in "Thirteen Ways of Looking at a Blackbird," the white ground is systematically covered with tiny points of pure color—or black—that blend together when seen from a distance, producing a luminous affect. The optical mix of Georges Seurat had the grayish aspect that Baudelaire attributed to the molecular quality of nature; not only Imagism, but the desire to look at nature in miniature—stimulated by Pointillism and Baudelaire—may have influenced Stevens.

As much as a Surrealistic collage by Max Ernst, Stevens undermines our traditional expectations of what we see. For Stevens, aspiring in 1917 to a pure poetry, abstraction is an aristocratic mode of thinking that takes us away from the pedestrian, utilitarian, and philistine world of *doing* into an aesthetic realm of *being*. He aligns himself with those modern painters— Dadaists, Surrealists, Suprematists—who searched for forms and icons that would give man a different view of his reality. In "Thirteen Ways of Looking at a Blackbird," does not the very preoccupation with black suggest such abstract compositions as Kozimir Malevich's *Suprematist Composition: Red Square and Black Square*? Even if he does not mention it, surely Stevens had in mind the red-winged blackbird—the American blackbird never mentioned in his poem as if he were suppressing the realistic subject in favor of the abstract and parabolic one.

In stanza VII, Haddam is a rich image implying the paradox that traditional and experimental modes of mimesis often are mutually dependent on one another for meaning. Because Haddam, Little Haddam, and East Haddam were small, well-to-do New England villages on the Connecticut River's east bank where old established family lines are perpetuated from generation to generation and where roads have names like Petticoat Lane, Haddam stood, in Stevens's mind, for suburban and tradition-bound resistance to challenges to moral and artistic convention and for spiritual undernourishment. The homophonic pun in stanza VII on Haddam/Adam wittily suggests that the enthusiasm for enervated and mannered art follows Adam's loss of innocence and the corruption of the enclosed garden of nineteenth-century America. But does Haddam not also suggest Hadim in the Byzantine empire where—as Yeats stressed—exotic figures, such as golden birds, were created

by artificers and where nonmimetic iconographic art reached perfection? Does not the poem continually propose seduction away from our everyday world only to show us that such a seduction is evanescent if not impossible?

As W. J. T. Mitchell has suggested, the further the abstract painter goes from language and narrative, the more we need to recuperate our experience in language (348-47). According to the Horatian maxim, *"ut pictura poesis, as in painting, so in poetry."* Much as when observing abstract painting, the reader of the abstract and minimalist "Thirteen Ways of Looking at a Blackbird" must reorient himself to non-mimetic experience and must resituate himself in a mode of perception that requires his own verbal intelligence. Just as we must formulate our response to abstract painting in words, so we must verbalize a response to remote and esoteric poetry. Ironically, the very desire to overcome puzzling rhetoric and inchoate representation requires a response in words that situates the puzzling artistic experience within our own experience. Paradoxically, as we learn from their theoretical tracts—their verbal texts—abstract painters themselves rarely want their visual texts to be understood as abstract. Rosalind Krauss has remarked that the "greatest fear" of abstract artists is that they "may be making *mere* abstraction, abstraction uninformed by a subject, contentless abstraction" (237).

VI.

Let us return briefly to "Tea at the Palaz of Hoon," which should be read as the third part of a lyric sequence, the first two parts of which are "The Man Whose Pharynx was Bad" and "The Snow Man." If "The Snow Man" is about responding, "Hoon" is about actively defining our own position. When we read "Hoon"—and indeed much of Stevens—we might think of what Albert Elsen wrote of two great modern artists whom Stevens admired and who indirectly if not directly influenced him: "The spiritually inquisitive images of Rodin and Picasso established the modern realization of the uncertain or discordant self: exhortation to action was replaced by models of introspection; the defense of civilization supplanted by the quest for self-knowledge; the commitment to causes gave way to the quandary; the ideal to truth" ("Picasso's Man with a Sheep," 9). "Tea at the Palaz of Hoon" is a poem that not merely demonstrates a voice acting on the world but also desperation and determination, if not a hint of a primitive and obsessive urge for survival.

If "The Snow Man" is associated with present and winter, then "Tea at the Palaz of Hoon" is associated with optative and summer. "Hoon," the

companion or perhaps antiphonal poem, is woven whole cloth from the mind of the speaker, while "The Snow Man" is based on the sensibility of the speaker responding to external nature. "Hoon" is about a man imagining that he is making an elaborate entrance, even as he imagines himself addressing the audience that might question his pretensions. Stevens is simultaneously participating with full energy in Hoon's metaphoricity and mocking his solipsism and self-apotheosis. The iterated "not less" of the first tercet brings a note of hesitancy and defensiveness—the characteristic reticence or diffidence of "maybe" or "suppose" or "what if," which touches even Stevens's boldest personae—into Hoon's stance; even while he wears his odd and idiosyncratic mask, and claims "I am myself," the convoluted syntax and forced hyperbole question his stridency. Reading "Hoon," do we not think of Marcel Duchamp's *Nude Descending a Staircase*, No. 2 (1912)? As mentioned in the last chapter, Duchamp was enacting the Futurist credo that modern art must dramatize the energy and motion of contemporary life, and that included physical motion and bodily sensations.

Crucial to re-creating diverse planes on the model of Cubism is Stevens's use of the present participle as a way of creating two separate places in coterminous time. Stevens uses the participle to render the process of the mind actively seeking relationships—visual appositions, phonic parallels—and to give a sense of the mind's movement in quest of meaning. Notice how many poems have a participle or gerund in the title: "Thirteen Ways of Looking at a Blackbird," "Of Mere Being," "Ploughing on Sunday," "The Pleasures of Merely Circulating," "So-and-So Reclining on Her Couch," and "The Men That are Falling." The process of integrating diverse perceptions of reality that we find in Matisse and Picasso is accomplished by the present participles wittily, playfully, and outrageously gathering and juxtaposing diverse sights, sounds, and smells. Creating diverse planes, the participles tend paradoxically to focus attention on the speaker's interaction with the alleged subject as well as on his quest for metaphors and ways of seeing, rather than on the finished object.

When Stevens formed his poetic and aesthetic principles, silent cinema—as well as modern painting and sculpture—demanded intense attention. His rapidly changing metaphors not only have a kinship with cinema, but mime the condition of modern perception in which humans had far more impressions and far more variety to deal with than their predecessors. What I call Stevens's *metaferocity*—the rapid sequence of metaphors—owes something to Muybridge and to the concept of chronophotography; namely "the recording," to quote Russell, "of human beings or animals in motion by means of successive photographic exposures" (154). Is not the process of successive

exposure crucial to "Thirteen Ways of Looking at a Blackbird," even though that poem can also be perceived as a nonlinear collage? Indeed, that poem may owe something to Duchamp's *Large Glass*, the full title of which is *The Bride Stripped Bare by Her Bachelors* (1915-23); the donnée is a Feydeau farce in which nine bachelors pursue the same pretty girl. No more than when we perceive a collage should we limit our reading of a Stevens poem to our linear reading experience. The reader of Stevens needs to respond to odd juxtapositions and seemingly free associations, undoubtedly influenced by the liberation of chance from the logical gridlocks of Western epistemology by Dadaism, Freud, and Surrealism; as Hans Richter remarked, "Chance appeared to us as a magical procedure by which we could transcend the barriers of causality and conscious volition, and by which the inner ear and eye become more acute. . . . For us, chance was the 'unconscious mind,' which Freud had discovered in 1900" (quoted in Russell, 179).

Stevens wrote at a time when artists believed that the very nature of communication might be changed and when artists such as Duchamp believed that impersonal, nonassociative color might convey meanings beyond what they represent. In the 1920s, too, artists were fascinated by the possibility of a fourth dimension that was beyond the capacity of the human eye and thought. As John Golding put it, "Three-dimensional objects could be considered as the flat shadows or reflections of the fourth dimension, invisible because it could never be seen by the human eye" (quoted in Russell, 174-75).

Stevens knew well that the danger in "Hoon" was solipsism, a poetry that will not speak to, as he put it in "The Idea of Order at Key West" (1934), "ourselves and our origins." "Hoon" does not locate his reality in himself, in—to look forward to "The Man on the Dump" (1938)—"the the" of his being. In "The Man on the Dump," Stevens takes some cues from the provincialism and anti-intellectualism of the American regionalists, especially Thomas Hart Benton. Like the painters of the period, Stevens responds to social, political, and economical unrest. The visual ingredients of "The Man on the Dump" are influenced by the Works Progress Administration's large-scale murals and by the caricatural reformulations of the literal that we find in painters such as Jack Levine and Philip Evergood. These painters scorned the "intuitive and subjective in favor of the factual and objective" (Rose, 42). From the work of Edward Hopper, Stevens understood how to "generalize the sense of loneliness and alienation felt by many Americans into a universal theme" and to do so by "a severe laconic style compatible with his homely imagery and content" (Rose, 45). Like Hopper, Stevens addresses banality. But most of all Stevens got from Hopper and Charles

Burchfield the sense of a simple American life that was decaying and disappearing. With its ties to the Ashcan School and social conditions of the 1930s, its figure of the outcast, and its bathetic reductiveness to "the the," "The Man on the Dump" is indebted to John Dewey's pragmatic aesthetics, an aesthetics that is antithetical to the spirit of the American sublime. This spirit is figured by Sevens's early visions of the Hudson and the nightscape of Key West in "The Idea of Order at Key West." Even "The Man on the Dump" strongly modifies the Platonism of the "The Idea of Order at Key West"; it defines the debate between the contradictory impulses that rage not only throughout the Stevens canon but in American poetry and painting, between the sublime and the ordinary.

VII.

We might conclude by recalling Robert Morris's remark, "From the origins of such terms as 'theory' (from *theoria*—to look at) and 'idea' (from *idein*—to see) to Plato's metaphor of the cave, the visual is both privileged and concealed in language" (375). When reading Stevens, we see that beyond his word play, elusive syntax, difficult images, and/or seeming minimalism is a strong mimetic sense. And that mimetic sense was influenced by a strong response to modern painting in which he found images of his own quest to make sense of the world and himself.

Bibliography

Abrams, M. H. *The Mirror and the Lamp: Romantic Theory and the Critical Tradition* (New York: Norton, 1958).

Adams, Stephen. *The Impressionists* (Philadelphia, PA: The Running Press, 1990).

Altieri, Charles. *Painterly Abstraction in Modernist American Poetry: The Contemporaneity of Modernism* (Cambridge: Cambridge University Press, 1989).

Annan, Noel. "The Intellectual Aristocracy" in J. H. Plumb, ed., *Studies in Social History: A Tribute to George Trevelyan* (London: Longmans, Green, 1955), 241-87.

Austen, Allen. "T. S. Eliot's Theory of Personal Expression" *PMLA*, 81 (June 1966) 303-307.

Barnes, Julian. "The Proudest and Most Arrogant Man in France," *New York Review of Books* (22 October 1992), 3-5.

Barr, Alfred. *Picasso: Fifty Years of His Art* (New York: Museum of Modern Art, 1966).

Bates, Milton J. *Wallace Stevens: A Mythology of Self* (Berkeley: University of California Press, 1985).

Bell, Quentin. *Virginia Woolf: A Biography* (New York: Harcourt Brace Jovanovich, 1972).

Bernier, Rosamund. *Matisse, Picasso, Miro: As I Knew Them* (New York: Alfred A. Knopf, 1991).

Boehm, Gottfried. "A Paradise Created by Painting" in *Paul Cézanne: The Bathers* (New York: H. A. Abrams, 1989), 11-29.

Boggs, Jean Sutherland, ed. *Picasso and Things* (Cleveland: Cleveland Museum of Art, 1992).

Booth, Wayne. "Ten Literal 'Theses'" in Sheldon Sacks, ed., *On Metaphor* (Chicago: Chicago University Press, 1979), 173-174.

Bradbury, Malcolm. *Possibilities: Essays on the State of the Novel* (New York: Oxford University Press, 1972).

Bradley, F. H. *Appearance and Reality: A Metaphysical Essay*, 2nd ed. (London: S. Sonnenchein, 1908).

Brenson, Michael. *Picasso and Braque: Brothers in Cubism. New York Times Arts and Leisure* (22 September 1989), 1.

Brettell, Richard. *The Art of Paul Gauguin* (Washington, DC: Board of Trustees, National Gallery of Art, 1988).

Brower, Reuben. *Alexander Pope: The Poetry of Allusion* (Oxford: Clarendon Press, 1959).

Budgen, Frank. *James Joyce and the Making of Ulysses* (Bloomington, IN: Indiana University Press, 1960; orig. ed., 1934).

Callen, Anthea. "Degas' *Bathers:* Hygiene and Dirt—Gaze and Touch," in Kendall, Richard and Pollack, Griselda, eds., *Dealing with Degas: Representations of Women and the Politics of Vision* (New York: Universe, 1992), 159-85.

Caws, Mary Anne. *The Eye in the Text* (Princeton, NJ: Princeton University Press, 1981).

Cézanne (Philadelphia: Philadelphia Museum of Art, 1996).

Clifford, James. *The Predicament of Culture: Twentieth-Century Ethnography, Literature, and Art* (Cambridge, MA: Harvard University Press, 1988.

Conrad, Joseph. *Heart of Darkness and The Secret Sharer* in Morton Dauwen Zabel, ed., *The Portable Conrad* (New York: Viking, 1976, orig. ed., 1947).

———. *Lord Jim*, ed. Thomas L. Moser (New York: Norton, 1968).

———. *A Personal Record* (New York: Doubleday, 1926; orig. ed., 1912).

Dangerfield, George. *The Strange Death of Liberal England 1910-14* (1935) (New York: Capricorn Books, 1961).

Degas, Edgar. *Ballet Dancers* (New York: Universe, 1992).

de Man, Paul. "Semiology and Rhetoric" In Josue Harari, ed., *Textual Strategies* (Ithaca, NY: Cornell University Press, 1979), 121-140.

Derrida, Jaques. "The Supplement of Copula: Philosophy *Before* Linguistics" In Josue Harari, ed., *Textual Strategies* (Ithaca, NY: Cornell University Press, 1979), 83-120.

Di San Lazzaro, G. *Klee: His Life and Work* (London: Thames and Hudson, 1957).

Donne, John. *John Donne: The Anniversaries*, ed. Frank Manley (Baltimore: Johns Hopkins University Press, 1963).

Ducharme, Robert. "The Power of Culture in *Lord Jim.*" *Conradiana* 22 (1990), 3-24.

Elderfield, John. *Matisse in Morocco* (Washington, DC: National Gallery of Art, 1990).

———. *Matisse in the Collection of the Museum of Modern Art* (New York: Museum of Modern Art, 1978).

————. *Henri Matisse: A Retrospective* (New York: Museum of Modern Art, 1992).

Eliot, T. S. *On Poetry and Poets* (New York: Noonday, 1961).

————. *Selected Essays*, new edition (New York: Harcourt, Brace, and World, 1960, orig. ed., 1950).

————. *The Complete Poems and Plays 1909-1950* (New York: Harcourt, Brace and World, 1962).

Ellmann, Richard. *James Joyce* (New York: Oxford University Press, 1959).

Ellmann, Richard, and Charles Feidelson, Jr., eds. *The Modern Tradition: Backgrounds of Modern Literature* (New York: Oxford University Press, 1965).

Elsen, Albert. *Rodin* (New York: Museum of Modern Art, 1963).

————. "Picasso's Man with a Sheep: Beyond Good and Evil." *Art International* (March-April 1977), 8-31.

Emerson, Ralph Waldo. *The Portable Emerson*, edited by Carl Bode in collaboration with Malcolm Cowley (New York: Penguin Books, 1946).

Flam, Jack. *The Man and His Art 1869-1918* (Ithaca, NY: Cornell University Press, 1986).

Frank, Joseph. "The Master Linguist." *The New York Review of Books* (12 April 1984), 29-33.

Fried, Michael. *Manet's Modernism; or, The Face of Painting in the 1860s* (Chicago: University of Chicago Press, 1996).

Fussell, Paul. *The Great War and Modern Memory* (Oxford, England: Oxford University Press, 1975).

Garafola, Lynn. *Diaghilev Ballets Russes* (New York: Oxford University Press, 1989).

Glueck, Grace. "A Lively Review of the Futurist Experience." *New York Times, Arts and Leisure* (1 May 1983), 29.

Gopnick, Adam. "The Unnatural" (Review of Henri Matisse exhibit, Museum of Modern Art, New York). *The New Yorker* (12 October 1992), 106-113.

Gowing, Lawrence. *Matisse* (New York: Thames & Hudson, 1979).

Graff, Gerald. *Professing Literature* (Chicago: University of Chicago Press, 1987).

Great Victorian Paintings (London: Arts Council Publication, 1968).

Halverson, John. "Prufrock, Freud, and Others." *Sewanee Review* 76 (1968), 571-588.

Honolulu Academy of Arts: Selected Works (Honolulu, Hawaii, 1990).

Hynes, Samuel. *The Edwardian Turn of Mind* (Princeton, NJ: Princeton University Press, 1968).

James, Henry. *The Great Short Novels of Henry James,* ed. Philip Rahv (New York: Dial, 1965).

Janson, H. W. *History of Art* (Englewood Cliffs, NJ: Prentice-Hall, n.d.).

Joyce, James. *A Portrait of the Artist as a Young Man* (New York: Penguin, 1977; orig. ed., 1916).

———. *Ulysses* (New York: Vintage Books, 1986; orig. ed., 1922).

Julius, Anthony. *T. S. Eliot, Anti-Semitism, and Literary Form* (Cambridge, MA: Cambridge University Press, 1995).

Kagan, Donald. "Western Values are Central." *New York Times* (4 May 1991), 23.

Karmel, Pepe. "Symbolism's Voyage into Despair and Back." *New York Times* (27 August 1995), 31.

Kermode, Frank. *The Sense of an Ending: Studies in the Theory of Fiction* (New York: Oxford University Press, 1967).

Kies, Emily Bardace. *Picasso and Braque: Pioneering Cubism* (New York: Museum of Modern Art, 1989).

Kimmelman, Michael. "The Joy, Jazz, and Delicacy Under the Mondrian Grids," *New York Times* (29 September 1995), 10, 12.

Kirstein, Lincoln. "Classic Ballet" in Dalobert D. Runes and Harry Schrickel, eds., *Encyclopedia of the Arts* (New York: New York Philosophic Library, 1946), 226.

Kisselgoff, Anne. "A Man Who Imagined the Unimaginable," *New York Times* (14 January 1996), 6.

Kramer, Hilton. "Now that the Show is Over," *New York Times* (12 October 1980), 41.

Kramrisch, Stella. *Manifestations of Shiva.* (Philadelphia, PA: Philadelphia Museum of Art, 1981).

Krauss, Rosalind. *The Originality of the Avant-Garde and Other Modernist Myths* (Cambridge, MA: Harvard University Press, 1985).

Lacan, Jacques. *The Four Fundamental Concepts of Psycho-Analysis.* Ed. Jacques-Alain Miller. Trans. Alan Sheridan (New York: Norton, 1981).

Lawrence, D. H. *The Letters of D. H. Lawrewnce,* ed. Aldous Huxley (New York: Viking 1932).

———. *The Rainbow* (New York: Viking, 1961; orig. ed., 1915).

Leidy, Denise Patry. *The Cosmic Dancer: Shiva Nataraja* (New York: The Asia Society Galleries).

Little, Stephen. "The Cosmic Dancer: Shiva Natarja," *Honolulu Academy of Arts Calendar News* (September 1992).

Litz, A. Walton. *Introspective Voyager: The Poetic Development of Wallace Stevens* (New York: Oxford University Press, 1972).

Manet 1832-1883 (New York: Metropolitan Museum of Art, New York, 1983).

Mann, Thomas. *Death in Venice and Seven Other Stories by Thomas Mann*. Trans. H. T. Lowe Porter (New York: Vintage Books, 1936).

Marcus, Phillip. *Yeats and Artistic Power* (New York: New York University Press, 1992).

Martz, Louis. *The Poetry of Meditation*, 2nd ed. (New York: Yale University Press, 1962).

McNelly, Cleo. "Natives, Women, and Claude Levi-Strauss: A Reading of *Tristes Tropiques* as Myth." *Massachusetts Review* 16 (1975), 7-29.

Melville, Herman. *Moby Dick* (New York: Holt, Rinehart, & Winston, 1948; orig. ed., 1851).

Metropolitan Museum of Art, André Meyer Gallery. Fall of 1995 Vincent Van Gogh exhibit, "Self Portrait with Straw Hat" (1887) New York: Metropolitan Museum of Art.

Miller, J. Hillis. *The Form of Victorian Fiction* (Notre Dame, IN: Notre Dame University Press, 1968).

Miller, Jacques-Alain, ed. *The Four Fundamental Concepts of Psycho-Analysis*. (New York: Norton, 1981).

Mitchell, W. J. T. "*Ut Pictura Theoria*: Abstract Painting and the Repression of Language." *Critical Inquiry* 51, no. 2 (Winter 1989), 348-371.

Morris, Robert. "Words and Images in Modernism and Postmodernism" *Critical Inquiry* 51, no. 2 (Winter 1989), 337-347.

Mueller, Martin. "Yellow Stripes and Dead Armadillos," *Profession* 89, MLA (1989), 23-31.

Newman, Beth. "Getting Fixed: Feminine Identity and Scopic Crisis in *The Turn of the Screw*." *Novel* 26, no. 1 (Fall 1992-3), 49-63.

Perl, Jed. "The Founder" *The New Republic* (5 August 1996), 27-32.

Pollack, Griselda. *Avant-Garde Gambits 1888-1893: Gender and the Color of Art History* (New York: Thames and Hudson, 1992).

Pound, Ezra. "Vorticism." In Richard Ellmann and Charles Fiedelson, Jr., eds., *The Modern Tradition*: Backgrounds of Modern Literature (New York: Oxford University Press, 1965), 145-152.

Ransom, John Crowe. "Gerontion." *Sewanee Review* 74 (Spring 1966), 389-414.

Rhys, Jean. *Quartet* (New York: Carroll and Graf Publishers, 1969; orig. ed., 1929).

Richards, David. "The Jackhammer Voice of Mamet's 'Oleanna.'" *New York Times* (8 November 1992), 1.

Richardson, Joan, *Wallace Stevens: The Early Years, 1879-1923* (New York: William Morrow, 1986).

————. *Wallace Stevens: The Later Years 1923-1955* (New York: William Morrow, 1988).

Richardson, John. *A Life of Picasso, Vol I., 1881-1906, The Painter of Modern Life, Vol II., 1907-1917* (New York: Random House, 1996).

Rose, Barbara. *American Painting: The Twentieth Century* (New York: Rizzoli, 1969).

Rubin, William. "Introduction." In *Picasso and Braque: Pioneering Cubism* (New York: Museum of Modern Art, 1989).

Rubin, William, ed. *Pablo Picasso: A Retrospective* (New York: Museum of Modern Art, 1980).

————. *Picasso in the Collection of the Museum of Modern Art* (New York, 1972).

Russell, John. *The Meanings of Modern Art* (New York: Harper & Row, 1981).

Rye, Jane. *Futurism* (New York: Dutton, 1972).

Said, Edward W. *Culture and Imperialism* (New York: Alfred A. Knopf, 1993).

Schapiro, Meyer. *Paul Cézanne* (New York, H. N. Abrams, 1952).

Schneider, Pierre. *Matisse in Morocco: The Painting and Drawings 1912-13* (Washington, DC: The National Gallery of Art, 1990).

Schwarz, Daniel R. *Narrative and Representation in the Poetry of Wallace Stevens* (New York: St. Martin's, 1993).

————. *Reading Joyce's "Ulysses"* (New York: St. Martin's, 1987; rev. 1991).

————. *The Humanistic Heritage: Critical Theories of the English Novel from James to Hillis Miller* (Philadelphia, PA: University of Pennsylvania Press, 1986; revised, 1989).

————. *The Transformation of the English Novel, 1890-1930* (New York: St. Martin's Press, 1998; orig. ed., 1989).

Sieburth, Richard. "Dabbling in Damnation: The Bachelor, the Artist and the Dandy in Huysman." *Times Literary Supplement* (29 May 1992), 3-5.

Silver, Kenneth E. *Esprits de Corps: The Art of the Parisian Avant-Garde and the First World War, 1914-25* (Princeton, NJ: Princeton University Press, 1989).

Spacks, Patricia Meyer. "Introduction to *The Author in His Work*, Louis L. Martz and Aubrey Williams, eds. (New Haven, CT: Yale University Press, 1978), ix-xxix.

Steiner, Wendy. *Pictures of Romance: Form and Context in Painting and Literature* (Chicago: University of Chicago Press, 1968).

Stevens, Wallace. *Collected Poems* (New York: Alfred A. Knopf, 1954).

————. *Letters*, ed. Holly Stevens (New York: Alfred A. Knopf, 1966).

————. *The Necessary Angel: Essays on Reality and the Imagination* (New York: Alfred A. Knopf, 1951).

————. *Opus Posthumous*, ed. Milton Bates (New York: Alfred A. Knopf, 1989).

————. *Sur Plusieurs Beaux Sujects: Wallace Stevens's Commonplace Book*, ed.Milton Bates (Stanford, CA: Stanford University Press, 1989).

Stone, Wilfred. *The Cave and the Mountain: A Study of E. M. Forster* (Stanford, CA: Stanford University Press, 1966).

The Tate Gallery (London: Tate Gallery Publications, 1979).

Trilling, Lionel, ed. *The Portable Matthew Arnold* (New York: Viking, 1949).

Wadley, Nicholas, ed. *Noa Noa: Gauguin's Tahiti* (Oxford: Phaidon, 1985).

Willet, Frank. *African Art*, rev. ed. (New York: Thames and Hudson, 1993).

Woolf, Virginia. *The Captain's Death Bed and Other Essays* (New York: Harcourt, Brace, 1950).

————. *The Common Reader: First Series* (New York: Harcourt, Brace and World, 1925).

————. *The Diary of Virginia Woolf*, Vol. III., 1925-30, ed. Anne Oliver Bell with Andrew McNeillie (New York: Harcourt Brace Jovanovich, 1980).

————. "Mr. Bennett and Mrs. Brown." In *The Captain's Death Bed and Other Essays* (New York: Harcourt, Brace, 1950).

————. *To the Lighthouse* (New York: Harcourt, Brace and World, 1927).

Index